Art and Archaeology of the Erligang Civilization

Art and Archaeology of the
Erligang Civilization

Edited by Kyle Steinke with Dora C.Y. Ching

Robert Bagley

John Baines

Maggie Bickford

Roderick Campbell

Yung-ti Li

Robin McNeal

Kyle Steinke

Wang Haicheng

Zhang Changping

P.Y. and Kinmay W. Tang Center for East Asian Art
Department of Art and Archaeology, Princeton University

in association with PRINCETON UNIVERSITY PRESS

Published by
P.Y. and Kinmay W. Tang Center for East Asian Art
Department of Art and Archaeology
Princeton University
Princeton, New Jersey 08544-1018
princeton.edu/tang
in association with Princeton University Press

Distributed by
Princeton University Press
41 William Street
Princeton, New Jersey 08540-5237
press.princeton.edu

Library of Congress Control Number: 2013938186

ISBN: 978-0-691-15993-5 (cloth)
ISBN: 978-0-691-15994-2 (paperback)

British Library Cataloging-in-Publication Data is available

Managing Editor	Dora C.Y. Ching
Copyeditor	Laura Iwasaki
Map Maker	International Mapping Associates
Production	Marquand Books, Inc., Seattle
Color Management	iocolor, Seattle
Designer	Zach Hooker
Typesetter	Tina Henderson
Proofreader	Sharon Rose Vonasch
Indexer	Susan Stone

Printing and Binding C & C Offset Printing Co., Ltd., China

This book was typeset in Calluna and printed on 128 gsm Gold East matte.

Cover illustrations
Two *jue*, 14th century BCE. H. (left) 17 cm, (right) 20.1 cm. From Lijiazui Tomb 1, Panlongcheng, unearthed in 1974.

Design adapted from *zun*, 14th century BCE. H. 34.9 cm. Royal Ontario Museum, Toronto.

10 9 8 7 6 5 4 3 2 1

Contents

Contributors 7

Foreword and Acknowledgments 9

Preface 11

INTRODUCTION

1. Erligang Bronzes and the Discovery of the Erligang Culture 19
 Robert Bagley

2. Erligang: A Perspective from Panlongcheng 51
 Zhang Changping

DEFINING THE ERLIGANG CIVILIZATION

3. China's First Empire? Interpreting the Material Record
 of the Erligang Expansion 67
 Wang Haicheng

4. Civilizations and Empires: A Perspective on Erligang
 from Early Egypt 99
 John Baines

5. Erligang: A Tale of Two "Civilizations" 121
 Roderick Campbell

6. The Politics of Maps, Pottery, and Archaeology: Hidden
 Assumptions in Chinese Bronze Age Archaeology 137
 Yung-ti Li

ERLIGANG AND THE SOUTH

7. Erligang and the Southern Bronze Industries 151
 Kyle Steinke

8. Erligang Contacts South of the Yangzi River: The Expansion
 of Interaction Networks in Early Bronze Age Hunan 173
 Robin McNeal

PARTING THOUGHTS

9. Bronzes and the History of Chinese Art 191
 Maggie Bickford

References 213

Index 226

Image Credits 235

Contributors

Robert Bagley
Professor, Department of Art and Archaeology
Princeton University

John Baines
Professor of Egyptology
University of Oxford

Maggie Bickford
Professor Emerita of History of Art and Architecture
Brown University

Roderick Campbell
Assistant Professor of East Asian Archaeology and History
Institute for the Study of the Ancient World
New York University

Yung-ti Li
Assistant Research Fellow
Institute of History and Philology, Academia Sinica

Robin McNeal
Associate Professor of Pre-modern Chinese History and Literature
Department of Asian Studies, Cornell University

Kyle Steinke
PhD Candidate
Department of East Asian Studies
Princeton University

Wang Haicheng
Assistant Professor, Division of Art History
School of Art, University of Washington

Zhang Changping
Professor of Archaeology
Department of Archaeology, School of History
Wuhan University

Foreword and Acknowledgments

THE TANG CENTER FOR EAST ASIAN ART at Princeton University exists to enrich the scholarly communications of our faculty and students with other scholars, students, and the public community beyond our campus. We especially aim to provide our students with professional opportunities that enhance their education. This publication exemplifies, at its dramatic best, the unusual level of experience that the Tang Center makes possible. It is the final product of a sequence of events that began with a scholarly encounter in 2006 between Kyle Steinke, a Princeton graduate student in East Asian Studies, and archaeology professor and Bronze Age specialist Zhang Changping at the latter's institution, Wuhan University, where Kyle had gone to examine bronzes from Panlongcheng. Professor Zhang's offer to lend some of these bronzes for exhibition in the United States led to a return visit to Wuhan in 2007 by Kyle and his dissertation advisor, Professor Robert Bagley. The exhibition never materialized, but in 2008 a visiting fellowship at Princeton for Zhang Changping followed, coinciding with the international symposium "Art and Archaeology of the Erligang Civilization" in April of that year. The Tang Center had the privilege of sponsoring both the fellowship and the conference. Professor Bagley, who provided ongoing consultation, describes Kyle as "the motive force" at every stage of the conference, including selecting the speakers, planning the schedule, and reading drafts of many of the papers. This sequence now concludes with this publication of papers from the conference, the first book in a Western language devoted to the Erligang culture, edited by Kyle Steinke with Dora C.Y. Ching, associate director of the Tang Center, who also served as managing editor.

We are grateful to Kyle Steinke for the enormous amount of planning and energy he has put into every aspect of this project over the last four years, and particularly for his careful work with the individual authors and their presentations. Dora Ching provided valuable publishing experience and mentorship at every level, from book contracts to editing to page design and image proofing.

For his ongoing consultation and advice, based on his own Erligang expertise, we are most grateful to Professor Robert Bagley. We also owe a debt of gratitude to Vice Provost for Academic Programs Katherine Rohrer for her unstinting support of this project.

For their unique individual contributions to this volume, we especially thank each of the authors, who have been highly creative, responsive to our many requests and deadlines, and wonderfully patient.

For their irreplaceable help in book production, we are grateful to Marquand Books in Seattle. We thank Zach Hooker, our designer, who was creative and responsive to our every request. Copyeditor and proofreader Laura Iwasaki, who works with unusually high standards, was especially valuable to us. International Mapping Associates created the wonderful maps found throughout the book. Color management was provided by icolor, also in Seattle. Proofreader Sharon Rose Vonasch and indexer Susan Stone helped greatly to bring this volume to its current high level of reliability. Here at Princeton, Christopher (Kit) Moss provided excellent input and advice whenever asked. Kim Sum (Sammy) Li, a graduate student who works with Professor Bagley, provided highly reliable backup for typing Chinese characters and checking references, as well as proofreading Chinese.

We are grateful to the Barr Ferree Foundation Fund for Publications, Princeton University, for a generous subvention which underwrote the lavish number of illustrations in color and black and white, and made it possible to publish this volume in both cloth and paper editions.

Finally, as with every project we are involved in, we are pleased to express our special gratitude to the Tang family for making all the stages of this project possible.

Jerome Silbergeld
Director, P.Y. and Kinmay W. Tang Center for East Asian Art
P.Y. and Kinmay W. Tang Professor of Art History
Princeton University

Preface

WHEN I BEGAN to organize the conference that led to this volume, one of my first tasks was to design a mission statement that would explain to participants and to our general audience what the conference would be about and what we hoped to accomplish. The goals it sets forth are shared by this book:

> Named after a type site discovered in Zhengzhou in 1951, the Erligang civilization arose in the Yellow River valley around the middle of the second millennium BCE. Shortly thereafter, its distinctive elite material culture spread to a large part of China's Central Plain, in the south reaching as far as the banks of the Yangzi River. Source of most of the cultural achievements familiarly associated with the more famous Anyang site, the Erligang culture is best known for the Zhengzhou remains, a smaller city at Panlongcheng in Hubei, and a large-scale bronze industry of remarkable artistic and technological sophistication. Bronzes are the hallmark of Erligang elite material culture. They are also the archaeologist's main evidence for understanding the transmission of bronze metallurgy to the cultures of southern China.
>
> This conference brings together scholars from a variety of disciplines to explore what is known about the Erligang culture and its art, its spectacular bronze industry in particular. Participants will ask how the Erligang artistic and technological tradition was formed and how we should understand its legacy to the later cultures of north and south China. Comparison with other ancient civilizations will afford an important perspective.

To the goals stated above may be added one more—to bring the Erligang civilization to the attention of a wider audience. Sixty years have now passed since the discovery of the Erligang site, but the Erligang culture is still as unfamiliar as it is poorly understood. This volume aims to change that. For sixty years, Erligang has been filed under the heading "Shang archaeology," an unsubstantiated affiliation that risks distorting our view of the archaeological evidence by filtering it through the lens of much later historical texts. Nothing but contemporary written evidence could tell us the political identity of the rulers of the Erligang state. Insisting on a connection with the Shang dynasty attested later at Anyang shifts attention to the more thoroughly explored Anyang site and obscures the role of Erligang in the rise of civilization in East Asia.

But the absence of written sources contemporary with Erligang does not leave us helpless. Archaeology has revealed a startling wealth of Erligang material remains. We must address the problem of how to interpret the archaeological record on its own terms. To do that, we need to release ourselves from the preoccupations of later textual traditions and begin to explore the Erligang civilization with fresh eyes.

How do we approach the Erligang material record without the aid of contemporary texts and without the interference of later ones? In some way, every contributor to the volume has had to grapple with this problem. In the remainder of this preface, I would like to introduce their papers and the different methodological tools they use, from art history to cross-cultural comparison.

The volume opens with the introductory chapters of Robert Bagley and Zhang Changping. In chapter 1, Bagley discusses how the discovery of the Anyang site and

its subsequent excavation by Li Ji in the 1930s shaped interpretations of the origin of civilization in China. He traces Li Ji's thinking as Li attempted to "account for the sudden appearance of a whole complex of cultural possessions: rammed-earth construction, chariots, human sacrifice, writing, and bronze metallurgy" as the product of cultural contact involving prehistoric cultures in China and civilizations in the Near East. Bagley then describes how discoveries of Erligang bronzes and cultural sites beginning in the 1950s began to transform our view of the rise of civilization in East Asia. He closes by pointing out that important cultural contributions commonly credited to Anyang actually belong to the Erligang culture. In order to see them more clearly, he says, we must approach Erligang as a prehistorian would, "through material artifacts and cross-cultural comparison" without presuppositions derived from later texts.

In chapter 2, Zhang Changping turns from the Central Plain to southern Hubei and the Erligang city at Panlongcheng. With most of the Erligang city at Zhengzhou buried under the modern city, Zhang shows that the Panlongcheng site can tell us things about the Erligang culture that we cannot learn from Zhengzhou. His chapter sets out the history of the discovery and interpretation of the Panlongcheng site and explains its connection to Erligang finds in the Central Plain. Pointing out that the richest Erligang tombs ever found belong to the cemetery at Panlongcheng, he notes that the bronzes found in them allow us to study aspects of Erligang social stratification not currently accessible to study at Zhengzhou.

The next two chapters employ one of the primary tools of the prehistorian, cross-cultural comparison. In chapters 3 and 4, Wang Haicheng and John Baines throw light on the expansion of the Erligang state by examining similar instances of sudden, large-scale disseminations of elite material culture elsewhere in the ancient world. Wang focuses on comparisons with ancient Mesopotamia, the Indus Valley, and the Olmec civilization; Baines offers a close reading of possible Egyptian parallels.

Acknowledging the great difficulty of reading political events out of the geographic distributions of material remains, Wang proposes a stratified definition of the Erligang culture that recognizes the different social mechanisms by which different classes of object enter the archaeological record. His analysis of the organization of the Erligang state focuses on two kinds of object, ritual bronzes and utilitarian ceramics, and asks what each kind can tell us about the nature of the Erligang state. He then assesses comparative models of empire that center on resource procurement and trade and suggests an alternative that takes into account ideological motives.

In a response to Wang's chapter, Baines presents a detailed comparison between developments during the early Bronze Age in the Central Plain and during the period in Egypt that offers the closest parallels, Naqada IIIA–B. He stresses the complexities involved in making close cross-cultural comparison and provides a wealth of detailed examples. Baines notes that the consequences of the Erligang polity's expansion were dramatically different from those of the Egyptian extensions into Lower Nubia and that both used very different strategies in interactions with local populations. He closes by discussing the different patterns of material culture in Egypt and Erligang, giving special attention to the social implications of inventories of elite and nonelite material culture.

Roderick Campbell and Yung-ti Li turn our attention inward to the problem of diachronic comparisons between early Bronze Age sites within the Central Plain. Campbell opens chapter 5 by pointing out the shift in recent archaeological theory from definitions of civilization based on social-evolutionary typology to ones that seek to identify "a cultural order and sets of central symbols through which the rule of a coterie of inner elites was legitimated." Taking into account both definitions, he first explores the indexes for the scale and complexity of the

Erligang state by comparing architectural and ceremonial works at Zhengzhou as well as the geographic distribution of Erligang elite material culture with the evidence from earlier and later states at Erlitou and Anyang. He then looks at a suite of practices and artifacts that were the foci of political power at Erlitou, Erligang, and Anyang and concludes that "the central symbols of the Erligang world order and their social economies of production were similar to those found at Erlitou and Anyang whatever their exact articulation with power."

Yung-ti Li sees the archaeological record very differently, putting his emphasis on discontinuities between successive early Bronze Age polities in the Central Plain. In chapter 6, suggesting that a set of unexamined assumptions stemming from traditional Chinese historiography has interfered with the archaeological study of the Erligang civilization, he traces the influence of traditional dynastic models on the territorial maps of early Bronze Age states created by archaeologists and on their use of data from the geographic distribution of pottery remains. He concludes that the dynastic model that grew up around historical research at the Anyang site is both incompatible with the Anyang-period archaeological record and inappropriate to earlier Bronze Age states in the Central Plain. Li proposes that a new model of interregional interaction is needed in order to rescue archaeological research from a model supplied by traditional historiography.

The next section continues the research program that Li suggests by turning away from the Central Plain to cultures in the south that were contemporary with Erligang and Anyang. After the Erligang expansion, the archaeological record of China looks very different. Most notable are the beginnings of the first large-scale bronze-using societies outside the Central Plain. The most impressive are in the south. Chapters 7 and 8 discuss the impact of the Erligang expansion on this region.

In chapter 7, I explore the potential of art history to inform archaeological analysis. Relying on close art historical readings of bronzes, I suggest that Panlongcheng and points east felt the initial impact of the Erligang expansion in the south. I introduce the bronzes found at Xingan Dayangzhou in Jiangxi province as the earliest evidence for a large-scale bronze industry south of the Yangzi and then examine their connections with other early bronze finds in the lower Yangzi region. In conclusion, I discuss possible motives for Erligang settlements in the south and make a case for the existence of sophisticated societies in the lower Yangzi region before the moment of contact.

In chapter 8, Robin McNeal explores the emergence of bronze-using cultures in Hunan. Giving careful attention to topographic features, he traces a group of interaction networks that were central to the rise of civilization in Hunan. As he describes it, this region seems to have been rather different from the lower Yangzi region: he draws a picture of early Hunan as a "perpetual frontier." McNeal argues that Panlongcheng was just one hub in a complex of intersecting and overlapping networks that connected the Erligang culture with Hunan, acting as a "conduit for power, ideas, goods, people, and practices."

Chapter 9 closes the volume with the thoughts of Maggie Bickford, a historian of Chinese painting, on the value of the study of Erligang bronzes for art history. She makes a case that sophisticated methodological tools were developed in the field of bronze studies precisely because the art historian studying bronzes could not rely on textual sources for explanations of the objects. The study of early bronzes "calls for the fundamental skills of the art historian—sustained, directed observation, rigorous visual thinking, precise articulation." These, she says, are the skills necessary for an object-oriented approach to art history, an approach that emphasizes an understanding of the materiality of the object and the visual thinking behind it. Bickford concludes by drawing attention to the problems that confront the field of Chinese painting when art historical work of the type practiced in bronze studies destabilizes the master narratives of the field.

It is a pleasure to record my debt to the friends and colleagues whose unstinting labors produced first the Erligang conference and now this book. At the conference, Alain Thote, Directeur d'Études, École Pratique des Hautes Études, Paris, served as discussant, while Magnus Fiskesjö, associate professor of anthropology at Cornell University, and Jay Xu, director of the Asian Art Museum of San Francisco, served as session chairs. I am sure that the speakers join me in thanking them for their expert orchestration. The speakers, who have turned their presentations into splendid essays, have my deepest gratitude. They made the conference a success, and my job as editor satisfying and easy.

Two contributors deserve special mention. The first is Zhang Changping, whose zeal to make Panlongcheng and its bronzes better known laid the foundation for both the conference and the book. Several speakers are in Professor Zhang's debt for opportunities to examine with him the bronzes in the Hubei Institute of Cultural Relics and Archaeology. To him I owe also the opportunity to make the new photographs of the bronzes that are reproduced throughout the volume. The second is Robert Bagley, who published the first English-language article on Panlongcheng in 1977 and has been a pioneer in the study of Erligang ever since. His work was a major inspiration behind this project, and his advice and expertise have been invaluable.

This book would not have been possible without the generous support of the P.Y. and Kinmay W. Tang Center for East Asian Art. I am grateful to the center's director, Jerome Silbergeld, and its associate director, Dora Ching, for bringing this volume to press, and to Dora, again, for her hard work as managing editor. My thanks go also to Laura Iwasaki for her meticulous copyediting and to International Mapping Associates for their fine maps.

My parents, Kari and Greg, were a dependable source of encouragement throughout the editing process. The patience and good humor of my wife, Zoe, made even the most time-consuming tasks easy to bear. It is to my family that I dedicate my editorial efforts.

Kyle Steinke
Princeton, New Jersey

Introduction

Erligang Bronzes and the Discovery of the Erligang Culture

Robert Bagley

AS OPENING SPEAKER at the conference that produced this volume, my assignment was to make a start on the task we set ourselves for the conference as a whole: we wanted to introduce the Erligang civilization and to make a case that it deserves to be better known. The time that concerns us is about 1500–1300 BCE. This is the beginning of the Bronze Age in China—the beginning of civilization in East Asia, in fact—and our subject is an archaeological culture, that is, a culture defined purely in terms of material artifacts. The culture was discovered in 1951, in the middle Yellow River valley, at a place called Erligang in the modern city of Zhengzhou (map 1), and the material found there is taken to define it. In archaeological parlance, Erligang is the type site of the Erligang culture. Since 1951, related material has turned up at many other spots in and around Zhengzhou.

It has also turned up at places farther away. Zhengzhou is still the largest Erligang site known, but it is no longer the only one. Especially rich finds have been made at Panlongcheng, a site near the Yangzi River (Changjiang) on the outskirts of modern Wuhan. We call Panlongcheng a site of the Erligang culture because the material remains found there are a close match for the finds at the type site 450 kilometers to the north: bronze vessels unearthed at Panlongcheng are indistinguishable from vessels unearthed at Zhengzhou. Bronzes just like them have in fact been found over a large area of north and central China. Several of the chapters that follow will explore the implications of this geographic distribution.

Although the Erligang culture was not discovered until 1951, Erligang bronzes were known long before. The *he* shown in figure 1—a tripod with hollow legs, domed cover, tubular spout, and two-part strap handle—was in the Berlin Museum by 1929. The *zun* of figure 2 was offered for sale by a Paris antique dealer in 1924. The *jia* in figure 3 was in a Swedish collection by 1937. The *gu* in figure 4 was in the collection of the Qianlong emperor in the eighteenth century. Erligang bronzes have always been with us, so to speak. The problem was to recognize them. By that I mean two things: first, to recognize them as a distinct and early subset of the corpus of ancient bronzes; and second, to find a place for them in the archaeological record, to find the archaeological remains of the society that produced them. By 1955, both of those things had been accomplished, the first by a Western art historian and the second by Chinese archaeologists.

Nowadays, of course, Erligang bronzes are reasonably familiar, at least to specialists, so it may seem strange that recognizing them could ever have been a problem. But in 1924, the dealer who owned the *zun* of figure 2 called it Zhou. Since the Zhou period lasted close to a millennium, from the late eleventh century to 221 BCE, that is not a very precise date, and it is too late by at least four centuries, but it was not a bad guess at the time. Before 1955, when examples turned up at the Zhengzhou site, Erligang bronzes were not easy to isolate and focus on because

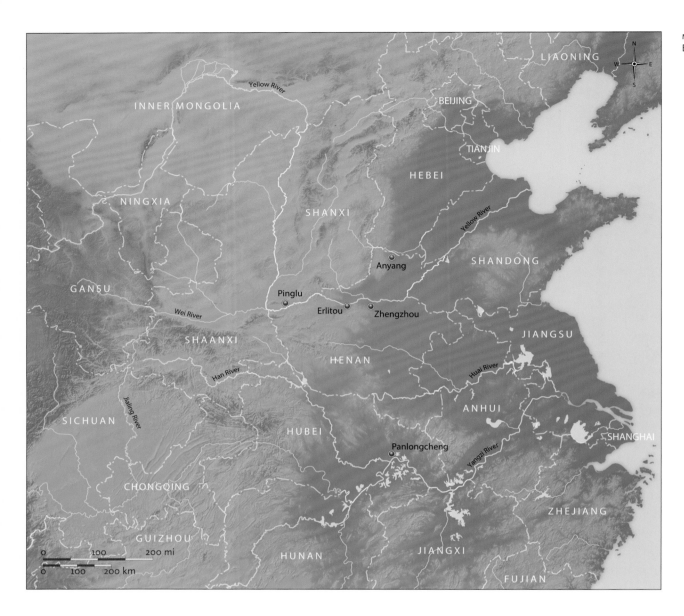

MAP 1. Archaeological sites of early Bronze Age China.

they were lost in the crowd, mixed up with a very much larger number of bronzes from later periods.

Bronzes like the two in figures 5 and 6 were much more familiar, and they still are: monumental, almost architectural objects, covered with decoration, often high-relief decoration. Of course, these bronzes too were known to collectors long before archaeologists supplied an identity for them. The archaeological culture that produced them was discovered in 1928. Between 1928 and 1937, an expedition sponsored by the Chinese government carried out a series of excavations at modern Anyang, 160 kilometers north of Zhengzhou. The expedition was headed by Li Ji (Li Chi; 1896–1979), an archaeologist who had been trained at Harvard (he entered the Harvard anthropology department in 1920 and received his PhD in 1923). Anyang was the birthplace of Chinese archaeology. Li Ji believed that it was also the birthplace of Chinese civilization.

The Anyang finds were abundant and extraordinary. Among the first discoveries were groups of large foundations, the rammed-earth foundations of wooden buildings large enough to have been palaces (fig. 7). A vertical section cut through one of them shows the successive layers of soil hammered hard (fig. 8).

FIGURE 1. *He*, 15th century BCE. H. 31.7 cm. Formerly in the Berlin Museum; whereabouts unknown (lost in World War II).

FIGURE 2. *Zun*, 14th century BCE. H. 34.9 cm. Royal Ontario Museum, Toronto.

FIGURE 3. *Jia*, 14th century BCE. H. 29 cm. Museum of Far Eastern Antiquities, Stockholm.

FIGURE 4. *Gu*, 14th century BCE. H. 16.3 cm.

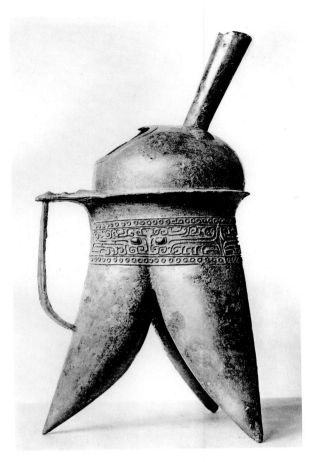

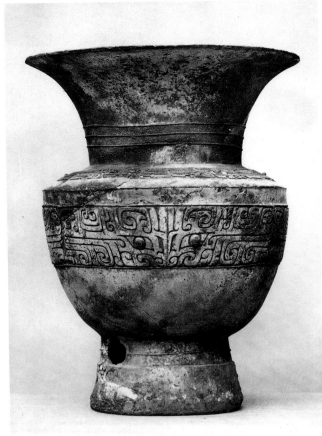

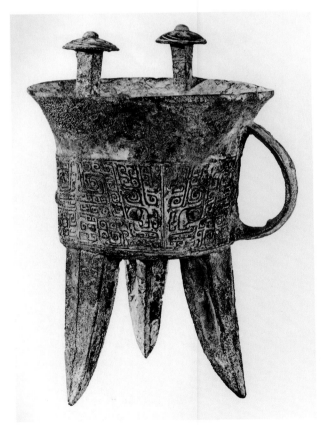

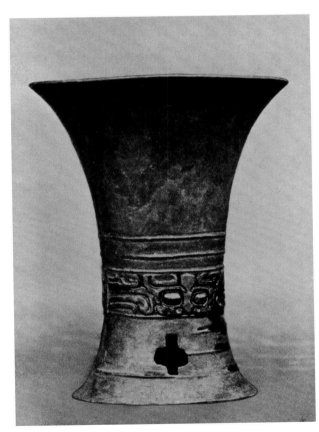

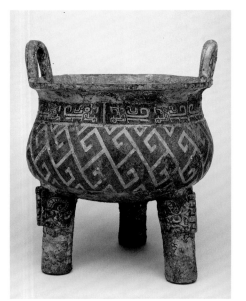
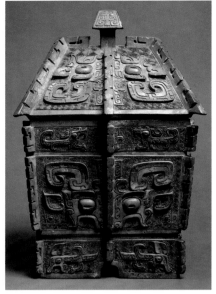

FIGURE 5. *Ding*, 12th century BCE. H. 33.9 cm. Royal Ontario Museum, Toronto.

FIGURE 6. *Fangyi*, 12th century BCE, with detail. H. 30.2 cm. Harvard Art Museums/Arthur M. Sackler Museum, Bequest of Grenville L. Winthrop (1943.52.109).

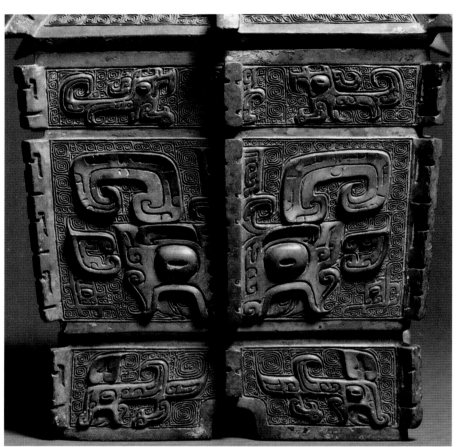

In 1934, across the Huan River from the palaces, the excavators found a dozen enormous shaft tombs with rammed-earth walls and gruesome evidence of human sacrifice (figs. 9, 10). In and around the tombs, they found traces of buried chariots. They did not succeed in recovering complete chariots—the chariot burial shown in figure 11 was excavated in 1987—but they found chariot remains, and Li Ji took these as evidence that Anyang was in contact with Western Asia. Large tombs with human sacrifice reminded him of the royal tombs at Ur in Mesopotamia that Leonard Woolley (1880–1960) had just discovered in 1927 and 1928.

The excavators also recovered bronze vessels, but only the ones that had been overlooked by tomb robbers, a tiny fraction of what the great tombs must once have contained. The two seen in figures 12–14 are by far the largest and finest. Not

FIGURE 7. Building foundation at
Xiaotun, Anyang.

FIGURE 8. Vertical cross section of a
rammed-earth foundation at Xiaotun.

FIGURE 9. Xibeigang Tomb 1217,
Anyang, during excavation, 1935.

FIGURE 10. Skulls on ramp of
Xibeigang Tomb 1550.

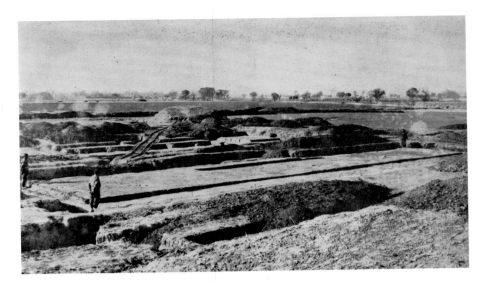

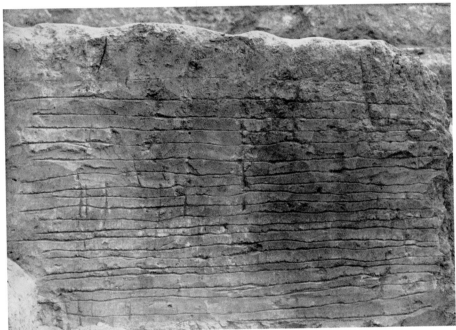

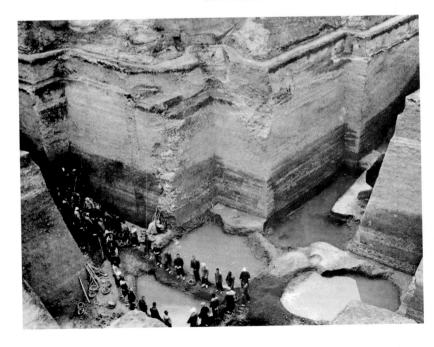

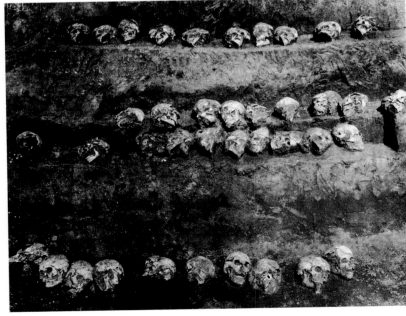

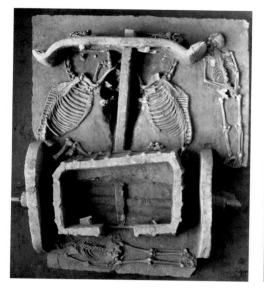

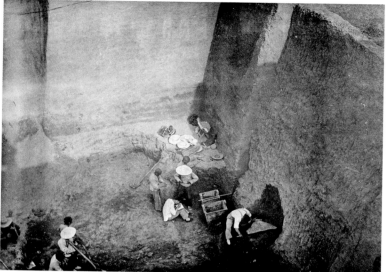

FIGURE 11. Chariot burial, 11th century BCE. From Guojiazhuang Tomb 52, Anyang.

FIGURE 12. Xibeigang Tomb 1004, with *fangding* pair in situ.

FIGURE 13. Xibeigang Tomb 1004, with *fangding* pair in situ.

FIGURE 14. *Fangding*, ca. 1200 BCE. H. 73.3 cm. From Xibeigang Tomb 1004.

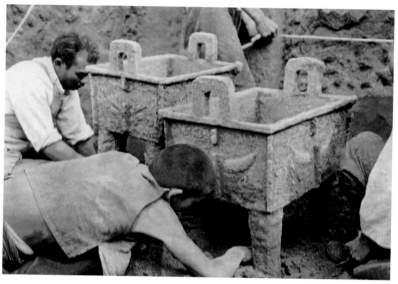

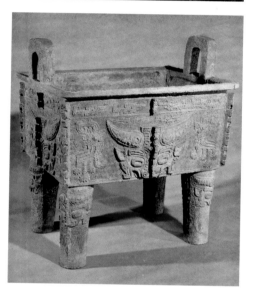

only had the tombs been looted in antiquity, they were still being looted. The vessel in figure 15, one of a set of three, was found by tomb robbers plying their trade across the river from the archaeologists. It was Li Ji's investigation of the robbery that led the archaeologists to the shaft tombs.

Finally, Anyang yielded what is still the earliest substantial corpus of Chinese writing and the earliest record of an East Asian language. It takes the form of inscriptions on shells and bones that the Anyang rulers used for divination. Inscribed oracle bones dug up by farmers had come onto the antiques market as early as 1898 or 1899; a decade later, a scholar named Luo Zhenyu (1866–1940) traced them to Anyang. Two decades after that, when the government sent Li Ji and his colleagues to excavate at Anyang, the oracle bones were the reason. Figure 16 shows a major recent discovery, a large deposit of turtle shells. Figure 17 shows a shell found in 1936 on which the writing was done in brush and ink. Brush and ink were the medium of everyday writing at Anyang, but brush writing seldom survives because the surface on which it was normally done was perishable wood or bamboo strips. Information given in the shell and bone inscriptions made it possible to identify the rulers for whom the divinations were performed: they were nine kings of a dynasty that later historical traditions call Shang, and they lived in the last two centuries of the second millennium BCE. To this day, Anyang is still the oldest site in China with inscriptions that connect it with the later written record.

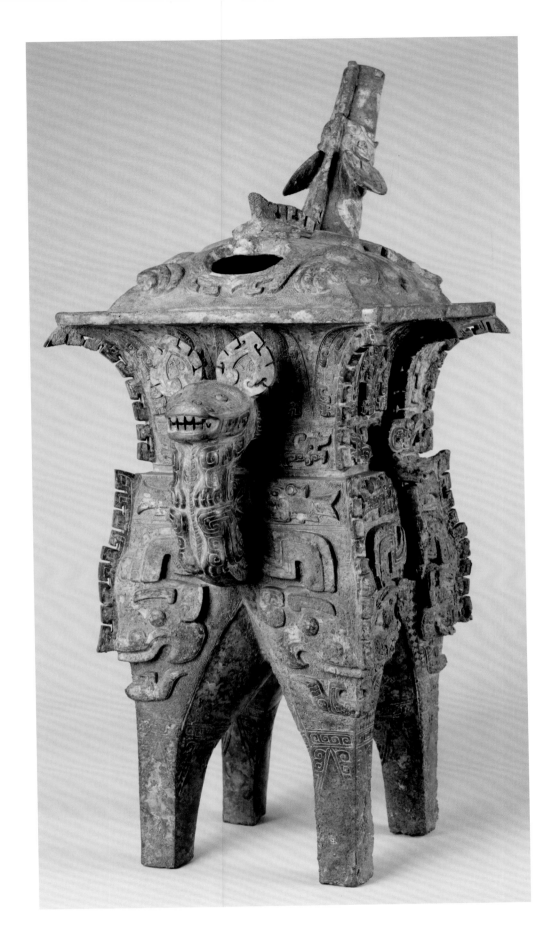

FIGURE 15. *He*, ca. 1200 BCE, one of three from Xibeigang Tomb 1001. H. 73 cm. Nezu Museum, Tokyo.

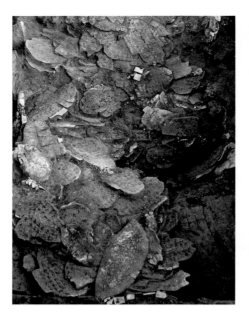

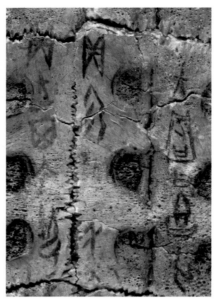

FIGURE 16. Oracle-bone pit deposit at Huayuanzhuang Dongdi, Anyang, excavated in 1991.

FIGURE 17. Turtle plastron (*Yibian* 3380) with brush-written inscription, reign of Wu Ding, ca. 1200 BCE.

The writing on the oracle bones is the oldest Chinese writing we have, but it cannot be the first. The writing system we encounter at Anyang in 1200 BCE is capable of transcribing speech; it is a fully developed system whose origins must lie further back. How and where did it come into being? The other Anyang discoveries raise the same question. Neither the writing nor the bronze industry nor anything else looks like a beginning. So the Anyang finds were not only sensational, they were puzzling. Where did this civilization come from?

Li Ji's answer to that question was conditioned both by his Western training and by his understanding of the Anyang stratigraphy. At one part of the site, he found the Bronze Age Anyang culture lying directly on top of some Neolithic levels. He thought this might mean that nothing intervened between the Neolithic and the Anyang culture; it might mean that the Anyang civilization appeared suddenly, fully formed. He had not encountered a more primitive phase of the Bronze Age at any other site, and his Western education had taught him that he should not necessarily expect to.

In the first half of the twentieth century, Western prehistorians believed that civilization had only one birthplace, the ancient Near East. They believed that civilization everywhere else was the result of cultural contact—ultimately, contact with the Near East. This is perfectly understandable if we can think ourselves back to their time. In the 1930s, the oldest civilizations of the Near East were recent discoveries. Their scripts had only recently been deciphered. Their cultural achievements and their immense antiquity were the stuff of newspaper headlines. Tutankhamun's tomb was discovered in 1922, and while Tutankhamun comes very late in Egyptian history, he was a century earlier than the Anyang kings. By comparison with Egypt and Mesopotamia, the rest of the world is young. By the 1930s, prehistorians had become accustomed to the idea that Europe got its civilization from the Near East, and they saw no reason to suppose that the story might be different anywhere else in the world. On the contrary, since the chariot was invented in the West, Li Ji's excavations seemed to be confirming their assumptions.

So for Li Ji—the product of a Western education—it was not automatic to look for older sites in China that might show the Anyang culture at an earlier stage of development. He had not been taught to look for the slow, step-by-step emergence of a civilization. He had been taught that isolated, undisturbed cultures do not change; cultural changes are caused by the spread of ideas or the movement of people. Believing that civilizations are brought into being by cultural contact, he guessed that Chinese civilization was the more or less instantaneous product of a

collision of cultures. The cultures he thought collided were mostly Neolithic and mostly indigenous to East Asia, but he suspected contributions from the civilized Near East as well. He did not believe that Chinese civilization developed gradually. He believed that the Anyang culture came into being suddenly, the moment all the necessary ingredients were brought together.

He therefore tried to separate out the various ingredients and trace them to their sources. His problem was to account for the sudden appearance of a whole complex of cultural possessions: rammed-earth construction, chariots, human sacrifice, writing, and bronze metallurgy. He had more to say about some of these than others, but the one that was really central to his thinking—and to everybody else's thinking too—was bronze metallurgy. Bronze claimed attention for two reasons. First, bronze vessels are by far the most abundant and most spectacular material artifacts that survive from China's antiquity. And second, metallurgy has always been regarded as one of the two most remarkable intellectual achievements of prehistoric times, the other being writing. In the first half of the twentieth century, the standard argument for the dependence of other civilizations on the Near East was that writing and metallurgy simply could not have been invented twice.

Li Ji therefore looked at bronzes like the ones in figures 5 and 6 and dissected them into contributions from several different sources. He thought that rounded vessel shapes must copy pottery prototypes, either the pottery of Anyang itself or a kind of Neolithic pottery he knew from a site in eastern China, in Shandong province. As for rectangular shapes, he thought they must copy vessels made from wooden planks. They must derive from a lost art of wood carving.

And he thought that the bronze decoration had two main sources. The Neolithic pottery of eastern China was mostly undecorated, but the pottery of northwest China was often painted with running spirals and other geometric motifs a little like the zigzag in figure 5. So Li Ji thought that the geometric motifs in bronze must be copied from the painted pottery; and the painted pottery, in the view of most scholars, came to China from the Near East. On the other hand the animal motifs were nowhere to be found in pottery. Li Ji speculated that animal-based decoration came from the same lost wood-carving tradition that supplied the rectangular shapes.

That culture of wood carving, unlike the two Neolithic cultures, was unknown to archaeology, presumably because its wooden artifacts had decayed away. It was purely hypothetical. But Li Ji thought that the decoration in figure 6 looked carved, and I would certainly agree. It reminded him of the wood carving of the American Northwest Coast Indians, which he knew from the work of Franz Boas (1858–1942), so he postulated an ancient culture of forest-dwelling hunters in eastern Mongolia and southern Siberia with an art of wood carving centered on the animals they hunted. Since the Anyang divination inscriptions mention royal hunting expeditions, he guessed that the Anyang ruling class came from a northern culture that was ancestral to a whole Pacific Rim tradition of wood carving. Perhaps he thought of its arrival as a sort of prehistoric Manchu conquest.

Thus, for Li Ji, the bronzes combined shapes and decorations from three different cultural traditions: the Painted Pottery Neolithic, which might be indebted to the Near East, and two traditions indigenous to East Asia, the Neolithic of eastern China and some hypothetical northern wood-carvers. What was the final ingredient in the mix? The final ingredient was the material, bronze. Li Ji believed that a fully developed indigenous art in pottery and wood was simply translated into a new medium the instant metal became available.

Now, Li Ji never really says where he thinks metallurgy came from; on that point he is rather coy. Reading between the lines, I have the feeling that he hoped it was a Chinese invention but feared that it came from the Near East. He clearly did not believe that it came from those hunting, wood-carving, forest-dwelling

FIGURE 18. Part of the mold for a *fangyi*, 12th or 11th century BCE. H. 25 cm, w. 11.2 cm, thickness 4.8 cm. Unearthed at Anyang Miaopu Beidi.

predecessors of the Anyang ruling class. He says rather vaguely that the hunters might have acquired metallurgy by conquering a metal-using people; and those metal-using people, he speculates, might have been located in the northwest . . . in Painted Pottery territory.

Before I go any further, let me take a moment to remove Li Ji's hypothetical wood-carvers from the picture. Li Ji believed that carved decoration could only have come from wood carving, and that rectangular shapes could only have come from making things with wooden planks. It did not occur to him that prehistoric woodworkers using stone tools do not saw wood into planks. He should have asked himself how the bronzes themselves were made. The bronze casters were using a piece-mold process in which the first step was to make a clay model of the vessel that was to be cast. To make a vessel like the one in figure 6, you begin by making a clay model that looks just like it. Then you form the clay pieces of the mold against the model.

Figure 18 shows two adjacent pieces of a clay mold from an Anyang foundry site. Together, they produced one side of a vessel like the one shown in figure 6. Flat-sided vessel types are a natural invention for the piece-mold caster because flat mold pieces are easy to work with—easy to cut decoration into, easy to withdraw from a model that already has decoration on it. As for the carved quality of the decoration, the bronze decoration *looks* carved because it *was* carved—into the clay of the mold or model. What looked to Li Ji like wood carving is in fact much less natural to wood carving than to piece-mold casting. This means that we cannot blame the animal motifs on a forest-dwelling hunter aristocracy. The forest aristocrats did not exist, and the animals came from somewhere else.

But the way Li Ji was thinking about the bronzes neatly epitomizes his model for the origin of Chinese civilization as a whole. The elements we might call "culturally distinctive" are contributed by an indigenous prehistory, while the civilized high technology that catalyzes everything comes from—well, as I said, he is a little evasive about where it comes from, but he was certainly very conscious of the possibility that it came from the Near East. (Western scholars took for granted a Near Eastern origin for the Chinese writing system; Li Ji's instincts rebelled, I

FIGURE 19. Zhengzhou city wall.

FIGURE 20. Vertical cross section of
Zhengzhou city wall.

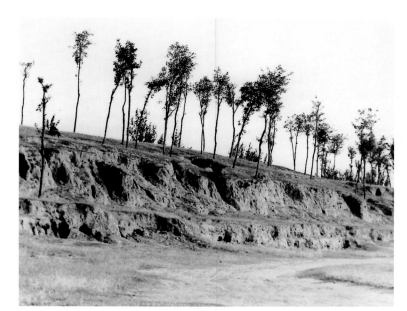 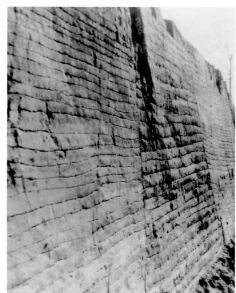

am sure, but lacking arguments with which to contest the point, he avoided it.)
Whatever the exact weight he gave to Western contributions, Li Ji believed that
the sudden appearance of a full-grown Bronze Age civilization at the Anyang site
in 1200 BCE was the result of cultural mixing and outside stimulus. When the
ingredients came together, Chinese civilization crystallized, China jumped from
the Neolithic to the Bronze Age. This is a scenario that would have made perfect
sense to any prehistorian of his generation, Western or Chinese. And it is a sce-
nario, notice, that does not send us out looking for a pre-Anyang Bronze Age. Li
Ji did not look for pre-Anyang bronzes because he did not think there were any.

Times changed. Li Ji was publishing the ideas I have summarized here in the
1940s and 1950s. With the founding of the People's Republic of China in 1949,
he and most of his fellow excavators moved to Taiwan, while on the mainland a
government with strong international connections was replaced by an isolationist
one. The new regime was not prepared to admit any outside contribution to the
formation of Chinese civilization; discovering local antecedents became a politi-
cal imperative. Postwar shifts in archaeological thinking in the West, driven by
the advent of radiocarbon dating and by growing awareness of pre-Columbian
civilizations, were entirely in sympathy with this reorientation. To a new genera-
tion of archaeologists, there was nothing at all obvious about Li Ji's belief that
Anyang represented "the beginnings of Chinese civilization." The new generation
was strongly disposed to believe that an earlier phase of the Bronze Age would be
found locally.

It was in this altered intellectual climate that some ancient pottery turned up
in 1951 at a place called Erligang. Experts studied the pottery and decided that
the settlement at Erligang was related to Anyang but older. Then, in 1955, the
rammed-earth city wall shown in figures 19 and 20 was recognized as an early
Bronze Age construction and a few graves with bronzes were discovered. Since
the wall has a circumference of seven kilometers, it established immediately that
Zhengzhou was an important place. In its day, it must have been the largest city
in East Asia. Unfortunately it is still one of East Asia's larger cities—it is today the
capital of Henan province—and this means that our knowledge of the ancient city
is very spotty. If Anyang is a household word and Erligang is not, the main reason
is that ancient Erligang is inaccessible beneath modern construction. Archaeolo-
gists cannot get at it.

Of the graves discovered in 1955, only four contained bronze vessels. The
graves were modest, and, as figures 21 and 22 show, the first publication of the

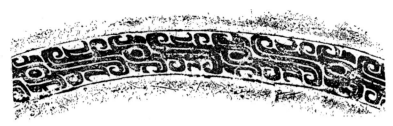

圖版十三銅盤頸部花紋拓本

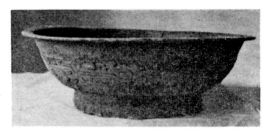

圖版十三　銅盤（墓2：3）

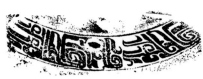

圖版十一銅尊肩部花紋拓本

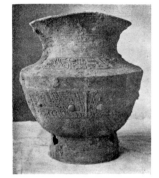

圖版十一　銅尊（墓3：9）

FIGURE 21. *Pan*, 14th century BCE, with rubbing of decoration. H. 10.5 cm, diam. 30 cm. From Baijiazhuang Tomb 2, Zhengzhou, unearthed in 1955.

FIGURE 22. *Zun*, 14th century BCE, with rubbing of decoration. H. 27.7 cm, diam. at mouth 19.5 cm. From Baijiazhuang Tomb 3, Zhengzhou, unearthed in 1955.

FIGURE 23. Bronzes, 14th century BCE. From Minggonglu Tomb 2, Zhengzhou, unearthed in 1965.

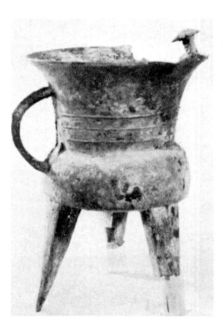

1. 斝（M2：20）

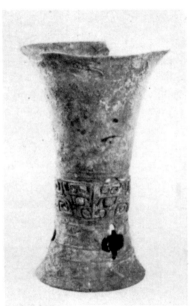

2. 觚（M2：8）

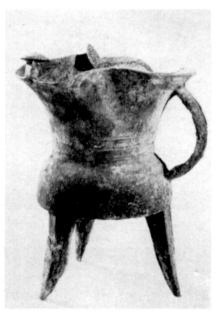

3. 斝（M2：7）

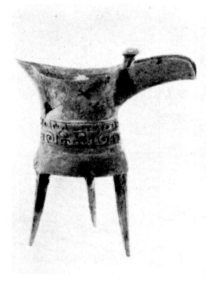

4. 爵（M2：21）

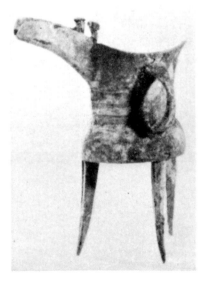

5. 爵（M2：22）

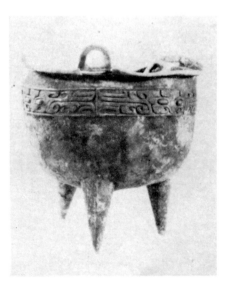

6. 鼎（M2：2）

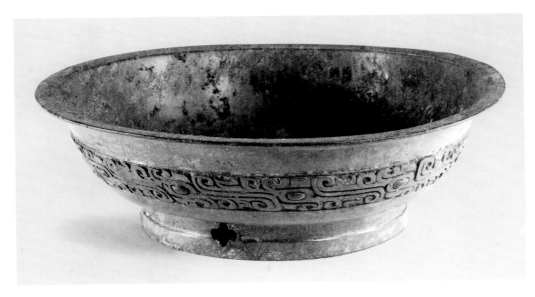

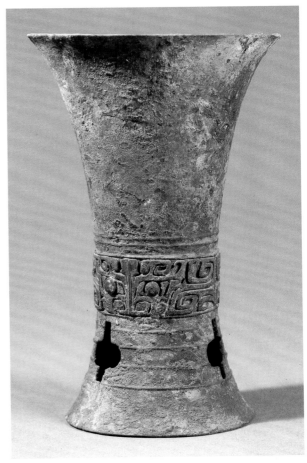

FIGURE 24. *Pan*, 14th century BCE, with rubbing of decoration. H. 10.5 cm, diam. at mouth 30 cm. From Baijiazhuang Tomb 2, Zhengzhou, unearthed in 1955.

FIGURE 25. *Gu*, 14th century BCE. H. 17.9 cm, diam. at mouth 10.9 cm. From Minggonglu Tomb 2, Zhengzhou, unearthed in 1965.

bronzes did not make a strong case for the achievements of Erligang casters. Nothing resembling a royal burial has ever been found at Zhengzhou—nothing befitting the ruler of a city with a wall seven kilometers long. Nevertheless, in 1955 it became possible to connect bronzes that had long been known to collectors with an archaeological site that is *older* than Anyang. The *zun* we saw in Paris in 1924 (fig. 2), for example, is not so very different from the one found at Zhengzhou in 1955 (fig. 22). Something close to Qianlong's *gu* (fig. 4) was found at Zhengzhou in 1965 (no. 2 in fig. 23).

Until the 1970s, the few excavated Erligang bronzes were poorly published, and very few people saw them firsthand. With nothing to feed it but illustrations like the ones in figures 21–23, the study of Erligang bronzes languished. Then, in the early 1970s, four important things happened. First, as the Cultural Revolution ended, some good picture books appeared, and it turned out that the *pan* shown in figure 21 actually looks more like what we see in figure 24. Second, the People's Republic began sending archaeological exhibitions overseas, and anybody who saw those exhibitions discovered that the *pan* in reality looks very much better than any photograph: it is an amazingly sharp casting, wonderful. Figure 25 is a good photograph of the Zhengzhou *gu* of figure 23. Both the *gu* and the *pan* visited Paris, London, and North America in 1973–75.

The third important development in Erligang studies was the excavation of the Panlongcheng site in 1974. Panlongcheng is in a rural area, mercifully free of skyscrapers. Although it was a much smaller city than the one at Zhengzhou, its excavators found a number of tombs with bronzes, two of them far richer than any burial yet discovered at Zhengzhou. Bronzes from the Panlongcheng tombs are shown in figures 26–34, 41, 43, 45, 51, and 52. Some of them, including the *jia* of figure 28, the *you* and *gui* of figures 31 and 32, and the *he* of figure 43, traveled abroad in those archaeological exhibitions in the 1970s and 1980s.

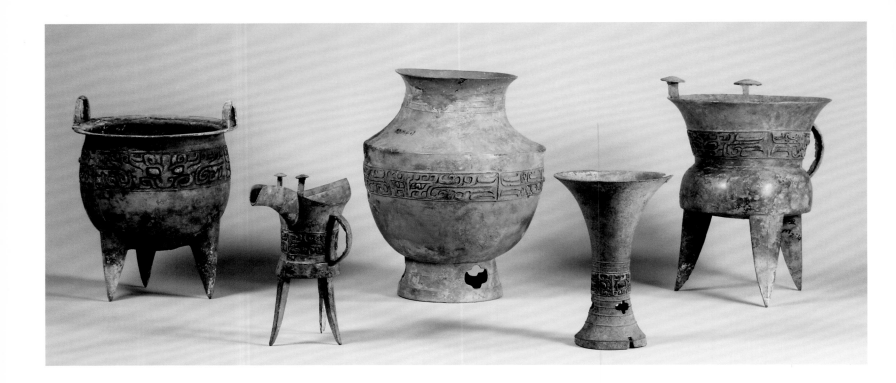

Erligang ritual required at least twenty bronze vessel shapes; almost all of them are represented in the Panlongcheng finds. The shapes fall into two main classes, tripods and ring-footed vessels (figs. 26, 27). Figure 28 shows a *jia*, a tripod with a round body, a strap handle, and two capped posts on the rim. Figure 29 shows a *ding*, a tripod cauldron with two loop handles on the rim. The ring-footed jar in figure 27 is called a *lei*. The ring-footed bowl in figure 30 is an *yu* (some authors prefer the name *gui* for this shape as well as for bowls with handles). The *ding* and *yu* of figures 29 and 30 are decorated with horizontal bands composed of three identical pattern units, three of the staring animal faces called *taotie*. The main register of the *lei* in figure 27 is formed of the same three units. The name *taotie*, like many of the names of vessel types, is a modern convention, but some of the vessel names are authentically ancient. No Erligang bronze is inscribed, but some Anyang *ding* have inscriptions in which they refer to themselves as *ding*.

The vessels in figures 31 and 32 are the earliest known examples of two shapes that were to have a big future, the bowl with handles called *gui* and the bottle with swing handle called *you*. On each of them, the main register is again divided into three compartments with three identical *taotie* units. That is the way the caster was accustomed to lay out decoration on round vessels without handles (compare fig. 30), and as the illustrations show, the addition of handles created problems of coordination; on the *gui*, one of the *taotie* actually has a handle in the middle of its face. This must have been felt as a discord, for ways around it were soon found, though to modern eyes it adds an interesting syncopation to an art in which symmetry is pervasive.

Figure 33 shows another *jia*, this time with a lobed body, and another *gu* like the one in Qianlong's collection. The *jia* has a *taotie* on the front but, as figure 34 shows, a slightly shorter, eyeless pattern unit in each of the compartments next to the handle. Handles were complications that required extra thought from the designer, and they sometimes prompted interesting inventions.

The fourth important development in Erligang bronze studies was a series of discoveries at Zhengzhou: three curious deposits, purpose unknown, found in 1974, 1982, and 1996. They are not burials. In the 1996 find (fig. 35), a disused well was adapted for the deposit of four large rectangular cauldrons—the shape is called *fangding*—and some smaller items (fig. 36). All three deposits contained

FIGURE 26. Bronzes excavated at Panlongcheng, Hubei. Vessel types (left to right): *ding, jue, lei, gu,* and *jia.*

FIGURE 27. *Lei* (left) and *jia* (right), 14th century BCE. *Lei*, h. 26.9 cm; *jia*, h. 25.4 cm. From Lijiazui Tomb 1, Panlongcheng, unearthed in 1974.

FIGURE 28. *Jia*, 14th century BCE. H. 29.7 cm. From Lijiazui Tomb 1, Panlongcheng, unearthed in 1974.

FIGURE 29. *Ding*, 15th–14th century BCE. H. 54 cm. From Lijiazui Tomb 2, Panlongcheng, unearthed in 1974.

FIGURE 30. *Yu* or *gui*, 14th century BCE. H. 23.7 cm. From Lijiazui Tomb 2, Panlongcheng, unearthed in 1974.

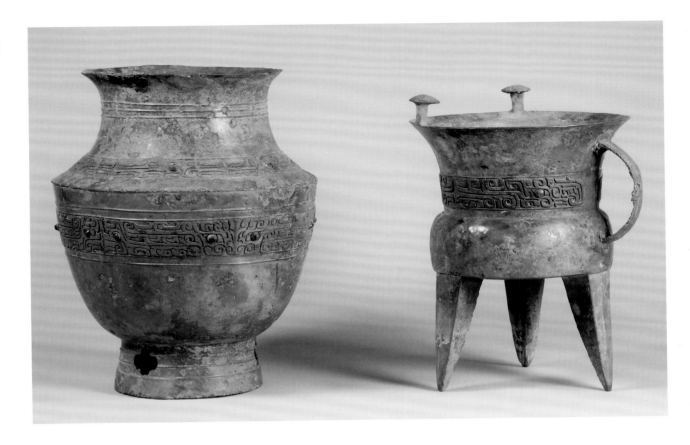

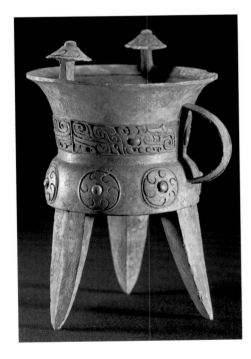

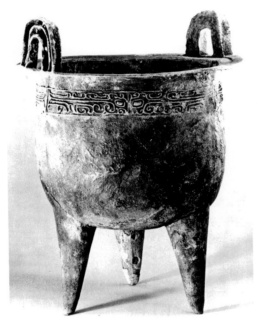

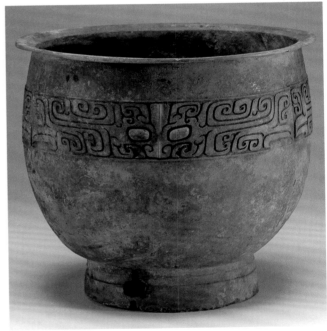

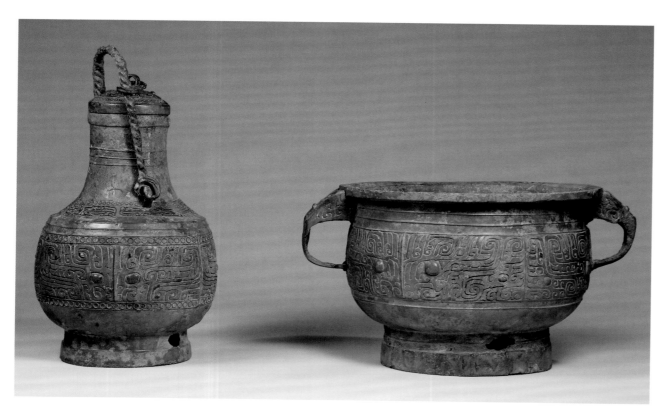

FIGURE 31. *You* (left) and *gui* (right), 14th century BCE. *You*, h. 31 cm; *gui*, h. 17.4 cm, diam. at mouth 22 cm. From Lijiazui Tomb 1, Panlongcheng, unearthed in 1974.

FIGURE 32. *You* and *gui* shown in figure 31, rotated.

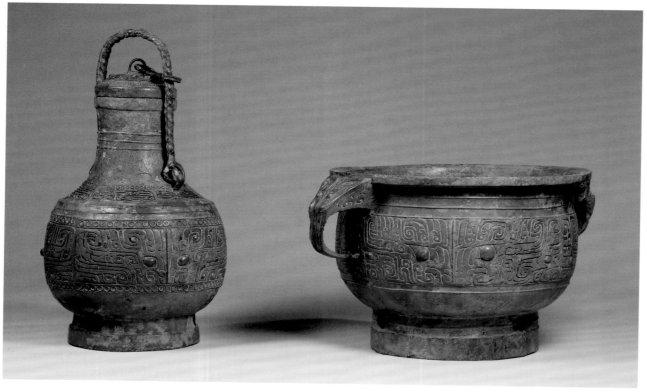

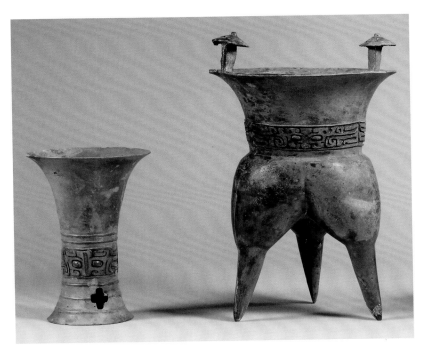
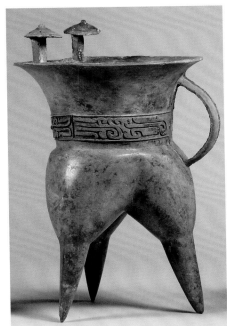

large *fangding*. The 1982 find, shown in figure 37, consisted of two *fangding*, an equally large round *ding* (fig. 38), and four smaller vessels that are not visible in figure 37 because they are inside the big ones. The *fangding* of figure 39, one of two in the 1974 find, stands a meter high and weighs 86 kilograms. At the time of its discovery, it was the only rectangular bronze known from the Erligang period, and it is still the largest. Perhaps these hoards give us an idea of the sort of thing we would find in the tomb of an Erligang king.

Deposits like these have never been found at Anyang (or at Panlongcheng either). But in 1990, a deposit containing a big Erligang *fangding* was found at Pinglu in southern Shanxi province, two hundred kilometers west of Zhengzhou. The *fangding* from Pinglu is shown in figure 40.

I have now gone hastily through forty years of archaeological finds of Erligang bronzes, from four Zhengzhou graves excavated in 1955 to the Panlongcheng tombs found in 1974 to the three hoards discovered at Zhengzhou between 1974 and 1996. At this point, let me jump back half a century to sketch equally hastily what art-historical study of the bronzes had achieved in the days before Erligang archaeology began. By 1955, the German art historian Max Loehr (1903–1988) had been studying bronzes for twenty years. He received his PhD from the University of Munich for a dissertation on bronzes in 1936 and then spent the 1940s in Beijing. Though he had strong archaeological interests, and a sound training in Greek archaeology, archaeology in China had yet to furnish much information that could help a scholar interested in bronzes. Until 1951, when explorations began at Zhengzhou, Anyang was the only known early Bronze Age site, and the Anyang discoveries were mostly unpublished. The bronze corpus Loehr studied thus consisted mainly of unprovenanced objects in public and private collections. And it consisted mainly of objects in what we now recognize as Anyang style, objects like the ones shown in figures 5 and 6. Mixed up with them, it included also a very few bronzes like the ones in figures 1–4, but most scholars, including Li Ji, believed those to be Anyang castings too. It should be stressed that the number of bronzes like those four was very small indeed: ten or twenty at the most, among thousands of later bronzes. I stress that because the simpleminded description I am about to give makes Loehr's research seem a great deal easier than it was.

Loehr took it as a working hypothesis that the bronze corpus he knew was a mixture of earlier and later objects, and he set out to find a chronological development

FIGURE 35. Nanshunchengjie bronze hoard, Zhengzhou, discovered in 1996.

FIGURE 36. Bronzes from the Nanshunchengjie hoard, Zhengzhou.

FIGURE 37. Xiangyang Huizu Shipinchang bronze hoard, Zhengzhou, discovered in 1982.

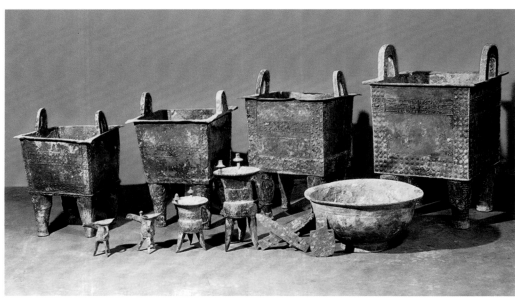

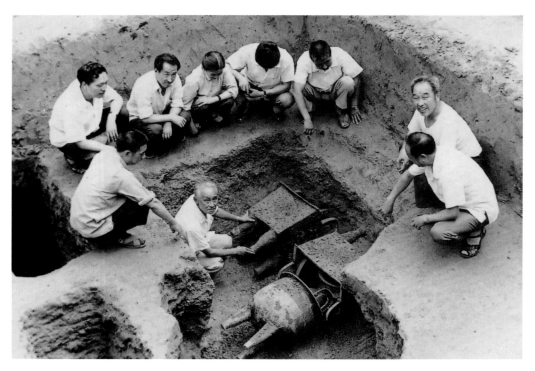

FIGURE 38. *Ding*, 14th century BCE. H. 77.3 cm. From the Xiangyang Huizu Shipinchang hoard, Zhengzhou.

FIGURE 39. *Fangding*, 14th century BCE. H. 100 cm. From the bronze hoard at Zhangzhai Nanjie, Zhengzhou, discovered in 1974.

FIGURE 40. *Fangding*, 14th century BCE. H. 82 cm. From a chance find at Pinglu, Shanxi, in 1990.

FIGURE 41. *Yan*, 15th century BCE. H. 36 cm. From Lijiazui Tomb 2, Panlongcheng, unearthed in 1974.

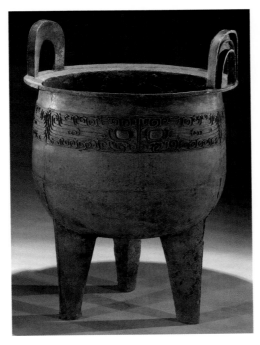

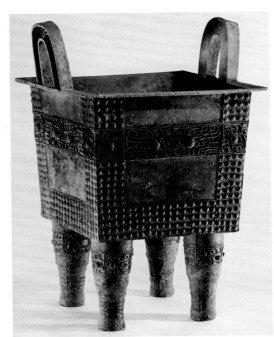

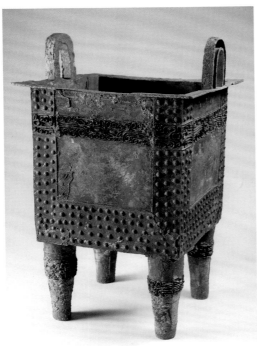

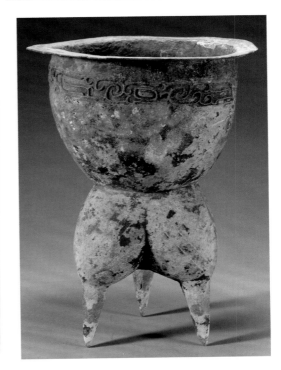

within it. He took Neolithic pottery shapes and bronze vessels dated Western Zhou by their inscriptions to be the endpoints of the development he sought: his goal was to plot the steps that led from the former to the latter. He began by immersing himself in the published bronze corpus, making himself deeply familiar with the full range of material. After much study, he picked out the *he* of figures 1 and 15, put them side by side, and said to himself: these are vessels of the same type, but one of them looks earlier than the other. He made many such comparisons; in other words, he did vessel typology. By careful typological arguments—arguments based mainly on vessel shape—he managed to work out a history of the decoration that led step by step from the thread relief of figure 1 to the ferocious high relief of figure 15. At the risk of oversimplification, we might say that he put the shapes in order and then read the history of the decoration off them. The first step in that history was from the thread relief of figure 1 to the broader raised lines of figure 2, carefully shaped lines that probably reflect preliminary drawing done

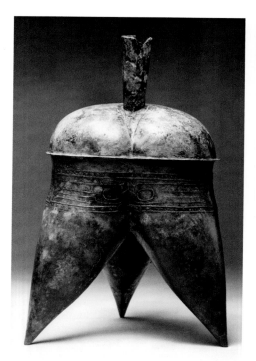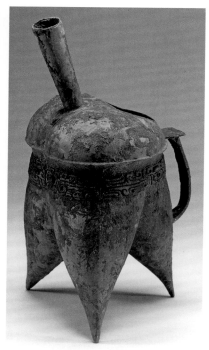

FIGURE 42. *He*, 15th century BCE. H. 23 cm. Asian Art Museum of San Francisco, Avery Brundage Collection (B60B53).

FIGURE 43. *He*, 14th century BCE. H. 36 cm. From Lijiazui Tomb 2, Panlongcheng, unearthed in 1974.

with brush and ink. From there, the development proceeded to denser patterns covering more of the vessel surface (fig. 3) and then onward to Anyang bronzes.

In figures 1–3 we see three *un*provenanced bronzes that Loehr singled out as early in a paper he published in 1953. Compare them with the bronzes unearthed twenty years later at Panlongcheng (e.g., figs. 29–31): Loehr's earliest forms of decoration account for the full range of designs found at Panlongcheng. By tracing a development within a corpus of mainly unprovenanced bronzes, he managed to identify all the characteristic forms of Erligang decoration before a single Erligang bronze had been recognized by archaeology. The development he laid out has some counterintuitive features—it is not obvious, and it cannot have been easy to find—but of course the counterintuitive features make it very interesting.

Now that we are better acquainted with Erligang bronzes, let us return to Li Ji's questions about the origins of the bronze industry. Li Ji's answers were mostly wrong. Do we now have the right answers?

I believe that we have some of them, but not all. We still know very little about the origins of Chinese metallurgy. Erligang metalworking is far too advanced to tell us anything about origins. Outside stimulus remains a possibility—relevant sites in northwest China are currently being investigated—but the stimulus would have to have acted at a stage long before Erligang. The Erligang metal industry is a local development, utterly unlike anything outside China.

As to the vessel shapes, there too I still see some puzzles. I am inclined to think that we understand the decoration pretty well, maybe about as well as we ever will, but the shapes are a problem. Let me begin with them. Simple rounded shapes undoubtedly originated with potters (figs. 29, 41). In the prehistoric pottery of the east coast of China, tripods and lobed tripods go back thousands of years. The *ding* in figure 29 and the *yan* in figure 41 are very old pottery shapes to which the metalworker has added only some decoration and, on the *ding*, a couple of handles. But rectangular shapes did not appear until the bronze industry was already flourishing (fig. 39). They are the invention of the piece-mold caster.

The pouring jugs shown in figures 1, 42, and 43 are more complicated. To my eye they have a hybrid look. Their hollow legs come from Neolithic pottery. But everything else about them imitates a vessel made from several pieces of metal

FIGURE 44. Pottery *he* of Qijia type,
ca. 2000 BCE. H. 27 cm.

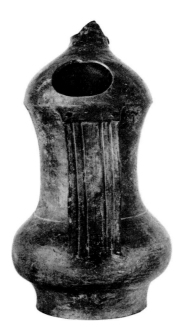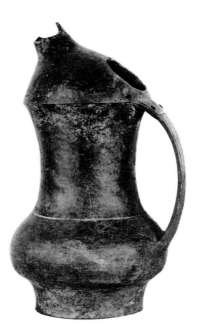

that were hammered to shape and then joined by crimping and riveting. In the hammered prototype the join between lid and body was made by crimping (you can see a crimped join on top of any tin can at the supermarket: the edges of two pieces of metal are rolled over each other and hammered down). In figure 1, the caster has imitated not only the crimped join but even the rivets joining the two parts of the strap handle: the bumps on top of the horizontal portion are imitation rivets. Apart from the legs, all the major features of these vessels seem to imitate a jug like the one in figure 44, from Gansu province in northwest China.

But here we come to an awkward complication. The jug in figure 44 is not hammered metal, it is a pottery copy of a hammered-metal vessel. So far, no actual vessel of hammered metal has been found in China, only imitations in pottery and cast bronze. Perhaps this should not be too surprising, since the hammered vessels are likely to have been made in small numbers. (Hammering makes thinner walls than casting and thus uses metal more sparingly, so it is the technique of choice for metalworkers with limited metal supplies.) Also, hammered metal is more vulnerable to corrosion than cast metal. Still, it would be nice if the archaeologists would find one or two of the prototypes that lie behind the objects in figures 42–44. Somewhere in north China around 2000 BCE smiths were hammering vessels from sheet metal; it would be nice to know where. Hammering is not something Erligang metalworkers ever did. They were under no pressure to conserve metal. They were monomaniacal casters.

The jugs with domed covers are the clearest hint of hammered-metal production but not the only one. The *jue* shape (fig. 45) does not look like anything a potter would invent, yet it is one of the very oldest bronze vessel types, one of only four types found so far at a site that is even older than Erligang. In 1973, primitive bronze vessels began turning up at a place called Erlitou, eighty kilometers west of Zhengzhou. Erlitou archaeologists have by now found about fourteen of these spidery little tripod cups (figs. 46, 47), as well as a *he* (fig. 48), two *jia* with hollow legs (fig. 49), and a *ding* with crude thread-relief decoration—at present probably the earliest decorated bronze known from China (fig. 50). None of these vessels was made by hammering; all of them were cast. But several of the *jue* and *jia* have stumps or prongs on the rim that do not originate in pottery and that do not seem to make sense as remnants of a casting process either. Many of the Erlitou vessels also have thick rims that might imitate a rim folded inward and hammered down (fig. 47).

FIGURE 45. Two *jue*, 14th century BCE. H. (left) 17 cm, (right) 20.1 cm. From Lijiazui Tomb 1, Panlongcheng, unearthed in 1974.

So for me, there is still something to be explained about the prehistory of the shapes. Somewhere in their past is a tradition that made metal vessels, in small numbers, by hammering. Hammering metal is a craft; the metalworker can operate like a blacksmith, working at home, by himself. I would like to know more about that elusive early craft tradition.

And then I would like to understand the shift from small-scale hammering to a large-scale industry run by casters. The Erligang bronze industry was casting complex objects in large numbers and sometimes of great size. This implies an abundance of metal and fuel, and it strongly suggests large foundries and significant division of labor. Erligang bronzes look like the products of a revolution not only in technology but also in the organization of work, in social organization. Their makers were casually producing objects like the ones in figures 43 and 51 despite staggering problems of mold building. The *he* in figure 43 was cast in one pour of metal. The problems of making and filling a mold for a shape as complicated as that are painful to think about. In figure 51 the body, the lid, the swing handle, and a link that connects the lid to the handle were all made by casting, and they are all permanently interlocked—they were *cast* interlocked! This is virtuoso casting, but in Erligang foundries it was business as usual. The basics of Erligang foundry practice were piece molds, metal spacers, and casting done in a sequence of pours, each new bit locked onto or around the previous bit. This remarkably versatile technology had possibilities that Chinese metalworkers spent the next millennium exploring.

As for the origin of the decoration, that is a simpler problem than the origin of the shapes. Li Ji believed that geometric motifs like the zigzag in figure 5 and the openwork and running spiral in figure 52 came from painted pottery; so did Loehr. But the painted pottery died out long before these bronzes were made. What both Li Ji and Loehr overlooked is that angular geometric patterns occur all over the world in textiles and basketry, media in which they arise naturally. The running spiral too has been invented and reinvented many times. The bronze casters could have copied geometric motifs off the textiles of their own time, and they could

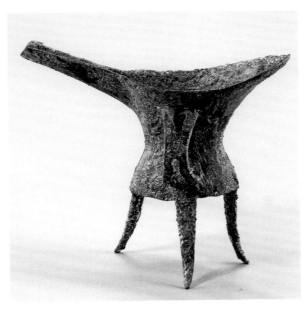
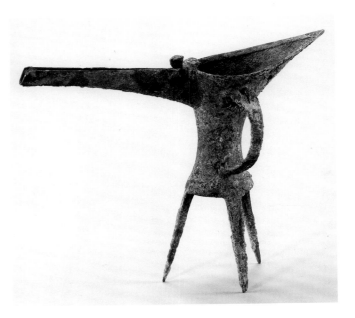

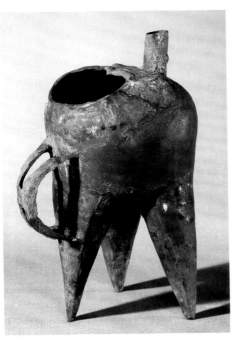
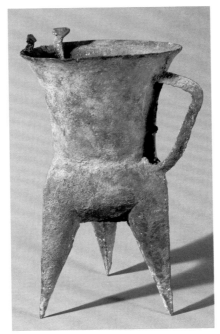
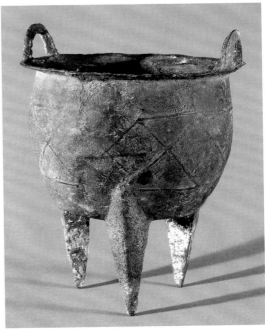

have invented the running spiral themselves. But these motifs are not very common in the bronze decoration. The motifs that really matter are the imaginary animals, above all the *taotie* and a vast menagerie of dragons and birds. Loehr thought that the animals were invented by the bronze casters, and I believe he was right.

The *taotie* began as a thread-relief design, a pair of eyes surrounded by scribbles (figs. 42, 29). Those first patterns centered on eyes gradually turned into animals as the bronze casters, generation after generation, added animal-like detail to them. Loehr traced that process step by step. His arguments for identifying thread relief as the earliest form of decoration were mainly typological: thread relief is the decoration found on the most primitive shapes. But his 1953 paper cited also a technical argument made in 1937 by Leroy Davidson (1908–1980), who pointed out that thread relief is an easy invention for a piece-mold caster because it is made by cutting lines directly into the mold pieces. To Davidson's observation we might add the further technical point that the vessels in figures 42 and 29 have three *taotie* each: on each of the three principal mold pieces the decorator carved a self-contained zoomorphic pattern. Decoration arranged in this

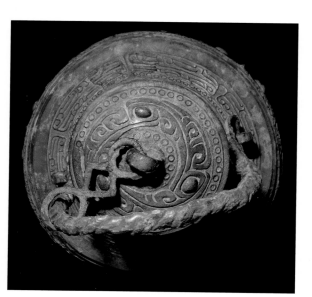

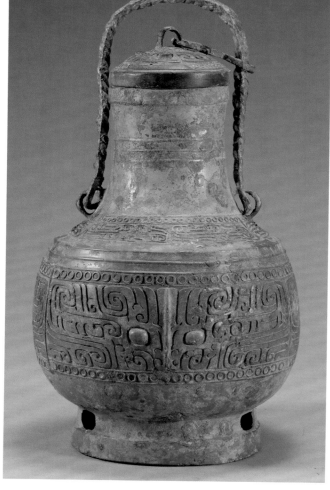

FIGURE 51. *You*, 14th century BCE, with detail of lid. H. 31 cm. From Lijiazui Tomb 1, Panlongcheng, unearthed in 1974.

way, in compartments, is characteristic of the bronzes all the way down to late Western Zhou, but only at the stage when the caster was working directly in the mold pieces—the thread-relief stage—was there any reason for the decoration to acquire the compartmenting of the mold. One last piece of evidence for the priority of thread relief is of course that it is the only form of decoration on bronzes from Erlitou. But Loehr never saw the *ding* of figure 50.

When Li Ji suggested that animal decoration was borrowed from a lost art of wood carving, he was not looking at the animal (if we can call it that) in figure 42, he was trying to explain the seemingly abrupt appearance of the animals in figure 6. But we now know that the animals in figure 6 did not appear abruptly, they slowly developed from the one in figure 42. We no longer need to invoke lost prototypes in other materials. We have the prototypes, and they are bronze.

Why some Erligang caster sketched paired eyes on the bronze in figure 42 is not known, and since we have no Erligang documents that talk about paired eyes or imaginary animals, we are not likely ever to know. Apart from that, however, the bronze decoration is pretty much a solved problem. We understand its history. For the next thousand years and more, the art that mattered in China was ornament formed from imaginary animals. And the whole system of decoration—animals, compartmenting, and ways of laying out designs on vessel surfaces—was an Erligang invention.

What about the other elements of the Anyang civilization that Li Ji wanted to explain? He was surely right about chariots. Chariots are a Western invention that arrived in China around 1200 BCE, at the beginning of the Anyang period. Before then we have little evidence for wheeled vehicles in China and no evidence

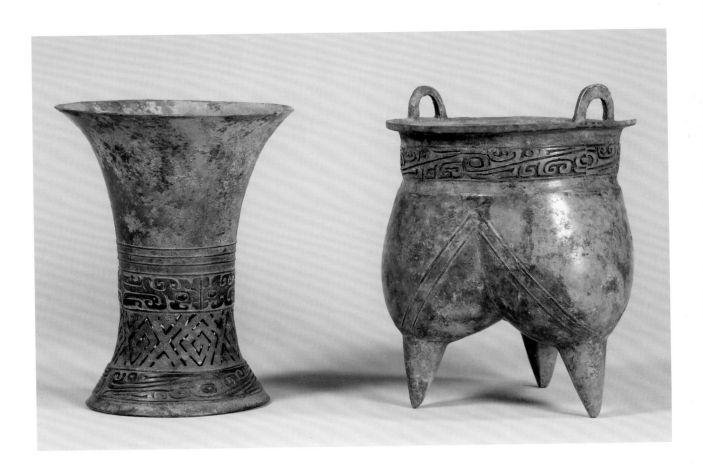

for domesticated horses. On the other hand, it does not seem necessary to derive large-scale human sacrifice from the Near East. The sacrifices in the Anyang royal tombs look rather different from what Woolley found at Ur, and the same is true of the more limited evidence for human sacrifice at Zhengzhou. The royal tombs themselves are gigantic enlargements of a burial form that goes very far back in the east coast Neolithic. Rammed-earth construction likewise has a long Neolithic history.

That leaves writing. By the end of his life, Li Ji felt safe in claiming that Chinese writing was a native invention. I believe so too, even though we still have only the scantiest traces of pre-Anyang writing.

Figure 53 shows some potsherds with brush-written characters that were found near Zhengzhou between 1995 and 1999. At the moment the corpus of Erligang writing does not go much beyond this, but we do not need these potsherds to make a case for Erligang writing. To persuade ourselves that the Erligang civilization was literate all we need to do is consider the alternatives. In other words, consider the other possible explanations for the writing system in use at Anyang in 1200 BCE—the inscriptions in figures 17 and 54. When we first encounter it, the Chinese writing system has several thousand characters, and it is capable of writing complete sentences. The scribes who wrote these inscriptions could have written letters; they could have taken dictation. How might we explain the sudden appearance of full writing in the archaeological record? There are three possible scenarios: either it was invented overnight in 1200 BCE, or it was imported from somewhere else, like the Near East, or it was invented gradually in an earlier period from which we do not have inscriptions. Let me take those possibilities in order.

Overnight invention is not an option, I believe. A writing system is a large investment for a society. No writing system exists without a group of people who use it and a system for training the next generation of users. In Mesopotamia, where the evidence is very full, we can trace a gradual development that started with clerks making a few simple marks on bookkeeping forms. That first

FIGURE 53. Brush-written inscriptions on potsherds unearthed at Xiao-shuangqiao, twenty kilometers from Zhengzhou, between 1995 and 1999.

bookkeeping system served a very limited function, and its users no doubt learned it on the job. Then, over a period of five or six centuries, the bookkeeping became more detailed, and the system grew more versatile. It was slowly elaborated to serve a range of functions that slowly expanded beyond bookkeeping, until finally, after centuries of growth, it could be used to transcribe speech—an application that those clerks at the beginning of the process certainly never dreamt of. As the system got more complex, of course, it got harder to learn. Literacy training got longer and more systematic. By the time there was full writing, there was also an educational establishment churning out scribes.

Overnight invention would collapse this whole development into one brief moment. Some visionary who grew up in a world without writing would have to think of using marks to record sounds and would have to imagine a use for recorded speech. In a world without writing, these are not obvious ideas. Then he would have to invent writing tools and materials, invent a system for notating his language, and write out a list of the words in his language. *And* he would have to persuade his king that his invention was going to be so useful that the king should immediately establish a school and command some hapless trainees to spend the next few years copying and recopying the list of words until they knew it by heart—knew it well enough to take dictation. I do not believe that anything like this ever happened anywhere.

The second scenario says that Mesopotamian writing somehow inspired or served as the model for Chinese writing. Fifty years ago, scholars who believed that writing could not have been invented more than once in human history took this for granted; they felt no need for evidence of something that had to be true. But how could it be true? The Chinese script around 1200 BCE had distinctly pictographic characters, while the signs of Mesopotamian scripts had lost all pictorial

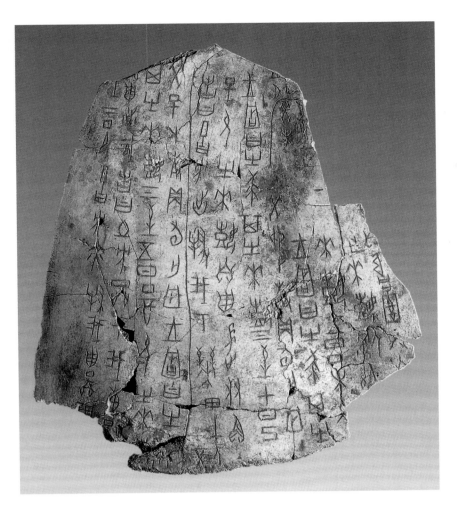

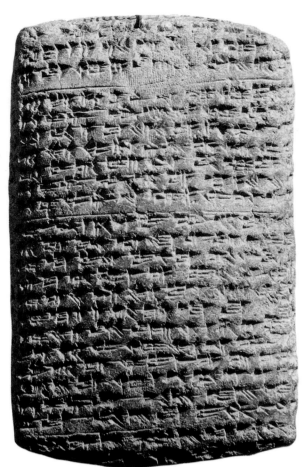

FIGURE 54. Inscribed bovine scapula, reign of Wu Ding, ca. 1200 BCE. From Anyang.

FIGURE 55. Clay tablet with cuneiform inscription (EA 161), mid-14th century BCE. From Tell el-Amarna, Egypt.

content a thousand years earlier. The clay tablet inscribed in cuneiform in figure 55 is a typical piece of Mesopotamian writing contemporary with Erligang. If the knowledge of writing was brought to China by people who wrote tablets like that, why would the Chinese then create a script with recognizable pictographs? Invoking foreign contact to explain the Anyang script creates more problems than it solves.

That leaves us with the third scenario: the Anyang script has an earlier history that is not preserved or at least not yet detected in the archaeological record. There is not much doubt in my mind that the Erligang civilization was literate and that, unfortunately for us, it did its writing on perishable materials—probably on wood or bamboo strips, the perishable material used for everyday writing in Anyang times. Erligang writing looks like a safe bet. Perhaps we can hope that a little of it survives on something durable archived in a palace somewhere beneath modern Zhengzhou.

I have now reviewed the current evidence bearing on Li Ji's list of defining features of the Anyang civilization—rammed earth, chariots, human sacrifice, the bronze industry, and writing—and you will have noticed that not one of them was an Anyang invention. Anyang was not the *beginning* of anything.

The Erligang civilization, on the other hand, has major achievements to its credit. Let me list them, starting with the bronze industry, the part of the Erligang culture we know the most about. In things connected with the bronze industry, the Erligang legacy is immense.

First, consider what might be called the strictly artistic legacy. By adding another fifteen or twenty vessel shapes to the four or five they inherited from Erlitou, Erligang bronze casters created pretty much the full ritual vessel repertoire of later periods. They also created the design principles—the compartmented design

system—that ruled the bronze art until late Western Zhou. And they created the imaginary animals that remained central to Chinese art all the way down to the Han period (206 BCE–220 CE).

Second, under the heading of technology, they developed foundry operations to a level of sophistication that had tremendous consequences for later periods. To mention only two, China was producing cast iron in large quantities by the sixth century BCE, two millennia before cast iron was made in Europe, and China also invented printing. The cast iron industry certainly grew out of the bronze industry. The exact origin of printing seems impossible to pin down; probably a great many things fed into it. But one of them is likely to have been the printing of textile designs, which is known as early as the Han period, and this in turn might owe a conceptual debt to transfer processes developed in Eastern Zhou times around the fifth century BCE for mass-producing bronze decoration.

Third, under a heading I might call "social technology," Erligang foundries were probably the starting point for the development of factory organization in China. By the Han period, division of labor in factories is documented in detail by quality-control inscriptions, but clearly it goes back long before that. It is a way of organizing production that astonished Western observers in the eighteenth century when they encountered it at the Jingdezhen porcelain kilns.

And finally, Erligang casters established the bronze vessel as the characteristic artifact of Chinese material culture—the piece of material culture onto which the society to this day projects its feelings about its past. When you drive along the highway in China and pass an object like the one shown in figure 56, you may be reminded of big steel sculptures by someone like David Smith, but the Chinese piece of steel invokes a tradition that is 3,500 years old. The artist who made it was thinking about Bronze Age artifacts that his culture has never forgotten.

And that is only what Chinese civilization owes to the Erligang bronze industry. At least two things more belong to the Erligang legacy. First, Erligang was the parent not only of the Anyang civilization but also of sister civilizations in other parts of China. The Erligang expansion, discussed in several of the chapters that follow, carried civilization outward from the middle Yellow River valley and catalyzed the formation of a multitude of bronze cultures, especially in the south. And second, the Erligang civilization certainly had, and may well have invented, the Chinese writing system.

You would think that with all this to its credit, Erligang would be a household word. The Erligang phenomenon was colossal; this was the first great civilization of East Asia. But Anyang gets all the attention; it is Anyang that gets the full-color spreads in *National Geographic*, for several reasons. The Anyang site was discovered first; it is more accessible to excavation than Zhengzhou; it has a large corpus of inscriptions; and through its inscriptions, it connects with later historical traditions. The unfortunate result is that Erligang is known mainly for being the source of something else.

This is a serious distortion of second-millennium realities. We must not allow ourselves to be hypnotized by the Anyang site; we must stop thinking of Erligang as the poor relation of the culture that really matters. I would like to propose a thought experiment. Let us pretend that Anyang never existed; let us pretend that some catastrophe—barbarian invasions or epidemic disease—put an end to Chinese civilization in 1300 BCE. Try to imagine that you never saw an Anyang bronze. Think of Erligang as a dead civilization, cut off in its prime, unconnected with anything in the later history of East Asia, a civilization that we can approach only through its material remains by the methods of prehistoric archaeology.

I recommend this mindset because I believe that our understanding of China in the second millennium BCE stands to gain immeasurably if we approach Erligang as a prehistorian would, through material artifacts and cross-cultural comparison.

FIGURE 56. Steel *jue* next to a highway in Hubei.

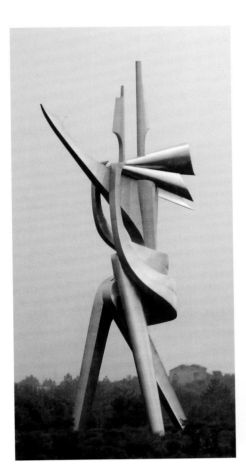
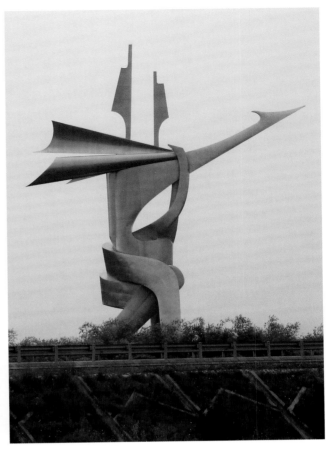

The orientation of Chinese archaeology has long been toward interpreting the material record of the second millennium in the light of much later traditions. One of the aims of this volume is to make a case for comparative study as an alternative. The Erligang culture has left us no documents, no written evidence; it tells us nothing about itself in words, but its material culture will speak loudly if we will only listen. With rich sites like Zhengzhou and Panlongcheng, with Erligang finds reported from a vast area, with the very distinctive artifacts this civilization has left us, we have a wealth of material at our disposal. We need to remind ourselves that we know much more about China in the second millennium BCE than any Han historian ever did. We should not allow our interpretation of the archaeological record to be confined within a picture given to us by Han writers who had much less evidence than we do and all sorts of axes to grind. Resolving to treat Erligang archaeology as prehistoric archaeology frees us to explore the possibility that the material evidence tells a story different from the one Han writers told.

Thus I have two main aspirations for this volume. First, I hope that it will make a case for Erligang bronzes as deserving of attention in their own right. We will understand them more deeply and admire them more if we stop thinking of them as stepping-stones to something else. And second, I hope that it will serve as an advertisement for approaching Erligang archaeology with the mindset and intellectual tools of the prehistorian. We will understand the rise of civilization in East Asia better if we let the material record tell us how it happened.

Most of the ideas of Li Ji that I have discussed can be found in one or more of his English-language publications (in all of which he romanizes his name as Li Chi): "Importance of the Anyang Discoveries in Prefacing Known Chinese History with a New Chapter," *Annals of Academia Sinica* (*Zhongyang Yanjiuyuan yuankan*) (Taipei), no. 2, pt. 1 (1955): 91–102, and "Diverse Backgrounds of the Decorative Art of the Yin Dynasty," ibid., 119–30; *The Beginnings of Chinese Civilization: Three Lectures Illustrated with Finds at Anyang* (Seattle: University of Washington Press, 1957); and *Anyang* (Seattle: University of Washington Press, 1977). His ideas about the sources of the bronze shapes and bronze decoration are presented in detail in his article "Ji Xiaotun chutu zhi qingtongqi," *Zhongguo kaogu xuebao* 3 (1948): 1–99.

On early twentieth-century Western prehistorians and their views about the origin of civilization, see Bruce Trigger, *A History of Archaeological Thought*, 2nd ed. (Cambridge: Cambridge University Press, 2006).

The literature on Zhengzhou, Panlongcheng, and Erlitou is vast. The main excavation reports are *Zhengzhou Shang cheng: 1953–1985 nian kaogu fajue baogao*, 3 vols. (Beijing: Wenwu chubanshe, 2001); *Panlongcheng: 1963–1994 nian kaogu fajue baogao*, 2 vols. (Beijing: Wenwu chubanshe, 2001); and *Yanshi Erlitou: 1959 nian–1978 nian kaogu fajue baogao* (Beijing: Zhongguo dabaike quanshu chubanshe, 1999). The idea of an Erligang expansion was first proposed in Bagley, "P'an-lung-ch'eng: A Shang City in Hupei," *Artibus Asiae* 39, no. 3 (1977): 165–219 (see 210–13), though I would now call Panlongcheng not a Shang city (a guess) but an Erligang city (a strictly archaeological diagnosis of its material culture).

For a concise introduction to the archaeology of the early Bronze Age, see Bagley, "Shang Archaeology," in *The Cambridge History of Ancient China*, ed. Michael Loewe and Edward L. Shaughnessy (Cambridge: Cambridge University Press, 1999), 124–231. For the bronze industry, see 139–55 (146–55 for an account of Loehr's bronze styles); for Erlitou, Erligang, and Panlongcheng, 155–71; and for the Anyang site, including chariot burials, the royal tombs, and human sacrifice, 180–208. For the carved execution of the bronze decoration, see Bagley, "Anyang Mold-Making and the Decorated Model," *Artibus Asiae* 69, no. 1 (2009): 39–90. On Erligang writing, the views I have sketched here are presented in detail in Bagley, "Anyang Writing and the Origins of the Chinese Writing System," in *The First Writing: Script Invention as History and Process*, ed. Stephen D. Houston (Cambridge: Cambridge University Press, 2004), 190–249. In the same book, see also Jerrold S. Cooper, "Babylonian Beginnings: The Origin of the Cuneiform Writing System in Comparative Perspective," 71–99, for many pertinent ideas (72–80 on origins, especially 78, on schooling).

Loehr's 1953 paper on the history of the bronzes is "The Bronze Styles of the Anyang Period," *Archives of the Chinese Art Society of America* 7 (1953): 42–53. For a detailed analysis of this work, see Bagley, *Max Loehr and the Study of Chinese Bronzes: Style and Classification in the History of Art* (Ithaca, NY: Cornell University East Asia Program, 2008). On the origin of the bronze decoration, see Bagley, "Ornament, Representation, and Imaginary Animals in Bronze Age China," *Arts Asiatiques* 61 (2006): 17–29. On the occurrence in many parts of the world of running spirals, geometric motifs, and motifs centered on paired eyes, see Bagley, "Interpreting Prehistoric Designs," in *Iconography without Texts*, ed. Paul Taylor, Warburg Institute Colloquia 13 (London: Warburg Institute, 2008), 43–68. On late Zhou bronze casting and related technologies, see Bagley, "Replication Techniques in Eastern Zhou Bronze Casting," in *History from Things: Essays on Material Culture*, ed. Steven Lubar and W. David Kingery (Washington, DC: Smithsonian Institution Press, 1993), 234–41, and "What the Bronzes from Hunyuan Tell Us about the Foundry at Houma," in *Chinese Bronzes: Selected Articles from "Orientations" 1983–2000* (Hong Kong: Orientations Magazine, 2001), 214–22.

CHAPTER 2

Erligang
A Perspective from Panlongcheng

Zhang Changping

THE ERLIGANG CULTURE has left rich sites all the way from its home in the Central Plain to the banks of the Yangzi River. Perhaps the most impressive of these sites is the Erligang city at Zhengzhou.[1] The wall at Zhengzhou was nearly seven kilometers in circumference. The city it enclosed was certainly one of the largest of the ancient world. But as Robert Bagley points out in chapter 1 in this volume, that city lies underneath a modern metropolis of four million people. At Zhengzhou, archaeologists have found few elite burials and hence few bronzes. The richest Erligang tombs ever found are located outside of Zhengzhou at the much smaller Erligang city at Panlongcheng in Hubei. Of particular interest are the bronzes found there. They tell us interesting things about the Erligang bronze industry—things that we cannot learn from Zhengzhou.

The Panlongcheng site is located 450 kilometers south of Zhengzhou in present-day Hubei province, about five kilometers north of Wuhan in Huangpi county (map 1).[2] The remains at Panlongcheng are spread over a square kilometer. At its center are the remnants of an ancient city wall enclosing an area of about 75,000 square meters (figs. 1, 2). Inside the wall, archaeologists found the foundations of three large buildings. Thirty-eight tombs were found outside the walls.

The tombs are much richer than any yet discovered at Zhengzhou; most contained bronzes. Zhengzhou has yet to produce more than a handful of bronze-yielding tombs. The tombs from Panlongcheng contained more than 350 bronzes, and the largest tomb from Panlongcheng is the largest Erligang tomb ever found. This makes Panlongcheng a very rich source for the study of Erligang social stratification. For the study of Erligang bronzes, Panlongcheng also provides much better conditions than Zhengzhou.

The Panlongcheng site was first discovered in the 1950s, a time when a great number of archaeological discoveries were being made in China. The People's Republic of China had just been established, and along with it the first wave of large-scale building projects began. All over China, construction led to the discovery of new archaeological sites. But outside of the Central Plain, the conditions for excavation work, especially the training of archaeological personnel, were often inadequate. In these areas, many of the new finds were not properly recognized. The discovery of the Panlongcheng settlement came at a time when archaeologists in the Central Plain were only just coming to recognize the Erligang cultural remains at Zhengzhou.

The ancient walls at Panlongcheng were discovered in 1954 when workers came upon pottery mixed in with the earth they were removing for a flood prevention project. The investigator called to the site recognized the similarity of the pottery to that found at Zhengzhou, but because the remains also included polished stone objects, he dated the inception of the site to the Neolithic.[3]

1. For the excavation report of the city, see *Zhengzhou Shang cheng: 1953–1985 nian kaogu fajue baogao*, ed. Henan sheng wenwu kaogu yanjiusuo, 3 vols. (Beijing: Wenwu chubanshe, 2001).

2. For the Panlongcheng excavation report, see *Panlongcheng: 1963–1994 nian kaogu fajue baogao*, ed. Hubei sheng wenwu kaogu yanjiusuo, 2 vols. (Beijing: Wenwu chubanshe, 2001).

3. Lan Wei, "Hubei Huangpi xian Panlongcheng faxian gu cheng yizhi ji shiqi deng," *Wenwu cankao ziliao* 1955.4: 118–19.

MAP 1. Erligang walled sites.

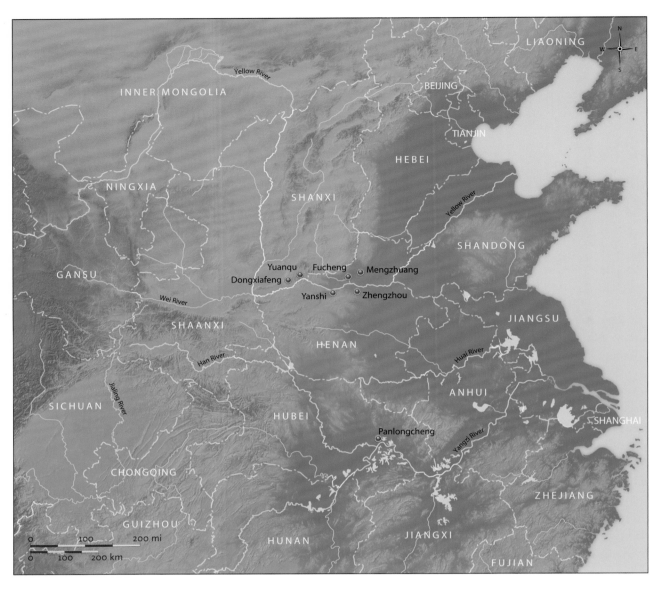

In 1957, another major discovery occurred at Panlongcheng with the unearthing of a group of bronze vessels. The bronzes included a *jue*, a *jia*, and a knife. Because the investigators were sure that bronzes did not appear so far south until the arrival of the Zhou, they dated the site to the Western Zhou.[4]

Fortunately, the editor of the report recognized that the bronzes looked very similar to bronzes from Zhengzhou. He inserted a note in the article stating that the Panlongcheng bronzes should be the same date as the bronzes found at Zhengzhou.[5] This was the first time that the date of the site was accurately reported. In 1963, bronzes were again discovered within the Panlongcheng site, this time at Louziwan, just west of the walled city (fig. 2). When investigators excavated the area where the bronzes had been unearthed, they found not only more stray bronzes but also five tombs containing bronzes.

The discovery of Erligang bronzes at Panlongcheng marked the first identification of Erligang cultural remains outside of the Yellow River valley. This discovery had tremendous implications for both scholarship and politics. In particular, the Panlongcheng site was a boost for scholars who were seeking evidence of a large Shang cultural sphere centered at the capital sites of Zhengzhou and Anyang. It was with this in mind that the Archaeology Department of Peking University and the Hubei Provincial Museum teamed up to excavate the Panlongcheng site in 1974 and 1976.[6] These excavations led to the dating of the Panlongcheng city walls to the Erligang period and the discovery of three large building foundations inside

4. Guo Binglian, "Hubei Huangpi Yangjiawan de gu yizhi diaocha," *Kaogu tongxun* 1958.1: 56–58.

5. Ibid., 58.

6. Hubei sheng bowuguan, Beijing daxue kaogu zhuanye, and Panlongcheng fajuedui, "Panlongcheng 1974 niandu tianye kaogu jiyao," *Wenwu* 1976.2: 5–16.

FIGURE 1. Site at Panlongcheng, Hubei. (a) View from north of the city walls. (b) East wall. Extant sections of the city wall reach as high as three meters. The original height has been estimated at seven to eight meters.

FIGURE 2. Plan of the Panlongcheng site. The gaps in each side of the wall are thought to be the city gates.

FIGURE 3. Vertical cross section of the Erligang-period city wall at Zhengzhou. (a) North-to-south view of an excavation trench cut through the south wall (CST3). (b) Plan of the internal arrangement of rammed-earth courses.

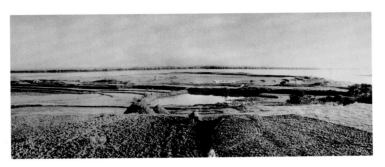

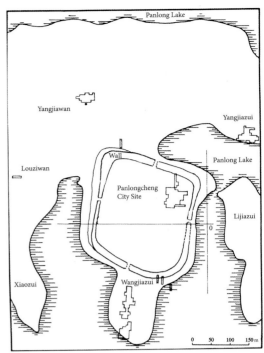

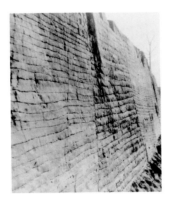

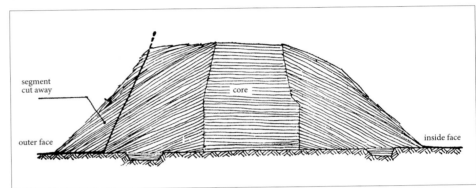

the city walls that were identified as local palaces based on their size and location. When the author of the resulting excavation report argued that the remains at Panlongcheng exhibit a remarkably high degree of similarity to Erligang remains found in the Central Plain, he based his argument on six features of the site.[7]

The first similarity is the rammed-earth city wall. Excavators noticed that the technique used to build the city wall at Panlongcheng was exactly the same as at Zhengzhou. Figure 1b shows the wall at Panlongcheng. The construction method of the excavated Zhengzhou wall shown in figure 3 is exactly the same as that used for the Panlongcheng wall. At both sites, the walls were constructed of rammed earth built up in level layers directly from ground level, with slanting courses on both sides.

Second, the two sites also shared architectural similarities, such as the structure and the location of the palaces. And the palaces at both sites were built on raised rammed-earth platforms encircled by corridors. Figures 4 and 5a show the largest of the palaces from Panlongcheng, and figure 5b shows the plan of a palace foundation from Zhengzhou.

The third feature is burial custom. Both in the Yellow River valley and at Panlongcheng, tombs were constructed as rectangular shaft pits. The highest-ranking tombs all contained bronzes and jades and sometimes sacrificial victims as well. Another shared feature of the burials is the presence of sacrificial waist pits (*yaokeng*) beneath the corpse, a feature seldom seen outside the cultural sphere defined by Erligang and Anyang. Figure 6 shows a small burial from Panlongcheng; figure 7

7. Ibid.

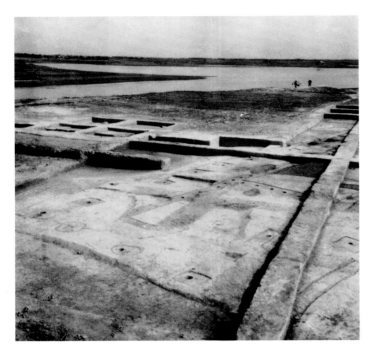

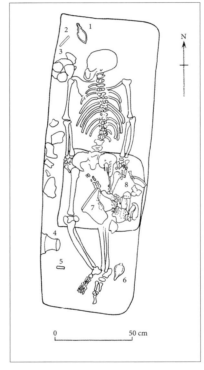

FIGURE 4. Panlongcheng palace foundation (F1). View from east to west during excavation.

FIGURE 5. Plans of palace foundations at Panlongcheng and Zhengzhou. (a) Panlongcheng foundation (F1). Dimensions 39.8 by 12.3 meters. Postholes with stone footings surrounding the four chambers are numbered in the plan and appear to be supports for eaves over an open corridor. Holes for secondary posts were also found at the edge of the building platform flanking the larger postholes. (b) Zhengzhou foundation (C8F15). Dimensions of extant portion 65 by 13.6 meters.

FIGURE 6. Plan of Yangjiawan Tomb 9, Panlongcheng. Tomb inventory. 1, 6: pottery *guo*; 2: bronze *gu*; 3: bronze *jue*; 4: bronze *jia*; 5: glazed stoneware *bei*; 7: glazed stoneware *guan*; 8: clay disk; 9, 10: pottery *li*.

FIGURE 7. Plan of Beierqilu Tomb 4, Zhengzhou. Tomb inventory. 1: bronze *jue*; 2: jade hairpin; 3, 7: pottery *jia*; 4: pottery *dou*; 5: pottery spindle; 6: pottery *jue*; 8: pottery *li*.

shows a comparable tomb from Zhengzhou. The cross-sectional view in figure 6 shows the sacrificial pit, which contained the remains of a dog, set below the main burial level.

The fourth feature is the similarity in the bronzes found at the two sites. The bronze types found in the Panlongcheng burials included all the types known from tombs at Zhengzhou, such as the *gu, jue,* and *jia* wine vessels and *li* and *ding* cooking vessels, among others. The vessel shapes and decoration are nearly identical (figs. 8, 9). The same could be said for their repertoire of section-mold casting techniques. There were also extensive finds of bronze weapons matching types found at Zhengzhou, including arrowheads, spearheads, knives, *ge,* and, from the largest tombs, particularly impressive *yue* (see figure 8 in Campbell, ch. 5, p. 132).

The fifth feature the excavators noted is the similarity in jades. There were not many jades found at Zhengzhou, but the types that have been discovered largely

FIGURE 8. (a) *Jia*, 14th century BCE. H. 29.7 cm. From Lijiazui Tomb 1, Panlongcheng, unearthed in 1974. (b) *Jia*, 14th century BCE. H. 25.2 cm. From a tomb at Baijiazhuang, Zhengzhou, unearthed in 1958.

FIGURE 9. (a) *Ding*, 14th century BCE. H. 22.3 cm. From Lijiazui Tomb 1, Panlongcheng, unearthed in 1974. (b) *Ding*, 14th century BCE. H. 18.5 cm. From a tomb at Baijiazhuang, Zhengzhou, unearthed in 1958.

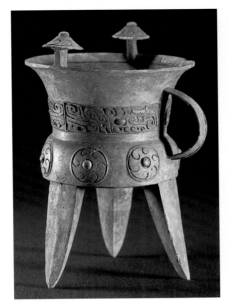
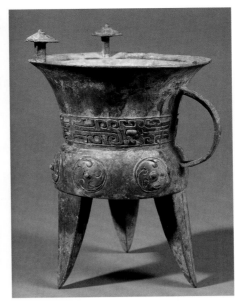
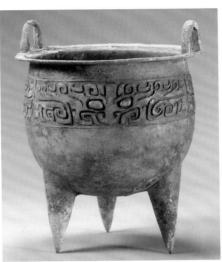
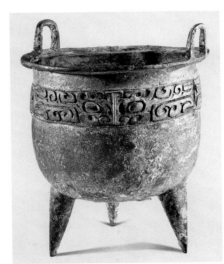

matched those found at Panlongcheng—jade handles and *ge*, for example (figs. 10, 11). During the Erligang period, jade handles and *ge* are not found outside the Erligang cultural sphere. The *ge* found at Panlongcheng are technically stunning. The example in figure 11b is carved from a single piece of jade and measures almost a meter in length.

The sixth and final feature is the ceramics. Some of the pottery found at Panlongcheng is very similar to pottery from Zhengzhou. In both places, the vessel types include *li*, *jia*, *jue*, wide-mouthed *zun*, and even some stoneware *zun* (see below). However, Panlongcheng also had pottery quite different from that at Zhengzhou, including red clay pottery and different vessel shapes. In particular, excavators found a large number of wide-mouth *gang*, a type known from other contemporary sites nearby.

From these observations the excavator concluded that the Panlongcheng site must have been under Erligang political control and that it was populated by members of the same ethnic group that lived at Zhengzhou. This is a view that the majority of archaeologists in China agree with today. The cultural and political identity between Panlongcheng and Zhengzhou has also been accepted by most international scholars. The consensus view is that Panlongcheng was probably a frontier outpost.[8] But uniform material culture cannot automatically prove political or ethnic unity. The nature of the political relationship between Zhengzhou and Panlongcheng is a subject other chapters in this volume have more to say

8. Robert Bagley, "Shang Archaeology," in *The Cambridge History of Ancient China: From the Origins of Civilization to 221 B.C.*, ed. Michael Loewe and Edward L. Shaughnessy (Cambridge: Cambridge University Press, 1999), 170.

FIGURE 10. (a) Handle-shaped object, 14th century BCE. Jade, l. 12.8 cm. From Lijiazui Tomb 2, Panlongcheng, unearthed in 1974. (b) Handle-shaped object, 14th century BCE. Jade, l. 9.6 cm. From a tomb inside the palace complex area at Zhengzhou.

FIGURE 11. (a) *Ge*, 14th century BCE. Jade, l. 37.9 cm. From a tomb at Baijiazhuang, Zhengzhou, unearthed in 1955. (b) *Ge*, 14th century BCE. Jade, l. 94 cm. From Lijiazui Tomb 3, Panlongcheng, unearthed in 1974.

about (see Wang, ch. 3, and Baines, ch. 4, in this volume). For now, let me just add a few remarks about the broader context of the Panlongcheng site.

During the Neolithic period, the region around Panlongcheng was home to its own advanced Neolithic culture, known today as Shijiahe, the latest Neolithic culture in the Jianghan valley. Around 2000 BCE, the Shijiahe culture disappeared. Then some two or three hundred years after that, a late stage of the Erlitou culture began to spread southward into the Jianghan valley. The Panlongcheng site yielded quite a few examples of pottery descended from Erlitou types. Around 1500 BCE, the Erligang culture succeeded Erlitou and established a city at Panlongcheng that flourished for the next two hundred years.[9] Panlongcheng does not seem to have been an old settlement of local people who suddenly adopted the culture of the Central Plain. Instead it seems to have been established by an intrusive population from the north.

Apparently Panlongcheng belonged to a network of walled cities that the Erligang culture established surrounding its territory (see Wang, ch. 3 in this volume). It is located at a crucial point on the travel routes between north and south China, at the entrance to the Yun River and close to several main tributaries of the Yangzi. It appears to be the southern boundary of the Erligang culture. Just to the north, at Huangpi, Xiaogan, and Dawu (map 2), there is an assortment of Erligang cultural sites of varying size connecting Panlongcheng with the north.[10]

The establishment of walled cities appears to have been an important way for the Erligang culture to assert political control (map 1). There are huge walled cities at Zhengzhou and Yanshi in the Erligang metropolitan zone.[11] We also have Erligang cities to the north of the metropolitan zone at Jiaozuo Fucheng and Huixian Mengzhuang in northern Henan province and, farther west, cities in southern Shanxi province at Yuanqu Gucheng Nanguan and Xiaxian Dongxiafeng. In 2002, another city connected with Erligang was found in Hubei about a hundred kilometers northwest of Panlongcheng at Yunmeng.[12] Panlongcheng seems to be a southern outpost in this system of political control.

There is evidence at Panlongcheng to suggest that the site represents a community in continuous, direct contact with Zhengzhou. The Panlongcheng remains span a period of about two hundred years and include both early and late stages of the Erligang culture. The Panlongcheng bronzes also show the same course of development as seen in the bronzes found at Zhengzhou; their decoration and shape at different stages mostly coincide.

9. For dating of the Panlongcheng site, see *Panlongcheng*, 447–50.

10. For references, see *Zhongguo kaoguxue: Xia Shang juan*, ed. Zhongguo shehui kexueyuan kaogu yanjiusuo (Beijing: Zhongguo shehui kexue chubanshe, 2003), 266–69.

11. For an introduction to Yanshi and other Erligang walled sites, see Robert L. Thorp, *China in the Early Bronze Age: Shang Civilization*, Encounters with Asia (Philadelphia: University of Pennsylvania Press, 2006), 62–76.

12. The site is discussed briefly in Jiang Gang, "Panlongcheng yizhi qun chutu Shangdai yicun de jige wenti," *Kaogu yu wenwu* 2008.1: 35–46.

FIGURE 12. (a) *Zun*, 14th century BCE. Stoneware, h. 19.2 cm. From Lijiazui Tomb 1, Panlongcheng, unearthed in 1974. (b) *Zun*, 14th century BCE. Glazed stoneware, h. 28 cm. From a tomb at Minggonglu, Zhengzhou.

Panlongcheng appears to have served at least partly as a conduit for Zheng-zhou's interaction with the south. Examples of stoneware found at Zhengzhou are identical to stoneware found at Panlongcheng, but Panlongcheng yielded more and greater variety. The stoneware in figure 12a is from Panlongcheng; the one in figure 12b is from Zhengzhou. Stoneware from this time was likely an import from the lower Yangzi (see Steinke, ch. 7 in this volume). This material may have reached Zhengzhou by way of Panlongcheng.

Having reviewed the evidence that suggests that Panlongcheng might have been an Erligang fortress, I want to turn to the Panlongcheng bronzes. As I mentioned earlier, the bronzes from Panlongcheng provide the most comprehensive view of the Erligang bronze industry. And the bronze-bearing Panlongcheng tombs give us our clearest archaeological context for their role in Erligang society.

From very early in the Bronze Age, bronze artifacts, vessels in particular, were used as tomb offerings. Even before Erligang, at the Erlitou site, bronzes in tombs seem to have been important indicators of status.[13] They were certainly luxury items. Were they also at the center of ritual ceremony? Were we to believe that the vessels in Erlitou tombs were part of a ritual system, we would need evidence for stable groupings of vessels or ritual sets. The few bronzes so far found at Erlitou do not supply such evidence. What about Erligang? Were the bronzes found in graves there just luxury items, or did they have larger ritual and social functions? I want to try to answer this question by looking at evidence from the Panlongcheng tombs.

Before we can answer this question, however, I need to explain a few things about the information in the Panlongcheng excavation report.[14] The report was published decades after the excavations took place, and it has a number of problems. Of the thirty-eight tombs it describes, quite a few were chance finds made by local farmers and were not properly excavated. Because of this, it is likely that in some cases, the reported inventory of a tomb does not exactly correspond to the original contents of the tomb. Also, many of the artifacts were broken into pieces, making it difficult for the excavators to identify single objects. Thus, the report's statistics are not very accurate. There were also some inconsistencies. For example, the preliminary report differs from every subsequent report as to the vessel count in Lijiazui Tomb 1: the tomb reportedly contained more than twenty vessels, but the number of *jue* given in the reports varies from three to five. So in the case of the Panlongcheng tombs, we cannot make a very precise statistical

13. For references to the Erlitou site, see Bagley, "Shang Archaeology," 158–65.

14. *Panlongcheng.*

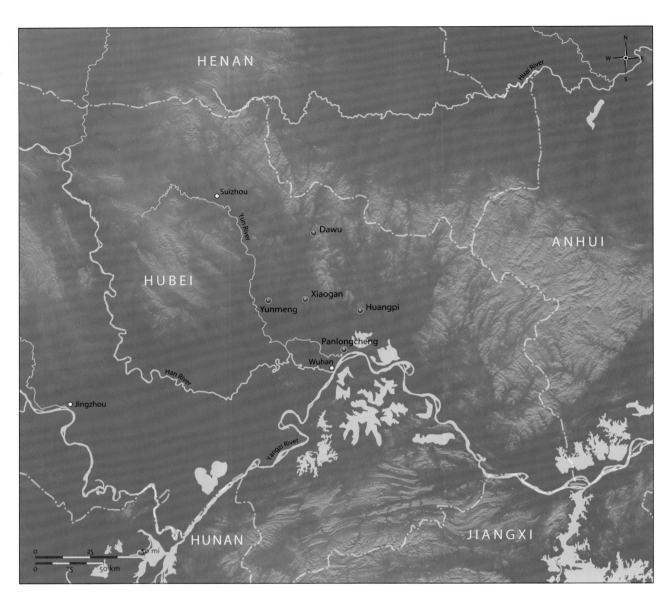

MAP 2. Erligang-period sites in Hubei.

analysis, but we do not need to reject the overall picture of the evidence reported. For those tombs that were scientifically excavated and do not have discrepancies in the number and types of artifacts found in the tombs, we have no reason to doubt the accuracy of the reports.

A second problem has to do with the excavators' difficulty in identifying the tombs. Because the tombs occurred within cultural layers of the Panlongcheng site, it was difficult to locate the walls of the tomb shafts. Not only that, but the skeletons of the tomb occupants had completely decomposed; the excavators had to rely mainly on grave goods to help them identify tombs. As a result, some burials may have been overlooked—they may have been classified as some other kind of deposit. Several deposits that the report calls "refuse pits" contained traces of vermilion and bronze vessel sets. These may actually have been tombs. Tombs that contained only pottery and no bronzes were particularly hard for the excavators to identify. If we compare the burials at Panlongcheng with those at Zhengzhou, it is surprising how few burials without bronzes were discovered at Panlongcheng (see table 1). It is likely that Panlongcheng had a greater number of tombs with very few artifacts and that the excavators simply failed to recognize them.

The scale of the Panlongcheng tombs and the types of artifacts contained in them very clearly reflect different levels of social status. The tomb chamber of Lijiazui Tomb 2 measured more than three meters in length: this is the largest tomb found at Panlongcheng and the largest Erligang tomb known (fig. 13).[15]

15. For an English-language description of the tomb, see Robert Bagley, "P'an-lung-ch'eng: A Shang City in Hupei," *Artibus Asiae* 39, no. 3 (1977): 165–219.

FIGURE 13. Lijiazui Tomb 2 during excavation, 1974.

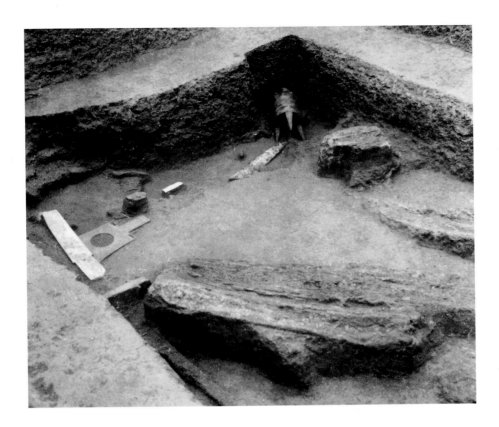

TABLE I. Comparison of Panlongcheng and Zhengzhou Tomb Offerings[16]

SITES	TOMBS CONTAINING BRONZE	TOMBS CONTAINING OTHER OFFERINGS	TOMBS CONTAINING NO OFFERINGS
Panlongcheng	31	7	0
Zhengzhou	22	38	68

It contained three sacrificial victims and a wealth of grave goods. At Panlongcheng, the larger the tomb, the richer the grave goods in both number and variety. Bronzes, jades, and stoneware were found only in the largest and richest tombs. Very small tombs either did not have bronzes or contained only a few bronze knives and spears but no bronze vessels. We can conclude from this that jades, stoneware, and bronzes were luxury objects and their presence in a tomb represented high social status. The role of pottery and stone objects is less clear, but we certainly cannot say that these artifact types played much of a role as a standard in marking social status.

The Panlongcheng tombs very clearly show different social rankings reflecting something of the contemporary social structure. Those tombs that were recognized by archaeologists clearly display three basic levels. The first is represented by tombs that contained a bronze vessel set or multiple sets. The second is represented by tombs that contained pottery and only a few bronze weapons and tools and the occasional jade. The third is an even lower class of burials that the excavators mostly failed to identify and that would have contained no offerings.

A closer look at the burials that contained bronze vessels reveals regularities in the distribution of bronze vessel types that indicate further distinctions of status. Vessels for wine are more numerous than those for food and occur in certain regular combinations. The most commonly encountered combination is *gu*, *jue*, and *jia* (fig. 14) or just *jue* and *jia*. These wine vessels seem to be the most basic group.

16. Zhengzhou also had another seventy burials containing no offerings, but these would appear to be sacrificial pits.

TABLE 2. Bronze Assemblages of Panlongcheng Tombs

PANLONGCHENG TOMBS	WINE VESSELS	FOOD VESSELS
Lijiazui M2	1 *gu*, 4 *jue*, 3 *jia*, 1 *zun*, 1 *he*	6 *ding*, 1 *gui*, 1 *li*, 1 *yan*, 1 *pan*
Yangjiawan M11	4 *gu*, 4 *jue*, 4 *jia*, 3 *zun*	1 *ding*, 1 *gui*
Yangjiawan M4	2 *gu*, 2 *jue*, 2 *jia*, 1 *zun*	1 *li*
Yangjiazui M2	2 *gu*, 2 *jue*, 2 *jia*	
Yangjiawan M5	1 *gu*, 1 *jue*, 2 *jia*	
Louziwan M4	1 *jue*, 2 *jia*	1 *ding*, 1 *li*
Yangjiazui M1	1 *jue*, 2 *jia*	1 *ding*
Louziwan M1	1 *gu*, 1 *jue*, 1 *jia*	1 *ding*
Louziwan M7	1 *gu*, 1 *jue*, 1 *jia*	1 *li*
Louziwan M9	1 *gu*, 1 *jue*, 1 *jia*	
Louziwan M5	1 *gu*, 1 *jue*, 1 *jia*	
Louziwan M6	1 *gu*, 1 *jue*, 1 *jia*	
Yangjiawan M6	1 *jue*, 1 *jia*	1 *li*
Louziwan M1	1 *jue*, 1 *jia*	1 *ding*

They are found even in tombs with only a few bronze vessels, which must belong to a rather low level of the elite.

In wealthier tombs, the numbers of *gu, jue,* and *jia* are multiplied to produce sets with two, three, or even four of each of these types (see table 2), which must indicate a higher status. Assemblages in these higher-status tombs also held other wine vessels, sometimes one or more *zun*, sometimes a *lei*, a *you*, or a *he*. These regular combinations of vessels seem to be a clear indication that Erligang bronze vessels were already used in ritual sets.

The wine vessel sets at Panlongcheng with their emphasis on sets of *gu, jue,* and *jia* seem to be the direct ancestors of the wine sets found in tombs at Anyang. At both sites, the absolute number of *gu, jue,* and *jia* seems to be a clear marker of status, that is to say that during the Erligang period, a bronze vessel ritual system centered on sets of wine vessels had already come into being.

As for the food vessels, what do they tell us about their status in ritual assemblages? The *yan* and *gui* appear only in the very wealthiest tombs; the only common food vessels are *li* and, above all, *ding*. The richest tombs at Panlongcheng include multiple *ding*, while more modest tombs often have only a single *ding*. But it is not only the number of *ding* that indicates status: in the wealthiest tombs, the *ding* both outnumber other types and are often much larger. *Gu, jue,* and *jia* wine vessels, in contrast, indicate social status only by their numbers. They do not vary much in size. For Erligang ritual ceremonies, the different sizes of the *ding* must have had the greatest visual impact (fig. 15). The presence of definite vessel combinations and the variety in their number and sizes suggest that bronze vessels were already part of ritual sets that were intimately connected to the social status of their owners.

This brings me to the question of where the Panlongcheng bronzes were produced. Whether Panlongcheng had its own foundries is a problem that has garnered considerable attention from scholars. Some scholars have argued that since Erligang belonged to a period of early state formation, it is likely that the state exerted tight control on the circulation of important technological practices. They

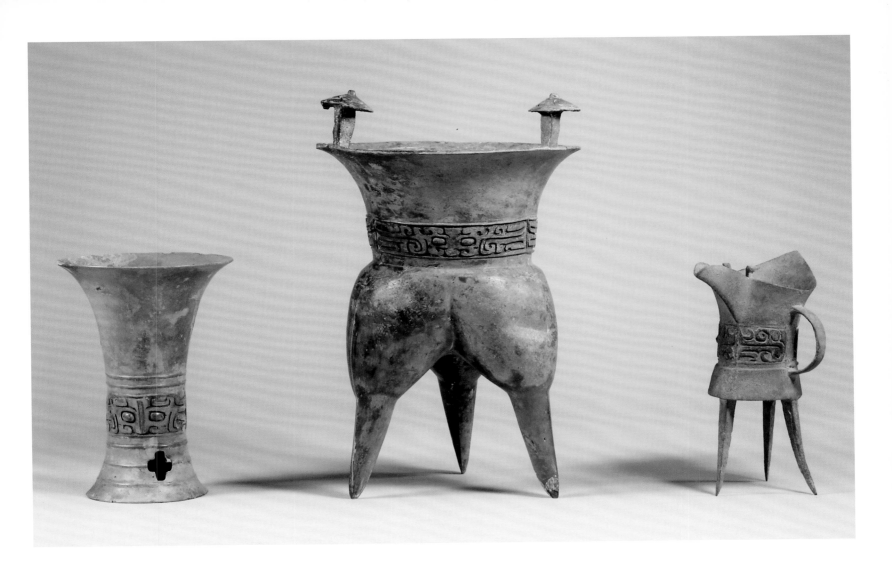

FIGURE 14. Bronzes from Panlongcheng, 14th century BCE. Vessel types (left to right): *gu*, *jia*, and *jue*.

posit that the foundries at Zhengzhou should be the only Erligang casting site and that bronzes found at Panlongcheng and other peripheral sites were imported from Zhengzhou.[17]

A more widely accepted view takes the position that there were local foundries capable of producing the bronzes found at Panlongcheng.[18] The main support for this view comes from evidence presented in the Panlongcheng excavation report. In the preliminary report on the 1963 Louziwan excavation, first published in 1976, the authors state that the site yielded ceramic smelting crucibles and that remnants of copper slag were found in these pots.[19] From this, they inferred that the bronze found at Panlongcheng was the product of local bronze foundries. Unfortunately, when these so-called slag samples were examined under an electron microscope, scientists concluded that the samples were not slag.[20]

As for the ceramics in which the so-called slag was found, there is also no evidence to support their identification as smelting crucibles. The excavators did successfully experiment with smelting copper ore in replicas of the ceramic pots found at Panlongcheng, but there is no direct evidence that any of the Panlongcheng pottery vessels were actually smelting crucibles.[21]

The bronzes themselves offer the best evidence of whether or not there were bronze foundries at Panlongcheng. And one convincing piece of evidence comes from repairs. Perhaps because of the thinness of the vessel walls, many of the Panlongcheng bronzes have cast-on repairs, sometimes as substantial as a whole new leg. What is interesting about these repairs is that while some of them appear to be repairs of casting defects—repairs made immediately after casting—others appear to be repairs of damage that occurred during use. Certain vessel types, *ding* and

17. See Li Liu and Xingcan Chen, *State Formation in Early China* (London: Duckworth, 2003), 117. Cf. note 65 in Wang, chapter 2 in this volume.

18. Bagley, "P'an-lung-ch'eng," 196. Kwang-chih Chang, *Shang Civilization* (New Haven, CT: Yale University Press, 1980), 303.

19. Hubei sheng bowuguan, "1963 nian Hubei Huangpi Panlongcheng Shangdai yizhi de fajue," *Wenwu* 1976.1: 55.

20. Hao Xin and Sun Shuyun, "Panlongcheng Shangdai qingtongqi de jianyan yu chubu yanjiu," in *Panlongcheng*, 1:526.

21. Xu Jinsong and Dong Yawei, "Panlongcheng chutu da kou taogang de xingzhi ji yongtu," in *Panlongcheng*, 1:599–607.

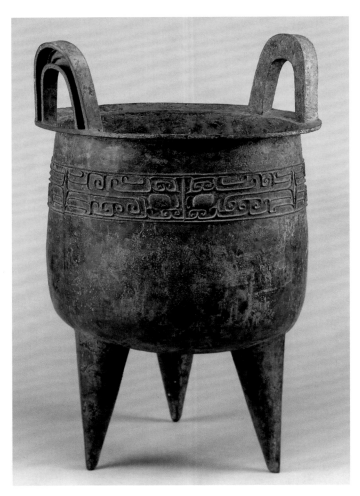

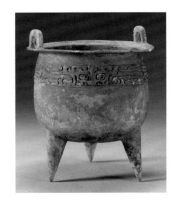

FIGURE 15. *Ding* from Panlongcheng, 14th century BCE. (a) From Yangjia-wan Tomb 11. H. 55 cm. (b) From Lijiazui Tomb 2. H. 35.6 cm. (c) From Lijiazui Tomb 2. H. 18.8 cm. All to the same scale.

FIGURE 16. *Ding*, 14th century BCE. H. 45 cm. From Lijiazui Tomb 1, Panlongcheng, unearthed in 1974.

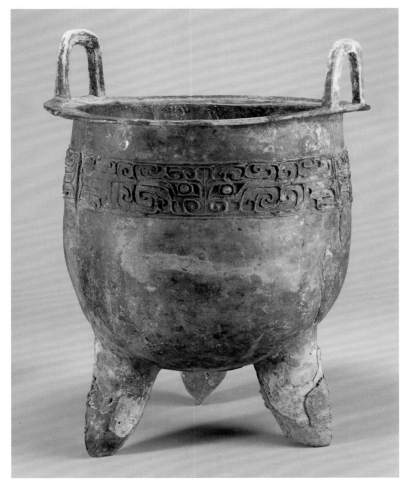

jia, for instance, seem to have needed repairs especially often. Perhaps something in the way these shapes were used caused them to break more frequently than other shapes (perhaps because they were heated over a fire?). The legs of the *ding* in figure 16 were repaired several times. Another *jia* vessel had thirteen repairs. Both must have been used over a long period, and they clearly were in frequent need of maintenance.

The casting technique used to make repairs, particularly repairs as substantial as a new leg, is not all that different from the casting technique used to make the vessel in the first place. Unless we are willing to believe that *ding* and *jia* were sent back to Zhengzhou every time they needed repairs, someone at Panlongcheng must have been able to cast bronze—in other words, repairs to breakage that occurred in use would seem to be evidence for local bronze casting at Panlongcheng. Of course, it would be nice if we had a foundry site with molds for vessels at Panlongcheng, but so far we do not.

Wherever they were cast, the bronzes at Panlongcheng are sensational. The greatest city of the Erligang period was Zhengzhou, and there may have been dozens of cities the size of Panlongcheng. But in the present state of archaeology, our richest source of information about Erligang bronzes comes from this small city on the banks of the Yangzi.

Defining the Erligang Civilization

China's First Empire?

Interpreting the Material Record of the Erligang Expansion

Wang Haicheng

IN 1952, Chinese archaeologists excavated a habitation site at a place called Erligang in the modern city of Zhengzhou (no. 1 on map 1; fig. 1). Ceramic seriation and stratigraphy indicated that the site represented a stage preceding the late Shang period, the material culture of which was well known from excavations at modern Anyang 160 kilometers to the north. By convention, the pottery assemblage was taken to define an archaeological culture, the Erligang culture (ca. 1500–ca. 1300 BCE), named after the type site.

Subsequent discoveries of ritual bronzes and enormous city walls at Zhengzhou suggested that the Erligang material culture was the product of a powerful state. The Zhengzhou city has two walls built of rammed earth (fig. 1a). The perimeter of the inner wall is about seven kilometers. It is unclear whether the outer wall completely enclosed the inner one. The inner wall is about twenty-two meters thick at the base. Remnants of it are still standing today (see figs. 19 and 20 in Bagley, ch. 1 in this volume). The Erligang site is located in the southeast corner of the outer city (no. 7 in fig. 1a).

In the decades since those first discoveries, archaeologists have found three separate hoards of bronzes immediately outside the inner wall (no. 25 at Zhangzhai Nanjie and no. 46 at Xiangyang Huizu Shipinchang in fig. 1a and at Nanshunchengjie, near the southwest corner of the inner city). Figure 2 shows the Nanshunchengjie hoard in situ. It contained nine ritual vessels and three weapons. Among these, the four *fangding* together weigh more than 120 kilograms. The Zhangzhai Nanjie hoard (no. 25 in fig. 1a) contained two *fangding* that together weigh 150 kilograms (see fig. 39 in Bagley, ch. 1 in this volume).

Because the pottery and bronze assemblages at Zhengzhou look like ancestors of Anyang pottery and bronzes, and because transmitted texts talk about a Shang dynasty that ruled from Anyang and earlier capitals, archaeologists unhesitatingly assigned the Zhengzhou city and the state that built it to the Shang dynasty. Thereafter, the Erligang culture was often equated in the literature with "the early Shang culture."[1]

It was soon realized that the geographic distribution of the Erligang material culture is much wider than that of the Anyang culture. Figure 3 shows a walled settlement at a place called Panlongcheng located 450 kilometers south of Zhengzhou, near the north bank of the Yangzi River (no. 32 on map 1). Excavations at Panlongcheng brought to light finely cast bronze vessels indistinguishable from those found at Zhengzhou. A consensus was soon reached that Panlongcheng was an outpost of the state that ruled at Zhengzhou (see Bagley, ch. 1, and Zhang, ch. 2, in this volume).

More bronzes of the same Erligang type have by now been found at many other locations between the Yellow and Yangzi Rivers. Map 1 shows the distribution

1. For a time in the 1960s, archaeologists identified the Erlitou site as "early Shang" and therefore called the Erligang culture "middle Shang," but when radiocarbon dates persuaded them that Erlitou was too early to belong to the Shang dynasty, they returned to calling Erligang "early Shang."

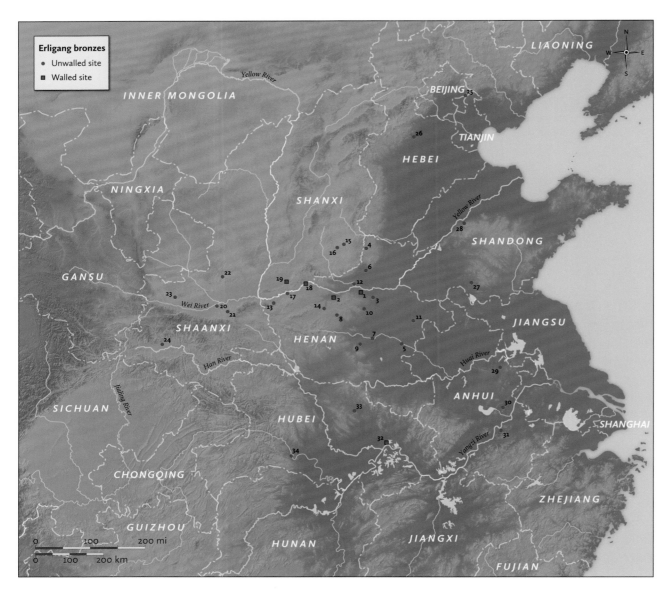

Erligang bronzes
- Unwalled site
- Walled site

of Erligang bronze finds; map 2 shows the distribution of Erligang pottery finds. Seven of the settlements with Erligang pottery are fortified with walls (the squares on map 2). What we see in these maps is a widely disseminated archaeological culture that, on present evidence, seems to have originated at its largest site, the city at Zhengzhou. The problem I want to focus on is the expansion—called the "Erligang expansion"—that carried this culture outward from its point of origin. The Erligang culture lasted about two centuries, and the expansion must have gone on for a substantial part of that time, but the unity of material culture it brought about did not last. Some of the fortified settlements seem to have been abandoned after only a brief occupation, and regional bronze styles soon appeared in former Erligang territory (see Steinke, ch. 7 in this volume).

The Erligang expansion was hugely important. It carried a newly invented metal technology and perhaps even civilization itself outward to a large area of north and central China. It is the mechanism by which the early Bronze Age changed from a local to a regional phenomenon.

But it has yet to receive the attention it deserves. Archaeologists working on the Erligang culture have occasionally speculated about reasons for the expansion, but mostly they are preoccupied with constructing minute pottery typologies for individual sites and matching walled city sites with capitals of the Shang dynasty recorded in later texts.[2] Art historians are inclined to ignore pottery and focus on bronzes, and their interest is usually the inner logic of stylistic developments.

2. For a study of the Erligang culture based mainly on pottery and site distribution, see Wang Lixin, *Zao Shang wenhua yanjiu* (Beijing: Gaodeng jiaoyu chubanshe, 1998). For a general account, see *Zhongguo kaoguxue: Xia Shang juan*, ed. Zhongguo shehui kexueyuan kaogu yanjiusuo (Beijing: Zhongguo shehui kexue chubanshe, 2003), ch. 4. See also Robert L. Thorp, *China in the Early Bronze Age: Shang Civilization, Encounters with Asia* (Philadelphia: University of Pennsylvania Press, 2006). Half of Li Liu and Xingcan Chen's *State Formation in Early China* (London: Duckworth, 2003) is devoted to the Erligang expansion, but it focuses more on a rather simple theoretical model than on archaeological evidence (see below). For a condensed presentation, see Li Liu and Xingcan Chen, *The Archaeology of China: From the Late Paleolithic to the Early Bronze Age* (Cambridge: Cambridge University Press, 2012), 284–90.

FIGURE 1. (a) Plan of the Erligang-period walls at Zhengzhou. Hatched areas represent palatial foundations. (b) Plan of a palatial building foundation at Zhengzhou (no. 8 in fig. 1a), oriented 20 degrees east of north. Postholes in the foundation are numbered in the plan.

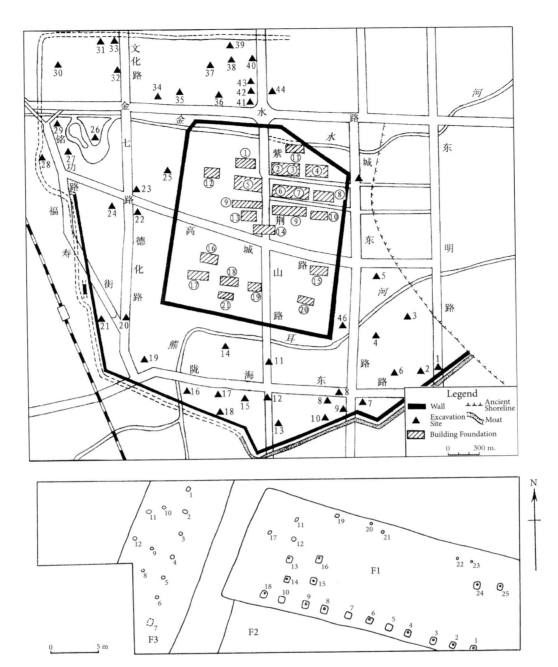

When Robert Bagley, an art historian and contributor to this volume, used evidence from bronzes to suggest that the Erligang expansion was an episode of military conquest that created an empire, archaeologists tended to reject the suggestion because they do not see the same picture in the pottery record.[3] This divide—a divide between disciplines and the forms of evidence they are comfortable with—raises important theoretical questions for archaeology. What are the criteria for correlating archaeological remains with political structures?[4] What is the logic of privileging bronze or pottery in describing and interpreting the evidence for an expansion?

I would like to approach these questions by looking at both forms of evidence, and by looking at them from the perspective of a comparativist. The phenomenon that confronts us—the large-scale dissemination of a distinctive material culture—is not unique to Erligang. On the contrary, it seems to have been fairly common in the initial stages of civilizations. Probably the best-known instance is the so-called Uruk expansion in Mesopotamia in the fourth millennium BCE.

The first civilization in the world arose in southern Mesopotamia, modern-day southern Iraq. Excavators long ago established that the city of Uruk had a leading

3. Robert Bagley, "P'an-lung-ch'eng: A Shang City in Hupei," *Artibus Asiae* 39, no. 3 (1977): 210–13; Bagley, "Shang Archaeology," in *The Cambridge History of Ancient China: From the Origins of Civilization to 221 B.C.*, ed. Michael Loewe and Edward L. Shaughnessy (Cambridge: Cambridge University Press, 1999), 165–71. Bagley's idea of an Erligang expansion, military in nature, is rejected, for example, by Tang Jigen, "Kaoguxue, zhengshi qingxiang, minzu zhuyi," *Dushu* 2002.1: 42–51 (see note 33 below). But it has been adopted, though without acknowledgment, by Li Liu and Xingcan Chen (see Liu and Chen, *State Formation in Early China*, 127).

4. For an early theoretical statement on this issue, see Bruce Trigger, "The Archaeology of Government," *World Archaeology* 6, no. 1 (1974): 95–106. J. N. Postgate, "In Search of the First Empires," *Bulletin of the American Schools of Oriental Research* 293 (1994): 1–13, strikes an emphatic note on the integration of textual and archaeological evidence in reconstructing political phenomena.

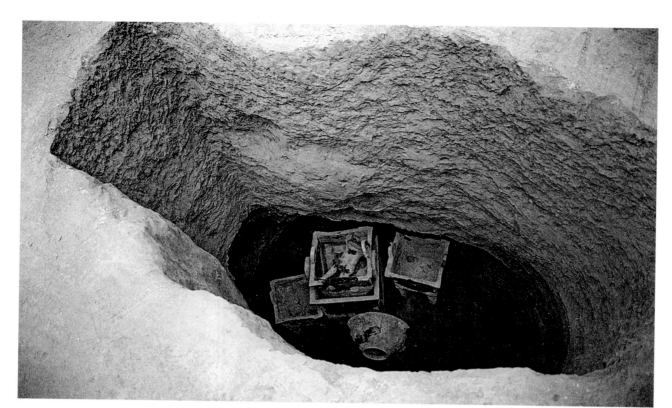

FIGURE 2. Nanshunchengjie bronze hoard, in situ, Zhengzhou, discovered in 1996.

FIGURE 3. Plans of the Erligang city at Panlongcheng. (a) The walls and excavated areas. (b) The palatial foundations inside the city, oriented 20 degrees east of north (cf. fig. 1).

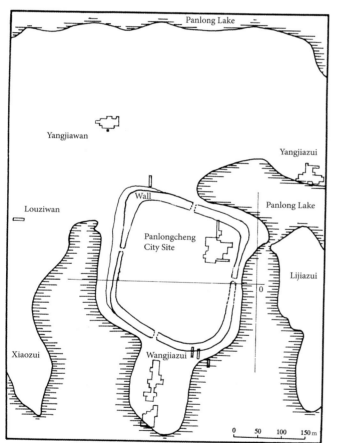

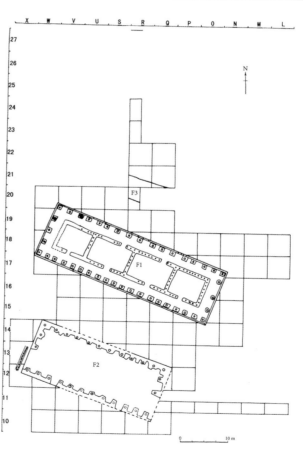

MAP 2. Distribution of Erligang pottery assemblages (see appendix 2 for site names and sources).

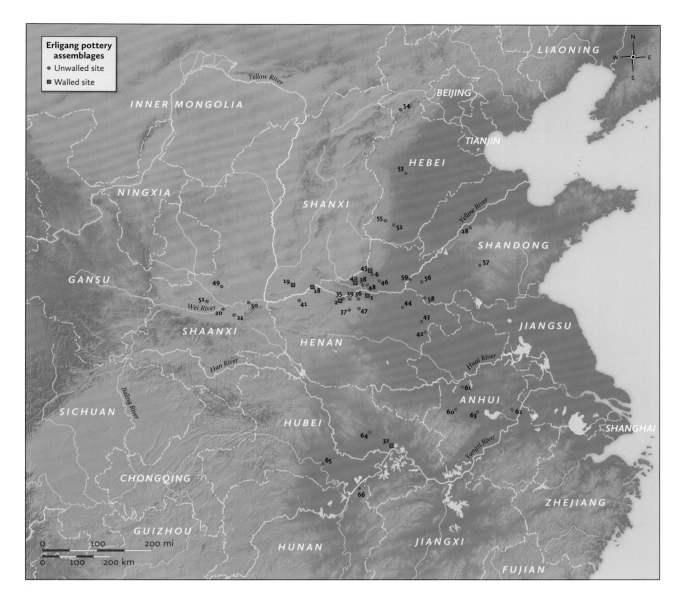

role in this development: sudden, explosive urban growth occurred there during the second half of the fourth millennium BCE. More recently, archaeologists have found that the characteristic traits of Uruk material culture recur widely, often at sites very distant from southern Mesopotamia, particularly in western Iran, northern Mesopotamia, and southeastern Anatolia (map 3). These widespread cultural traits include architectural plans, building techniques, cylinder seals and their motifs, administrative devices, and certain ceramic types (fig. 4).

The Harappan civilization in the Indus Valley and the Olmec civilization in Mesoamerica provide other possible parallels to the Erligang expansion. In all four cases, the homogeneity of material culture over a large area suggests something more than casual contact. So far, however, specialists have reached no consensus as to the social mechanisms involved, no agreement as to how things, ideas, and/ or people were spreading. Let me give some examples.

Over a period of about twenty years, Guillermo Algaze, a leading expert on the Uruk expansion, has substantially revised his theories, moving from the expansion of a primordial Uruk empire (1986) to an organic, inevitable outward colonization driven by competing city-states in southern Mesopotamia (1993, 2001, and 2008).[5] Strong reactions to his changing theories are summarized in *Uruk Mesopotamia & Its Neighbors*, edited by Mitchell Rothman.

A recent general survey by the Indian archaeologist D. P. Agrawal describes points farther east, stating that

5. See Guillermo Algaze, *Mesopotamian Expansion and Its Consequences: Informal Empire in the Late Fourth Millennium B.C.*, PhD diss., University of Chicago, 1986; Algaze, *The Uruk World System: The Dynamics of Expansion of Early Mesopotamian Civilization*, 2nd rev. ed. (Chicago: University of Chicago Press, 2005); Algaze, "The Prehistory of Imperialism: The Case of Uruk Period Mesopotamia," in *Uruk Mesopotamia & Its Neighbors: Cross-Cultural Interactions in the Era of State Formation*, ed. Mitchell Rothman (Santa Fe, NM: School of American Research Press, 2001), 27–84; and Algaze, *Ancient Mesopotamia at the Dawn of Civilization: The Evolution of an Urban Landscape* (Chicago: University of Chicago Press, 2008).

MAP 3. Major ancient Near Eastern sites during the Uruk period.

[t]he Indus civilization or Harappa culture (named after the first discovered site, Harappa) is remarkable for its uniformity and standardization in weights, measures, ceramics, architecture, and in other arts and crafts, though there is considerable variation in ceramics and town-plans. This uniformity appears all the more imposing when one considers that the culture extended over more than a million sq km, an area more than that of Pakistan today. What this uniformity reflects, can only be a speculation. . . . Recent studies, however, are bringing out a good deal of regional variation. . . . Thus we find that the Harappan culture exhibits both the traits: a uniformity which characterizes it as a uniform culture, and the regional diversity which allows for expression of local religious beliefs and traditions. This unity in diversity has always been a hallmark of the Indian civilization.[6]

As for the Olmec culture, Richard Lesure, an archaeologist of pre-Columbian Mesoamerica, writes, "[f]rom 1200 to 400 B.C., Olmec iconography was widely but unevenly distributed across Mesoamerica. In some periods and places it seems very pure; in others, it is mixed with more localized themes and styles. The artistic media used are also diverse. They include monumental stone sculptures, portable stone objects, modeled ceramic artifacts, and pottery vessels."[7] He goes on to ask a series of instructive questions for which he has no certain answers: "Why might an iconographic complex such as Olmec be shared so widely? What kinds of connections between people did that sharing involve? How stable were these connections? Could it be that a variety of different kinds of connections operated simultaneously? . . . Did shared symbols acquire unique local meanings? Were they associated with elites? . . ."[8]

6. D. P. Agrawal, *The Indus Civilization: An Interdisciplinary Perspective* (New Delhi: Aryan Books International, 2007), 63.

7. Richard Lesure, "Shared Art Styles and Long-Distance Contact in Early Mesoamerica," in *Mesoamerican Archaeology: Theory and Practice*, ed. Julia Hendon and Rosemary Joyce (Oxford: Blackwell, 2004), 74.

8. Ibid., 79.

FIGURE 4. Similarities between sites in the ancient Near East during the Uruk period.

9. This is not to deny that we can learn useful things from later historical documents (another kind of comparative study), as Postgate has admirably shown (see, e.g., "In Search of the First Empires"); however, scholarship of Postgate's caliber rests on a deep foundation of archaeology, epigraphy, and sophisticated historiography that is not yet available to scholars working in the early China field.

10. Here I have conflated two overlapping lists given in Lesure, "Shared Art Styles," 78, and Gil Stein, "From Passive Periphery to Active Agents: Emerging Perspectives in the Archaeology of Interregional Interaction," *American Anthropologist* 104, no. 3 (2002): 903.

11. First stated by V. Gordon Childe in *The Danube in Prehistory* (Oxford: Oxford University Press, 1929), v–vi: "We find certain types of remains—pots, implements, ornaments, burial sites, house forms—constantly recurring together. Such a complex of regularly associated traits we shall term a 'cultural group' or just a 'culture.' We assume that such a complex is the material expression of what today would be called a people." The latest edition of a standard textbook by Colin Renfrew and Paul Bahn, *Archaeology: Theories, Methods and Practice*, 5th ed. (London: Thames & Hudson, 2008), quotes this passage and states its preference for the term "assemblage" instead of "culture" (119). Renfrew's call for "the total abandonment of the notion of the culture . . . as recognizable archaeological units" is, it seems to me, impractical. See Colin Renfrew, "Space, Time and Polity," in *The Evolution of Social Systems*, ed. J. Friedman and M. J. Rowlands (Pittsburgh, PA: University of Pittsburgh Press, 1978), 94.

12. See, for example, Zou Heng, *Xia Shang Zhou kaoguxue lunwenji*, 2nd ed. (Beijing: Kexue chubanshe, 2001), 4.

Although writing seems to have been in use in all four of the above-mentioned civilizations, inscriptions are few, short, and poorly understood, so it is only material culture that gives us much hope of learning about the archaeological problem of the spread of a material culture.[9] A number of possible mechanisms can be imagined: emulation, exchange, migration of elite groups, religious proselytization, colonization, or outright conquest, to name but a few.[10] Hoping that comparison will sharpen my sense of which mechanism might best fit the evidence in each case, I am currently at work on a study of the four expansions. In this chapter, I want to sketch my current thinking about Erligang.

DEFINITION

Let me begin with the problem of defining the Erligang culture. In theory, the definition of an archaeological culture is straightforward: the textbooks speak of "a constellation of material traits that occur together consistently at different sites."[11] But in practice, there are problems—the "constellation" sometimes has very few traits—and scholars can disagree. Archaeologists are in the habit of taking utilitarian pottery to be the best reflection of what ancient people did, but mainly for the practical reason that utilitarian pottery is the most common artifact in the archaeological record.[12] When the society under study is highly stratified, downplaying objects made for and used by elites will seriously distort the picture. The democratic instincts of modern academics are out of place here. If there were no Erligang bronzes, no Uruk architecture and seals, no Olmec stone monuments

13. Here it seems to me particularly important to check the common claim that such-and-such a pot in settlement A is similar to one in settlement B by closely examining actual pots or at least photographs of pots rather than trusting the simple line drawings that most Chinese archaeologists rely on. Because trace element analyses (such as by neutron activation) that might identify clay sources have rarely been performed, archaeologists have at present little besides visual inspection to go on in guessing what sort of human contact might have caused the similarities in pots from different sites. But visual inspection can be instructive. Pots can resemble or differ from one another in a wide variety of features—shape, decoration, hardness and firing temperature, construction method, temper particles, clay color and consistency, and more—and similarities in different features may mean slightly different things. Kiln types supply another line of evidence.

14. See Bagley, "Shang Archaeology," 136–39, for a detailed argument on the indexical role of bronzes in early China. As Trigger states, "In complex societies the material culture associated with high status groups may provide the best clue to the political structure of an area, since sharing a common style may serve as a badge of political identity. Particularly in areas of diversity in village culture, an elite culture may serve as evidence of political unity" ("The Archaeology of Government," 99).

15. Some archaeologists have begun to notice the tenuous nature of claims for abandonment that are based only on a few intrusions that might instead reflect a peculiar burial custom or an unfamiliar ritual activity. See Henan sheng wenwu kaogu yanjiusuo, "Zhengzhou Shang cheng xin faxian de jizuo Shang mu," Wenwu 2003.4: 19.

16. One you and one lei; see Zhongguo qingtongqi quanji (Beijing: Wenwu chubanshe, 1993), vol. 1, plates 123, 136. They are not visible in figure 37 in Bagley, chapter 1 in this volume, because they are inside the big vessels.

17. If the Erligang culture originated at Erligang in Zhengzhou (or at the Yanshi site eighty kilometers west of Zhengzhou) and then spread to distant places like Panlongcheng, then certainly the Erligang site (or the Yanshi site) must be used to define its starting point. As we might expect, Lower Erligang material at Panlongcheng is scanty. One potential objection to my use of Panlongcheng as the end point of the Erligang period is that a few other major Erligang sites in Shandong province (e.g., Daxinzhuang in Jinan, Shandong province [for the most recent excavation reports, see app. 2, n. 3, in this chapter]) are likely to have continued to flourish after the abandonment of Panlongcheng. However, materials from those sites have not yet been published well enough to allow close comparisons with Zhengzhou and Panlongcheng, so for the time being, I will use Panlongcheng as my major dating standard. For discussion of the end dates of Erligang sites based on pottery typology, see Wang Lixin, Zao Shang wenhua yanjiu, 107–15 passim.

or jades, no cities at Harappa and Mohenjo-daro, would archaeologists ever have noticed anything remarkable in the wide distribution of certain material cultures? People in stratified societies were socially, politically, and economically differentiated, and we should expect the different strata of society to be reflected differently in the archaeological record. If a certain pottery assemblage and a certain bronze assemblage show related but different patterns of occurrence, the reason may be that they entered the archaeological record by different social mechanisms. The political order, the central theme of this chapter, involved all members of the society—even those at the top!

My definition of the Erligang culture will consequently be stratified. On the plane of the common people, I will assess what components of a given site recur at other sites. These components include pottery, bone implements, stone tools, houses, burial customs, and so on.[13] On the level of the elite, I will argue for taking ritual bronzes to be the defining trait of the Erligang culture, not public architecture or such luxury materials as jade or silk. Bronze was the key element in the legitimation of elite power and authority. Even if architecture, jade, and silk had survived better than they do, we might still find that the society invested a larger share of its resources in the production of bronzes. (If we include the cost of mining, elite expenditure on the bronze industry probably outstripped spending on buildings.) The scale and organization of the Erligang bronze industry testify to the power of the political body that directed it.[14]

A definition of the Erligang culture should include an estimate of its duration. Though a lot of ink has been spilled over the question of dating, discussion has focused mainly on the starting date, as most writers have been concerned only with arguing whether Zhengzhou was the first capital of the Shang dynasty. (This argument is fundamentally nonarchaeological, since its primary aim is to attach an archaeological site to a narrative in transmitted texts of much later date.) My concern is instead the Erligang expansion and the material record of whatever human activity attended it, so the beginning of the period, when materials were scarce and confined to one or two cities, is of less interest to me than the end, and the end, unfortunately, has not been clearly defined.

The traditional way of defining the end of the Erligang period is to align it with the abandonment of the biggest Erligang city, Zhengzhou. But the abandonment of Zhengzhou is an event that tends to dissolve on inspection. Because the ancient city is underneath modern Zhengzhou, it has been excavated to only a very limited extent. As evidence of abandonment, archaeologists can only point to a few test trenches in which features intrude on the city wall: they take the intrusions to mean that the city wall was no longer being maintained. The truth is that archaeology has not pinpointed a moment when the Zhengzhou elite left the city and when bronzes and buildings ceased being made there.[15] The idea of abandonment owes more to transmitted texts, with their stories of Shang kings moving their capitals, than to archaeology. If hoards of big bronzes are taken to imply an elite presence, as they surely must be, then an elite was still in residence when the hoard at Xiangyang Huizu Shipinchang (no. 46 in fig. 1a) was deposited, and two bronzes in that hoard are slightly but unmistakably later than anything else yet found at Zhengzhou, later than anything normally understood by the expression "Erligang style."[16] Archaeologists simply do not know the Zhengzhou site well enough to be able to draw a clear chronological line in its material culture.

By contrast, at the apparent southern limit of the Erligang expansion, at the site of Panlongcheng, extensive survey has been possible, and abandonment of the site seems to have been a punctual event. I propose therefore to take the abandonment of Panlongcheng as defining the end of the Erligang period, and to use the latest bronzes recovered there as a standard by which to judge whether a stray find

elsewhere qualifies as belonging to the Erligang period. In effect, I am proposing that the type site of the Erligang culture is not Erligang but Panlongcheng—or rather, that we use the Erligang site to define the beginning of the period but the Panlongcheng site to define the end.[17] The period so defined may or may not be aligned with major events in the life of the city at Zhengzhou, but it has a good chance of being aligned with major events on a larger geographic scale. My definition is not exactly orthodox, but it is realistic, and I believe it is time we faced the reality that our understanding of the Zhengzhou site is very inadequate.[18]

METHODOLOGICAL CONSIDERATIONS

With these preliminaries out of the way, let us now take a closer look at Erligang pottery and Erligang bronzes and try to answer one of the questions I posed at the beginning: What is the logic of privileging bronze or pottery in describing and interpreting the evidence for an Erligang expansion?

Interpreting Pottery

Though we find a stock of shared vessel types in Erligang pottery, any given type varies slightly from one locality to another (figs. 5, 6). In bronze, by contrast, there is no such variation (see Bagley, ch. 1, and Zhang, ch. 2, in this volume). Chinese archaeologists distinguish seven or eight regional types of pottery assemblage that they group together under the Erligang rubric,[19] but no one has ever claimed to detect regional styles in Erligang bronzes. One reason, obvious but seldom acknowledged, is the social stratification of artifact types mentioned already. Pottery and bronzes were made for different people and served different functions, and their manufacture differed accordingly.[20]

Specialists have recently pointed out that the period when complex societies were forming in Egypt and Mesopotamia saw a marked trend toward the simplification of everyday articles, above all a trend toward the large-scale production of ever more routine pottery vessels.[21] The classic instance is the Uruk beveled-rim bowl (see fig. 4, A and F in the top row). These crude, chaff-tempered bowls take their name from their distinctive rims. They were produced in very large numbers in molds or by hand in many places in Mesopotamia during the Uruk period. They often compose 50 percent or more of the total recovered pottery and frequently were discarded in large quantities.[22]

Specialists are still arguing about the function or functions of the beveled-rim bowls, but surely they are the material reflection of a dramatic social change of some kind. With the rise of complex societies, carefully shaped and beautifully painted Neolithic pots died out.[23] The monotonous appearance of the pottery of the Uruk expansion gives an impression of standardization, and we tend to associate standardization and plainness with mass production, but we should not leap to the conclusion that Uruk pottery was produced in a few centralized workshops.[24] The truth may be just the opposite: the apparent standardization of the beveled-rim bowl might be an almost accidental consequence of the fact that so simple a design was easily transmitted and could be manufactured by any kiln anywhere.[25]

The wide distribution of a few stereotyped forms that we see in the Uruk expansion is paralleled in the Erligang culture and also in the Naqada II culture (ca. 3600–ca. 3300 BCE) in Egypt.[26] In all three places it might reasonably be interpreted as a consequence of state formation, so in this sense, pottery is indeed a helpful source for inferring political structures. Moreover, in China, unlike Uruk, the archaeological evidence hints at centralized production.

Just before the Erligang period, in the Erlitou period (ca. 1800–ca. 1500 BCE), the major cooking vessel in the middle Yellow River region was the *guan*, a sort of

18. The situation in Mesopotamia is rather similar: "Ironically, the data collected from the most intensively excavated sites [in Syria] have provided a more detailed picture of an Uruk community than is available from southern Mesopotamia itself." See Peter Akkermans and Glenn Schwartz, *The Archaeology of Syria: From Complex Hunter-Gatherers to Early Urban Societies (ca. 16,000–300 BC)* (Cambridge: Cambridge University Press, 2003), 190–91. The German excavations of Uruk were a mess. See Hans Nissen, "Uruk: Key Site of the Period and Key Site of the Problem," in *Artefacts of Complexity: Tracking the Uruk in the Near East*, ed. J. N. Postgate (London: British School of Archaeology in Iraq, 2002), 1–16.

19. Wang Lixin, *Zao Shang wenhua yanjiu*, 148–98; *Zhongguo kaoguxue: Xia Shang juan*, 188–203.

20. The other main reason is the mixing of indigenous local pottery with intrusive Erligang pottery. See below and *Zhongguo kaoguxue: Xia Shang juan*, 202.

21. First noted by John Baines, in "Communication and Display: The Integration of Early Egyptian Art and Writing," *Antiquity* 63, no. 240 (1989): 477: "Most dynastic Egyptian pottery is uniform and almost devoid of aesthetic significance." See David Wengrow, "The Evolution of Simplicity: Aesthetic Labour and Social Change in the Neolithic Near East," *World Archaeology* 33, no. 2 (2001): 168–88; and Wengrow, *The Archaeology of Early Egypt: Social Transformations in North-East Africa, 10,000 to 2650 BC*, Cambridge World Archaeology (Cambridge: Cambridge University Press, 2006), ch. 8, with references. See also David Wengrow and John Baines, "Images, Human Bodies, and the Ritual Construction of Memory in Late Predynastic Egypt," in *Egypt at Its Origins: Studies in Memory of Barbara Adams*, ed. S. Hendrickx et al. (Leuven: Peeters, 2004), 1081–1114.

22. Susan Pollock, "Bureaucrats and Managers, Peasants and Pastoralists, Imperialists and Traders: Research on the Uruk and Jemdet Nasr Periods in Mesopotamia," *Journal of World Prehistory* 6 (1992): 317. The figure of 50 percent is only an estimate, since it is difficult to be sure what fraction of the assemblage a given pottery type accounted for just by counting shards.

23. Harriet Crawford, *Sumer and Sumerians* (Cambridge: Cambridge University Press, 1991), 127. Max Loehr noticed a similar trend in China as early as 1936, but as Robert Bagley points out, "the explanation that artists have transferred their activity to other media is too simple" (*Max Loehr and the Study of Chinese Bronzes: Style and Classification in the History of Art* [Ithaca, NY: Cornell University East Asia Program, 2008], 51–52n172).

24. Henry Wright used to argue that pottery from the Susiana Plain was manufactured in a few large workshops and distributed through a system of local exchange that was centrally administered; see Pollock, "Bureaucrats and Managers," 316–17. He now argues that "the available evidence suggests a continuous circulation of potters throughout the Uruk world" (Wright, "Cultural Action in the Uruk World," in Rothman, *Uruk Mesopotamia & Its Neighbors*, 134–35).

25. I am grateful to John Baines for this reminder.

26. For Egypt, see Wengrow, *The Archaeology of Early Egypt*, ch. 4, esp. 87–98.

FIGURE 5. Upper and Lower Erligang pottery assemblages at Zhengzhou.

FIGURE 6. Two regional types of Erligang pottery assemblage. Top: the so-called Dongxiafeng type around southwest Shanxi. Bottom: the Panlongcheng type around the middle Yangzi region.

Dongxiafeng Type 22~24、27、28、31、32. 0 5cm

25、26、29、33、34. 0 5cm

35~38、40、42~44. 0 5cm

39、41、45. 0 5cm

Panlongcheng Type

27. See the discussion of food change at Panlongcheng below. Chinese archaeologists seem to agree that the quantity of *li* (whole and shards) in the archaeological record increased dramatically after the advent of the Erligang culture (Cao Dazhi, personal communication, December 2008; Qin Xiaoli, "Jin xinan diqu Erlitou wenhua dao Erligang wenhua de taoqi yanbian yanjiu," *Kaogu* 2006.2: 57–58, 60, 62).

28. For the ceramic workshop remains at Zhengzhou, see *Zhengzhou Shang cheng: 1953–1985 nian kaogu fajue baogao*, ed. Henan sheng wenwu kaogu yanjiusuo (Beijing: Wenwu chubanshe, 2001), 1:384–460. For Yanshi, see Liu Zhongfu, "Yanshi xian Shang cheng yizhi," in *Yanshi Shang cheng yizhi yanjiu*, ed. Du Jinpeng and Wang Xuerong (Beijing: Kexue chubanshe, 2004), 592. Six kilns were found in very poor condition, so there is only one paragraph of description. For Panlongcheng, see *Panlongcheng: 1963–1994 nian kaogu fajue baogao*, ed. Hubei sheng wenwu kaogu yanjiusuo (Beijing: Wenwu chubanshe, 2001), 1:84–113. The excavators date this workshop to a time from late Erlitou to early Erligang. A ceramic workshop district has been reported within Gucheng Nanguan city in the Yuanqu basin. See *Yuanqu pendi juluo kaogu yanjiu*, ed. Zhongguo guojia bowuguan kaogubu (Beijing: Kexue chubanshe, 2007), 377. An Jinhuai asserts that the majority of Erligang pots were wheelmade (*An Jinhuai kaogu wenji* [Zhengzhou, Henan: Zhongzhou guji chubanshe, 1999], 194), but Li Wenjie, a ceramic specialist, finds that most of the pots from the Gucheng Nanguan site were either handmade or mold-made ("Yuanqu Shang cheng taoqi de zhizuo gongyi," in *Yuanqu Shang cheng 1: 1985–1986 niandu kancha baogao*, ed. Zhongguo lishi bowuguan kaogubu et al. [Beijing: Kexue chubanshe, 1996], 309); Li seems to be correct (Cao Dazhi, personal communication, March 2011).

flat-bottomed pot (fig. 7a). In Erligang, this was replaced by the hollow-legged tripod called *li* (fig. 7b), which is a diagnostic Erligang type. Since culinary custom is strongly bound to a particular culture, the change in cooking vessels between Erlitou and Erligang might be taken as a signal that population change was involved.[27]

At three Erligang city sites, archaeologists have found ceramic workshops.[28] At Zhengzhou, a ceramic workshop district covering an area of about twelve hectares has been partly excavated (no. 28 in fig. 1). It was probably within the outer city wall, and it is believed to have been in operation throughout the life span of the city. In 1955, archaeologists explored about 1,500 square meters of the district and found no fewer than fifteen Erligang kilns (fig. 8). They also found extensive traces of studios, outdoor preparation spaces where clay was dug and washed (batches of unused clay have been found in situ), and graves possibly belonging to

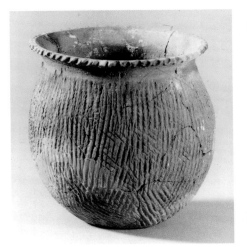
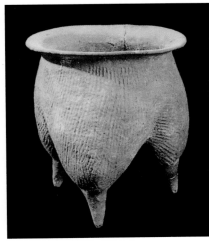

the workmen, to judge from their proximity to the ceramic production areas. The site also yielded many clay and bone tools used to make pottery, as well as other clay debris such as kiln wasters (figs. 9a–f). Erligang pottery includes untempered drinking vessels, untempered food vessels, and tempered cooking vessels. The debris shows that this particular workshop specialized in untempered food vessels. The other pot types must have been produced by specialized workshops elsewhere in the city.

In view of workshop finds like these, it seems possible that each walled Erligang city mass-produced pottery not only for the city itself but also for distribution outward to smaller settlements nearby.[29] This production system was quite different from the decentralized manufacture suggested for Uruk pottery. The major Erligang settlements need not have been closely coordinated, nor were they engaged in any kind of artistic rivalry, but they would have produced basically similar pottery. Whatever authority ran the workshops—the state or some independent enterprise—it is likely to have prescribed only shapes and quantities.[30]

Mass production of this kind is likely to have entailed quotas, as the later Qin empire specified in its third-century BCE statutes on artisans.[31] The function of most Erligang pottery was purely utilitarian, so its design was casual. The potter, struggling to meet his quota, was not heavily invested in research and development; he was making cooking pots whose function had not changed in all the years he had been making pots. Since it was not a function that required any particular visual styling, we cannot reasonably hope to make sense of the changes in the pottery produced at one site or to extract information from the differences between pottery from one site and pottery from another. Such differences are likely to have been mostly random drift.[32]

Not surprisingly, therefore, the many regional variants of the Erligang pottery assemblage defined by Chinese archaeologists are hard to interpret as reflections of political structures. In figure 6, the upper drawing shows the pottery assemblage from Dongxiafeng, an Erligang site in southwestern Shanxi, while the lower one shows the assemblage at Panlongcheng in southern Hubei. The assemblages are different, but do the differences signify any difference of political structure? It is hard to imagine constructing an argument that would justify reading political information out of taller and shorter *li* tripods. These are differences that could have arisen by pure chance.[33]

In China, as in Egypt and Mesopotamia, the formation of complex societies deprived the common people of aesthetic gratification by denying them the leisure to design: the richly painted Neolithic pot belongs to a different world from that of the drearily functional Erligang pot.[34] In a production setting that did not

29. As John Baines reminded me, transport cost and distance are important issues in discussing material culture distribution. In theory, we can imagine a situation in which pottery vessels were used to ship more valuable commodities such as grain, wine, and oil via water, as in the ancient Near East (e.g., Algaze, *Ancient Mesopotamia*, 50–62). Even though the major Erligang centers were connected by rivers, the wide distribution of Erligang pottery cannot be accounted for in this way, because a significant portion consists of cooking vessels. Two kilns have been found in two small Erligang sites in southwest Shanxi (Qin, "Jin xinan diqu Erlitou wenhua," 64, 66), which indicates that some settlements around major Erligang centers were equipped to produce their own pottery, but this does not rule out local redistribution of pottery made in the large centers.

30. Compare J. N. Postgate's remarks on pottery production in the Middle Assyrian and Hittite states: "While the requirements of the state system no doubt did determine the types of pot produced, it seems they had a relaxed attitude to the detail, allowing a range of variation. . . . [A]lthough it is difficult to ignore the general impression of a correlation between centralized state administration and standardized repertoires, this may have been less the consequence of a deliberate drive for uniform production, requiring direct intervention by state administrators in the ceramics industry, than a response by whatever local industrial resources were available to their demand for particular types and quantities of pottery" ("The Debris of Government: Reconstructing the Middle Assyrian State Apparatus from Tablets and Potsherds," *Iraq* 72 [2010]: 32).

31. A. F. P. Hulsewé, *Remnants of Ch'in Law: An Annotated Translation of the Ch'in Legal and Administrative Rules of the 3rd Century B.C. Discovered in Yün-meng Prefecture, Hupei Province, in 1975* (Leiden: Brill, 1985), 61 entry A 58. For similar approaches used by the Ur III empire, see Hans Nissen, Peter Damerow, and Robert Englund, *Archaic Bookkeeping*, trans. Paul Larsen (Chicago: University of Chicago Press, 1993), 82–83.

32. See Bagley, *Max Loehr*, 59.

33. As mentioned, Tang Jigen rejects Bagley's idea of an Erligang expansion, apparently because he believes that political structures are recorded in pottery, not bronze:

"Analysis of site distribution and pottery shows that in different regions the Shang culture [the Erligang and Anyang cultures] manifests regional characteristics. Therefore Chinese scholars usually speak of regional variants of the Shang culture. Regional variants persisted during the early, middle, and late phases. Importantly, the high degree of cultural unity of the Shang culture derived from analyzing the distribution of bronzes in [Bagley's] 'Shang Archaeology' is, upon analysis of site distribution and pottery, shown to have diversity under the relative unity. In other words, analysis of pottery and site distribution yields a different conclusion from that of analysis of bronzes. In these circumstances, how can we trust an interpretation based merely on studying the distribution of bronzes? In his article, Bagley attempts to equate the sphere of Shang bronze distribution with an 'Erligang empire.' This seems very risky. According to research, the sphere of bronze distribution was only a 'cultural sphere of ritual vessels,'

a concept absolutely not equal to 'empire.' In studying the Shang civilization we need at least to look for a unified interpretation based on analysis of site distribution, pottery, and bronzes, or more types of material." ("Kaoguxue, zhengshi qingxiang, minzu zhuyi," 50)

But does regional variation in pottery really have any bearing on the political question? Nobody doubts that the Han dynasty ruled an empire, but neither utilitarian nor funerary pottery was uniform throughout that empire. Why should it have been? Accustomed by training and habit to rely on pottery, archaeologists sometimes fall into the error of supposing that, whatever question is of interest to them, pottery holds the answer. (Tang Jigen writes that "pottery contains more information than bronzes regarding ancient culture, especially human life.") But we must think more carefully about what information a given artifact type has to offer. Different artifacts tell us different things. Note also that while Tang questions Bagley's use of the word "empire," he himself does not doubt stories of Shang conquests when they appear in transmitted texts. Zou Heng used the Chinese equivalent of "empire" (*diguo* 帝國) in an oft-cited 1980 article on the so-called Xia culture ("Shi lun Xia wenhua," reprinted in Zou, *Xia Shang Zhou kaoguxue lunwenji*, 163).

34. Cf. Baines, "Communication and Display," 477: "The differentiation and privileging of certain forms and materials deprived most people of artistic expression of any kind to which the elite accorded significance."

35. See Robert Bagley, *Shang Ritual Bronzes in the Arthur M. Sackler Collections* (Cambridge, MA: Harvard University Press, 1987), 38–41; Bagley, *Max Loehr*, 118n399; Bagley, "Anyang Mold-Making and the Decorated Model," *Artibus Asiae* 69, no. 1 (2009): 39–90.

36. The patron must have played an important role, but perhaps chiefly the role of choosing among alternatives invented by his craftsmen. As Bagley has argued, the bronze casters of the early Bronze Age seem in some respects to have had more latitude for invention than artisans in the ancient Near East. See Robert Bagley, "Shang Ritual Bronzes: Casting Technique and Vessel Design," *Archives of Asian Art* 43 (1990): 6–20; Bagley, *Max Loehr*, esp. 86 and 118–19.

37. Bagley, *Max Loehr*, esp. 96–97 and 128–29.

allow the potter latitude for aesthetic initiatives, we might almost hesitate to apply the word "styles" to different pottery types.

A few Erligang pots were given a bit of embellishment: the one in figure 10 has intricate patterns on its belly that were impressed by means of a carved clay stamp, perhaps by a block similar to that shown in figure 9e. Decorated pots like this one imitated both the shape and the decoration of bronzes (figs. 11, 12), and the key point here is that the imitation was done cheaply, by a technique that was not used in the bronze foundries. Erligang bronze casters never used stamps or pattern blocks. Each piece of a mold or model was individually carved by expert designers.[35] The beautifully sharp-edged designs of the expensive and prestigious bronze vessels were translated cheaply into coarse designs on pottery in the same way that we might replace carved wood with stamped plastic.

The bronze decoration was imitated not only in pottery but also on wooden coffins in elite tombs (fig. 13). In the early Bronze Age, the best designers worked at the bronze foundries—which must have had a near monopoly on talent—and as far as we can tell from what has survived, other media copied the ideas that came out of the foundries.[36] This has implications for the interpretation of the archaeological record. Let me turn now to the question of what the bronzes can tell us about the Erligang culture and the Erligang expansion.

Interpreting Bronzes

Unlike the gradual drift that occurs in the pottery industry, any distinctive change in the bronzes is likely to be the result of a conscious decision by a bronze maker. In a functional weapon, the change could answer a practical need. In a ritual vessel, it might be the caster's attempt to attract his patron's attention with an interesting departure from previous models, or, to put it another way, the caster's attempt to satisfy the patron's demand for an object with fresh visual impact. The function of the bronze ritual vessels was, after all, mainly visual.[37] Since the starting point for any artist is the objects he sees around him—the objects his tradition has already produced—his work inevitably has a debt to previous works. Except

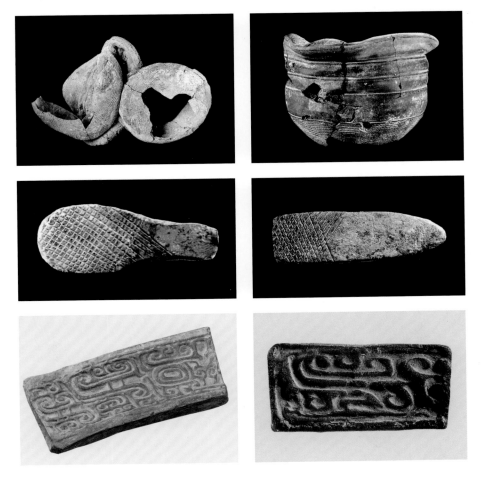

FIGURE 9. Centralized pottery production at the West Minggonglu pottery workshop site, Zhengzhou. (a, b) Wasters. (c, d) Textured ceramic paddles for making patterns. (e, f) Decorated ceramic blocks.

38. Max Loehr, "The Bronze Styles of the Anyang Period," *Archives of the Chinese Art Society of America* 7 (1953): 42–53; Bagley, *Max Loehr*, ch. 6.

39. For two foundry sites at Zhengzhou, see *Zhengzhou Shang cheng*, 1:307–84. Traces of bronze casting have been reported from Yanshi (Du Jinpeng and Wang Xuerong, eds., *Yanshi Shang cheng yizhi yanjiu* [Beijing: Kexue chubanshe, 2004], 24) and Panlongcheng (*Panlongcheng*, 1:228-30, 317–18, 394–97, 499, 503, 599–607; cf. Zhang, ch. 2 in this volume). The Huaizhenfang site at Lantian in Shaanxi is also reported to have foundry remains (see Xi'an Banpo bowuguan, "Shaanxi Lantian Huaizhenfang Shang dai yizhi shijue jianbao," *Kaogu yu wenwu* 1981.3: 48). Liu and Chen (*State Formation in Early China*, 111) identify it as a copper-smelting site. Traces of smelting are reported inside the city at the Gucheng Nanguan city site in Shanxi (*Yuanqu pendi juluo kaogu yanjiu*, 383). For the question of whether Erligang bronzes were cast locally or exclusively at Zhengzhou, see Nan Puheng et al., "Hubei Panlongcheng chutu bufen Shangdai qingtongqi zhuzaodi de fenxi," *Wenwu* 2008.8: 77–82, which concludes that bronzes from Panlongcheng were locally cast. Its main argument is that petrographic analysis shows strong affinity between the clay cores inside Panlongcheng bronzes and potsherds and soil samples from the site. I find this conclusion of dubious value because the sample is very small for Panlongcheng and even smaller for Zhengzhou (just one clay mold and one soil sample from Zhengzhou).

40. For the Western Zhou conquest and colonization, see Jessica Rawson, "Western Zhou Archaeology," in Loewe and Shaughnessy, *The Cambridge History of Ancient China*, 385–413; Wang Haicheng, *Writing and the State in Early China in Comparative Perspective* (PhD diss., Princeton University, 2007, 221–35, with further references). Archaeologists of the Roman empire can identify a fragmentary bust of a Roman emperor from its hairstyle. Sanctioned sculptors specializing in images of the emperors no doubt made models to be sent to the provinces for local sculptors to copy (Christopher Hallett, personal communication, October 2007). Provincials emulated metropolitan models not because they were required to but because they wished to; the same may well have been true of Zhou foundries.

41. For a succinct history of the idea of empire, see Stephen Howe, *Empire: A Very Short Introduction* (Oxford: Oxford University Press, 2002), 15–22. In this chapter, I call Erligang both an "empire" and a "state," which is another contentious word that I have defined elsewhere (see Wang Haicheng, *Writing and the State*, 4). With a fuller material record at his disposal, J. N. Postgate makes a more nuanced state-versus-empire distinction, describing it as "the difference between a polity which has a unified system of government, possibly integrating previously separate components into a larger but unitary state, and one which extends its dominion over other polities without attempting to integrate their separate power structures or to control their internal political order" ("The Debris of Government," 20).

when he adopts something from a totally foreign intrusion, therefore, we should be able to link the bronzes produced by a caster of one generation with his starting point in the bronzes of the previous generation. This is the reasoning behind Max Loehr's renowned sequence of five bronze styles, the first three of which belong to the Erligang period.[38] The fact that the development Loehr described proceeds through the same steps, producing bronzes without regional peculiarities, in all the places where Erligang bronzes are found argues that Erligang foundries were in close and constant communication with one another.[39]

Could such artistic homogeneity have been maintained in foundries operated by different states? Surely not. Later in the Bronze Age, in periods such as the late Shang and Eastern Zhou (770–221 BCE), when there were many states coexisting with one another, we see no such homogeneity. The closest parallel to the uniform bronze assemblage of the Erligang period is the bronze assemblage spread across north China at the beginning of the Western Zhou period, and that is the material trace of an empire established by military conquest followed by colonization.[40] Historically, empire building increased cultural diversity in an empire's territories, but homogeneity was the rule rather than the exception in the elite apparatus.

Although the word "empire" has acquired numerous and sometimes ponderous definitions, for Bagley and most other writers, including this one, an empire is a large polity formed by a centrally directed conquest, uniting a variety of peoples under one rule and often entailing large population movements.[41] The material record of the Erligang culture fits this definition.

Comparing Erligang elite culture with the elite material culture of Uruk, the Indus Valley, and the Olmec reveals some interesting differences. The Uruk expansion is now thought to have been a prolonged phenomenon, lasting about six hundred years and having definable stages.[42] The Indus Valley and Olmec material cultures may also have taken a considerable time to spread, but the process is

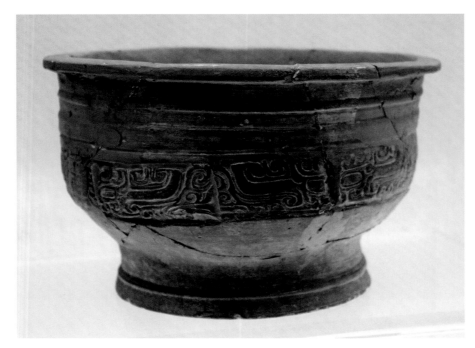

FIGURE 10. Pottery *gui* with stamped decoration. From Zhengzhou. Zheng-zhou Museum.

42. Mitchell Rothman, "The Local and the Regional: An Introduction," in *Uruk Mesopotamia & Its Neighbors*, 6. The political situation in southern Mesopotamia, the heartland of the Uruk culture, is rather murky, because there are few excavated sites besides Uruk. Assyriologists now tend to believe that there were many city-states in southern Mesopotamia, but this is largely a conjecture based on better-documented later history. See ibid, 12; Algaze, "Prehistory of Imperialism," 54–57; Akkermans and Schwartz, *Archaeology of Syria*, 208.

43. Jonathan Kenoyer remarks that "it is now possible to identify and date several major phases in the growth and development of the city [Harappa]. Changes in artifact styles and painted pottery motifs are also being identified. However, it is still premature to apply these findings to other cities such as Mohenjo-daro, and for the purposes of this book we must be content with the big chronological picture [2600–1900 BCE]" (Kenoyer, *Ancient Cities of the Indus Valley Civilization* [Oxford: Oxford University Press, 1998], 25).

44. A perusal of Kenoyer, *Ancient Cities*, ch. 8, on Indus technology and crafts, reveals that copper metallurgy was the Indus civilization's most complex technology and the one with the highest division of labor, but its operations are dwarfed by those of the Erligang bronze industry.

45. The most common motif on the Indus seals is the unicorn. "Carved in many different styles, unicorn seals were probably made by local artisans at all of the major sites" (ibid., 87). However, while the unicorn figurines indeed show local features (ibid., 87 fig. 5.15), the unicorn seals from Harappa and Mohenjo-daro are to my eyes very close in style, almost indistinguishable (cf. ibid., 189 cat. nos. 11, 12). The seals were easily portable, of course, and they, or impressions made by them, are likely to have traveled widely.

46. For a concise summary, see Christopher Pool, *Olmec Archaeology and Early Mesoamerica* (Cambridge: Cambridge University Press, 2007), 105–24.

47. Pool does suggest that the Olmec case can be narrowed to two major phases: the Early Formative and the Middle Formative, each lasting about five hundred years, and each with different patterns of interregional interaction; see ibid., ch. 6.

difficult to track in the archaeological record because little in the way of a chronology for Indus and Olmec elite material culture has been established.[43]

In the Indus Valley, the objects we would associate with an elite are mostly very small: seals, painted pottery, ornaments, cubical stone weights, terra-cotta figurines, and so on. These are all likely to be the work of individual artisans rather than the products of large workshops with complex division of labor; hence they are not strong indicators of state power.[44] The most important are probably the stone seals, which have a shared repertory of animal figures and writing yet are said to differ in style from one city to another.[45] As these objects cannot be more narrowly dated than to the seven hundred years of the Indus civilization itself, their distribution reveals little about the timing of its spread.

As for Olmec elite culture, its characteristic manifestation is monumental stone sculpture, including colossal heads, smaller sculptures, altars or thrones, and flat stelae—a corpus of about two hundred items belonging to a period of about 1,100 years.[46] These items have a recognizable iconographic consistency, but like the Indus seals, they are not factory products, and their stylistic variety argues against continuous production managed by a continuous state. A colossal head can be produced by a team brought together for one project and dispersed immediately on its completion. As in the Indus case, specialists are not agreed on the stylistic development of the Olmec corpus. Its spread may have occurred in two episodes, coinciding with the floruits of the two centers at San Lorenzo and La Venta, but even this is not certain. In short, in the absence of finer chronological understanding, the pace of expansion of the Indus and Olmec cultures is unknown.[47]

Against the background of these comparisons, the Erligang case seems distinctive and rather tidy. First, it is narrowly dated; the Erligang culture lasted about two hundred years, from around 1500 to 1300 BCE, perhaps less. Second, within those two centuries, elite material culture is well sequenced; chronological refinements within Loehr's three styles can even be made. And third, the bronzes have a stylistic and technological consistency that argues strongly for manufacture under the control of a powerful state. They are the products of large foundries where the work of many skilled foundrymen had to be supervised and carefully coordinated. The stylistic consistency that makes it possible for us to sequence the bronzes is

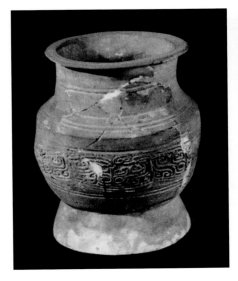

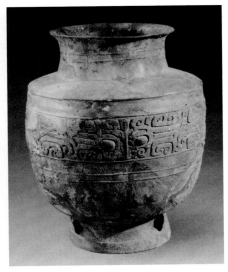

FIGURE 11. Pottery *lei*. H. 47.6 cm, diam. at mouth 20.2 cm. From the West Minggonglu pottery workshop site, Zhengzhou.

FIGURE 12. Bronze *lei*. H. 24 cm, diam. at mouth 13.1 cm. From Zhengzhou.

FIGURE 13. Fragment of a wooden coffin. From Lijiazui Tomb 2, Panlongcheng (see fig. 17).

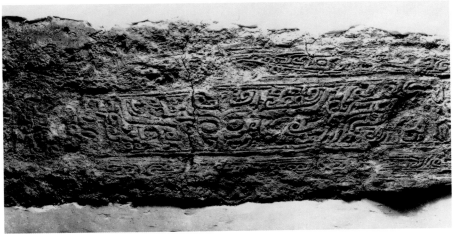

owed to this mode of production. And the picture of the Erligang expansion that we see in elite material culture is of a rather sharply defined, punctual event.[48]

MAPPING THE ERLIGANG MATERIALS

To this point, I have not really given a full picture of the landscape of the Erligang expansion. Map 1 plots the locations of all known finds of Erligang bronzes—defined, let us say, as "bronzes that could have been found at Panlongcheng"—among them many that are stray finds. Map 2 plots all sites that are reported to have Erligang pottery assemblages. Comparing the two maps will show the difference between using elite culture to define the geographic distribution of an archaeological culture and using "folk culture" to define it. One similarity is that the site density is transparently largest in the area around Zhengzhou city on both maps. Naturally, some sites occur on both maps: except for two sites in Henan (Jiaozuo Fucheng and Huixian Mengzhuang), all of the walled settlements are on both, and so are some big settlements far away from Zhengzhou, such as Jinan Daxinzhuang in Shandong to the east and Xi'an Laoniupo in Shaanxi to the west. The dots on the bronze distribution map that do not show up on the pottery map are mostly places that have not been properly surveyed or excavated. In other words, these places have stray finds of Erligang bronzes but as yet no Erligang pottery. Though archaeologists have often found Erligang sites by investigating chance finds of bronzes, I am not suggesting that every stray find represents an Erligang settlement. Bronzes enter the archaeological record in many ways[49]—in

48. It probably did not take long to build a city the size of Panlongcheng. Neither would it require much time for the Erligang elite to transplant the bronze industry from Zhengzhou to other regional centers—the transfer of a few experts would suffice. The real difficulty would have been steady supplies of raw materials; securing them involved mining, smelting, fuel procurement, and transport. Securing raw materials is likely to have been part of the Erligang expansion—maybe one of the reasons for it, as we shall see.

49. As pointed out in Wang Lixin, *Zao Shang wenhua yanjiu*, 124.

fact, in 2002, some impressive Erligang bronzes turned up in the Beijing tomb of a powerful eunuch of the Ming dynasty (1368–1644).[50] Nevertheless, the brief news reports of the stray finds make clear that they often come from sites with surface finds of Erligang potsherds. Many of them are close to known Erligang settlements, and others are close to rivers, a likely location for settlements.

In map 2, the Daxinzhuang site (no. 28), the Laoniupo site (no. 20), and the Panlongcheng site (no. 32) seem rather isolated. If we add the finds of stray bronzes, however, they do not look so cut off from the rest of the Erligang world (map 4). So I am suggesting as a working hypothesis that we take the two kinds of evidence together in order to develop the best available reflection of the distribution of Erligang material culture; however, I am not yet ready to argue that this new map plots the territory of an Erligang empire. It is one thing to recognize an Erligang object, quite another to identify an Erligang settlement, and yet another to claim that a given settlement was under the political control of an Erligang empire. Before we decide how we want to interpret these maps, several facts and assumptions should be laid out clearly.

First, map 4 tells us that the Erligang culture *did* have a center: clearly, it centered on the area around Zhengzhou, the heart of modern Henan province. Second, under the broad heading of "the Erligang culture," Chinese archaeologists distinguish an "Erligang type" characteristic of the area around Zhengzhou and six or seven other pottery types characteristic of other regions. They believe that all the regional types derive from the Erligang type; in other words, they believe that the regional types are consequences of the Erligang expansion, and I agree.[51] Figure 5 shows the pottery of the area around Zhengzhou, the so-called Erligang type.

Pots belong to folk culture; they are objects used in the everyday lives of common people. Erligang elite culture is of course represented by the bronze assemblage. The Erligang bronze repertoire includes about twenty different vessel shapes; figure 14 shows the five most common ones. But the material culture inventory characteristic of Erligang is not limited to pottery and bronzes. Four features of burials should be added to our definition of the archaeological culture. If we use the presence or absence of bronze vessels as way of distinguishing elite from nonelite burials, three of the four are confined to the elite. First, in an elite tomb, that is, in a shaft tomb with bronze vessels, there is usually a small pit under the deceased. A sacrificed dog is usually buried in the pit (figs. 15a, 15b). The Erligang people inherited this feature from the Neolithic of the east coast and passed it on to the Anyang people; it gradually died out after the Anyang period.[52] Second, Erligang elite tombs often have a layer of red cinnabar at the bottom of the shaft (the stippling in fig. 15a).[53] The third feature is a sort of clay disk that is often found in both elite and nonelite tombs (figs. 15c, 15d). The tomb in figure 15a has three of these (nos. 29, 32, 33); the number can vary from one to four. The disks were either made from potsherds or manufactured as disks, and one side is often coated with a layer of cinnabar.[54] The disks and also the cinnabar sprinkled in the tomb are features that seem to have originated in the Erlitou culture, the immediate predecessor of Erligang.[55] The last feature is a mysterious hard-stone object that resembles a flat handle (fig. 15e). Erligang burials that have the other three features often have these stone objects as well. Their origin and function are not clear.[56]

Adding these four features gives us a relatively rich definition of the Erligang culture in terms of material artifacts and burial customs.[57] Excavation has moreover made it possible to divide these materials into two major phases, Lower Erligang (fig. 5, bottom row) and Upper Erligang (fig. 5, top row), each lasting about a century, maybe less. And we can confidently locate the origin and development of these cultural traits in central Henan around the great city at Zhengzhou.

50. *Beijing gongshang daxue Mingdai taijian mu*, ed. Beijing shi wenwu yanjiusuo (Beijing: Zhishi chanquan chubanshe, 2005).

51. *Zhongguo kaoguxue: Xia Shang juan*, 202.

52. On the pit and the dog sacrifice, see Zhang Weilian, "Erlitou wenhua dui Shang wenming xingcheng de yingxiang," in *Erlitou yizhi yu Erlitou wenhua yanjiu*, ed. Du Jinpeng and Xu Hong (Beijing: Kexue chubanshe, 2006), 394nn26–27.

53. Archaeologists habitually call any red residue "cinnabar," but to my knowledge, the identification is usually made only with the naked eye.

54. *Zhengzhou Shang cheng*, 2:674–76, 825–26, 928.

55. Zhang, "Erlitou wenhua dui Shang wenming xingcheng de yingxiang," 391. The clay disks have been found in many sites across north and south China, in contexts dating from the Neolithic to the Han period. An Zhimin has convincingly argued that they were used for scrubbing sweaty or oily skin. See "Gudai de caomian taoju," *Kaogu xuebao* 1957.4: 69–77. I am grateful to Alain Thote for this reference.

56. On the possibility that at Anyang they functioned as ancestral tablets, see Wang Haicheng, *Writing and the State*, 37n86, 430 fig. 1.13 (top). An inventory can be found in Cao Nan, "Sandai shiqi chutu bingxing yuqi yanjiu," *Kaogu xuebao* 2008.2: 141–74.

57. For a recent elite tomb from Zhengzhou that contains all these features, see Henan sheng wenwu kaogu yanjiusuo, "Zhengzhou Shang cheng xin faxian." In principle, architecture is another important component of material culture, but it is so poorly preserved in Chinese archaeology that we have to relegate it to a subsidiary position.

MAP 4. Distribution of Erligang bronzes and pottery.

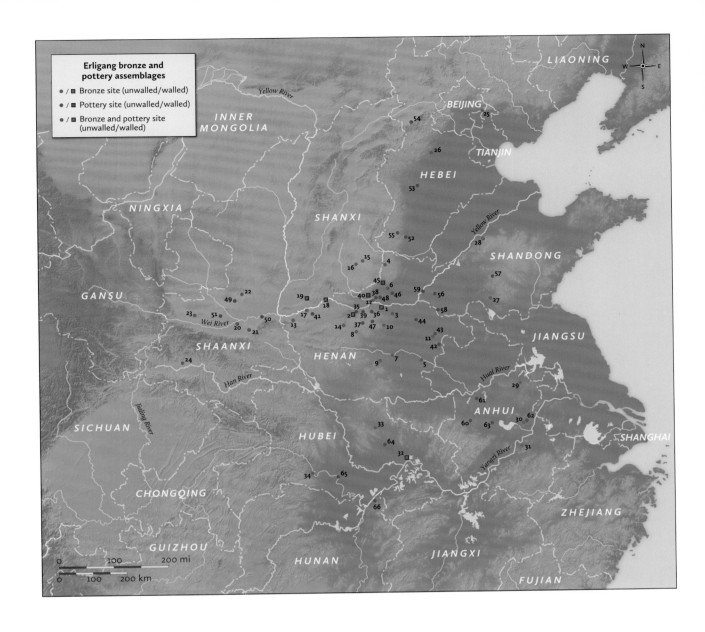

INTERPRETING THE ERLIGANG EXPANSION

With these facts in hand, we are ready to state the first of the assumptions we need in order to interpret our distribution maps. We will assume that these cultural traits "are the material expression of a coherent set of cultural practices shared (to a greater or lesser degree) by the members of" the polity that was centered on the city at Zhengzhou.[58] Although archaeologists have to be cautious about the objects-as-people assumption, it is a reasonable premise, and in the absence of writing, it is the only way to track the behavior of ancient people.

Next, we should consider the regions that were affected by the Erligang expansion. To begin with, before the expansion, these regions all had indigenous local cultures that were well on their way to becoming complex societies.[59] If we are to understand the possible motives and mechanisms for the Erligang expansion, we have to understand the relationship between the intruding Erligang cultural traits and the local culture. In order to do this, we must examine the Erligang materials in local context so as to decide what kind of intrusion was present at a given site. Again, we have to infer human interactions from material remains.

Cultural exchange has been a feature of human societies since the Paleolithic, but when state societies appear, it takes new forms. As the archaeologist Gil Stein observes, "It has become clear over the last two decades that many, if not most, early state societies in the Old and New World established colonies as one aspect

58. The quotation is from Pool, *Olmec Archaeology*, 14–15, on the Olmec culture.

59. Before the Erligang expansion, some of the regions had already been penetrated by the Erlitou culture, which also originated in central Henan. For simplicity, I treat the Erlitou cultural traits in those regions on the same footing as the earlier indigenous local cultures.

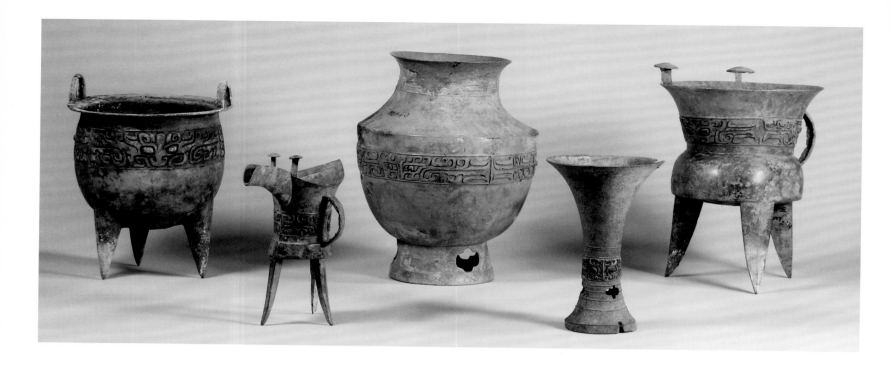

of their overall expansionary dynamics, such as trade, alliance formation, or conquest."[60] Stein uses the term "colony" to refer to a special form of settlement. In his definition, a colony is

> an implanted settlement established by one society in either uninhabited territory or the territory of another society. The implanted settlement is established for long-term residence by all or part of the population and is both spatially and socially distinguishable from the communities of a host society. The settlement onset is marked by a distinct formal corporate identity as a community with cultural/ritual, economic, military, or political ties to its homeland, but the homeland need not politically dominate the implanted settlement.[61]

Are all the dots on map 4 Erligang colonies? Do they even qualify as Erligang sites? At present, we cannot be sure. All have some elements of the Erligang culture, but few have been adequately excavated. But let me suggest a way of thinking about the question for cases in which our information is reasonably detailed. For a site to qualify as Erligang, its material culture should include a substantial number of the items characteristic of the area around Zhengzhou (figs. 5, 15). Depending on its distance from Zhengzhou and the nature and degree of interaction between intruders and local populations, the site should be expected to have a more or less strong admixture of Erligang and indigenous materials.[62] The relationship between the intruding community and its hosts must be sought in the mixture.[63]

We may examine the problem of identifying colonies and inferring relationships between colony, host, and homeland by looking at Panlongcheng, the best-excavated Erligang colony (figs. 16, 17). The first thing to remember about Panlongcheng is that it is far away from Zhengzhou. As the crow flies, it is 450 kilometers to the south, and the area around it had a long history of distinctive local cultures before the Erligang period.

At the beginning of the Upper Erligang phase at Panlongcheng, a walled city of about seven hectares was built on a natural elevation surrounded by water (fig. 3a). A moat was dug around the city. Excavations and surveys inside and outside the city wall have revealed a cluster of settlements centered on the city. The highest point in the city is the northeast corner, and here, archaeologists found a large

60. Gil Stein, "Colonies without Colonialism: A Trade Diaspora Model of Fourth Millennium B.C. Mesopotamian Enclaves in Anatolia," in *The Archaeology of Colonialism,* ed. Claire Lyons and John Papadopoulos (Los Angeles: Getty Research Institute, 2002), 27.

61. Ibid., 30. Stein's definition is more neutral than that of M. I. Finley, who insists that the homelands control colonies, while the colonies in turn dominate indigenous peoples. See Finley, "The Fifth Century Athenian Empire: A Balance Sheet," in *Imperialism in the Ancient World,* ed. P. D. A. Garnsey and C. R. Whittaker (Cambridge: Cambridge University Press, 1978), 103–26.

62. Cf. Algaze, "Prehistory of Imperialism," 38, on the identification of Uruk outposts. Also cf. Stein, "Colonies without Colonialism," 36.

63. Sadly, I must report that it is almost impossible to come up with a ratio between Erligang and local objects at any site. Chinese archaeologists are fond of using statistics, but no one who has seen how they deal with their tens of thousands of potsherds will be eager to trust their statistics. Not least among the possible sources of error is the difficulty of distinguishing Erligang sherds from local ones. Thus, mentions of proportions should usually be regarded as impressionistic at best (e.g., *Panlongcheng,* 498; Qin, "Jin xinan diqu Erlitou wenhua").

FIGURE 15. Burial customs for an elite tomb at Zhengzhou, Beierqilu Tomb 1. (a) Plan of the tomb. Dimensions at mouth, 2.7 x 1.5 m. (b) Detail of the waist pit showing a sacrificed dog. (c, d) Disks from nonfunerary contexts similar to disks from Beierqilu Tomb 1. Clay. Diam. (c) 5.5 cm, (d) 7 cm. (e) Handle-shaped object (no. 24 in the tomb plan). Jade, l. 6.9 cm.

Tomb inventory. 1, 2, 4: bronze *jia*; 3: bronze *ding*; 5: bronze fragment; 6, 16–23, 26: stone and jade *ge*; 7, 9: bone daggers; 8: bronze knife; 10, 11, 15, 36: jade tablet-shaped axes; 12: bronze *jue*; 13, 35: bronze *gu*; 14: tusk ornament; 24, 25, 28, 31: stone and jade handles; 27: jade disk; 29, 32, 33: clay disks; 30: jade cicada-shaped ornament; 34, 39: bone hairpins; 37: bone arrowhead; 38: stone bowl

terrace of rammed earth bearing the foundations of three palatial buildings. The buildings are oriented 20 degrees east of north. Interestingly, the two dozen or so palatial buildings at Zhengzhou all have the same orientation (fig. 1). Four tombs east of the Panlongcheng city wall at Lijiazui (fig. 3a) are also oriented to the northeast (fig. 17), and so are most elite tombs at Zhengzhou (fig. 15a). The orientation of the Zhengzhou tombs varies from 5 to 20 degrees east of north, but it seems clear that an orientation to the northeast was intended and had some significance to the Erligang people.[64]

The two tombs in figures 15 and 17 are roughly contemporary. Their form and contents leave no doubt of the link between Panlongcheng and Zhengzhou. Both tombs have sacrificial pits, cinnabar, clay disks, and stone handles. The fifty or so bronze vessels and weapons from the Panlongcheng tomb could just as well have been found at Zhengzhou. Emulation by a local elite could not explain so many similarities; almost nothing in the Panlongcheng tomb is recognizably local. We cannot reasonably doubt that some members of the Zhengzhou elite moved to Panlongcheng during the Upper Erligang phase and established a fortified settlement there.

The pottery in the Panlongcheng tomb includes types very similar to Zhengzhou pottery. The full inventory of Erligang-type pottery has been found all over the Panlongcheng site, both inside and outside the walled city (compare fig. 5 with fig. 6, bottom). Potters therefore must have been among the settlers from

64. See Yang Xizhang, "Yinren zun dongbei fangwei," in *Qingzhu Su Bingqi kaogu 55 nian lunwen ji*, ed. Qingzhu Su Bingqi kaogu 55 nian lunwenji bianjizu (Beijing: Wenwu chubanshe, 1989), 305–14.

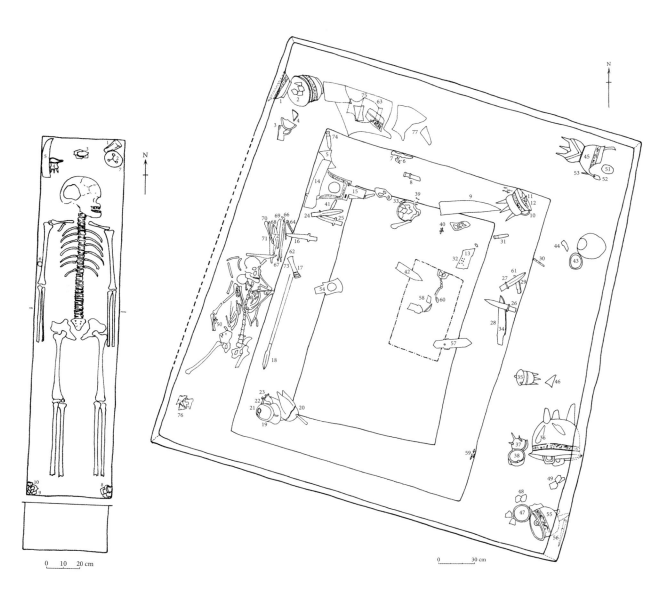

65. As Baines nicely puts it: "if you are members of an elite, you bring your entire world with you. In Egypt you see that in the funerary models of Meketre, who travels with kitchen boats, presumably so that he will not need to sample local cuisine" (personal communication, January 2008). Liu and Chen argue that ritual vessels "were probably cast at Zhengzhou and then imported to Panlongcheng" (*State Formation in Early China*, 117). The authors also believe that bronzes from the Daxinzhuang site were imported from the core areas in Henan (see ibid., 114), but this can hardly be correct. If all the Erligang bronzes found at places like Panlongcheng were cast at Zhengzhou—if Zhengzhou was the only city with foundries producing bronzes in Erligang style—then where did the Wucheng culture in Jiangxi province, far to the south and east of Panlongcheng, get its bronze casting technology? On the evidence of a remarkably rich tomb at Xingan, a few kilometers from the Wucheng site, extremely fine bronzes based on Erligang prototypes but distinctly local in style began to be made at or near Wucheng right around the end of the Erligang period by casters who had a complete mastery of Erligang techniques. Are we to suppose that in the two centuries of the Erligang period, Zhengzhou casting technology never spread to Panlongcheng, but that as the period ended, Zhengzhou

Zhengzhou, and since potsherds of Erligang type have been found in the remains of modest houses, the new arrivals also must have included other commoners, who were supplied by their compatriots with the pottery they were accustomed to using at home. Evidently, the elite founders of the Panlongcheng colony traveled fully equipped to replicate the culture of the homeland.[65]

A small tomb at Yangjiawan (fig. 3a), to the north of the walled city, contained the familiar clay disk, the drinking and storage vessels typical of Zhengzhou tombs, and, more interestingly, a stone ax and sickle, suggesting that the deceased had some role in agricultural production (fig. 16). Similar stone sickles have been found in site surveys and even in a few elite tombs that have characteristic Erligang clay disks and bronzes.[66]

It thus seems that some craftsmen and farmers—perhaps farmer-soldiers?—migrated along with the elites from Zhengzhou to Panlongcheng. These migrants were evidently unwilling to change their culinary habits, for they used the full range of Erligang pottery forms, including cooking, serving, and storage types. Food preferences and food preparation procedures can be very culture specific.[67] But the homesick Erligang migrants at Panlongcheng faced a problem: the staple food in their homeland was millet, a product of dry farming, while the main food in the Yangzi region was and still is rice, grown in paddy fields. The change from eating millet to eating rice might not have been easy; the change from dryland to paddy farming would certainly have been hard. Did the Erligang migrants make these changes, and, if so, to what extent? Analysis of skeletal remains and flotation

FIGURE 18. Local pottery assemblage from Panlongcheng.

of faunal and floral remains may someday answer this question. At present, we cannot answer it, and it bears directly on the question of the nature of the Erligang expansion. Is it possible that one objective of the expansion was to look for farmland? In the north, it might well have been, since colonies in the same agricultural zone as Zhengzhou would need no adjustments in diet and farming practice.[68] If it was not the main objective in the south, then the migrants at places like Panlongcheng must have acquired at least some of their food from the host communities. By what mechanism did they accomplish this—taxation or exchange? The two mechanisms would mean two different relationships between migrants and locals. Can archaeology tell us what the situation was at Panlongcheng?

It can certainly give strong hints. Almost all the elite tombs have bronze weapons (visible in fig. 17). Some of the weapons are clearly ceremonial objects, but many are functional types. In other words, at Panlongcheng, we see an elite class backed by military force. The bronze ritual vessels and public architecture embodied the ideology of this class and gave it the visual apparatus for promoting corporate solidarity. But a subject population, which might have been intimidated by architecture but did not see the rituals in which the bronzes were used, would not have been very susceptible to the persuasions of ideology. Coercion might have been needed to extract agricultural surplus from the local population as well as to control the migrant commoners.[69]

As for the local population, the only practicable means of detecting it at present is the analysis of pottery. There are some distinctive vessel types that are unknown at Zhengzhou (fig. 18). It is the local vessels that archaeologists point to when they classify the Panlongcheng assemblage as a regional variant of the Erligang culture.[70] The local vessels seem less common than the Erligang types, but they are found all over the settlement clusters around the walled city. They signify either the presence of a local population or the colonists' adoption of local pottery. But if a local population was present, there is no sign of an elite among its members. Perhaps a local elite lived in other, as yet undiscovered settlements. On the other hand, Erligang bronzes have been found in several places in Hubei, suggesting that the Zhengzhou elite at Panlongcheng was widespread.[71] Certainly there was no local elite material culture capable of competing with Erligang elite culture. The relationship between the Erligang colonies and the host communities looks like one of dominance achieved through military conquest. The close coordination of the Panlongcheng and Zhengzhou bronze industries might even be taken to suggest tight control of the colony by the home city. It certainly suggests close relations.

This model for the Erligang expansion, or at least for the part of it that was directed toward the Yangzi region, is consistent with traditional understandings of European colonialism, and not surprisingly, some investigators have consciously turned to European analogies for it.[72] In recent years, however, comparisons with European colonialism have been criticized for their parochial assumptions. Gil Stein has proposed instead a more comprehensive model, the trade diaspora model, borrowed from studies of ethnic enclaves in West Africa.[73] Trade diasporas are defined as "inter-regional exchange networks composed of spatially dispersed specialized merchant groups which are culturally distinct, organizationally cohesive, and socially independent from their host communities while maintaining a high level of economic and social ties with related communities who define themselves in terms of the same general cultural identity."[74]

Stein argues that a trade diaspora can have many possible relationships with its homeland, with other diasporas, and especially with its host community. He uses three points to define a continuum of diaspora-host community relations. At one end of the continuum, the rulers of the host community treat the trade diaspora as a marginal group to be exploited at will. In the middle ground, the diaspora

casting technology suddenly spread to places far beyond Panlongcheng? Surely the arrival of Erligang style and technology at Xingan is understandable only as the consequence of an earlier spread to places like Panlongcheng (see Steinke, ch. 7 in this volume). Nor is that earlier spread in any way surprising. When a ruling elite transplants itself, it takes its culture with it in the form of the craftsmen and other specialists needed to reproduce the culture of the home city. Bronze vessels were central to Erligang elite material culture, and Erligang colonizers establishing a permanent settlement would naturally include skilled bronze casters in their enterprise.

66. See *Panlongcheng*, 1:233 fig. 168 no. 10, 375 fig. 276 no. 13, 429 fig. 315 nos. 14–16 (surface survey), 431 fig. 316 no. 1. Many similar sickles made of stone and shell have been found in the outer city at Zhengzhou; see *Zhengzhou Shang cheng*, 2:606, 615, 617, 692, 705, 900. Liu and Chen suggest that there were farmers living in the outer city (*State Formation in Early China*, 98).

67. Stein, "Colonies without Colonialism," 47, 63n77.

68. E.g., see *Yuanqu Shang cheng 1*, plates 70, 84.

69. For the unifying powers of a dominant ideology, see James C. Scott, *Domination and the Arts of Resistance: Hidden Transcripts* (New Haven, CT: Yale University Press, 1990), chs. 3 and 4, esp. 68–69. Scott argues that the subordinate group never really buys the ruling ideology—it has the imaginative capacity to reverse or negate the elite's propaganda—and that the rulers are well aware of this. In sociology, there is an influential theory to explain the compliance of subordinate groups when there is no apparent use of coercion to secure it. This theory holds that "the dominant ideology achieves compliance by convincing subordinate groups that the social order in which they live is natural and inevitable." Scott has offered a decisive critique of this explanation (ibid., 77–85).

70. Jiang Gang, "Panlongcheng yizhi qun chutu Shangdai yicun de jige wenti," *Kaogu yu wenwu* 2008.1: 35–46.

71. See the list in *Panlongcheng*, 1:503–4, which includes some settlements that have Erligang pottery but not bronzes. Notice especially the Jingnansi site, which is likely to be a local settlement but has some connections with Erligang migrants (see McNeal, ch. 8 in this volume).

72. E.g., Liu and Chen, *State Formation in Early China*. For a critique of their approach, see Wang Haicheng, *Writing and the State*, 202–8.

73. Stein, "Colonies without Colonialism." See also Stein, "Indigenous Social Complexity at Hacınebi (Turkey) and the Organization of Uruk Colonial Contact," in Rothman, *Uruk Mesopotamia & Its Neighbors*, 265–306, and Stein, "From Passive Periphery to Active Agents."

74. Stein, "Colonies without Colonialism," 30, quoting Abner Cohen. The ancient example that comes immediately to mind is the Assyrian trading colony at Kanesh Kültepe in Anatolia, whose nature is well understood because some of its correspondence with its home base in the Assyrian capital survives.

FIGURE 19. Two types of Uruk colony in northern Mesopotamia. (a) Topographic map of main excavation areas at Hacınebi (see map 3). (b) Topographic map of main excavation areas at Habuba Kabira (no. 9 on map 3).

enjoys a protected autonomy within the host community, usually granted by the local rulers. At the other end, the trade diaspora controls its host community, in the way familiar to us from European trading-post empires in Africa and Asia in the eighteenth and nineteenth centuries. Stein thinks that this last is a fairly unusual situation. His own excavations of an Uruk trade diaspora at Hacınebi in Turkey convince him that it is the middle ground, that is, the peaceful coexistence of the autonomous diaspora and the local community, that seems to have been the norm.

Stein's argument depends on his spatial-functional analyses of material culture patterning at Hacınebi (fig. 19a). First, he argues for the presence of an ethnically distinct Uruk colony at Hacınebi by noting the presence there of the full range of Uruk material culture. Hacınebi has the entire repertoire of Uruk ceramics, beveled-rim bowls included, along with accounting devices such as clay tokens, glyptic art on cylinder seals, and clay cones for decorating Uruk architecture.

Next, he argues that this colony was an autonomous trade diaspora that did not dominate the indigenous society by showing that all the Uruk material traits were confined to one area of the site, Area A in figure 19a. The other two excavated areas show exclusively local Anatolian material traits, including an administration that used stamp seals rather than cylinder seals. According to Stein, there was no evidence to suggest that the host community supplied the Uruk colony with foodstuffs or craft goods, whether as trade items or as tribute or taxes. The faunal and archaeological evidence suggests that each group produced its own food (e.g., clay sickles from Area A are Uruk types) and made its own stone tools, ceramics, and textiles. Each group maintained its own distinctive record-keeping system, indicating that the two groups had fairly autonomous economic and administrative spheres, operating in parallel and rarely interacting. In short, there is no

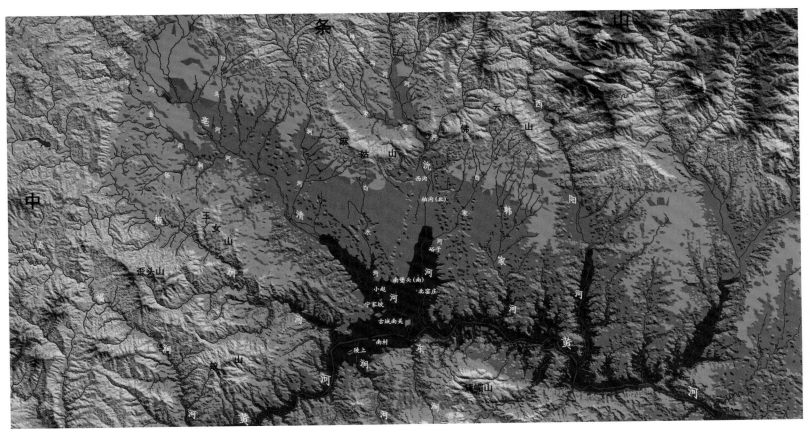

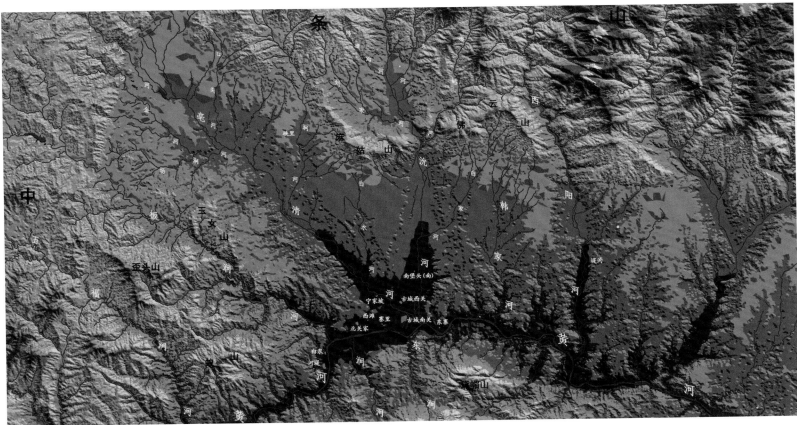

MAP 5. Topographic maps of the distribution of settlements in the Yuanqu basin of southeast Shanxi: (a) Upper Erligang, (b) Lower Erligang. The biggest red diamond is the Gucheng Nanguan site; at bottom is the Yellow River.

evidence to suggest large-scale unequal transfers of commodities of the sort we would expect on the European colonial dominance model.

Stein's arguments are consistent and compelling for the Hacınebi case, especially the spatial analysis that enabled him to discern the presence of an ethnic enclave. This kind of analysis depends on extensive exposure of a given site and careful recording of find loci, requirements not easily met in the archaeology of the Indus Valley and Mesoamerica, though a case can be made for one possible Olmec enclave in Mesoamerica.[75]

However, his model of peaceful coexistence does not apply to all the sites that were influenced by the Uruk expansion, for example, the Habuba Kabira site,[76] a cluster of settlements in northern Syria, south of Hacınebi. A large horizontal area of this site has been excavated, and its date is secure: it had a short occupation of no more than a century or two. The topographic map in figure 19b shows clearly that the steep side was left undefended while the smooth side was fortified with multiple walls, towers, and at least two gates. The walled area is about ten hectares, and the whole site is estimated to have covered forty hectares.

Domestic and public architecture at Habuba Kabira, and the central planning of the street and drainage system, are all consistent with practices in southern Mesopotamia, and so are the material assemblages. At first sight, therefore, Habuba Kabira seems to be a close parallel to Panlongcheng. However, there are some crucial differences. Habuba Kabira was founded as a completely new community on virgin soil with scarcely any trace of local population. "[T]here is little indication of a local rural population large enough to service the urban conglomeration of Habuba!"[77] Panlongcheng was situated in a region with a long history of habitation; if the Erligang colonists claimed a share of the local agricultural surplus, they are likely to have done so by force.

Another difference is that Habuba Kabira was not close to important sources of raw materials, nor is it connected to distant sources by Uruk sites in intermediate locations. One archaeologist suggests that it was precisely the "vacancy" of the area, which is well located in a zone of rainfall agriculture, that attracted Uruk settlers.[78] In contrast, the Panlongcheng site was founded at a traffic node at the intersection of an east-west river route and a north-south inland corridor. It is located in prime agricultural land that already had a significant population of local farmers, and it is not far from two important copper-mining areas just across the Yangzi.[79] Because the Erligang bronze industry required enormous quantities of copper, tin, lead, and charcoal, it is plausible that the sources of these raw materials were the target of colonial enterprise at Panlongcheng,[80] though the region's rich agricultural resources may also have been a consideration. And this brings me to some concluding comments on models for the dissemination of material culture in early complex societies.

CONCLUDING REMARKS

In all four of our case studies, the standard model for explaining the wide dissemination of a distinctive material culture is resource procurement and trade. Both the traditional colonial dominance model and Stein's trade diaspora model emphasize long-distance exchange. The cases of Panlongcheng and Hacınebi fit the two models rather well, and study suggests that trade may have played an important role in the Indus Valley too.[81] However, the likely farming colony at Habuba Kabira forces us to reconsider the function of the many small Erligang villages that cluster around a walled Erligang settlement.

The best-surveyed region in the Erligang world is the Yuanqu basin of southeastern Shanxi, a small basin covering about 230 square kilometers (no. 18 on map 4). An Erligang city was founded here during the Lower Erligang phase. Today

75. See Pool, *Olmec Archaeology*, 192.

76. A more precise archaeological name is Habuba Kabira South/Tell Qannas.

77. Glenn Schwartz, "Syria and the Uruk Expansion," in Rothmann, *Uruk Mesopotamia & Its Neighbors*, 259. The possibility should be acknowledged that a local population existed but was not detected archaeologically, either because it was seminomadic or simply because of the limitations of rescue archaeology (John Baines, personal communication, October 2007).

78. Schwartz, "Syria and the Uruk Expansion," 260. See also Akkermans and Schwartz, *The Archaeology of Syria*, 190–97, 204–5.

79. Panlongcheng's strategic location and its advantages in transport and economy are described in *Panlongcheng*, 1:502–3.

80. Jessica Rawson, review of *The Great Bronze Age of China: An Exhibition from the People's Republic of China*, ed. Wen Fong, *Ars Orientalis* 13 (1982): 193–95; Bagley, "Shang Archaeology," 170.

81. Shereen Ratnagar, *Trading Encounters: From the Euphrates to the Indus in the Bronze Age* (Oxford: Oxford University Press, 2004). See also Agrawal, *Indus Civilization*, 258–82, and the pertinent articles collected in Gregory L. Possehl, ed., *Harappan Civilization: A Recent Perspective*, 2nd rev. ed. (New Delhi: American Institute of Indian Studies and Oxford and IBH Publishing, 1993).

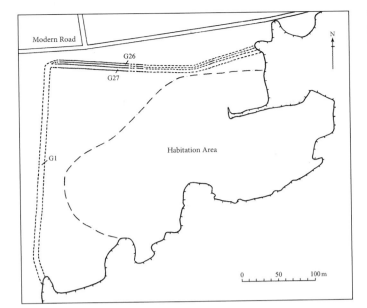
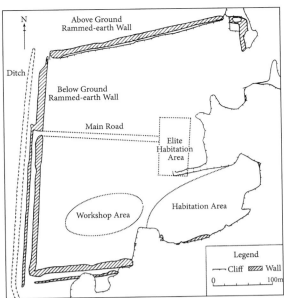

FIGURE 20. Plans of the Gucheng Nanguan site. (a) Erlitou period (ca. 1800–ca. 1500 BCE). (b) Erligang period (ca. 1500–ca. 1300 BCE). Hatched areas indicate rammed-earth walls.

called Gucheng Nanguan, it is a site about thirteen hectares in area (map 5). It is situated on the northern bank of the Yellow River, at the confluence of the Yellow River and two tributaries. Cross the Yellow River and go eastward downriver for two hundred kilometers, and you will reach Zhengzhou.

The Yuanqu basin is flanked by the Zhongtiao mountains (colored yellow in map 5). The Zhongtiao range is rich in mineral and timber resources that Erlitou colonists may have explored before the Erligang expansion.[82] However, the material assemblages of the earlier arrivals were replaced by typical Erligang material culture during the Erligang expansion.

At the onset of the Erligang expansion, the Gucheng Nanguan site was transformed from a settlement with encircling ditches into a fortress (fig. 20) with palatial foundations inside. The elaborate double-wall structure along the most exposed side of the city suggests that the city dwellers felt a need for protection and hence, perhaps, that the Erligang expansion into the area was military in nature. Of course, this is not to say that defense is the only function served by walls. The Egyptian forts in Nubia built in the Middle and New Kingdoms "constitute part of an aggressive policy of territorial expansion" for which the fortresses "serve as very visible reminders."[83] In other words, fortresses are statements.

All the Erligang settlements in the Yuanqu basin were located in valleys along rivers (map 5). Apparently, ease of transportation and water procurement were major considerations in the choice of location, and it is conceivable that minerals and timber were transported from the Zhongtiao mountains by water to the Gucheng Nanguan city and forwarded from there to Zhengzhou. Such enterprises, not to mention fortress building, would have required large amounts of labor, as well as planning and administration. Local inhabitants and migrant farmers both must have supplied the necessary labor and food. Many farming implements have been found inside the Gucheng Nanguan city, and we can expect to find more in the small village settlements. The Yuanqu basin is highly suitable for dryland farming. We might even wonder which was the primary motive for colonization here, wood and mineral resources for the elite or agricultural land for the population at large?

But land and resources do not constitute the whole allure of empire. Though attempts at understanding imperial strategies sometimes acknowledge ideological motives, they tend to view economic motives as decisive, in part because economic factors are more visible in the archaeological record. Yet as one archaeologist remarks, "ideology shapes decisions as much as it legitimizes them."[84] Rulers

82. Liu and Chen, *State Formation in Early China*, 42–43, 69.

83. Kate Spence, "Royal Walling Projects in the Second Millennium BC: Beyond an Interpretation of Defence," *Cambridge Archaeological Journal* 14, no. 2 (2004): 267; John Baines, personal communication, October 2007.

84. Barry J. Kemp, "Why Empires Rise," review of *Askut in Nubia*, by Stuart Tyson Smith, *Cambridge Archaeological Journal* 7, no. 1 (1997): 131.

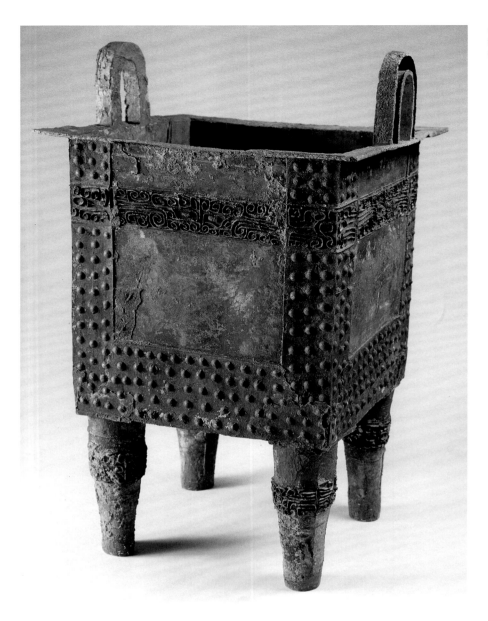

FIGURE 21. *Fangding*, 14th century BCE. H. 82 cm. From a 1990 chance find at Pinglu, Shanxi.

85. An obvious example is Hitler, described as a ruler who "rejects . . . the notion that state policy should be driven by economic concerns, and explicitly asserts that the state should be willing to take decisions even when they run counter to economic rationality or the needs of the economy" (see Neil Gregor, *How to Read Hitler* [New York: W. W. Norton, 2005], 16). Neither were the expansion policies adopted by Rameses II of New Kingdom Egypt and Emperor Wu of the Han dynasty driven solely by economic concerns. See K. A. Kitchen, *Pharaoh Triumphant: The Life and Times of Ramesses II* (Warminster: Aris & Phillips, 1982), 44–72, and Nicola Di Cosmo, *Ancient China and Its Enemies: The Rise of Nomadic Power in East Asian History* (Cambridge: Cambridge University Press, 2002), 247–51.

have visions of expansion that may have nothing to do with economic gain.[85] In this respect, Stein's trade diaspora model, though incorporating the possibility of colonial dominance, does not adequately address the issue of ideology in interpreting material culture.

The locations of some Erligang cities may well have been dictated by commercial or military imperatives, but rulers are swayed by other ambitions too. One of the largest Erligang bronzes known, and the only Erligang *fangding* yet found anywhere outside Zhengzhou, is a vessel from Pinglu in Shanxi province that comes not from a tomb but from a small deposit on the northern bank of the Yellow River (fig. 21; no. 17 on map 4). There was no settlement in the vicinity. Why place so commanding a ritual vessel here? Might the reason be that the Erligang expansion brought with it opportunities to take possession of the ritual landscape, the landscape of mountains and great rivers? As we interpret our Erligang distribution maps, we should remember that empire building often has aims and motives that would not seem practical to us. We must try to think like a king.

This essay is a belated answer to a question that my adviser, Robert Bagley, asked in my general exams, and the comparative approach I adopt here is deeply indebted to his guidance. I hope he is pleased that I have now taken the same topic for my first major English publication that he took for his. Parts of this work have been presented in talks at the University of California, Berkeley, the University of California, Los Angeles, and Princeton University. I owe much to the helpful comments of my audiences, and I thank the hospitality of those who turned my sojourn into memorable episodes: David Schaberg, Lothar von Falkenhausen, and Dora Ching. I am grateful to John Baines for his insightful notes on an earlier draft; many of my discursive footnotes can be seen as a dialogue between the fields of early China and ancient Egypt. I am greatly indebted to Cao Dazhi, who contributed to the making of the three Erligang maps and helped in tracking down references. And I would like to thank Kyle Steinke for inviting me to the wonderful conference at Princeton, for many interesting discussions, and for persistence in getting to the bottom of the matter. I also thank the anonymous reviewers for their helpful comments. All translations are my own.

Appendix 1
List of Sites for Map 1

Walled sites are numbered inside a square.[1]

HENAN PROVINCE 河南省

☐1. Zhengzhou 鄭州
Zhengzhou Shang cheng: 1953–1985 nian kaogu fajue baogao, ed. Henan sheng wenwu kaogu yanjiusuo, 3 vols. (Beijing: Wenwu chubanshe, 2001).

☐2. Yanshi Shixianggou 偃師尸鄉溝
Zhongguo shehui kexueyuan kaogu yanjiusuo and Henan dier gongzuodui, "1983 nian qiuji Henan Yanshi Shang cheng fajue jianbao," *Kaogu* 1984.10: 870–79; *Kaogu zhonghua,* ed. Zhongguo shehui kexueyuan kaogu yanjiusuo (Beijing: Kexue chubanshe, 2010), 146.

3. Zhongmu xian 中牟縣
Zhao Xinlai, "Zhongmu xian Huangdian, Dazhuang faxian Shangdai tongqi," *Wenwu* 1980.12: 89–90; *Zhongguo qingtongqi quanji* (Beijing: Wenwu chubanshe, 1993), vol. 1, plates 61, 102.

4. Linxian 林縣
Zhang Zengwu, "Henan Linxian jianxuan dao sanjian Shangdai qingtongqi," *Wenwu* 1986.3: 92–93.

5. Xiangcheng xian 項城縣
Deng Tongde, "Henan Xiangcheng chutu Shangdai qianqi qingtongqi he kewen taopai," *Wenwu* 1982.9: 83–84.

6. Huixian 輝縣
Huixian fajue baogao, ed. Zhongguo kexueyuan kaogu yanjiusuo (Beijing: Kexue chubanshe, 1956); Tang Aihua, "Xinxiang shi bowuguan shoucang de wuyan shoumianwen gu," *Wenwu* 1983.7: 72; *Zhongguo qingtongqi quanji,* vol. 1, plates 153, 154, 156.

7. Yancheng xian 郾城縣
Meng Xin'an, "Yancheng xian chutu yipi Shangdai qingtongqi," *Kaogu* 1987.8: 765–66; *Zhongguo qingtongqi quanji,* vol. 1, plates 94, 126, 127, 158.

8. Linru xian 林汝縣
Zhang Jiuyi, "Henan Linru xian Lilou chutu Shangdai qingtongqi," *Kaogu* 1983.9: 839–40.

9. Wuyang xian 舞陽縣
Zhu Zhi, "Beiwudu Shangdai tongli," *Kaogu* 1983.9: 841; and "Henan Wuyang xian luxu faxian Shangdai wenwu," *Kaogu* 1987.3: 275.

10. Xinzheng xian 新鄭縣
Xue Wencan, "Henan Xinzheng xian Wangjinglou chutu de tongqi he yuqi," *Kaogu* 1981.6: 556; *Zhongguo qingtongqi quanji,* vol. 1, plate 151.

11. Zhecheng xian 柘城縣
Zhang Heshan, "Henan Zhecheng Xinmensi yizhi faxian Shangdai tongqi," *Kaogu* 1983.6: 560–61.

1. Many of the bronzes can be found in *Zhongguo qingtongqi quanji,* 16 vols. (Beijing: Wenwu chubanshe, 1993–98).

12. Wuzhi xian 武陟縣

Qian Pingxi, "Wuzhi xian zao Shang muzang qingli jianbao," *Henan wenbo tongxun* 1980.3: 38–39; *Zhongguo qingtongqi quanji,* vol. 1, plate 93.

13. Lingbao xian 靈寶縣

Henan sheng bowuguan and Lingbao xian bowuguan, "Henan Lingbao chutu yipi Shangdai qingtongqi," *Kaogu* 1979.1: 20–22; *Zhongguo qingtongqi quanji,* vol. 1, plates 99, 113, 135.

14. Yichuan xian 伊川縣

Ning Jingtong, "Henan Yichuan faxian Shangmu," *Wenwu* 1993.6: 61–64.

SHANXI PROVINCE 山西省

15. Changzhi shi 長治市

Wang Jinxian, "Shanxi Changzhi shi jianxuan, zhengji de Shangdai qingtongqi," *Wenwu* 1982.9: 49–52.

16. Changzi xian 長子縣

Guo Yong, "Shanxi Changzi xian beijiao faxian Shangdai tongqi," *Wenwu ziliao congkan* 3 (1980): 198–201; *Zhongguo qingtongqi quanji,* vol. 1, plate 124.

17. Pinglu xian 平陸縣

Wei Si, "Pinglu xian Qianzhuang Shangdai yizhi chutu wenwu," *Wenwu jikan* 1992.1: 18–19; *Zhongguo qingtongqi quanji,* vol. 1, plates 37, 125.

[18]. Yuanqu Gucheng Nanguan 垣曲古城南關

Yuanqu Shang cheng 1: 1985–1986 niandu kancha baogao, ed. Zhongguo lishi bowuguan kaogubu, Shanxi sheng kaogu yanjiusuo, and Yuanqu xian bowuguan (Beijing: Kexue chubanshe, 1996).

[19]. Xiaxian Dongxiafeng 夏縣東下馮

Xiaxian Dongxiafeng, ed. Zhongguo shehui kexueyuan kaogu yanjiusuo, Zhongguo lishi bowuguan, and Shanxi sheng kaogu yanjiusuo (Beijing: Wenwu chubanshe, 1988).

SHAANXI PROVINCE 陝西省

20. Xi'an shi Laoniupo 西安市老牛坡

Liu Shi'e, ed., *Xi'an Laoniupo* (Xi'an, Shaanxi: Shaanxi renmin chubanshe, 2001); *Shaanxi chutu Shang Zhou qingtongqi,* ed. Shaanxi kaogu yanjiusuo, Shaanxi sheng wenwu guanli weiyuanhui, and Shaanxi sheng bowuguan (Beijing: Wenwu chubanshe, 1979), vol. 1, plates 1, 2.

21. Lantian xian 藍田縣

Fan Weiyue and Wu Zhenfeng, "Shaanxi Lantian xian chutu Shangdai qingtongqi," *Wenwu ziliao congkan* 3 (1980): 25–26.

22. Tongchuan shi 銅川市

Tongchuan shi wenhuaguan, "Shaanxi Tongchuan faxian Shang Zhou qingtongqi," *Kaogu* 1982.1: 107, 102.

23. Qishan xian 岐山縣

Wang Guangyong, "Shaanxi Qishan xian faxian Shangdai tongqi," *Wenwu* 1977.12: 86–87.

24. Chenggu Yangxian 城固洋縣

> Cao Wei, ed., *Hanzhong chutu Shangdai qingtongqi,* 3 vols. (Chengdu, Sichuan: Ba Shu shushe, 2006).

HEBEI PROVINCE 河北省 AND BEIJING 北京

25. Pinggu xian 平谷縣

> Beijing shi wenwu guanlichu, "Beijing Pinggu xian faxian Shangdai muzang," *Wenwu* 1977.11: 1–8.

26. Mancheng xian 滿城縣

> *Hebei sheng chutu wenwu xuanji,* ed. Beijing shi wenwu guanlichu (Beijing: Wenwu chubanshe, 1980); Robert Bagley, *Shang Ritual Bronzes in the Arthur M. Sackler Collections* (Cambridge, MA: Harvard University Press, 1987), 78 fig. 48.

SHANDONG PROVINCE 山東省

27. Tengzhou shi 滕州市

> Tengzhou shi bowuguan, "Shangdong Tengzhou shi faxian Shangdai qing-tongqi," *Wenwu* 1993.6: 95–96; "Shandong Tengzhou shi Xuehe xiayou chutu de Shangdai qingtongqi," *Kaogu* 1996.5: 29–31.

28. Jinan shi 濟南市

> Qi Wentao, "Gaishu jinnian lai Shandong chutu de Shangzhou qingtongqi," *Wenwu* 1972.5: 3–18.

ANHUI PROVINCE 安徽省

29. Jiashan xian 嘉山縣

> Ge Zhigong, "Anhui Jiashan xian Bogang Yinhe chutu de sijian Shangdai tongqi," *Wenwu* 1965.7: 23–26.

30. Hanshan xian 含山縣

> Yang Debiao, "Anhui sheng Hanshan xian chutu de Shang Zhou qing-tongqi," *Wenwu* 1992.5: 92–93.

31. Tongling xian 銅陵縣

> *Wannan Shang Zhou qingtongqi,* ed. Anhui daxue and Anhui sheng wenwu kaogu yanjiusuo (Beijing: Wenwu chubanshe, 2006), nos. 1, 2.

HUBEI PROVINCE 湖北省

32. Huangpi Panlongcheng 黃陂盤龍城

> *Panlongcheng: 1963–1994 nian kaogu fajue baogao,* ed. Hubei sheng wenwu kaogu yanjiusuo, 2 vols. (Beijing: Wenwu chubanshe, 2001).

33. Suizhou shi 隨州市

> Suizhou shi bowuguan, "Hubei Suixian faxian Shangdai qingtongqi," *Wenwu* 1981.8: 46–48.

34. Zhicheng shi 枝城市

> Li Zegao and Zhao Ping, "Zhicheng shi bowuguan cang qingtongqi," *Kaogu* 1989.9: 775–76.

Appendix 2
Site Names for Map 2

Walled sites are numbered inside a square.[1]

HENAN PROVINCE 河南省

1. Zhengzhou 鄭州
2. Yanshi Shixianggou 偃師尸鄉溝
6. Huixian Liulige 輝縣琉璃閣
35. Yanshi Erlitou 偃師二里頭
36. Xingyang Xishicun 滎陽西史村
37. Dengfeng Wangchenggang 登封王城崗
38. Wuzhi Zhaozhuang 武陟趙莊
39. Gongxian Shaochai 鞏縣稍柴
40. Jiaozuo Fucheng 焦作府城
41. Shanxian Qilipu 陝縣七里鋪
42. Luyi Luantai 鹿邑欒台
43. Zhecheng Mengzhuang 柘城孟莊
44. Qixian Lutaigang 杞縣鹿台崗
45. Huixian Mengzhuang 輝縣孟莊[2]
46. Xinxiang Luwangfen 新鄉潞王墳
47. Mixian Quliang 密縣曲梁
48. Xiuwu Ligu 修武李固

SHANXI PROVINCE 山西省

18. Yuanqu basin 垣曲盆地
19. Xiaxian Dongxiafeng 夏縣東下馮

SHAANXI PROVINCE 陝西省

20. Xi'an Laoniupo 西安老牛坡
21. Lantian Huaizhenfang 藍田懷真坊
49. Yaoxian Beicun 耀縣北村
50. Huaxian Nanshacun 華縣南沙村
51. Liquan Zhumazui 禮泉朱馬嘴

HEBEI PROVINCE 河北省
AND BEIJING 北京

52. Handan Guitaisi 邯鄲龜台寺
53. Gaocheng Taixi 藁城台西
 and Beilonggong 北龍宮
54. Weixian 蔚縣
55. Wu'an Zhaoyao 武安趙窯

SHANDONG PROVINCE 山東省

28. Jinan Daxinzhuang 濟南大辛莊[3]
56. Heze Anqiu Gudui 荷澤安邱堌堆
57. Sishui Yinjiacheng 泗水尹家城
58. Caoxian Shenzhongji 曹縣莘塚集
59. Dongming Dougudui 東明竇固堆

ANHUI PROVINCE 安徽省

60. Liu'an Zhongdesi 六安眾德寺
61. Shouxian Doujitai 壽縣鬥雞台
62. Hanshan Dachengdun 含山大城墩
 and Sunjiagang 孫家崗
63. Feixi Dadunzi 肥西大墩子

HUBEI PROVINCE 湖北省

32. Huangpi Panlongcheng 黃陂盤龍城
64. Anlu Huayuan 安陸花園
65. Jingzhou Jingnansi 荊州荊南寺[4]

HUNAN PROVINCE 湖南省

66. Yueyang Tonggushan 岳陽銅鼓山[5]

1. From *Zhongguo kaoguxue: Xia Shang juan*, ed. Zhongguo shehui kexueyuan kaogu yanjiusuo (Beijing: Zhongguo shehui kexue chubanshe, 2003), ch. 4; and Wang Lixin, *Zao Shang wenhua yanjiu* (Beijing: Gaodeng jiaoyu chubanshe, 1998.

2. See the final report, *Huixian Mengzhuang*, ed. Henan sheng wenwu kaogu yanjiusuo (Zhengzhou, Henan: Zhongzhou guji chubanshe, 2003).

3. The most recent report on the 1984 excavation is Shandong daxue dongfang kaogu yanjiu zhongxin, "Daxinzhuang yizhi 1984 nian qiu shijue baogao," *Dongfang kaogu*, no. 4 (2008): 288–521. The latest finds made in 2010 can be found in Shandong daxue lishi wenhua xueyuan kaoguxi and Shandong sheng wenwu kaogu yanjiusuo, "Jinan Daxinzhuang yizhi 139 hao Shangdai muzang," *Kaogu* 2010.10: 3–6.

4. See the final report, *Jingzhou Jingnansi*, ed. Jingzhou bowuguan (Beijing: Wenwu chubanshe, 2009).

5. I follow Xiang Taochu in classifying this site as an outpost of Panlongcheng; see Xiang Taochu, *Xiangjiang liuyu Shang Zhou qingtong wenhua yanjiu* (Beijing: Xianzhuang shuju, 2008), 48–52.

CHAPTER 4

Civilizations and Empires

A Perspective on Erligang from Early Egypt

John Baines

WANG HAICHENG PRESENTS a brilliant analysis of the Erligang phenomenon and how it can be related to the concept of empire as it applies both within East Asia and among early civilizations in other regions of the world (see ch. 3 in this volume). He concludes in a different spirit, with a call to scholars to think in terms of the interests and priorities of an Erligang king, the figure who must be posited at the core of the ancient state. In considering how best to respond to his chapter and its implications, as well as to other points that I learned during the Princeton conference in 2008, I have identified several themes that can be compared and contrasted with the case of ancient Egypt, which is my area of specialization. These are naturally just a few among many possibilities. I have selected the following for brief discussion: time spans of development, interactions of expanding states with surrounding societies, characteristic products of material culture, and social implications. Wang Haicheng has chosen telling exemplars, notably in the Uruk expansion and the Indus Valley civilization, for the comparative parts of his study. Ancient Egypt offers generally less close parallels but nevertheless valuable ones: when attempting to characterize social forms, contrasts as much as convergences can provide stimuli to thought.

TYPES OF STATES

First, however, it is desirable to mention an issue of another type. Erlitou and Erligang, both based in the middle Yellow River valley, were by far the largest-scale societies in their areas during their respective periods. Wang Haicheng proposes that Erligang turned itself into a short-lived empire, in the process extending its scale enormously. Both these polities arose in a wider region where there were significant numbers of other cultures. Did the context in which their civilization appeared form a city-state pattern, comparable with many others worldwide, in accord with the analyses of Norman Yoffee?[1] Or were they territorial states, as Bruce Trigger saw them?[2] Yoffee interprets early Egypt, my comparative case, as a territorial state that formed the main exception to the city-state groupings which he identifies in other regions where early states emerged. The unique sharpness of the geographical definition of Egypt probably had a significant impact on how it developed; it is the only place in the world that has been a state-level political unit, whether or not part of a larger empire, for most of five millennia. Trigger grouped Egypt, Anyang-period China, and the Inka polity of the fifteenth and sixteenth centuries CE as territorial states. This is a very disparate assemblage, consisting of (1) a civilization that was a single state in most periods, (2) a state and civilization—not necessarily identical in extent—among a number of other polities in a large region, and (3) an enormous but ephemeral state, probably better described as an

1. Norman Yoffee, *Myths of the Archaic State: Evolution of the Earliest Cities, States, and Civilizations* (Cambridge: Cambridge University Press, 2005), 50–51; for Egypt as a territorial state, see 47–48.

2. Bruce G. Trigger, *Understanding Early Civilizations: A Comparative Study* (Cambridge: Cambridge University Press, 2003), 104–13. See also Bruce G. Trigger, "Going Still Further?" *Cambridge Archaeological Journal* 15 (2005): 256–58.

empire, that exercised dominance over many other states and cultures and sought to unify them culturally as well as politically. In order to treat them together, one would need to use criteria other than their overall societal types. It is necessary to be cautious about the wider utility of the category of territorial states.

The polity centered on Erlitou constituted a state by normally accepted criteria, and it emerged before other states in East Asia.[3] However, complex societies were present in a region stretching at least as far as the Yangzi River, so that it did not arise in a cultural vacuum. Erlitou preserved features of material culture that were the shared Neolithic inheritance of cultures and polities spread over a much larger area. At a later stage, the Anyang period offers a case of significant diversity in the culture of elites in a number of societies located within essentially the same region: although a single center may have predominated, it did not exercise exclusive political power or cultural hegemony. To my eyes, neither Erlitou nor Anyang fits easily with the concept of a territorial state, in which a single culture predominates and fills its territory, defining itself to a great extent by its boundaries. Moreover, Anyang followed some time after the Erligang phase and constituted a decentralization in comparison with its predecessor. The scale of polities in East Asia in the second millennium BCE seems to have been much larger than in early Mesopotamia and probably than in Egypt, but the only phase in which a single polity dominated much or all of the "civilized" region was the Erligang.

In this perspective, the typological distinction between city-state and territorial state has more to do with how one polity relates to those surrounding it than with its scale. Among Trigger's group of territorial states, the Inka case may be most similar to that of Erligang: both were very large, short-lived polities that expanded across regions in which there were already other complex societies and probably states. While the reasons for their demise were no doubt different— Erligang was hardly overthrown by a Pizarro from across the ocean—they shared the ephemeral character of empires, many of which have lasted no more than a few generations even when they have had profound transformative influence in the regions and societies they have sought to dominate. This parallel does not favor seeing either example as a territorial state.

In comparing Erligang with early Egypt, specifically the Naqada III period of the late fourth and early third millennia BCE (see the chronological table; dates are BCE), one may be comparing an empire with a territorial state that briefly entertained something like imperial ambitions. Here features that bring Erligang close to Egypt, despite many differences, are the uniform character of its elite culture over a large geographical area and its position in a long view as a formative phase of a larger development. It is acceptable to compare societies that were not closely similar in general type, so long as it is made explicit which elements are being compared, and so long as typology is not treated as a causative agent.

TIME SPANS OF DEVELOPMENT

The overall time span of the phases Erlitou–Erligang–Anyang was around seven hundred years (ca. 1800–ca. 1050 BCE). Here comparison with Egypt is useful. The period in Egypt that saw analogous developments runs from Naqada IIIA–B, the latest "prehistoric" phase, to the end of the Early Dynastic period, a no doubt deceptively similar number of centuries (ca. 3250–ca. 2550 BCE, archaeologically Naqada IIIA–D; for further dates, see the chronological table).[4] Developments in the two civilizations were punctuated rather than continuous and are not mutually comparable in any straightforward way. These phases are, however, similar in their fundamental importance in both regions, defining essential forms and genres that endured for millennia, presumably in part as materializations of cultural practices and ideologies.

3. See, e.g., Robert L. Thorp, *China in the Early Bronze Age: Shang Civilization, Encounters with Asia* (Philadelphia: University of Pennsylvania Press, 2006), 21–61; Sarah Allan, "Erlitou and the Formation of Chinese Civilization: Toward a New Paradigm," *Journal of Asian Studies* 66 (2007): 461–96; Li Liu and Hong Xu, "Rethinking Erlitou: Legend, History and Chinese Archaeology," *Antiquity* 81, no. 314 (2007): 886–901.

4. In this essay, I use the "archaeological" designation "Naqada III," which encompasses material culture phases that are divided "historically" into late Predynastic times and the Early Dynastic period. The term "Naqada III," which Werner Kaiser introduced as part of the sequence Naqada I–III in his landmark article "Zur inneren Chronologie der Naqadakultur," *Archaeologia Geographica* 6 (1957): 69–77, designates a phenomenon of which scholars were already aware in part. Later studies by Kaiser and others have refined the chronology and introduced improvements; see, especially, Stan Hendrickx, "La chronologie de la préhistoire tardive et des débuts de l'histoire de l'Égypte," *Archéo-Nil* 9 (1999): 13–81. It remains difficult to correlate the archaeological phases with absolute dates. Here a new project that seeks to refine radiocarbon chronology and exploit Bayesian statistics may clarify matters; see "A New Chronology for the Formation of the Egyptian State," Oxford Radiocarbon Accelerator Unit, University of Oxford, http://c14.arch.ox.ac.uk/embed.php?File=egypt2.html. In this essay, I use the period designations adopted by David Wengrow, *The Archaeology of Early Egypt: Social Transformations in North-East Africa, 10,000 to 2650 BC*, Cambridge World Archaeology (Cambridge: Cambridge University Press, 2006), 272–76.

CHRONOLOGICAL TABLE. Dates for the Naqada Culture in Egypt and for the A-Group in Lower Nubia, Fourth and Early Third Millennium BCE. After Wengrow, *The Archaeology of Early Egypt*, 273.

EGYPT		LOWER NUBIA	
Periods	*Dynasties*	*Approx. Dates BCE*	*Periods*
Naqada IA–IIB	–	3900–3600	Early A-Group
Naqada IIC–IID2	–	3600–3300	Classic A-Group
Naqada IIIA	–	3300–3150	Terminal A-Group
Naqada IIIB	"o"	3150–3000	...
Naqada IIIC	1st	3000–2850	No clear evidence
Naqada IIID	late 1st–3rd	2850–2600	

The length of seven hundred years bears consideration. Prehistorians who deal in multiple millennia may view such periods as brief, but for the actors, they were not: they might have lasted thirty generations. Major changes in societal forms and in culture and ideology clustered in shorter periods on the order of generations. For both regions, scholars find it convenient to subdivide the phases into units of around a couple of centuries; each of those units too lasted for a number of generations. Except during phases of formation or collapse, life was not necessarily perceived by the actors as changing very rapidly or being particularly unstable. In many ways, changes may have affected elites more strongly than populations as a whole, although the former relied on the labor of the latter to carry out and sustain their projects and lifeways. Elites influenced the lives of the rest, in general adversely, through their appropriation of resources in increasingly unequal societies.[5]

In Egypt, archaeology supplies a nearly continuous record for the entire period, whereas the principal sites in East Asia are discontinuous, so that Erligang did not necessarily succeed Erlitou directly, while Anyang seems to have come after a transitional phase that followed the disappearance of Erligang.[6] Crucial changes are archaeologically invisible in both regions, notably the first appearance of writing—though this is more tangible in Egypt than in East Asia—while elaborate bronze casting techniques and decorative styles, which are so central to continuing traditions, appear at Erligang with little beyond basic shapes as forerunners at Erlitou.

Erligang comes as a second stage in the local sequence of the development of states—or better, of civilization[7]—and constitutes a state on a scale unprecedented in the region. For Egypt, Naqada IIIA–B designates the second phase—late Naqada II (Naqada IID) was the first—in which material culture was uniform all over the lower Nile valley and delta, replacing the earlier separate delta culture of Buto–Ma'adi, but it is the first stage that most scholars accept as constituting several states and ultimately a single one. Both Erligang and Naqada IIIA–B lasted roughly two centuries. What characterizes them is not so much the rapidity of change as the crystallization and dissemination of cultural forms. Both were recovered by archaeology, Naqada III in the late nineteenth and early twentieth centuries (though not designated by the term until the 1950s) and Erligang since the 1950s. Neither has a simple counterpart in "historical" sources from later periods in antiquity: both constitute segments of development that do not fit subsequent indigenous periodizations, with Erligang being a modern subdivision of a traditional period.

In both cases, finds of materials from the period at issue demonstrate that in much later times their artifacts and/or sites were known and reused, but not with any precise sense of the historical context of what was found or revived.[8] For Egypt,

5. Compare the position of Yoffee, *Myths of the Archaic State*, 2, on the exploitative character of early civilizations.

6. Robert Bagley, "Shang Archaeology," in *The Cambridge History of Ancient China: From the Origins of Civilization to 221 B.C.*, ed. Michael Loewe and Edward L. Shaughnessy (Cambridge: Cambridge University Press, 1999), 124–231, 157–58, 175–80; Jigen Tang, Zhichun Jing, and George (Rip) Rapp, "The Largest Walled Shang City Located in Anyang, China," *Antiquity* 74, no. 285 (2007): 479–80.

7. See, e.g., John Baines and Norman Yoffee, "Order, Legitimacy, and Wealth in Ancient Egypt and Mesopotamia," in *Archaic States*, ed. Gary M. Feinman and Joyce Marcus (Santa Fe, NM: School of American Research Press, 1998), 199–260.

8. I am grateful to Wang Haicheng for advice on the Chinese treatment of antiquities, including the find of an Erligang bronze in the tomb of a Ming dynasty (1368–1644) eunuch. Robert Bagley cites an early Western Zhou (ca. 1050–771 BCE) bronze that was influenced by Erligang decoration, at a time when this must have been a revival of a long-past style that required a deliberate recourse to old objects: Robert Bagley, *Max Loehr and the Study of Chinese Bronzes: Style and Classification in the History of Art* (Ithaca, NY: Cornell University East Asia Program, 2008), fig. 11. For later Chinese attitudes to bronzes, many discovered in old burials or deposits, see Jessica Rawson, "The Ancestry of Chinese Bronze Vessels," in *History from Things: Essays on Material Culture*, ed. Steven Lubar and W. David Kingery (Washington, DC: Smithsonian Institution Press, 1993), 51–73; Jenny F. So, "Antiques in Antiquity: Early Chinese Looks at the Past," *Journal of Chinese Studies* 48 (2008): 373–406. None of the material these authors cover is from the Erligang period. For early Egyptian objects reused in much later periods, see, e.g., James F. Romano, *The Luxor Museum of Ancient Egyptian Art: Catalogue* (Cairo: American Research Center in Egypt, 1979), no. 10 = Bernard V. Bothmer, "On Photographing Egyptian Art," *Studien zur Altägyptischen Kultur* 6 (1978): 51–53, plate v; Bernard V. Bothmer, "A New Fragment of an Old Palette," *Journal of the American Research Center in Egypt* 8 (1969–70): 5–8.

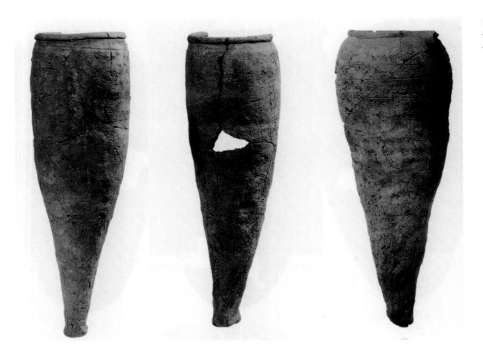

FIGURE 1. Three crude Nile silt storage jars, Naqada IIIA. H. (average) 45–50 cm. From Tomb U-j at Abydos.

it can be established that 1st dynasty royal tombs were excavated and restored in the Middle Kingdom.[9] The periods that followed, the Early Dynastic in Egypt and Anyang/Late Shang in East Asia, may have reimagined events and transformed the preceding formative phases into essentially mythical pasts. In Egypt, continuity with Naqada IIIA–B was lost, or more likely denied, in the Early Dynastic period (see also Bagley, ch. 1 in this volume). At Anyang, finds of bronzes show that there was a continuity of development from Erligang across the intervening transitional period,[10] but Anyang itself provides no evidence that awareness of Erligang as a historical reality persisted. It might prove very difficult to identify such evidence— for example, in the particular ancestors invoked for divination—but the pattern of change in material culture suggests that the new was valued over the old, at least in the vital category of bronzes.

In both Egypt and East Asia, archaeology and the recovery of written materials offer a progressively more informed, but naturally still contested, account of how what we might term the late prehistoric past was imagined in later times. In the case of Erligang, correspondence with a sequence of kings given in texts written more than a millennium later has been sought, although in archaeological terms the sequence Erligang–transition period–Anyang does not map straightforwardly onto the Shang dynasty of tradition. It is unlikely that a single kin-based ruling house would have survived such clear disruptions in continuity, even though the idiom used in referring to ancestors as rulers was one of kinship, with breaks marking changes in dynasty.

In Egypt, the material culture of Naqada III (see fig. 1 for its crudest aspect) shows progressive development—with major changes especially in writing— either side of the beginning of the 1st dynasty, which was traditionally taken as the start of Egyptian "history."[11] In the late nineteenth century, scholars identified the 1st dynasty by comparing names of kings found in the royal tombs at Abydos with the kinglists known from later Egypt. Werner Kaiser, however, showed that the country was probably a single polity from an earlier date, and the royal names from that phase are now grouped as "dynasty 0." It is not known whether this was a single line of kings, but the latest group of them seems to have been buried in sequence in Cemetery B at Abydos.[12] It appears clear that the rulers of the 1st dynasty reformed and extended the maintenance of records, effectively consigning their predecessors, who could well have been their political opponents,

9. On the tomb of the 1st dynasty king Den, which was excavated in the Middle Kingdom, see Günter Dreyer et al., "Umm El-Qaab: Nachuntersuchungen im frühzeitlichen Königsfriedhof, 9./10. Vorbericht," *Mitteilungen des Deutschen Archäologischen Instituts, Abteilung Kairo* 54 (1998): 77–167, 147.

10. Bagley, "Shang Archaeology"; for Erligang bronzes excavated at Anyang, see, e.g., Li Ji and Wan Jiabao [Li Chi and Wan Chia-pao], *Yinxu chutu wushisan jian qingtong rongqi zhi yanjiu* (*Studies of Fifty-three Ritual Bronzes*) (Taipei: Institute of History and Philology, Academia Sinica, 1972), plates 22, 24–26.

11. For a more nuanced view, see, e.g., Marc Van De Mieroop, *A History of Ancient Egypt*, Blackwell History of the Ancient World (Chichester: Wiley-Blackwell, 2011), 2, 27–29.

12. Especially Werner Kaiser, "Einige Bemerkungen zur ägyptischen Frühzeit III: Die Reichseinigung," *Zeitschrift für Ägyptische Sprache und Altertumskunde* 91 (1964): 86–125; Werner Kaiser and Günter Dreyer, "Umm El-Qaab: Nachuntersuchungen im frühzeitlichen Königsfriedhof, 2. Vorbericht," *Mitteilungen des Deutschen Archäologischen Instituts, Abteilung Kairo* 38 (1982): 211–69. Kaiser's later conclusion, that political unity of the entire country was achieved at the end of Naqada II, has not been widely accepted; see his "Zur Entstehung des gesamtägyptischen Staates," *Mitteilungen des Deutschen Archäologischen Instituts, Abteilung Kairo* 46 (1990): 287–99. The arguments about material culture in that article remain very important.

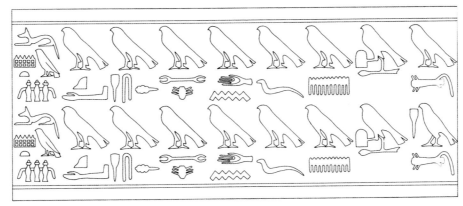

to a phase that was subsequently presented either as a set of rulers with fantastic names, as on the Palermo Stone from about six hundred years later,[13] or as dynasties of gods and spirits, in New Kingdom kinglists and the *Aegyptiaca* of the third-century BCE Greco-Egyptian writer Manetho.[14] That kinglists were being constructed from the 1st dynasty onward is established by various sources, notably a "dynastic seal" of which two 1st dynasty versions are known (fig. 2), one from the reign of Den in the middle of the dynasty and the other from that of its last king, Qa'a.[15] This retrospective definition of the past as different and irrelevant by the next dynasty is paralleled in many traditions.

EXPANSION AND NEIGHBORING CULTURES

The salient process that Wang Haicheng addresses in chapter 3 is the expansion of Erligang culture from its core in the Central Plain. Many early states expanded far beyond their cores during and after the period when their civilizations formed (in whatever way that process may be defined). Such expansions have occurred also in modern times, notably in the eighteenth- to twentieth-century "age of empires." A widespread characteristic of empires seems to be their very rapid growth. There is no one explanation for this pattern. Surprise can be an important element. In some cases, gross technological differences between conqueror and conquered were major factors. In others, the dominant culture had a compelling appeal that could win over local elites, who then became agents of imperial control—and some such process is a necessary part of establishing and consolidating any empire. In a third, rarer case, which applies to one direction of the expansion of early Egypt, the newly dominant polity more or less obliterates a nearby culture rather than integrating it or imposing its own forms on it. Variants of this process are seen in modern Western imperial and colonizing expansions—for example, in Argentina, North America, and Tasmania—but these may not be closely comparable with what I discuss here.

Erligang expanded from its core in the Central Plain of China southward as far as the Yangzi and over very large but as yet less securely defined regions in

13. John Baines, "The Earliest Egyptian Writing: Development, Context, Purpose," in *The First Writing: Script Invention as History and Process*, ed. Stephen D. Houston (Cambridge: Cambridge University Press, 2004), 150–89, 173–75, 182, with references.

14. Werner Kaiser, "Einige Bemerkungen zur ägyptischen Frühzeit II: Zur Frage einer über Menes hinausreichenden Geschichtsüberlieferung," *Zeitschrift für Ägyptische Sprache und Altertumskunde* 86 (1961): 39–61.

15. Günter Dreyer, "Ein Siegel der frühzeitlichen Königsnekropole von Abydos," *Mitteilungen des Deutschen Archäologischen Instituts, Abteilung Kairo* 43 (1987): 33–43; Günter Dreyer et al., "Umm el-Qaab: Nachuntersuchungen im frühzeitlichen Königsfriedhof, 7./8. Vorbericht," *Mitteilungen des Deutschen Archäologischen Instituts, Abteilung Kairo* 52 (1996): 72.

MAP 1. Egypt, Lower Nubia, and Palestine in Naqada III.

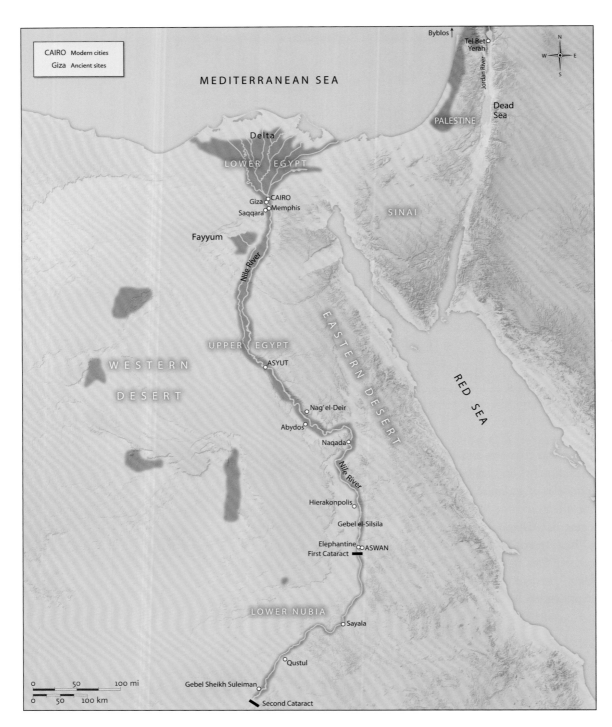

16. For Libya in early Egyptian ideology, see John Baines, "Early Definitions of the Egyptian World and Its Surroundings," in *Culture through Objects: Ancient Near Eastern Studies in Honour of P. R. S. Moorey*, ed. Timothy Potts, Michael Roaf, and Diana Stein (Oxford: Griffith Institute, 2003), 27–57, 29–39.

17. On the Eastern Desert, see Russell D. Rothe, William K. Miller, and George Rapp Jr., *Pharaonic Inscriptions from the Southeastern Desert of Egypt* (Winona Lake, IN: Eisenbrauns, 2008), 93, no. QS03 = Hans A. Winkler, *Rock-Drawings of Southern Upper Egypt: Sir Robert Mond Desert Expedition, Preliminary Report*, vol. 1, *Season 1936–1937* (London: Egypt Exploration Society; Humphrey Milford, Oxford University Press, 1938), plate xi:1; on the western desert, see Winkler, *Rock-Drawings of Southern Upper Egypt*, plate xi:2.

other directions. Egypt's expansion in the Naqada III period, to Lower Nubia in the south and Palestine in the northeast, did not take in so large an area. Libya is a prominent motif on decorated objects of the period, and there may have been some expansion in that direction—perhaps along the northwest coast of modern Egypt—but no archaeological evidence of such a development has been identified.[16] The eastern and western deserts of Egypt and the Sinai peninsula were targets of expeditions, notably to acquire minerals, but these are arid areas that have never sustained significant settled populations (although evidence may yet emerge from the oases of the western desert). It remains noteworthy that the name of Narmer, the best-attested king of Naqada IIIB, is known from rock inscriptions in both eastern and western deserts.[17]

Wang Haicheng's principal argument about the Erligang expansion is twofold. First, the process was rapid, imposing the core elite culture on remote places that were situated in regions that possessed markedly different material cultures,

FIGURE 3. Fragment of Egyptian relief palette, Naqada IIIB. H. 5 cm. From a secondary context at Tel Bet Yerah, Israel.

18. See, e.g., Edwin C. M. van den Brink and Thomas E. Levy, eds., *Egypt and the Levant: Interrelations from the 4th through the Early 3rd Millennium BCE*, New Approaches to Anthropological Archaeology (London: Leicester University Press, 2002); Marcelo Campagno, "Ethnicity and Changing Relationships between Egyptians and South Levantines during the Early Dynastic Period," in *Egypt at Its Origins II: Proceedings of the International Conference "Origin of the State: Predynastic and Early Dynastic Egypt," Toulouse, 5th–8th September 2005*, ed. Béatrix Midant-Reynes and Yann Tristant, Orientalia Lovaniensia Analecta 172 (Leuven: Peeters, 2008), 689–705. The extent of Egyptian presence is disputed. A maximal view is presented by Yuval Yekutieli, "Symbols in Action—the Megiddo Graffiti Reassessed," in Midant-Reynes and Tristant, *Egypt at Its Origins II*, 807–37, and a minimal one by Edwin C. M. van den Brink and Eliot Braun, "Appraising South Levantine–Egyptian Interaction: Recent Discoveries from Israel and Egypt," in ibid., 643–88; see also Eliot Braun, "South Levantine Early Bronze Age Chronological Correlations with Egypt in Light of the Narmer Serekhs from Tel Erani and Arad: New Interpretations," *British Museum Studies in Ancient Egypt and Sudan* 13 (2009): 25–48. Some earlier Egyptian objects have been found on the same sites, e.g., Ulrich Hartung, *Umm el-Qaab II: Importkeramik aus dem Friedhof U in Abydos (Umm el-Qaab) und die Beziehungen Ägyptens zu Vorderasien im 4. Jahrtausend v.Chr.*, Deutsches Archäologisches Institut, Abteilung Kairo, Archäologische Veröffentlichungen 92 (Mainz: Philipp von Zabern, 2001), 356 fig. 70k, from Taur Ikhbeineh.

19. See, e.g., Leon Marfoe, "Cedar Forest to Silver Mountain: Social Change and the Development of Long-Distance Trade in Early Near Eastern Societies," in *Centre and Periphery in the Ancient World*, ed. Michael Rowlands, Mogens Trolle Larsen, and Kristian Kristiansen, New Directions in Archaeology (Cambridge: Cambridge University Press, 1987), 25–35, 26–28; Karin N. Sowada, *Egypt in the Eastern Mediterranean during the Old Kingdom: An Archaeological Perspective*, Orbis Biblicus et Orientalis 237 (Fribourg: Academic Press; Göttingen: Vandenhoeck & Ruprecht, 2009).

20. David Wengrow points out that the spread of Nile valley material culture into the delta in Naqada IID might constitute a parallel for Erligang settlement outside one's home region. This is the phase that immediately preceded Naqada III, which is the focus of the present chapter.

21. Nigel Strudwick, *Texts from the Pyramid Age*, Writings from the Ancient World 16 (Atlanta, GA: Society of Biblical Literature, 2005), 335, 336; John Baines, "Travel in Third and Second Millennium Egypt," in *Travel, Geography and Culture in Ancient Greece and the Near East*, ed. Colin Adams and Jim Roy, Leicester Nottingham Studies in Ancient Society 10 (Oxford: Oxbow, 2007), 5–30, 14, 17.

22. For a synthesizing treatment, see Edwin C. M. van den Brink and Thomas E. Levy, "Interaction Models, Egypt and the Levantine Periphery," in van den Brink and Levy, *Egypt and the Levant*, 3–38, 22–32.

probably achieving that end at least in part by military force. Second, the imposed forms are characterized by the material culture and practices, notably in burial, of the elite rather than of the general population. This settling of elites, with the full repertory of their material culture, in distant "colonies" such as Panlongcheng is a crucial feature of the expansion. Erligang forms were succeeded by a diversification of local styles that several contributors to this volume discuss. That diversification depended in part on existing contacts, including channels for the acquisition of raw materials such as metal ores, but it also built on existing traditions that had been sidelined during the Erligang period.

Palestine

The Egyptian case can be contrasted with Erligang in useful ways (see map 1). Expansion into Palestine, which began in Naqada IIIA and lasted through much of the subsequent 1st dynasty (Naqada IIIC), brought Egyptian presence and influence into a region that had its own Early Bronze culture.[18] Palestine produced wine and oils that were imported into Egypt. Longer-distance trade probably went at first by land, moving up and down the eastern littoral of the Mediterranean Sea, but as seagoing ships developed, it seems to have become focused farther to the north, concentrating especially in modern Lebanon, where the port of Byblos was a major Egyptian point of contact for two thousand years.[19] The timber of the area, both pine and cedar, was a vital import into Egypt. Precious materials such as lapis lazuli, which came ultimately from Afghanistan, might have traveled by either land or sea. Unlike the Erligang pattern, there is no trace in the cemetery record of elite settlement outside Egypt itself.[20] Moreover, later Egyptian texts mention the recovery of corpses from abroad and express a horror of dying outside Egypt, at least for those who could afford a proper burial.[21] This ideological and, it seems, real reluctance to put down roots outside Egypt is corroborated by strongly negative attitudes toward exile.

Egypt had relatively little impact on forms of material culture in Palestine, which already possessed a well-developed Early Bronze Age culture of its own, although without large polities. Since various sites yield locally made Egyptian-style pottery, including shards inscribed with royal names of dynasties 0–1,[22] there appears to have been some Egyptian settlement, but major and lasting cultural influence cannot be discerned before a much later period. In 2009, a very fine

FIGURE 4. Selection of inscribed bone tags, Naqada IIIA. H. (average) approx. 1.5 cm. From Tomb U-j at Abydos.

fragment of an Egyptian decorated "relief palette," a characteristic royal product of Naqada IIIB, was discovered in a secondary context at Tel Bet Yerah, an urban site next to the Sea of Galilee in northern Israel (fig. 3).[23] This find suggests that the accepted picture is too simple and that significant Egyptian contact extended some way to the north. Nonetheless, the object is more likely to be the product of gift exchange between the king in Egypt and a local ruler than an indicator of conquest: something with such royal and divine associations might have had no place in a colonial context.

The connection between Egypt and Palestine had significant impact in other ways, perhaps more on Egypt than on Palestine. Egyptian royalty and elites acquired a taste for wine and oil produced in Palestine, but the numerous wine vessels of Palestinian type excavated in Tomb U-j at Abydos, which belonged to a significant ruler, seem to be of local Egyptian manufacture,[24] suggesting that the necessary crops had been introduced into Egypt (botanical evidence is not available from this period). The institutions that were necessary for sustaining long-distance exchange of such bulky and heavy products created economic interdependence, and they probably also fostered development of sea transport in addition to the use of the river in Egypt. Whether or not the Tomb U-j vessels were imported, a significant level of Egyptian interaction with Palestine is assured by archaeological evidence in Palestine itself, while connections farther north, with Lebanon and Syria, seem to be mostly of rather later date.

23. Raphael Greenberg, David Wengrow, and Sarit Paz, "Cosmetic Connections? An Egyptian Relief Carving from Early Bronze Age Tel Bet Yerah (Israel)," *Antiquity* 84, no. 324 (2010), Project Gallery, at http://antiquity.ac.uk/projgall/greenberg324/. This has been followed by finds of undecorated material (David Wengrow, personal communication, 2011).

24. See Wengrow, *The Archaeology of Early Egypt*, 137–40, 198–207, with references. Another view is that the vessels were made in Palestine; the Egyptian option is supported by thin-section analyses of ceramics.

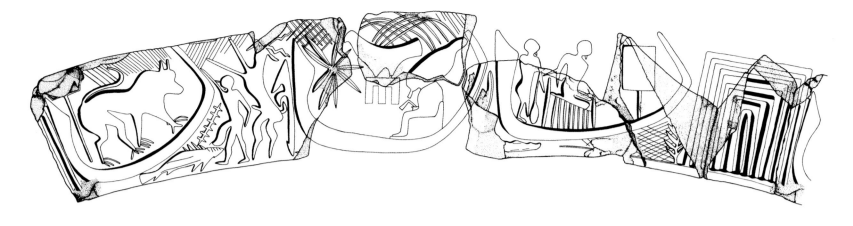

FIGURE 5. Line drawing of one of two incense burners with incised decoration, including royal motifs. Limestone, h. 8.5–9 cm, diam. 15 cm. From Cemetery A, Qustul, Lower Nubia, Tomb 24, Terminal A-Group. Chicago, Oriental Institute Museum (E24069).

FIGURE 6. Egg-shaped pestles together with grindstones decorated with spirals on the undersides. Largest grindstone, h. 32 cm. From a secondary context in Cemetery L, Qustul, Lower Nubia, Terminal A-Group.

FIGURE 7. Two "eggshell ware" vessels. (a) Vessel from Tomb L 11 (E 24291). H. approx. 18.5 cm. (b) Vessel from tomb L 17 (E 24292). H. approx. 12.5 cm. Both from Cemetery L, Qustul, Lower Nubia, Terminal A-Group. Chicago, Oriental Institute Museum.

25. See, e.g., David O'Connor, *Ancient Nubia: Egypt's Rival in Africa* (Philadelphia: University Museum, University of Pennsylvania, 1993), 10–23. Jane Roy, *The Politics of Trade: Egypt and Lower Nubia in the 4th Millennium BC*, Culture and History of the Ancient Near East 47 (Leiden: Brill, 2011), collects available evidence but has little to say about societal forms.

26. Günter Dreyer, Ulrich Hartung, and Frauke Pumpenmeier, *Umm el-Qaab I: Das prädynastische Königsgrab U-j und seine frühen Schriftzeugnisse*, Deutsches Archäologisches Institut, Abteilung Kairo, Archäologische Veröffentlichungen 86 (Mainz: Philipp von Zabern, 1998); for much subsequent discussion of the written materials, see, e.g., Ludwig D. Morenz, *Bild-Buchstaben und symbolische Zeichen: Die Herausbildung der Schrift in der hohen Kultur Altägyptens*, Orbis Biblicus et Orientalis 205 (Fribourg: Academic Press; Göttingen: Vandenhoeck & Ruprecht, 2004).

27. Bruce Beyer Williams, *Excavations between Abu Simbel and the Sudan Frontier I, The A-Group Royal Cemetery at Qustul: Cemetery L*, Oriental Institute Nubian Expedition 3 (Chicago: Oriental Institute, University of Chicago, 1986).

28. O'Connor, *Ancient Nubia*, 21, suggests that the incense burners were made in Egypt, and this view is supported by their material of limestone, which is not available in Nubia. However, in style and content of decoration, the burners do not have close parallels in Egypt, so that if they did come from there, they must have been created as exotica specifically for export.

29. Cecil M. Firth, *The Archaeological Survey of Nubia: Report for 1910–1911* (Cairo: Ministry of Finance, Survey Department, 1927), 204–12, noting the regal character of some of the graves; Harry S. Smith, "The Princes of Seyala in Lower Nubia in the Predynastic and Protodynastic Periods," in *Nubie, Soudan, Éthiopie*, vol. 2 of *Hommages à Jean Leclant*, ed. Catherine Berger, Gisèle Clerc, and Nicolas Grimal, Bibliothèque d'Étude 106/2 (Cairo: Institut Français d'Archéologie Orientale, 1994), 361–76; Wengrow, *The Archaeology of Early Egypt*, 169–70; Andrés Diego Espinel, *Abriendo los caminos de Punt: Contactos entre Egipto y el ámbito afroárabe durante la Edad del Bronce [ca. 3000 a.C.–1065 a.C.]* (Barcelona: Bellaterra, 2011), 132–35 with fig. 2.5.

FIGURE 8. (a) Mace with sheet-gold-covered and relief-decorated handle. H. 28.5 cm. (b) Line drawing of decoration, not to scale. From Cemetery 137, Tomb 1, at Sayala, Lower Nubia. Formerly in Egyptian Museum, Cairo; stolen in 1920, whereabouts unknown.

FIGURE 9. Siltstone pouring vessel, date uncertain, perhaps Naqada IIIA. Dimensions not given. From Cemetery 137, Tomb 1, at Sayala, Lower Nubia. Whereabouts unknown.

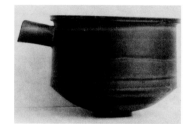

Lower Nubia

In the fifth and early fourth millennia BCE, cultures upstream from the first Nile cataract as far as central Sudan were not fundamentally different in lifeways from those in the Egyptian Nile valley and appear to have been based more on animals than on agriculture. The two regions began to draw apart as agriculture expanded in Egypt in the Naqada I and II periods (ca. 3900–ca. 3300 BCE). In the second half of the fourth millennium BCE, what is known as the A-Group in Lower Nubia developed into a complex society with a material culture distinct from that of Egypt.[25] During Naqada II, Egyptian material culture spread permanently southward past the narrows of Gebel el-Silsila to the Aswan area just north of the first cataract, creating a politically incorporated zone that remains culturally mixed to this day. The latest phase of the A-Group corresponds with Naqada IIIA in Egypt, the period of Tomb U-j at Abydos, which has produced the earliest-known Egyptian writing (fig. 4).[26] Two exceptional sites of the A-Group have been excavated, at Sayala in central Lower Nubia and at Qustul, a little north of the second Nile cataract.[27] Cemetery L at Qustul showed clear traces of kingship, major symbols of which were carved on the sides of incense burners (fig. 5). Their iconography is partly dependent on Egyptian models—which is what makes it intelligible—but it has a distinctive character.[28] Grindstones with large-scale spiral patterns on their backs (fig. 6) and very fine decorated pottery ("eggshell ware") that was a favored A-Group product (fig. 7) were characteristic elements of the local elite culture. The cemetery had been deliberately destroyed; most finds were badly broken.

The Sayala cemetery appears to be of similar or slightly earlier date, but the finds are different in character.[29] A multiple tomb that probably included the burial

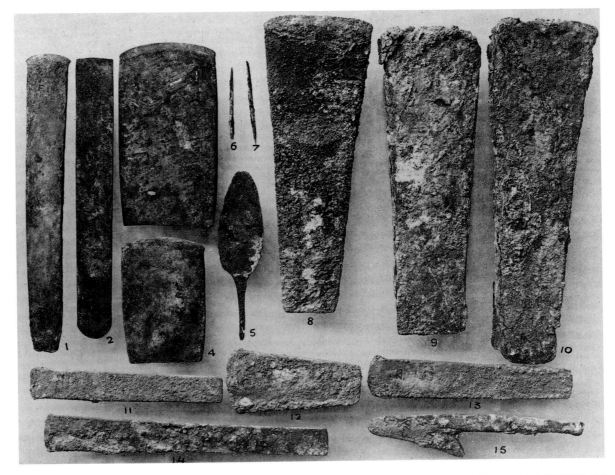

FIGURE 10. Deposit of copper tools, date uncertain, perhaps Naqada IIIA/Terminal A-Group. Dimensions not given. From Cemetery 137, Tomb 1, at Sayala, Lower Nubia. Whereabouts unknown.

FIGURE 11. Copper implements, 1st dynasty. (a) Adzes with wooden handles and spare blades. (b) Knives with wooden handles. From Tomb 3471 at North Saqqara, Room S.

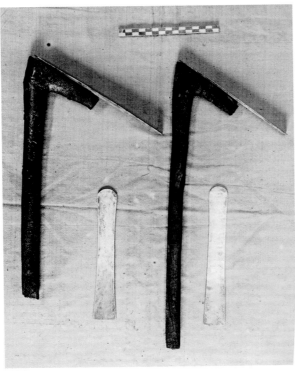

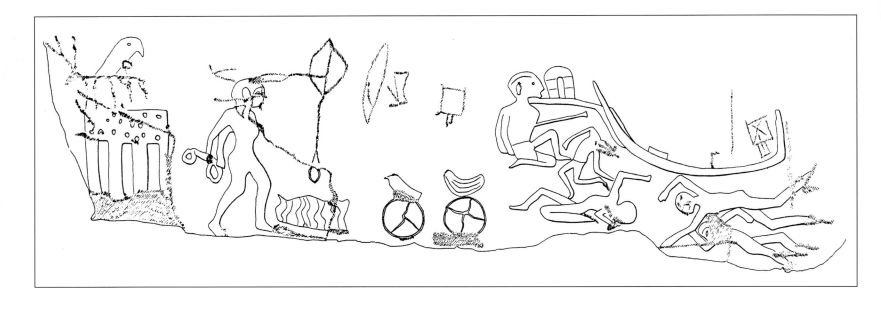

of a ruler contained two sheet-gold-covered mace handles, one of them with very fine relief decoration using motifs similar to those found in Egypt (fig. 8). This is likely to have been an import, as is a banded siltstone vessel of perfect manufacture and unique form (fig. 9), as well as numerous copper tools, including some notably heavy pieces (fig. 10).[30] The assemblage might have belonged to the leader of a small polity, a client whose wealth depended on Egypt and for whom metal implements were a scarce and prestigious resource. While no comparable deposit of metal objects is known from this date in Egypt itself, large tombs are so heavily looted that the absence of a parallel may not be significant. A 1st dynasty elite tomb at Saqqara contained many hundreds of copper vessels and tools (fig. 11).[31]

An important monument is a rock relief from Gebel Sheikh Suleiman at the north end of the second cataract of the Nile (fig. 12), probably of Naqada IIIB date, that bears the name of an Egyptian king (not legible) and depicts the defeat of enemies.[32] Scholars have linked this with the destruction of Cemetery L, around sixty kilometers to the north, which must have occurred during the same period. Hardly any finds from Lower Nubia seem to be contemporary with the Egyptian Early Dynastic period (Naqada IIIC–D, ca. 3000–ca. 2600 BCE). It seems as if Egyptian depredations led to the area's abandonment by archaeologically visible populations.[33] This does not necessarily mean that it was uninhabited but perhaps indicates that the inhabitants of the period did not use mortuary display— the principal form of evidence from the region for all periods—or became partly nomadic.[34]

Erligang and Naqada III Compared

Thus, while the Erligang polity expanded over large regions, including the rich, settled basin of the Yangzi, and succeeded in imposing itself there for a short time during a period of strong cultural development, Egyptian expansion in Lower Nubia, which was into a relatively marginal, sparsely populated area, was not creative but destructive, having the probably deliberate consequence that the local polities were eliminated; for the following period very few traces of settlement have been recovered. In their periods of expansion, shortly after the formation of the state, both Erligang and Egypt sought to dominate surrounding regions, but their strategies were different. The repressive Egyptian approach in Nubia is less widely paralleled in other parts of the world than is that of Erligang and differs evidently from Egyptian policy in Palestine, where the aim seems to have been more to trade with the local elite than to replace or eliminate it.

FIGURE 12. Line drawing of a rock, with Egyptian victory carving, probably Naqada IIIB. From Gebel Sheikh Suleiman, near Wadi Halfa (Sudan). Now in Khartum National Museum garden.

30. Firth, *The Archaeological Survey of Nubia: Report for 1910–1911*, 207, plates 18f, 22b.

31. For the find, see Walter B. Emery, *Great Tombs of the First Dynasty I*, Service des Antiquités de l'Égypte, Excavations at Saqqara (Cairo: Government Press, Bulâq, 1949), 18–57, plates 4–10.

32. William J. Murnane, in Bruce Beyer Williams and Thomas J. Logan, "The Metropolitan Museum Knife Handle and Aspects of Pharaonic Imagery before Narmer," *Journal of Near Eastern Studies* 46 (1987): 282–85; for original publication and photographs, see A. J. Arkell, "Varia Sudanica," *Journal of Egyptian Archaeology* 36 (1950): 24–40.

33. See, e.g., O'Connor, *Ancient Nubia*, 21–23. See Birgit Glück, "Zur Frage der Datierung der frühen C-Gruppe in Unternubien," *Ägypten und Levante* 15 (2005): 131–53, for possible sites from the following period, the Old Kingdom, which would be the earliest attestations of the C-Group, the successor culture to the A-Group in Lower Nubia.

34. Barry J. Kemp in "Explaining Ancient Crises," *Cambridge Archaeological Journal* 1 (1991): 239–44, 240, comments on these developments, but his specific explanation of an Egyptian search for manpower is problematic, both because far more people were available for major projects within Egypt than in Nubia and because the projects postdate the disappearance of the A-Group by some centuries. He may have been influenced by Wolfgang Helck ("Die Bedeutung der Inschriften J. Lopez, Inscripciones Rupestres Nr. 27 and 28," *Studien zur Altägyptischen Kultur* 1 [1974]: 215–25], who took military statistics in graffiti in Lower Nubia at face value even though the totals mentioned exceed any plausible population of the region for the Old Kingdom.

The Erligang expansion can appropriately be termed a "colonizing empire" and should be added to the range of cases considered in comparative studies.[35] As in most parallel cases, the numbers of Erligang elites and settlers who controlled the incorporated areas were probably small. Until the early Zhou dynasty, more than two centuries later, there was no regional unification on a comparable scale, and that unification too did not endure. Erligang was succeeded instead by a period of diversity, during which local states formed across a region still larger than that occupied by Erligang,[36] including the distinctive civilization of Sanxingdui in Sichuan.[37]

Egypt presents a different case. Its geographical setting constrains directions of expansion so much that ventures in different periods followed similar patterns even though they reached beyond the core area of the lower Nile valley and delta to very different degrees. The first move was normally to the south, no doubt for practical reasons, since Nubia is directly adjacent to Egypt and a channel for acquiring exotic goods, but also for ideological ones, because the Egyptians oriented themselves to face south, so that Nubia was at the "front" of the world, an idea that finds direct expression in the Egyptian language.[38] In several periods, southward expansion was followed by activity in the Levant: raids, ephemeral conquest, or longer-term dominance. This could have been the order of events in Naqada III. The southward move at that date did not constitute any form of colonization or settlement, but in the Levant a small colonial area was established that endured for perhaps a century or two. Insofar as this northward foray constituted control of a culturally distinct region, it could fit a minimal definition of empire, but the area affected was limited and the long-term impact seemingly slight. It is best to see Egypt as having possessed an empire in Nubia and the Levant during two periods in the second millennium BCE from which distinctive evidence of many types survives, but not in the fourth or third millennium BCE.

A final evident difference between the expansions of Egypt and Erligang is their aftermaths. Both Erligang and its proposed empire disappeared, to be succeeded after a time of transition by the nonimperial Anyang and by probable rivals such as Sanxingdui, whereas Egyptian retrenchment from expansion into Nubia and Palestine in the Early Dynastic period only marginally affected the core polity, which continued its largely uninterrupted development. For Egypt, the expansion was less integral to maintaining the polity.

Furthermore, Egyptians always maintained a stereotyped vision of Nubians as inferior foreigners, whereas in some periods they viewed peoples of the Near East less negatively. The stereotyped images were in practice acknowledged to be ideological, because they did not get in the way of more realistic modes of action—such as acceptance of Nubians and Levantines into the Egyptian elite—but it is significant that the definition of what constituted Egypt and what constituted "abroad" did not change significantly after Naqada III. There was no progressive enlargement of the realm, as happened in China in the first millennium BCE. Relevant attitudes are largely inaccessible for Erligang: it cannot be known whether the expansion was into a realm conceived as "Greater Erligang" or as "abroad." Yet the juxtaposition of two different material cultures in a region such as that around Panlongcheng, with a stratification signifying that one was superior to the other from the Erligang perspective, is suggestive more of an imperial context than of complete incorporation. There must also have been some accommodation with local elites. Perhaps Erligang entertained views of neighboring cultures that were more like Egyptian views of Palestine than of Nubia in the late fourth millennium BCE.

35. E.g., Susan E. Alcock et al., eds., *Empires: Perspectives from Archaeology and History* (Cambridge: Cambridge University Press, 2001).

36. See Bagley, "Shang Archaeology," 171–80.

37. Robert Bagley, ed., *Ancient Sichuan: Treasures from a Lost Civilization* (Seattle: Seattle Art Museum; Princeton: Princeton University Press, 2001); Chengdu Institute of Cultural Heritage and Archaeology, comp., *The Jinsha Site: A 21st Century Discovery of Chinese Archaeology*, trans. Wang Pingxing (Beijing: China Intercontinental Press, 2006); Jay Xu, ed., "Special Section: Art and Archaeology of the Sichuan Basin," *Journal of East Asian Archaeology* 5 (2003 [2006]): 101–276.

38. Baines, "Travel in Third and Second Millennium Egypt," 6–10, with references.

FIGURE 13. Group of stone vessels, 1st–2nd dynasties. Left to right: bowl, gneiss, h. 5.7 cm (JE 64886); jar, amethyst, h. 9.2 cm (JE 65416); tall vessel, speckled siltstone, h. 16.5 cm (JE 65422). From deposits of older material found under the Step Pyramid of Djoser at Saqqara. Cairo, Egyptian Museum.

CHARACTERISTIC PRODUCTS OF MATERIAL CULTURE

Erligang and Naqada III produced or developed material forms that had an influence on successor periods lasting for millennia. Those forms were at a large scale—vast city walls for Erligang and elaborate mortuary monuments for Egypt—and a small scale, notably bronzes for Erligang and various genres of prestige stoneworking for Egypt. In Egypt, it is possible to observe developing conventions of integrated pictorial decoration and writing. This feature has no attested close parallel in Erligang: writing was probably invented there too, but scarcely any is preserved, so that one can hardly discuss its impact in the period.[39]

The aesthetic domain of high culture was more broadly important.[40] In both regions, essential features of that domain are lost, such as fine textiles and uses of color in many media, and this loss should constantly be borne in mind. High culture employs large numbers of people to create and maintain its forms. The availability of people is critical both to its existence and to its status in its own and neighboring societies. Here Egypt had far greater potential than Lower Nubia or the small-scale societies of Palestine. While Lower Nubia imported and emulated some Egyptian products, it could hardly sustain comparable social forms on a large scale. In Palestine too there is no clear tendency toward forming significantly larger political units. Erligang, which was within reach of large and populous areas, was probably not set apart from its neighbors to the same degree.

39. See Bagley, chapter 1 in this volume.

40. For discussion of this concept, see Baines and Yoffee, "Order, Legitimacy, and Wealth," 233–52.

FIGURE 14. Narmer Palette, Naqada IIIB. Siltstone, h. 64 cm. (a) Smiting side. (b) Grinding side. From Hierakonpolis Main Deposit. Cairo, Egyptian Museum (CG 14716).

In Egypt, two well-attested Naqada III aesthetic modes are stone vessels (fig. 13) and carved relief decoration in stone and ivory.[41] The vessels required an enormous investment in materials, many of which were extracted by expeditions to the eastern desert, as well as in specialized workshops, which produced pieces of matchless refinement and bravura. Stone vessels superseded ceramics as prestige goods no later than the end of Naqada II and, in turn, were gradually supplanted by copper, and probably gold, during the Early Dynastic period, declining to relative unimportance in the Old Kingdom (ca. 2600–ca. 2150 BCE). Evidence for metal is rather poor, in part because it was scarce and much recycled but also because of the status of stone, making it difficult to study the development of prestige containers; by contrast, the abundance of metal in China is conducive to a far more extensive archaeological record. A marked difference here is that Egyptian vessel forms and associated ideas and values changed more radically than their Chinese counterparts. Naqada III stone vessels had relatively little impact in the very long term, whereas in China, ceramic and then bronze shapes retained significant similarities from the Neolithic onward.[42] Their decoration, however, was transformed in the Erligang period, setting the pattern for more than a millennium of elaboration and creating a centrally important form.

In Egypt, decoration on both ivory and stone developed strongly during Naqada III, culminating in the compositional forms exemplified on the Narmer Palette (fig. 14) and setting an overall schema for later periods. Yet the medium

41. An important older collection of evidence is in Henri Asselberghs, *Chaos en beheersing: Documenten uit het aeneolitisch Egypte*, Documenta et Monumenta Orientis Antiqui 8 (Leiden: E. J. Brill, 1961); this work does not use the term "Naqada III."

42. See Bagley, chapter 1 in this volume.

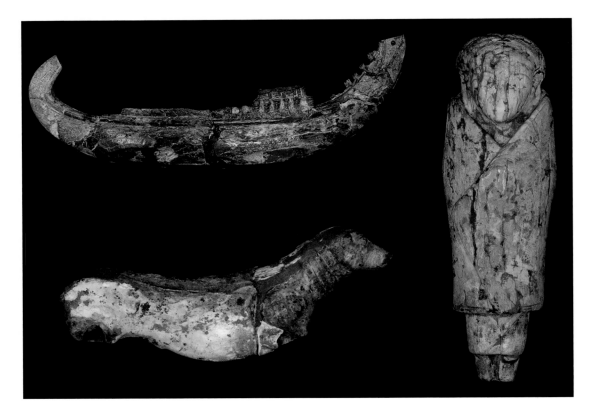

of the portable palette, which derived from practices of ornamenting bodies of gods, kings, or humans, disappeared after Narmer's time, probably replaced by wall paintings and reliefs, of which examples happen not to survive from any time before a couple of centuries later. The same pattern seems to apply to relief-decorated ivories, which are rare from dynastic-period Egypt. It is perhaps no coincidence that both the Narmer Palette and a vast assemblage of ivories were among the artifacts buried in the Hierakonpolis Main Deposit (fig. 15), the large majority of which probably dates to Naqada III, with such pieces as the Two Dog Palette (fig. 16) being old and curated before they were finally discarded. All of this seems to mark a conscious change to new media and, to a lesser extent, new conventions of decoration, but the date when the deposit was made is very uncertain.[43]

Egyptian conventions for pictorial decoration integrated with writing, a combination that remained at the core of artistic usage in all later periods, have no parallel in East Asia, where representational art did not emerge to any great extent until a millennium after Erligang. Artifacts that were both decorated and inscribed became relatively common in post–Erligang times, but the two modes did not come together in the same way as in Egypt. I suggest that in Egypt integration was intended from the earliest stages of the invention of writing,[44] and it may have slowed the development of the script's ability to notate language fully, something that happened no later than Anyang times in China.

Egypt and East Asia exhibit marked differences in patterns of material culture, including uses of writing. Whereas Egyptian elite aesthetic culture stood apart from that of neighboring areas, which appreciated media such as ceramics that were devalued in Egypt, in East Asia there was more uniformity in focuses of prestige, with bronze, jade, ceramics, lacquer, and silk having high value across a vast region in which there was considerable variation in forms and styles. Thus, Erligang arose from a broad sphere with which it interacted and to which it contributed. While Egypt, too, partook in exchanges over a large area, in Naqada III and the third millennium BCE, it retained distinctive cultural forms; it became more closely integrated with the Near East only in the second millennium, and with Africa to its south only for a century or so in the first millennium BCE.[45]

43. Liam McNamara, "The Revetted Mound at Hierakonpolis and Early Kingship: A Reinterpretation," in Midant-Reynes and Tristant, *Egypt at Its Origins II*, 899–934; Richard Bussmann, *Die Provinztempel Ägyptens von der o. bis zur 11. Dynastie: Archäologie und Geschichte einer gesellschaftlichen Institution zwischen Residenz und Provinz*, Probleme der Ägyptologie 30 (Leiden: Brill, 2010), 42–50. Since writing this chapter, I have done further research on the issues outlined in this paragraph. See John Baines, "Sources of Egyptian Temple Cosmology: Divine Image, King, and Ritual Performer," in *Heaven on Earth: Temples, Ritual, and Cosmic Symbolism in the Ancient World*, ed. Deena Ragavan, Oriental Institute Seminar 9 (Chicago: Oriental Institute, University of Chicago, 2013), 395–424.

44. John Baines, "Aesthetic Culture and the Emergence of Writing in Egypt during Naqada III," *Archéo-Nil* 20 (2010): 134–49.

45. See, notably, Marc Van De Mieroop, *The Eastern Mediterranean in the Age of Ramesses II* (Oxford and Malden, MA: Blackwell, 2007).

FIGURE 16. The Two Dog Palette, possibly Naqada IIIA. Siltstone, h. 43 cm. Grinding side (left); lion and griffin side (right). From the Main Deposit at Hierakonpolis. Oxford, Ashmolean Museum (AN.1896–1908 E.3924).

As already indicated, the ruling groups of early states, whether in Egypt, East Asia, or Mesopotamia, divided their populations into elite and others and deprived nonelites of symbolic resources, the unequal distribution of which had been less extreme in Neolithic societies. Norman Yoffee and David Wengrow term this deprivation the "evolution of simplicity."[46] Its effects and implications can be seen in most large-scale complex societies. A twofold division is inevitably a simplification of the configuration of any society, but it is also a powerful metaphor that the elite legitimize, in their own eyes at least, by taking responsibility for maintaining the cosmos and associated high culture.

Wang Haicheng presents valuable insights into these matters, informed by a comparative perspective, as they can be studied in Erligang material culture (see Wang, ch. 3 in this volume). He comments on the implications of the wide distribution of utilitarian ceramics in the period. Whereas bronzes and other items of central elite culture are uniform in character wherever Erligang remains are found, this is not true of ordinary ceramics, which vary significantly over the region of likely political control. The tight definition of elite forms and styles of decoration, both in artifacts and in mortuary forms, brings out the enormous significance of practices surrounding burial and communication with the ancestors. It implies either a positive interest in spreading the highest culture across the entire Erligang dominion or an absolute requirement of the elite that they be accompanied by these forms. This interest or requirement holds irrespective of whether the key artifacts were made at the center or—more plausibly—the techniques of foundries and other elite modes were disseminated to a number of places.

In Egypt, Naqada III material culture is most clearly defined in terms of its ceramic repertory (e.g., fig. 1), which is plainer, cruder, and at a larger scale than that of Naqada II and no longer includes fine wares. Ceramics, however, carried almost no prestige and constitute no more than a lowest common denominator. The elite products, which absorbed vast investments of resources and creativity, are much more variable, and it is difficult to date those that do not bear inscriptions, have no good archaeological context, or do not belong in a clear sequence. The relative variability of Erligang everyday ceramics, in contrast with the uniformity of elite artifacts, might therefore seem to present a pattern opposite to that found in Egypt. The difference at the level of ceramics could, however, be illusory: it may be that significant regional differences in everyday forms existed in Naqada III but have not yet been identified in excavation and analysis. A striking characteristic of the crudest Egyptian vessels, which are bread molds and beer jars, is that they survived for many centuries with relatively little change in form, are as widespread at mid-third-millennium BCE Old Kingdom sites as at those of Naqada III, and were also used in elite contexts (the examples in fig. 1 are from a ruler's tomb).[47] The contrast between this constancy in everyday forms and marked change in elite material forms—most evident in tomb structures and decoration—is symptomatic of the high level of investment in the latter.

These differences between the two cases under consideration do not obscure the importance of the wider contrast between elite and nonelite inventories of material culture. The most important members of the elite were those who occupied the otherworldly sphere. In Erligang, these are assumed—but only by analogy with better-documented later periods—to have been mainly the deceased ancestors; in Egypt, they probably included the gods as well.[48] Denizens of the other world could not actively influence styles and manners.

In self-aware fashion, human elites exploited the contrast between their material culture and that of lower social orders through a variety of aesthetic strategies. Deliberate play between the two is most clearly visible in forms of the Early Dynastic period and early Old Kingdom. A 1st or 2nd dynasty siltstone bowl of elaborate

46. Norman Yoffee, "The Evolution of Simplicity: Review of James C. Scott, *See-ing Like a State*," *Current Anthropology* 42 (2001): 767–69; David Wengrow, "The Evolution of Simplicity: Aesthetic Labour and Social Change in the Neolithic Near East," *World Archaeology* 33, no. 2 (2001): 168–88; Wengrow, *The Archaeology of Early Egypt*, 150–74.

47. For Old Kingdom examples from a provincial site, see George Andrew Reisner, *A Provincial Cemetery of the Pyramid Age, Naga-ed-Dêr*, University of California Publications in Egyptian Archaeology 6 (Oxford: University Press, John Johnson, 1932), plates 36–37; on Giza, south of the pyramids, see Anna Wodzińska, "Main Street Ceramics," in *Giza Reports: The Giza Plateau Mapping Project*, vol. 1, *Project History, Survey, Ceramics, and Main Street and Gallery III.4 Operations*, ed. Mark E. Lehner and Wilma Wetterstrom (Boston: Ancient Egypt Research Associates, 2007), 143–52.

48. Bussmann, *Die Provinztempel Ägyptens*, 506–13, emphasizes how decentralized and small in scale temple cults appear to have been in early Egypt. Evidence from iconography and personal names shows that deities were a very important presence, so that religious forms operated on more than one level.

FIGURE 17. Siltstone vessel in the shape of an open basket dish, inscribed with the hieroglyph for "gold" on the left rim, 2nd dynasty. H. 4.8 cm, l. 22.7 cm. From an elite tomb at North Saqqara. Cairo, Egyptian Museum (JE 71298).

manufacture imitates the form of one made of reeds while being inscribed with the hieroglyph for "gold" (fig. 17), perhaps implying that it would ideally be made of gold or, alternatively, that it was intended as a symbolically humble receptacle for gold jewelry.[49] A copper vessel from the tomb of the 1st dynasty king Den that is inscribed with his name is impressed with a pattern evoking basketry.[50] A comparable example belonging to a queen from the time of the Great Pyramid (ca. 2500 BCE) is a gold water pitcher that imitates the form of a ceramic vessel rather than the copper form already widespread for centuries.[51] Usages like these display a developed aesthetic irony in addition to a sense that significant practices, such as customs of washing before eating and drinking, crossed the demarcations of higher and lower social orders and that the elite could take some cues from those beneath them. Examples highlighted by Wang Haicheng, in which styles of decoration developed for bronzes were applied to ceramics and wood, seem to run in the opposite direction. Perhaps Erligang elites isolated themselves more thoroughly from those beneath them, especially in their burials of the dead and cult of ancestors.

CONCLUSION

As Wang Haicheng argues and I mention above, reconstructing the perspective or ideology of an Erligang king is one of the goals to which research on the period of those kings should aspire. The double transformation that can be observed, in the shift of power from Erlitou to Erligang and in the definition of symbolic and institutional forms that endured for more than a millennium, has a parallel in Egypt in the political unification of the land and the introduction of forms that were comparably significant and lasting for Egyptian culture. It is, however, very difficult to offer solidly based arguments for motivations that stimulated the ruling groups in ancient societies to introduce the particular changes they chose. Modern interpretations often amount to little more than imagining "if I were in this position and were driven by the priorities that seem natural to me, I would do such-and-such." We are limited by the gaps in our understanding and imaginations, and we need to find ways to enlarge and to focus our realms of discourse and frames of reference.

The example Wang Haicheng offers, of exceptionally large bronzes deposited in the landscape near a major confluence of rivers two hundred kilometers west of the presumed Erligang capital, suggests something specific about landscape and

49. Walter B. Emery, *Archaic Egypt* (Harmondsworth: Penguin, 1961), plate 39b; Jaromir Malek, *Egypt: 4000 Years of Art* (London: Phaidon, 2003), 38.

50. Helen Whitehouse, "King Den in Oxford," *Oxford Journal of Archaeology* 6 (1987): 257–67.

51. For discussion and references, see John Baines, "Modelling the Integration of Elite and Other Social Groups in Old Kingdom Egypt," in *Élites et pouvoir en Égypte ancienne*, ed. Juan Carlos Moreno García, *Cahiers de Recherches de l'Institut de Papyrologie et d'Égyptologie de Lille* 28 (2009–10) (Lille: Université Charles-de-Gaulle, 2010), 118, 126, 141–44.

territory, which are crucial elements for developing a more situated understanding of what drove the ancient actors. The example may be less informative about imperial extension, because Erligang culture expanded so much farther from its heartland in other directions. The act of making the deposit, which was surely accompanied by visible ceremonies, had important symbolic implications, not least because bronzes were costly ritual instruments. Moreover, such deposition, of which we may never have more than the spotty knowledge supplied by chance finds and metal detectors, has parallels in other regions of China and was probably not a rare practice.

The controlled dissemination of material culture and related practices in colonies as far away as the Yangzi shows a different facet of Erligang expansion, one that existed in complex interaction with local cultures. Perhaps large bronzes were deposited in the landscape there as well and happen not to have been recovered. If so, two ways of asserting rule would have been complementary.

Nothing closely resembling this Erligang evidence has been recovered from the early Egyptian expansions southward into Lower Nubia and northeast into Palestine. In Lower Nubia, the Gebel Sheikh Suleiman rock relief (fig. 12), which was carved at the southern limit of the area, in a location that was perhaps also the frontier of the polity whose rulers were buried at Qustul, emblematically represents the king destroying his enemies and does not imply homage to a place but quite likely awareness of its strategic significance. As in many societies, the dismissal of foreigners was probably more ideological than realistic—though ideology all too often influences what is done, so that people act out their prejudices at the expense of despised groups. Nor is the strategy of eliminating local societies without parallels in many periods and places. The relationship between Naqada III Egypt and places to the south in particular appears bleaker than interactions known from the third and second millennia BCE.[52]

In ideological terms, a significant factor both for Erligang and for early Egypt is that the definition of a larger political realm requires that there be a preexisting conception of the ideal extent of the actors' world. Here the two cases are different. Despite difficulties of communication posed by mountain ranges and arid regions, connections over large distances were well established in East Asia before Erligang times. The Erligang expansion took place within this wider realm. Arguments for seeing it as "imperial" rather than as simply incorporating additional territory within the state are essentially archaeological. Imperial ambitions presumably required a sense that, although this larger world was diverse, some elements were common across all of it. More than a millennium later, the same regions and more were brought under a single rule, in a more encompassing unification. In Egypt, cultural and political unification in late Naqada II and Naqada IIIA–B must have been driven by a comparable sense of a common world, but one that was later seen as internal to the state and in any case very much smaller than that of East Asia. The resulting definition of that world hardly changed in later times. This consistency almost certainly related to Egypt's unique geographical position as a corridor through deserts and next to the sea, without large contiguous polities before the first millennium BCE. But that position also made the country into a perpetual place of transition and magnet for immigrants: the geography should not be seen as simply isolating. Egypt, however, lacked the progressive expansion of China.

In this chapter, I have confined myself to only a few aspects of expansion and empire in two rather disparate early states. Other aspects could also be profitably explored through comparison. We owe a great debt to Wang Haicheng for raising the issue of "empires" in relation to Erligang. He has presented a rich and open-ended analysis of a case that had not hitherto been considered in that light, one that can stimulate thought about how far other expansions of early states might be viewed through the lens of "empire."

52. Baines, "Early Definitions of the Egyptian World"; Baines, "Travel in Third and Second Millennium Egypt," 13–15.

I am very grateful indeed to Kyle Steinke for inviting me to attend the wonderfully stimulating Erligang conference as a discussant. Much of what I say about Erligang depends on knowledge acquired at the conference. Discussion and references can be found in other contributions to this book and are not given here. I should also like to thank Robert Bagley, David Wengrow, and Wang Haicheng himself for references and very valuable comments on drafts, as well as, again, Kyle Steinke for judicious improvement of the final version.

Erligang
A Tale of Two "Civilizations"

Roderick Campbell

AS OTHER AUTHORS in this volume note, Zhengzhou in the Erligang period was a remarkable place.[1] To the list of advances in bronze casting and perhaps writing (see Bagley, ch. 1 in this volume), we could add Zhengzhou's unprecedented size, its massive walls, the scale of its bronze production, its rammed-earth architecture, and its position at the center of an expansive distribution of Erligang material culture, including a group of smaller walled sites within this distribution showing similar orientation and architecture. To these things in turn could be added Zhengzhou's sacrificial remains, burials, and bone and ceramic workshops, which, though less dramatic, are nonetheless suggestive of potentially important activities. Site size, production specialization and scale, the extent of material culture distribution, the scale of labor organization, and mortuary and residential hierarchy have all been used in past comparative archaeological discussions of social complexity, state formation, or the rise of civilizations, as has the inferred relationship between the complexity of Erligang bronze workshop organization and the general level of Erligang sociopolitical complexity.[2] Accordingly, much ink has been spilled over the interpretation and utility of these potential markers of social complexity, at what point a state or, more expansively, a civilization is indicated, and, more recently, whether or not social-evolutionary typological exercises are really productive after all.[3] Archaeological theory of the past ten years, exhausted through pursuit of such slippery prey as the "chiefdom" and the "state," has shifted from questions of "what" to questions of "how"—or, in other words, not so much "What was it?" but "How did it work?" In step with this trend, "civilization," a term with a questionable past, has received a conceptual makeover.[4]

In addition to, or instead of (depending on the theorist), the older meaning of an advanced level of sociopolitical evolution marked by the "urban revolution" and the first states, "civilization" is now most commonly used in archaeological theory to mean a kind of cultural ecumene in which the earliest polities were embedded.[5] John Baines and Norman Yoffee's "Order, Legitimacy, and Wealth in Ancient Egypt and Mesopotamia" is perhaps the watershed statement for this second meaning of "civilization," linking it to a cultural order and sets of central symbols through which the rule of a coterie of inner elites was legitimated.[6] To understand "civilization" in the second sense then, we need to investigate the social and political meaning of those foci of social energy, those central symbols, and (I would add) practices, that order the world. As I have argued elsewhere, these nexuses of resources, knowledge, and concern are never the sole purview of elites but rather keys to local fields of power and meaning peopled by nonelites as well.[7]

In what follows, I will attempt to pursue Erligang civilization in both archaeological senses of the word. Since, however, the ancient city at Zhengzhou lies below contemporary Zhengzhou, many aspects of Erligang civilization can be

1. My estimates for the chronology of the Bronze Age sites discussed in this chapter differ slightly from those used by the other authors of this volume. They are as follows: Erlitou period (ca. 1800–ca. 1600 BCE), Erligang period (ca. 1600–ca. 1400 BCE), transition period (ca. 1400–ca. 1250 BCE), and Anyang period (ca. 1250–ca. 1050 BCE).

2. On the relationship between Erligang bronze industries and sociopolitical complexity, see Robert Bagley, "Shang Archaeology," in *The Cambridge History of Ancient China: From the Origins of Civilization to 221 B.C.*, ed. Michael Loewe and Edward L. Shaughnessy (Cambridge: Cambridge University Press, 1999), 124–231. For archaeological discussions of social complexity, state formation, and the rise of civilizations, see V. Gordon Childe, "The Urban Revolution," *Town Planning Review* 21, no. 1 (1950): 3–17; Morton Fried, "On the Evolution of Social Stratification and the State," in *Culture in History*, ed. Stanley Diamond (New York: Columbia University Press, 1960), 713–31; Elman Service, *The Origin of the State and Civilization: The Process of Cultural Evolution* (New York: Norton, 1975); Henri Claessen, "Internal Dynamics of the Early State," *Current Anthropology* 25, no. 4 (1985): 365–79; Timothy Earle, "Evolution of Chiefdoms," *Current Anthropology* 30, no. 1 (1989): 84–88; K. V. Flannery, "The Ground Plans of Archaic States," in *Archaic States*, ed. Gary M. Feinman and Joyce Marcus (Santa Fe, NM: School of American Research Press, 1998), 15–57; Bruce G. Trigger, *Understanding Early Civilizations: A Comparative Study* (Cambridge: Cambridge University Press, 2003).

3. For indicators of civilization, see Childe, "Urban Revolution," 3–17; Flannery, "Ground Plans of Archaic States," 15–57; Henry T. Wright, "Toward an Explanation of the Origin of the State," in *Origins of the State: The Anthropology of Political Evolution*, ed. Ronald Cohen and Elman R. Service (Philadelphia: Institute for the Study of Human Issues, 1978), 49–68. Regarding the viability of social-evolutionary typological exercises, see Feinman and Marcus, *Archaic States*; Trigger, *Understanding Early Civilizations*; Norman Yoffee, *Myths of the Archaic State: Evolution of the Earliest Cities, States, and Civilizations* (Cambridge: Cambridge University Press, 2005); Rod Campbell, "Toward a Networks and Boundaries Approach to Early Complex Polities: The Late Shang Case" *Current Anthropology* 50, no. 6 (December 2009): 821–48.

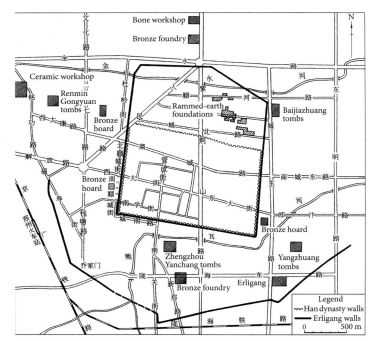

FIGURE 1. Plans of Zhengzhou and Rome, to the same scale. (a) Erligang-period Zhengzhou. (b) Aurelian wall and city, Rome, 3rd century CE.

studied only indirectly: extrapolated from unsystematic and fragmentary discoveries, interpolated from contemporaneous Erligang sites such as Yanshi or Panlongcheng, or analogized from earlier and later practices within the same general traditions.[8] My goal here, then, will be to attempt to weave together disparate strands of evidence, placing the two notions of Erligang civilization within their regional and diachronic contexts.

In pursuing the first, materialist and traditional use of "civilization," we will be interested in finding evidence of hierarchy, concentrations of resources and populations, and increased specialization and scale of social, economic, and political organization.

ERLIGANG CIVILIZATION IN THE FIRST SENSE: EVIDENCE OF SCALE AND COMPLEXITY

At 1,300 hectares, the size of Zhengzhou was truly remarkable. It was more than four times larger than Erlitou, the largest site in north China that predates Zhengzhou, and, like Erlitou, it dwarfed all contemporaneous sites yet found in East Asia. Indeed, Zhengzhou was probably the largest site of its time anywhere in the world—that is to say, it was larger than Babylon's 890 hectares and more than twice as large as New Kingdom Thebes.[9] Indeed, Zhengzhou would not be surpassed in East Asia until the Great Settlement Shang (*Da yi Shang* 大邑商) at Anyang or matched outside East Asia until imperial Rome (fig. 1).

But what exactly does site size mean? It might be seen as a crude proxy for population, but population density is difficult to estimate at the best of times, and with little work done on residential areas and no real idea of the uniformity of occupation during Erligang's various phases, we have very little on which to base a population estimate. In fact, with the current near-exclusive archaeological focus on large-scale architecture and tombs, we are actually a long way from understanding the nature of early Chinese urbanism and urban site structure. Nevertheless, the pattern of a single megasite centering an expansive distribution of material culture had a precedent at Erlitou and a descendant at Anyang, giving a monocentric appearance to the cultural, economic, and political landscape of the Central Plain Bronze Age, a point to which I will return.[10]

4. Thomas Carl Patterson, *Inventing Western Civilization* (New York: Monthly Review Press, 1997).

5. Feinman and Marcus, *Archaic States*; Yoffee, *Myths of the Archaic State*.

6. John Baines and Norman Yoffee, "Order, Legitimacy, and Wealth in Ancient Egypt and Mesopotamia," in Feinman and Marcus, *Archaic States*, 199–260. See also Patterson, *Inventing Western Civilization*.

7. Rod Campbell, *Blood, Flesh and Bones: Kinship and Violence in the Social Economy of the Late Shang* (PhD diss., Harvard University, 2007), 85–264; Campbell, "Toward a Networks and Boundaries Approach," 821–48.

8. For an introduction to the Yanshi site in English, see Robert L. Thorp, *China in the Early Bronze Age: Shang Civilization*, Encounters with Asia (Philadelphia: University of Pennsylvania Press, 2006), 62–76.

9. For the size of Babylon, see Marc Van De Mieroop, *The Ancient Mesopotamian City* (Oxford: Oxford University Press, 1997). For Thebes, see Yoffee, *Myths of the Archaic State*, 66.

10. Cf. *Zhongguo kaoguxue: Xia Shang juan*, ed. Zhongguo shehui kexueyuan kaogu yanjiusuo (Beijing: Zhongguo shehui kexue chubanshe, 2003).

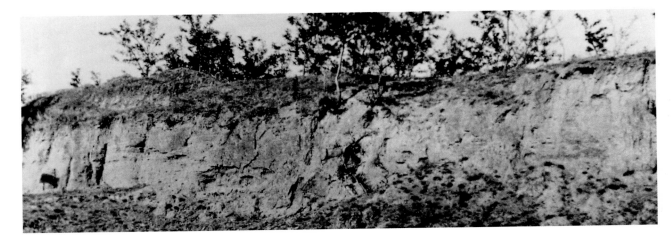

There are other indirect measures and hints of Zhengzhou's vast scale. One of the most obvious are the inner and outer walls that surrounded the site (fig. 2). At a combined thirteen kilometers in length, these massive rammed-earth constructions could have taken as much as 110 million person-hours to construct.[11] The construction of this and other large-scale architectural projects within the site, such as the many rammed-earth foundations inside the inner wall, would have required the mobilization and direction of large labor forces. How this was accomplished, however, is not understood and, as is well known from Neolithic Britain and Pre-Ceramic and Initial Period South America, even very large labor projects may serve cooperative and relatively egalitarian ends.[12] Indeed, according to Moseley, the Initial Period ceremonial complex of La Florida (ca. 1750–ca. 1650 BCE) is estimated to have required 67 million man-hours (assuming a ten-hour day), yet this site seems to have served a wide region as a ceremonial complex and is not necessarily indicative of a centralized polity.[13]

The large-scale rammed-earth foundations discovered at Zhengzhou might also be indicative of social hierarchy or even kings and, indeed, these areas are termed "palaces" in the Chinese literature. In part this is due to their size, form, and general location within a circumscribed "palace-temple" area presaging later imperial architectural traditions. Nevertheless, although the basic form may have existed since Erlitou, the uses to which these structures were put might have been radically different from those of later times.[14] Were they public architecture or restricted kingly residences and ancestral temples? Huge courtyard structures within walled enclosures suggest both restricted access and large audiences, but what was the social context of that access or the political ethos of those gatherings?[15]

The sacrificial remains that have been found at Zhengzhou and Yanshi are also potentially telling of intercommunity conflict and/or intracommunity hierarchies (fig. 3). Among the scattered sacrificial remains of dogs and humans found at Zhengzhou, perhaps the most impressive deposit is the ditch discovered near rammed-earth structures in the northeast "palace-area" within the inner wall, which contains the tops of some one hundred human skulls.[16] Although this was initially reported as a skull-cup workshop, the lack of tools or other production debris suggests that this site was more likely related to sacrifice. Sacrificial remains at Yanshi in the "palace-temple" zone are even better preserved, and here we can see both the variety and the organization of sacrificial practices.[17] Impressive though the remains at Zhengzhou and Yanshi are, however, without a religious and political context, they are very difficult to interpret. Were the human sacrifices willing participants as in some Inka ritual?[18] Was the ritual for the good of the community, or the benefit of elites, or both? If human and animal lives can be seen as resources, to what end and with what cultural logic were these resources expended?

11. The inner walls are approximately 7,000 meters in length, with a central core 10 meters wide and a surviving height of up to 9 meters. Protecting the core, there was a wide inner slope of approximately 7 meters and a narrower outer one of approximately 4 meters (ibid., 220–21). Assuming an average width of 15 meters to account for the slopes, there was 9m height × 15m width × 7,000m length = 945,000m³ of rammed earth. The outer wall has a foundation 1–2 meters deep and is roughly 6,000 meters in length. See Yuan Guangkuo and Zeng Xiaomin, "Lun Zhengzhou Shang cheng neicheng he waiguocheng de guanxi," *Kaogu* 2004.3: 59–67. The average thickness of the core is 16–25 meters. Little of the original height remains. See *Zhengzhou Shang cheng: 1953–1985 nian kaogu fajue baogao*, ed. Henan sheng wenwu kaogu yanjiusuo (Beijing: Wenwu chubanshe, 2001), 1:298–301. The presence of slopes for the outer wall is unattested but can be inferred from contemporaneous rammed-earth walls. If the outer wall had proportions similar to those of the inner wall, then it would have been 40 meters wide at the base and 18 meters high. Adding 1–2 meters for the foundation would yield roughly 20m height × 40m width × 6,000m length = 3,600,000m³ of rammed earth. Adding the volumes of both walls together yields approximately 4.5 million cubic meters of rammed earth. Modern building estimates for rammed-earth construction without power tools are 1.5 ft³/person-hour or 0.042m³/person-hour. This yields an estimated construction time of about 110 million person-hours.

12. For Neolithic Britain, see Colin Renfrew, *British Prehistory: A New Outline* (London: Duckworth, 1974).

13. See Michael E. Moseley, *The Incas and Their Ancestors: The Archaeology of Peru* (New York: Thames & Hudson, 2001), 139.

14. See Robert L. Thorp, "Erlitou and the Search for the Xia," *Early China* 16 (1991): 1–38.

15. Cf. Anne Porter, "Beyond Dimorphism: Ideologies and Materialities of Kinship as Time-Space Distanciation," in *Nomads, Tribes and the State in the Ancient Near East: Cross Disciplinary Perspectives*, ed. Jeffery Szuchman, Oriental Institute Seminars 5 (Chicago: University of Chicago Press, 2009), 201–26.

16. See *Zhengzhou Shang cheng*, 480–82.

17. Zhongguo shehui kexueyuan kaogu yanjiusuo, "Henan Yanshi Shang cheng Shangdai zaoqi wangshi jisi yizhi," *Kaogu* 2002.7: 6–8.

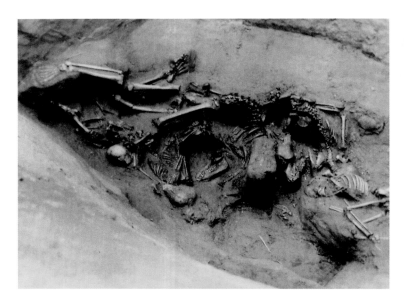
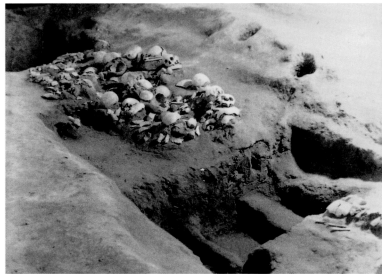

18. Cf. Terence N. D'Altroy, *The Incas* (Malden, MA: Blackwell, 2002).

19. Bagley, "Shang Archaeology," 142–46.

20. For examples of the conflation of the two, see Arthur A. Saxe, *Social Dimensions of Mortuary Practices* (PhD diss., University of Michigan, 1970); Lewis Binford, "Mortuary Practices: Their Study and Their Potential," in *Approaches to the Social Dimensions of Mortuary Practices*, ed. James A. Brown, Memoirs of the Society for American Archaeology 25 (Washington, DC: Society for American Archaeology, 1971), 6–29; Joseph Tainter, "Woodland Social Change in West-Central Illinois," *Mid-Continental Journal of Archaeology* 2, no. 1 (1977): 67–98; James A. Brown, "The Search for Rank in Prehistoric Burials," in *The Archaeology of Death*, ed. Robert Chapman, Ian Kinnes, and Klavs Randsborg (Cambridge: Cambridge University Press, 1981), 25–39; John M. O'Shea, "Social Configurations and the Archaeological Study of Mortuary Practices: A Case Study," in Chapman, Kinnes, and Randsborg, *Archaeology of Death*, 39–52; John M. O'Shea, *Mortuary Variability: An Archaeological Investigation* (Orlando, FL: Academic Press, 1984). For critiques, see Peter J. Ucko, "Ethnography and Archaeological Interpretation of Funerary Remains," *World Archaeology* 1, no. 2 (1969): 262–90; Ian Morris, *Death-Ritual and Social Structure in Classical Antiquity* (Cambridge: Cambridge University Press, 1992); Michael Parker Pearson, *The Archaeology of Death and Burial* (College Station: Texas A&M University Press, 1999).

21. Morris, *Death-Ritual and Social Structure*, 27.

22. See *Zhongguo kaoguxue: Xia Shang juan*, 170–248.

23. Ibid., 187.

Workshops at Zhengzhou, from bronze to ceramics, show specialization, and, with bronze, at least, complex workshop organization can be inferred.[19] From a political perspective, however, we need to know more about the relationship between production and social and political institutions. Who were the craftsmen? What was their status? What were the contexts of their production or the circulation of the products of their labor? How do bronze vessels fit into the Erligang social economy of power? This last question is one to which I will return.

Erligang tombs reveal the terminus of the circulation of at least some bronze vessels. Although no tombs to compare with the royal tombs at Anyang or even Panlongcheng have been found at Zhengzhou to date, grave goods and tomb sizes display an inegalitarian distribution.

In 1970s and 1980s Anglo-American archaeological literature on burials, mortuary hierarchy was generally conflated with social hierarchy, but critiques of this kind of approach have pointed to the variable and complex ways in which mortuary ritual may relate to social orders.[20] To paraphrase Ian Morris, "burials tell us more about death ritual than social structure."[21] In other words, with burials, any inferences about hierarchy and organization among the living must be refracted through the lens of ancient belief and practice concerning death. Without more context, then, mortuary inequalities in Erligang burials do not of themselves tell us anything certain about Erligang social hierarchy or, more usefully, the actual mechanics of power.

Another suggestive marker of Zhengzhou's scale and complexity is the wide distribution of Erligang ceramics and walled sites sharing orientation and architectural traditions, such as Yanshi, Yuanqu Gucheng Nanguan, Xiaxian Dongxiafeng, Jiaozuo Fucheng, and Panlongcheng (map 1).[22] Moreover, all of these sites were constructed during or just before Lower Erligang phase I, with the exception of Panlongcheng, which was constructed during Lower Erligang phase II. In other words, the major walled sites of the Erligang tradition (including Zhengzhou) were all built within a few generations of one another.[23] If this is so, then we can perhaps see them as a single expansive and monumental building program stretched out over about one hundred years. This was, moreover, a network for which Erligang appears to serve as a center of gravity. How centralized did the organization of this building program have to be? Can we see in this the early expansion of a great "state" (as most Chinese scholars believe), or is this more a phenomenon of peer-polity interaction within a common cultural ecumene, with the building at Zhengzhou sparking building programs elsewhere? Even if we do allow for a central political mandate, however, we would still be no closer

FIGURE 3. Sacrificial remains at Zhengzhou. (a) Pit containing human, dog, and pig skeletons. (b) Deposit of human skulls from a ditch in the palace area, view from north to south.

MAP 1. Erligang walled centers. Inset plans of Zhengzhou, Yanshi, and Panlongcheng, to the same scale.

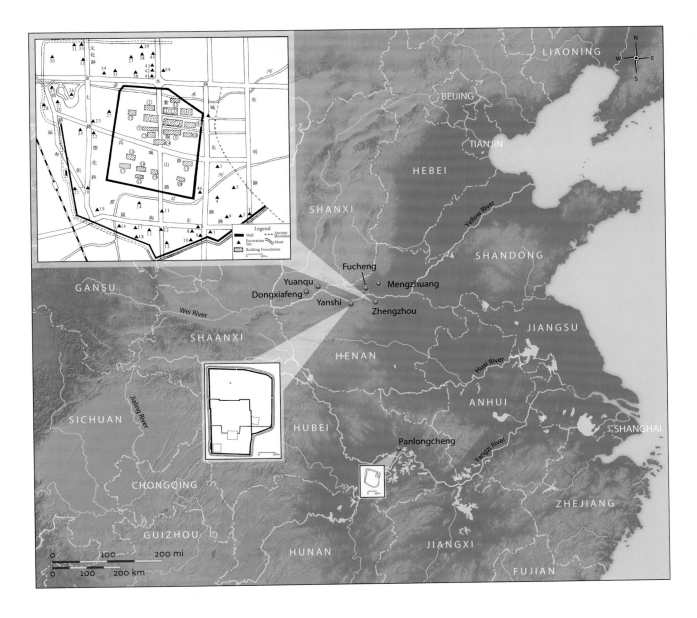

to understanding the actual mechanics of power or organization of relationships between these centers and the Zhengzhou metropole. Nor can traditional narrative or theoretical models fill in the blanks: without an understanding of the institutions and networks of social power, words like "state," "kingdom," and "empire" are empty boxes.[24]

The interpretation of material cultural distribution is even more indeterminate. Given that we know little about the production, distribution, and consumption of ceramics, which are the primary criteria for defining archaeological cultures in Chinese archaeology, the spread of a metropolitan Erligang type and seven or eight regional variants provides evidence of intensifying interactions over an increasingly large area but tells us nothing of the nature of those interactions. Without information concerning the production, distribution, and consumption of ceramics, the social and political significance of ceramic distribution is unclear. Were ceramics produced locally or in production centers, or both? How far and by what means did they travel? Who used what kinds of ceramics and why? Research into ceramic production, sourcing, and diverse local social uses would go a long way toward making ceramic tradition distributions more meaningful. For now, we can only speculate.

The chance finds of bronze vessels over a wide area also provide evidence of interaction. However, bronze vessels travel well and are durable, and since they can be gifted, taken as booty, or stolen, we cannot be certain that their presence

24. Campbell, "Toward a Networks and Boundaries Approach," 821–48.

implies the presence of the metropolitans who originally had them cast. As with ceramics, we lack information on production (despite some progress there), distribution, and, especially, consumption. Without depositional context for these "unearthed" bronzes, we cannot know if they participated in local variants of metropolitan ritual or, like the bronze *zun* and *lei* from Sanxingdui or the bronze ritual vessels from Xingan, were used in very different rituals.[25]

Taken together, Zhengzhou and Erligang culture in general have many remarkable features suggesting impressive scale and expansive networks of labor and resources. However, taking a vantage point among the wreckage of neo-evolutionary theory's holistic packages of traits and universal stages of sociopolitical evolution without contextualizing information about social organization or political structures, analogies from other areas of the world can only be suggestive. Indeed, without the second meaning of civilization, that is, the symbols, practices, and social economy of power that provide a logic and an order to human action in the world, the sociopolitical implications of walls, tombs, and bronze vessels remain unclear.

THE OTHER MEANING OF CIVILIZATION

Several of the other contributors to this volume have chosen to focus on Erligang bronze vessels. Indeed, it has been claimed that they are "indexical" in the first sense of the term "civilization," but what was the significance of bronzes at Zhengzhou in the second sense of "civilization"?[26] In other words, to what end was the enormous concentration of social energy involved in bronze casting directed? What was a bronze vessel to a person living in mid-second-millennium BCE Zhengzhou? What were the practices in which bronze vessels participated? As focal points of so much knowledge, innovation, labor, and resources, bronze vessels were certainly key nodes in the topography of Erligang collectives, but how did they relate to the circulation of power and the creation of a civilizational order?[27] If cast bronzes in second-millennium BCE East Asia are indexical of civilization in the first (and, frankly, theoretically indeterminate) sense of a certain level of social complexity, then perhaps we should also ask about their role in the second sense of "civilization" as a collection of practices and artifacts supporting a cultural order that, in turn, relates to political forms. What then can we say about Erligang civilization in the second sense?

Looking at Erligang's assemblage of material culture in diachronic perspective, it is possible to argue that Erlitou, Erligang, and Anyang appear as different stages in a common metropolitan tradition. As mentioned earlier, the pattern of a single megacenter and an expansive distribution of metropolitan culture with multiple regional variants is a feature of the Central Plain Bronze Age from Erlitou to Anyang. Seen diachronically, the impressive Erligang expansion was in fact a continuation of an earlier Erlitou expansion. This spread of metropolitan material culture did not reach its zenith until after Zhengzhou's decline in what Robert Bagley has termed the "transition period" and many Chinese archaeologists are now calling the Middle Shang period.[28] As noted above, the political implications of this half millennium of metropolitan material cultural spread or, indeed, its ebb during the Anyang period are ambiguous, and it appears not to correspond entirely with the fortunes of the metropole, suggesting, perhaps, a segmental or decentralized mechanism of dispersal.[29] The usual interpretation of the spread of Erligang material culture in terms of colonization or direct military intervention is predicated on an assumption of the relative impotence of local polities in the face of a putative Zhengzhou superpower.[30] In fact, we know next to nothing about the distribution of military power or the nature of the political landscape within this interaction zone except that Zhengzhou presumably had a large population

25. Cf. Bagley, "Shang Archaeology," 171–75, 212–19.

26. Ibid., 136–39.

27. Cf. Bruno Latour, *We Have Never Been Modern* (Cambridge, MA: Harvard University Press, 1993).

28. For the term "transition period," see Bagley, "Shang Archaeology," 150. For "Middle Shang period," see Yang Xizhang and Tang Jigen, "Yubei Jinan diqu de zhong Shang yicun yu Pangeng yi xian de Shang du qianxi," in *Sandai wenming yanjiu 1* (Beijing: Kexue chubanshe, 1999), 248–56; *Zhongguo kaoguxue: Xia Shang juan*, 249–83.

29. Campbell, *Blood, Flesh and Bones*, 359–77.

30. Bagley, "Shang Archaeology," 165–71; Li Liu and Xingcan Chen, *State Formation in Early China* (London: Gerald Duckworth, 2003), 127–30.

on which to draw. This, however, was not enough to save the much larger Anyang megacenter and its polity from falling to the archaeologically unimpressive Zhou alliance.

REGIONAL PERSPECTIVE

The image of the Central Plain metropolitan centers as the torchbearers of East Asian civilization surrounded by a passive periphery of benighted peoples, moreover, is in part due to both the relative underdevelopment of archaeological work outside the Central Plain for this period and a Central Plain–centric and traditional-history-derived interpretive framework for the work that has been carried out. While there is no space here for a critical survey of the archaeology of the Central Plain periphery in the second millennium BCE, there are a number of aspects of that partially understood story that bear highlighting. The first is that the Central Plain Bronze Age megacenters did not innovate everything. Bronze came to the Central Plain from the west, and by Erligang times, the Erligang variant areas (which in turn were not necessarily part of a unified polity) were ringed by metal-using and not necessarily militarily inferior neighbors, such as the peoples who produced the Jinzhong, Zhukaigou, and Datuotou traditions to the north, the Siwa and Xindian traditions to the west, the great center of Sanxingdui in Sichuan, the Yueshi tradition in the east, and the Hushu- and Maqiao-tradition areas to the southeast (map 2). By the Anyang period, chariots and horses had been introduced from the steppe, probably, at least initially, built and driven by northern charioteers, inaugurating a new dawn in warfare in northern China. Nor were interactions with the northern and western peripheries limited to weapons and warfare: cattle, sheep, goats, and wheat were all introduced from the northwest during the third millennium BCE and took on increasing importance during the second millennium BCE. Wheat cultivation dramatically increased in the Erligang period and with it the possibility of agricultural intensification through multi-cropping and security through crop diversification.[31] Cattle, sheep, and goats likewise enlarged the potential catchment area and diversified the environments used for provisioning the metropolitan centers with meat, even as cattle and sheep increasingly replaced pigs in ritual importance.[32] Culturally, the demarcation line between the Erligang regional variants and their neighbors, such as the Yueshi, Jinzhong, Jingnansi, Wucheng, or Hushu traditions, is gradual rather than sharp and suggests a variety of long-term local as well as long-distance interactions.[33]

The southern periphery was also neither passive nor backward. Though controversy still surrounds the issue of whether or not the stoneware found at Central Plain Bronze Age sites could have been locally made, the vessel forms and decoration all suggest Yangzi River valley origins. Though unfortunately still relatively poorly understood archaeologically and almost entirely dated through comparisons with Central Plain Bronze Age ceramics and bronzes, the middle and lower Yangzi areas were the homes of the precocious Shijiahe and Liangzhu cultures in the third millennium BCE and the powerhouse polities of Chu, Wu, and Yue in the first millennium BCE. Should we be surprised, then, if, in terms of pyro-technological sophistication and perhaps other things, the south surpassed the north? Although the Erligang site of Panlongcheng is generally seen as a north-ern colonial foray into the wilds of the south in search of ores, there is scattered evidence that the movement of things and people was neither unidirectional nor likely predicated on the kind of power differentials that typify the nineteenth-century European colonialism that frequently serves as the implicit model for ancient colonialization. Thus, in addition to ores, the south likely supplied the north with finished products such as stoneware and, perhaps, lacquer and other things that have not survived, even as metallurgy, casting technology, and their

31. Gyoung-ah Lee, G. W. Crawford, Li Liu, and Xingcan Chen, "Plants and People from the Early Neolithic to Shang Periods in North China," *Proceedings of the National Academy of Sciences* 104, no. 3 (2007): 1087–92; Yuan Jing and Rod Campbell, "The Origins of Chinese Civilization: Recent Archaeometric Advances and Remaining Issues," *Antiquity* 83 (2009): 96–109.

32. Yuan Jing and Rowan Flad, "New Zooarchaeological Evidence for Changes in Shang Dynasty Animal Sacrifice," *Journal of Anthropological Archaeology* 24, no. 3 (2005): 252–70.

33. On the demarcation line between Erligang variants, see *Zhongguo kaoguxue: Xia Shang juan*, 188–203. For local and long-distance interaction, see Campbell, *Blood, Flesh and Bones*, 334–51.

MAP 2. Erligang tradition in regional perspective.

Central Plains metropolitan tradition

⬤ Erligang variant
◼ Dongxiafeng variant
▲ Beicun variant
▼ Taixi variant
◆ Liulige variant
⬤ Daxinzhuang variant
⬤ Dachengdun variant
⬤ Panlongcheng variant
★ Variant uncertain

Yueshi tradition

⬤ Anqiugudui variant
◼ Yinjiacheng variant
▲ Haojiazhuang variant
▼ Wanbei variant
◆ Zhaogezhuang variant

Sanxingdui tradition

⬤ Metropolitan variant
◼ Chaotianzui variant

⬤ Hushu tradition
⬤ Maqiao tradition
⬤ Wannian tradition
⬤ Wucheng tradition
⬤ Baota tradition
⬤ Jingnansi tradition

○ Siwa tradition
⬤ Xindian tradition
⬤ Zhukaigou tradition
⬤ Jinzhong tradition
⬤ Datuotou tradition
⬤ Lower Xiajiadian tradition

products were introduced from the north. It has been suggested, based on ceramic typology, that, in addition to the colonists responsible for building a Central Plain Bronze Age center at Panlongcheng, southerners formed part of the early, multi-ethnic population at Zhengzhou; preliminary isotopic work on the elite occupant of Huayuanzhuang Tomb 54 at Anyang suggests he was a southerner.[34]

Rather than see the Central Plain Bronze Age horizon in terms of a homogeneous, militaristic expansion into an empty or impotent periphery, it would be better to see Zhengzhou and other Central Plain Bronze Age centers as nodes in far-reaching and constantly changing networks of warfare, alliance, ritual, trade, tribute, marriage, and other things, involving a variety of actors of different ethnicity.[35] The peripheries of the Central Plain Bronze Age were peopled by groups with technologies not significantly different from those possessed by the Central Plain polities, and they interacted with them in a number of ways across mutable boundaries of identity even as new configurations of power and community were

34. For Zhengzhou, see *Zhongguo kaoguxue: Xia Shang juan*, 164–69. For Huayuanzhuang Tomb 54, Jing Zhichun, personal communication, June 2010. The ongoing isotopic research performed on human teeth at Anyang (including strontium and oxygen isotopes) has the potential to at least distinguish between people born locally and nonlocally and, perhaps, eventually, to pinpoint their general place of origin.

35. Campbell, "Toward a Networks and Boundaries Approach," 821–48.

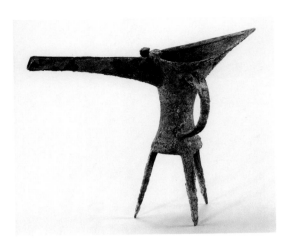
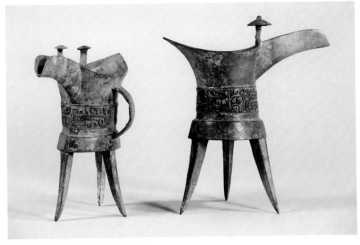

FIGURE 4. Development of *jue* wine vessel assemblages from Central Plain elite tombs. (a) *Jue* from Tomb 11, Zone VI, Erlitou, unearthed in 1984. H. 20.7 cm. No other bronze vessels were found in the tomb. (b) Two of three *jue* from Lijiazui Tomb 1, Panlongcheng, unearthed in 1974. H. (left) 17 cm, (right) 20.1 cm. (c) Drawing of the forty *jue* from Fu Hao's tomb, Anyang.

forged in the births and deaths of metropolitan centers. If urban centers create new identities in their crucibles of population and proximity, then beneath the story of Central Plain Bronze Age continuity and development, we must also recognize cycles of ethnogenesis and hybridity accompanying the creation and dissolution of supraregional as well as local centers.[36]

In the Anyang period, and despite some attempts to envision north China as belonging to a unified Shang empire, the oracle-bone inscriptions give an impression of incessant warfare among a myriad of political actors. Although colonization and forced movement of populations seem to have been part of the Anyang king's repertoire, the oracle bones give the lie to the impression of an expansive, centralized, and unified Shang polity.[37] Despite being more than twice the size of Zhengzhou and forming the center of an unprecedentedly large and homogeneous distribution of metropolitan-type material culture (as opposed to variants), the Anyang-period political landscape was fragmented, coercive resources were widely distributed, and the king's power, beyond a smaller, more centralized zone, was mostly indirect.[38] While the historical circumstances of the Anyang and Erligang periods may have been quite different, there is no reason to assume that, structurally speaking, Zhengzhou was any more centralized or institutionally advanced than Anyang. Indeed, if bronze casting is indexical of complicated networks of resource acquisition and sophisticated labor organization, then it should be noted that Anyang bronze production occurred on an order of magnitude greater than that at Zhengzhou.[39]

Beyond site sizes and material cultural distributions and their rather opaque relationship to political geography over time, there is the diachronic story of the suite of practices and artifacts that were the foci of Erligang energy and ingenuity. In terms of this "elite" material culture, the evidence of a common Central Plain Bronze Age tradition is even more striking. As Bagley notes, the bronze casting tradition that is so greatly expanded on and developed at Erligang appears to begin at Erlitou.[40] Indeed, as many have argued, bronze vessels begin to replace fine ceramics in Erlitou tombs. Anne Underhill, moreover, points out that drinking vessels and drinking vessel sets had long been part of mortuary ritual in eastern China and places both Erligang and Anyang bronze vessel sets within this tradition (fig. 4).[41]

Although to my knowledge no work has yet been done to identify feasting deposits zooarchaeologically at Zhengzhou, nor has residue analysis been successfully carried out on bronze vessels, it is nevertheless surely significant that the bronze artifacts that are so prominently a focus of Erligang innovation and resources appear to be vessels for the preparation, serving, and consumption of food and drink. Indeed, by Anyang and Western Zhou (ca. 1050–771 BCE) times,

36. Yoffee, *Myths of the Archaic State.*

37. For discussions of the Shang state at Anyang as a unified empire, see Li Xueqin, ed., *Zhongguo gudai wenming yu guojia xingcheng yanjiu* (Kunming: Yunnan renmin chubanshe, 1997); Li Xueshan, *Shangdai fenfeng zhidu yanjiu* (Beijing: Zhongguo shehuikexue chubanshe, 2004). For oracle-bone inscriptions on warfare, see Lin Yun, "Jiaguwen zhong de Shangdai fangguo lianmeng," in *Lin Yun xueshu wenji* (Beijing: Zhongguo dabaike quanshu chubanshe, 1998), 69–84; David N. Keightley, *The Ancestral Landscape: Time, Space, and Community in Late Shang China,* China Research Monograph 53 (Berkeley: Institute of East Asian Studies, University of California, Berkeley, 2000); Campbell, *Blood, Flesh and Bones.* For the Anyang king's military tactics, see Qiu Xigui, "Shuo Yinxu buci de 'dian'—shilun Shangren chuzhi fushuzhe de yizhong fangfa," *Bulletin of the Institute of History and Philology, Academia Sinica* 64, no. 3 (1993): 659–86.

38. By "metropolitan-type material culture," I am referring to the division of "Late Shang culture" into several variants, the "metropolitan" or "Yinxu type" being centered at Anyang. As mentioned earlier, the typology exercise of dividing assemblages into "cultures" and "regional variants" is based mostly, though not entirely, on ceramics (see David Cohen, *The Yueshi Culture, the Dong Yi and the Archaeology of Ethnicity in Early Bronze Age China* [PhD diss., Harvard University, 2001], for a useful critique). In addition to ceramics, the metropolitan Anyang variant shows relative homogeneity in burial practices and residential construction. Also see *Zhongguo kaoguxue: Xia Shang juan,* 325–51. For the political situation in Anyang, see Lin "Jiaguwen zhong de Shangdai fangguo lianmeng," 69–74; Keightley, *The Ancestral Landscape*; Campbell, *Blood, Flesh and Bones.*

39. Whether quantified in terms of excavated bronzes, production debris such as mold fragments, or bronze vessels in museum collections, Anyang bronze production dwarfs that of Zhengzhou.

40. Bagley, "Shang Archaeology," 141–46.

41. Anne Underhill, "Warfare and the Development of States in China," in *The Archaeology of Warfare: Prehistories of Raiding and Conquest,* ed. Elizabeth Arkush and Mark Allen (Malden, MA: Blackwell, 2006), 253–85.

there is no doubt that descendants of these vessels were used in ancestral sacrifice and feasting.

If ceramic drinking and feasting vessel sets have a long tradition, especially in what is now eastern China, weapons are an even older and more widespread form of material and symbolic capital. Nevertheless, the tradition of carving jade blades that continues through Anyang also has an origin, or at least early expression, at Erlitou (figs. 5–7). Indeed, if we consider bronze weapons as well, weapons or symbols of war and punishment become the second major class of elite material culture, behind feasting vessels. This pattern, evident in Erligang tombs and radically expanded at Anyang, is already visible at Erlitou and, indeed, can be seen as an inheritance of the late Neolithic worked out in new materials and increasingly elaborate forms.[42]

Erligang burial traditions in general have much in common with those of Erlitou and appear to be the direct ancestors of those at Anyang. The marked and hierarchical expenditure of resources on tombs both dramatically increases over time and is indicative of the social importance of death ritual in the Central Plain Bronze Age. In the Anyang period, the vast and widespread expenditures on burial can be related to a suite of practices revolving around ancestor veneration, and by extension lineage position, in a political landscape that can be seen as a hierarchically organized but contentious network of lineage polities. Recent work at the Anyang site as well as coring nearby at Huanbei, a recently discovered transition-period walled center, have suggested the existence of spatially discrete clusters of residences containing both large and small structures, which, along with the discrete but internally hierarchical burial grounds associated or intermixed with them, lend support to the widely held belief that descent groups formed the structural basis of the Shang social and political order.[43]

The image of the Anyang king as lineage leader of the world derived from oracle-bone inscriptions and the ancestral dedications seen on bronze vessels all support an interpretation of an intimate linkage between political power and ancestors.[44] Seen in another light, the ancestors, created through a complex of mortuary and sacrificial techniques aimed at domesticating the dangerous dead, also appear as the primary intermediaries between the living and the unseen and uncertain forces of the universe.[45] In the Anyang scheme of things, the focal repositories of social energy seem directed toward the production of order, or, in Anthony Giddens's terms, the reduction of ontological insecurity—simultaneously social, political, and cosmological.[46]

War and its relationship to authority manifested in jade and bronze symbolic weapons are also part of the Anyang social economy of power and legitimation. Warfare was figured in terms of punishment and authority in terms of violence, as is suggested both in the terms for "military campaign" (zheng 征 and zhi 𢓊), cognate with "correct" and "straight" respectively, and the graph for "king" (wang 王), which likely derives from a yue tipped on its blade (fig. 8).[47] Indeed, the remarkable expenditure of human lives occasioned by royal ancestral sacrifice was predicated on a practice of war that aimed at both reducing rank-and-file enemies to sacrificial livestock and commemorating victories over their leaders.[48]

If, as Robert Bagley has argued, many of the features of Anyang civilization were developed first at Erligang or even earlier, then we are perhaps justified in suspecting that a similar focus of social energy on bronze vessels, jades, tombs, rammed-earth architecture, and sacrifice at Erligang might have been predicated on a similar complex of political and cosmological ordering techniques. Nevertheless, there are differences as well as similarities between Erligang and Anyang. For one thing, the division of space into discrete clusters of residences and burials seen at Anyang is so far unattested within Erligang and Erlitou sites, and, frankly,

42. See Campbell, *Blood, Flesh and Bones*; Campbell, "Toward a Networks and Boundaries Approach," 821–48; Rod Campbell [Jiang Yude], "Guo zhi da shi: Shang-dai wanqi zhong de lizhi gailiang," in *Yinxu yu Shang wenhua: Yinxu kexue fajue 80 zhounian jinian wenji*, ed. Zhongguo shehui kexueyuan kaogu yanjiusuo (Beijing: Kexue chubanshe, 2011), 267–76. For the late Neolithic situation, see Underhill, "Warfare and the Development of States," 253–85.

43. For recent work at Anyang, see *Zhongguo kaoguxue: Xia Shang juan*, 284–369; Tang Jigen, *The Social Organization of Late Shang China: A Mortuary Perspective* (PhD diss., University of London, 2004). For coring at Huanbei, see Zhongguo shehui kexueyuan kaogu yanjiusuo and Anyang gongzuodui, "Survey and Test Excavation of the Huanbei Shang City in Anyang," trans. Jing Zhichun, *Chinese Archaeology* 4 (2004): 1–20. For the role that descent groups played in the Shang, see Zhu Feng-hang, *Shang Zhou jiazu xingtai yanjiu* (Tianjin: Tianjin guji chubanshe, 1991); Tang, *Social Organization of Late Shang China*.

44. David N. Keightley, "Shamanism, Death, and the Ancestors: Religious Mediation in Neolithic and Shang China," *Asiatische Studien* 52, no. 3 (1998): 763–832.

45. For domesticating the dead, see Michael Puett, *To Become a God: Cosmology, Sacrifice and Self-Divinization in Early China* (Cambridge, MA: Harvard University Asia Center, 2002).

46. Anthony Giddens, *A Contemporary Critique of Historical Materialism: Power, Property and the State*, vol. 1 (London: Macmillan Press, 1981). See also Campbell, *Blood, Flesh and Bones*.

47. Lin Yun, "Shuo wang," in *Lin Yun xueshu wenji*, 1–3.

48. Campbell, *Blood, Flesh and Bones*; Rod Campbell, "On Humanity and Inhumanity in Early China," in *Violence and Civilization: Studies of Social Violence in History and Prehistory*, ed. Rod Campbell, Joukowsky Institute Publication Series (Oxford: Oxbow Books, forthcoming).

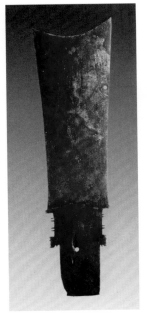

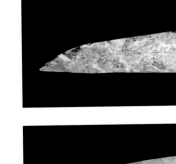
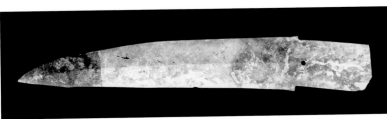
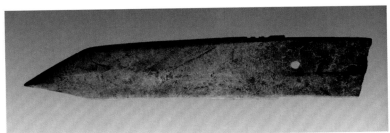
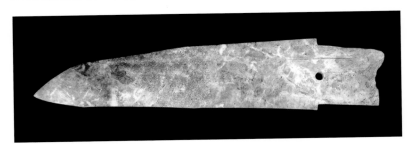

FIGURE 5. Jade weapons from Erlitou elite tombs. (a) Arc-ended blade (no. 4 in fig. 10a). L. 54 cm. From Zone V, Tomb 3, unearthed in 1980. (b) Disk-ax. H. 21 cm. From Zone V, Tomb 6, unearthed in 1981. (c) *Ge* blade. L. 43 cm. From Zone VI, Tomb 57, unearthed in 1987.

FIGURE 6. Jade *ge* blades. L. (a) 70 cm, (b) 61.6 cm, (c) 45.6 cm. From an Erligang elite tomb, Lijiazui Tomb 2, Panlongcheng, unearthed in 1974.

FIGURE 7. Jade weapons from Anyang elite tombs. (a) Disk-ax. H. 22.3 cm. From Huayuanzhuang Tomb 54, unearthed in 2000. (b) *Ge* mounted in a bronze handle with turquoise inlay. L. (total) 27.8 cm. From the tomb of Fu Hao, unearthed in 1976. (c) *Ge*. L. 31 cm. From Xiaotun Tomb 11, unearthed in 1976.

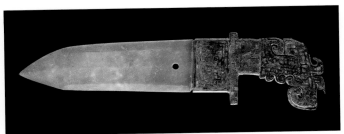
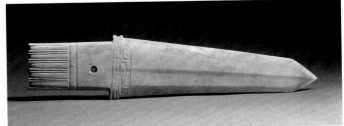

FIGURE 8. *Yue* (no. 15 in fig. 10b). H. 41.4 cm, w. 26.7 cm. From Lijiazui Tomb 2, Panlongcheng, unearthed in 1974.

untested, given the focus of archaeology at those sites on walls, tombs, and large-scale architecture.[49]

In other areas of comparison, however, there is a clearer sense of the development of the ancestral ritual complex over time, with a dramatic intensification and elaboration at Anyang. This can be seen in oracle bones, as Rowan Flad has recently argued, in sacrifice, in bronze vessel production, and in mortuary ritual in general.[50]

Yuan Jing and Flad argued for a development toward the use of larger, more expensive animals (such as cattle) in sacrifice over the course of the Central Plain Bronze Age.[51] To this trend I would add the development of human sacrifice and further note that although the well-preserved "palace-temple" sacrificial area at Yanshi shows both an elaboration of sacrificial types (although pigs are still the most common victims) and an organization of activities, nothing hitherto discovered prepares us for the scale and elaboration of sacrifice at Anyang; the royal burial ground at Xibeigang contained an estimated fifteen thousand victims (fig. 9).[52]

49. Cf. Li Liu and Hong Xu, "Rethinking Erlitou: Legend, History and Chinese Archaeology," *Antiquity* 81, no. 314 (2007): 886–901.

50. Rowan Flad, "Divination and Power: A Multi-regional View of the Development of Oracle Bone Divination in Early China," *Current Anthropology* 49, no. 3 (2008): 403–38. See also Campbell, *Blood, Flesh and Bones*.

51. Yuan and Flad, "New Zooarchaeological Evidence," 252–70.

52. For Yanshi, see Zhongguo shehui kexueyuan kaogu yanjiusuo, "Henan Yanshi Shang cheng," 6–8. For Xibeigang, see Tang Jigen, "The True Face of Antiquity: Anyang Yinxu Sacrificial Pits and the Dark Side of 'Three Dynasties Civilization'" (unpublished manuscript, 2005); Huang Zhanyue, *Gudai rensheng renxun tonglun* (Beijing: Wenwu chubanshe, 2004).

FIGURE 9. Sacrificial pits at Xibeigang, Anyang. (a) Overview of pits during excavation. (b) Pit containing thirty-three human skulls. (c) Sacrificial victims from Grave 5. (d) Beheaded skeletons from the south ramp of Xibeigang Tomb 1001.

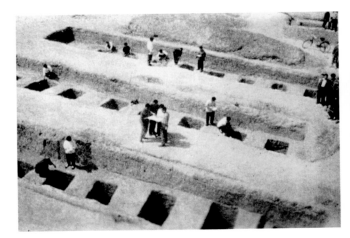
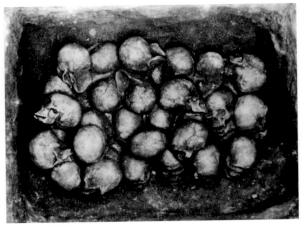
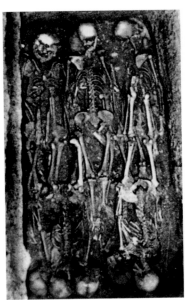
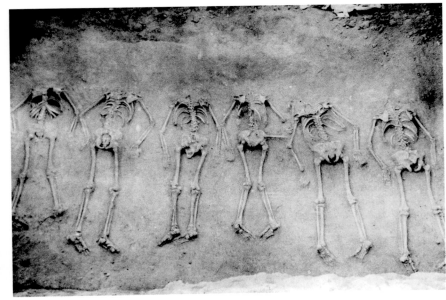

Tombs likewise show dramatic elaboration over time. Even if we exclude the royal burial ground at Anyang, there is a clear progression in the relative distinction between the largest and smallest tombs as well as an absolute increase in average tomb size (fig. 10). A similar trend toward elaboration can be seen in burial goods and tomb furnishings.[53] While this elaboration can in part be viewed in terms of a continuous process involving the historical emulation of elite burial practices by nonelites and subsequent attempts by elites to seek new and greater forms of distinction, there is also an increase in the scale of differentiation. Mortuary hierarchy becomes increasingly ramified and extreme.[54]

THE ZHENGZHOU SOCIAL ECONOMY OF POWER

The question, then, is how to interpret these developments. Did Zhengzhou sources of political power differ from those at Anyang? If the ancestral-ritual complex embodies a more or less symbolic economy of political status, perhaps the early Erligang building regime embodied a more coercive network of power—a new political apparatus in which ancestral claims and statuses were not as crucial? Or should we say, since the ancestral-ritual complex that was so central to the Anyang social economy of power and hierarchy seems also central to Erligang civilization but is nonetheless less developed there, that Erligang society was less hierarchical or centralized? In fact, these possibilities are not mutually exclusive, nor, unfortunately, is the question resolvable on current evidence. What we can take away from this exercise, however, is the realization that the central symbols

53. Campbell, *Blood, Flesh and Bones*.

54. Aubrey Cannon, "The Historical Dimension in Mortuary Expressions of Status and Sentiment," *Current Anthropology* 30 (1989): 437–58.

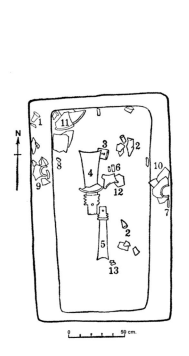

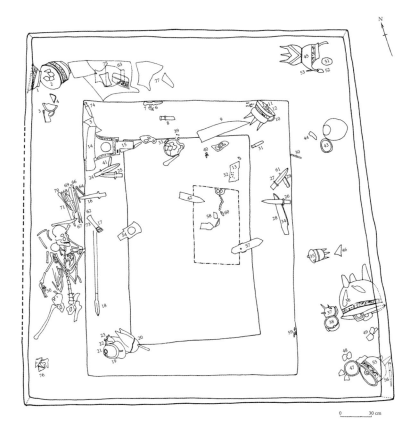

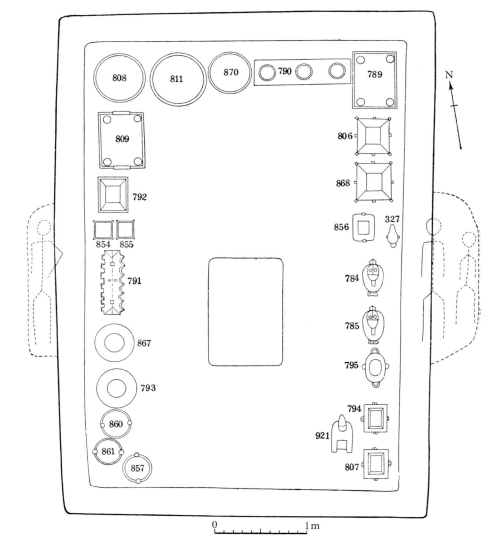

FIGURE 10. Plans of Central Plain elite burials, to the same scale. (a) One of the richest burials from Erlitou, Zone V, Tomb 3. At mouth, 2.15 by 1.3 m. (b) Richest Erligang tomb found to date, Lijiazui Tomb 2, Panlongcheng. At mouth, 3.67 by 3.24 m. (c) Richest Anyang burial found to date outside of the Xibeigang cemetery, tomb of Fu Hao, Xiaotun. At mouth, 5.6 by 4 m.

of the Erligang world order and their social economies of production were similar to those found at Erlitou and Anyang whatever their exact articulation with power. To me, at least, this suggests a similarity in social and political organization, an organization predicated on a more or less hierarchical ordering of internally hierarchical communities of descent. Indeed, if I can draw an analogy from the Anyang period, the era of greatest territorial extent was that of King Wu Ding (late 13th century BCE), a heterarchical period of alliances, networks of exchange, and ad hoc divination and sacrifice. By the time of the last Anyang king, Di Xin, perhaps a century and a half later, the territory of the polity had shrunk and Anyang itself had more than doubled in size. There are several lines of evidence, from funerary ritual to military endeavors, to suggest an unprecedented centralization and routinization of power by Di Xin's time.[55] If this analogy holds and Erligang, with its larger distribution of material culture but smaller center, more closely resembles Wu Ding's Anyang than Di Xin's Anyang, then Erligang is more likely to have had a more heterarchical, decentralized political apparatus and extensive networks of alliances than the more centralized, routinized, and standardized institutions and practices of the last kings at Anyang.

What I hope I have accomplished here is not to give a definitive answer to the question of the what or the how of Erligang civilization but rather to show that the available evidence, gathered by archaeologists under the assumption that they were dealing with a far simpler set of questions, is insufficient to really say much for certain about Erligang civilization in either of the senses I have been using. I have also sought, through problematizing the linked issues of Erligang's political apparatus, social structure, and cultural order, to suggest some productive areas of future research.

55. David N. Keightley, "The Late Shang State: When, Where, and What?" in *The Origins of Chinese Civilization*, ed. David N. Keightley (Berkeley: University of California Press, 1983), 523–64; Rod Campbell [Jiang Yude], "Guo zhi da shi: Shangdai wanqi zhong de lizhi gailiang," in *Yinxu yu Shang wenhua: Yinxu kexue fajue 80 zhounian jinian wenji*, ed. Zhongguo shehui kexueyuan kaogu yanjiusuo (Beijing: Kexue chubanshe, 2011), 267–76.

CHAPTER 6

The Politics of Maps, Pottery, and Archaeology
Hidden Assumptions in Chinese Bronze Age Archaeology

Yung-ti Li

IN HIS CHAPTER on Shang archaeology in *The Cambridge History of Ancient China*, Robert Bagley criticizes the extensive use of traditional historiography in Chinese Bronze Age archaeology: "Transmitted texts present us . . . with an ancient China in which the only civilized powers were Zhou and Shang, and with an ancient history in which the principal event was the transfer of rule from one to the other. . . . This is a distinctly schematic account of the past . . . that left us quite unprepared for archaeology's discovery of a wider civilized world."[1] Bagley argues that transmitted texts and oracle-bone inscriptions provide a recounting of the past solely through the eyes of Zhou and Shang. Such perspectives deliberately chose to emphasize the supremacy and legitimacy of the polities in the Central Plain while downplaying the significance of other contemporary polities and, indeed, civilizations.

Bagley's critique was published more than ten years ago, around the time when Western scholars of ancient China were also casting doubt on the government-initiated Xia-Shang-Zhou chronology project, which was aimed at establishing an official chronology of Bronze Age China with unprecedented funding from the central government.[2] The task was deemed by many scholars, Chinese as well as Western, to be impractical and unfeasible, but many chose to work with the government anyway for the sake of long-needed research funds. Bagley's criticism, amid the criticism of the Xia-Shang-Zhou chronology project, was perceived as only another attack by Western scholars on Chinese scholarship. The many valid and essential arguments made in Bagley's chapter were often rejected not on scholarly grounds but for ideological reasons, and they remain largely unanswered by Chinese archaeologists to this day. In recent publications in Chinese Bronze Age archaeology, we see not reassessments but reemphases on interpretive models based on traditional historiography. My essay is therefore intended to continue the efforts of Bagley, and of other Western-based scholars, to disentangle traditional history from Chinese Bronze Age archaeology. In particular, I would like to examine the prevalent historiographic model that sees Anyang as the supreme leader with solid territorial and political control over Bronze Age China, a model that focuses all interregional interactions into the pattern of a dynastic ruler and his loyal subordinates.

XIA AND SHANG VERSUS ERLITOU AND ANYANG: THE DYNASTIC MODEL AND ITS USE IN BRONZE AGE ARCHAEOLOGY

Western scholars have long questioned the extensive use of traditional historiography in Chinese Bronze Age archaeology. Lothar von Falkenhausen's 1993 article in *Antiquity*,[3] Bagley's chapter on Shang archaeology in *The Cambridge History of*

1. Robert Bagley, "Shang Archaeology," in *The Cambridge History of Ancient China: From the Origins of Civilization to 221 B.C.*, ed. Michael Loewe and Edward L. Shaughnessy (Cambridge: Cambridge University Press, 1999), 124–231.

2. For an English-language overview of the project, see Yun-kuen Lee, "Building the Chronology of Early Chinese History," *Asian Perspectives* 41, no. 1 (2002): 15–42.

3. Lothar von Falkenhausen, "On the Historiographical Orientation of Chinese Archaeology," *Antiquity* 67, no. 257 (1993): 839–49.

Ancient China, and critiques of the Xia-Shang-Zhou chronology project are well known and widely discussed both in the Western academic community and in China. While these critiques have generated heated discussions, perhaps more in private than in published forums, these efforts to disentangle Chinese Bronze Age archaeology from traditional texts have not had any significant impact on the field of archaeology in China. With some exceptions, notably the articles by Tang Jigen[4] and the recent papers by Xu Hong and Liu Li in both Chinese and English,[5] there has not been any substantial dialogue or discourse between the two sides.

The fact that Xu Hong and Liu Li are able to publish in Chinese an article that tries to disassociate Erlitou from Xia is a groundbreaking event in the field, and I await with high anticipation the discourse it should provoke. However, in the current Chinese literature, archaeological finds of the early Bronze Age are still invariably equated and labeled with the names of political entities found in traditional historiography: Erlitou is synonymous with Xia, and Erligang and Anyang are the embodiment of Shang. Terms such as "Xia dynasty" and "Shang dynasty" are freely used in the discussion of archaeological finds without any consideration of the social, political, and economic implications introduced by the concept of political dynasties. Rather than being empirically tested, social, political, and economic characteristics of the Xia and Shang "dynasties" are simply presumed, and the presumptions are based on terms and concepts derived from much later political entities. With the increasing exchange between Chinese and English-speaking academic communities through translations and scholars working bilingually, we are also beginning to see similar usage seeping into English-language publications. It is difficult for Western scholars to resist or even to be consciously aware of assumptions that are built into the Chinese archaeological literature on which they necessarily rely as the starting point for their own research.

The most common response from many Chinese archaeologists to criticism of the explicit use of historiography in Chinese archaeology is "We do not follow historical texts; the historians do." Chinese archaeologists therefore see a fundamental difference between how they and their colleagues in history treat historiography. What I would like to point out, however, is that even in cases in which traditional texts are not explicitly used as guidelines for archaeology, the implicit use of concepts and models inherited from traditional history can also lead to confusion and stagnation in the field. Even though archaeologists claim that they follow the data, not the texts, the ghost of traditional history is everywhere. The archaeologists who make this claim are simply unaware of the interpretive framework within which they view their data.

The dynastic model is ubiquitous in the Chinese archaeological literature. Too often we see in the organization of monographs on Xia or Shang archaeology an inner structure that resembles and reifies the political structure of the center (the capital region) and the periphery. Archaeological data are arranged and discussed according to a presumed political structure: the center where the political regime had its seat, normally the Central Plain region, is discussed first and in greater detail, while regions distant from the supposed center are treated as appendages and covered in subsequent chapters, usually in a more concise and generalized manner. Such a structure is present in the 1961 volume of *Xin Zhongguo de kaogu shouhuo* (*Archaeology in New China*)[6] and in the 1984 expanded edition *Xin Zhongguo de kaogu faxian he yanjiu* (*Archaeological Excavation and Researches in New China*).[7] A similar scheme is also found in the later chapters of Kwang-chih Chang's *Archaeology of Ancient China*.[8] In the new, comprehensive volume *Zhongguo kaoguxue: Xia Shang juan* (*Chinese Archaeology: Xia and Shang*),[9] published in 2003, the scheme is adopted unaltered. The assumed political structure is made even more explicit when terms such as Xia and Shang "regime" (*dai* 代) and Xia and Shang "dynasty" (*wangchao* 王朝) appear in chapter titles.

4. Tang Jigen, "Kaoguxue, zhengshi qingxiang, minzu zhuyi," *Dushu* 2002.1: 42–51.

5. Li Liu and Hong Xu, "Rethinking Erlitou: Legend, History and Chinese Archaeology," *Antiquity* 81, no. 314 (2007): 886–901; Xu Hong and Liu Li, "Guanyu Erlitou yizhi de xingsi," *Wenwu* 2008.1: 43–52.

6. *Xin Zhongguo de kaogu shouhuo*, ed. Zhongguo shehui kexueyuan kaogu yanjiusuo (Beijing: Wenwu chubanshe, 1961).

7. *Xin Zhongguo de kaogu faxian he yanjiu*, ed. Zhongguo shehui kexueyuan kaogu yanjiusuo (Beijing: Wenwu chubanshe, 1984).

8. Kwang-chih Chang, *The Archaeology of Ancient China*, 4th ed. (New Haven, CT: Yale University Press, 1986).

9. *Zhongguo kaoguxue: Xia Shang juan*, ed. Zhongguo shehui kexueyuan kaogu yanjiusuo (Beijing: Zhongguo shehui kexue chubanshe, 2003).

The dynastic model is also present in efforts to delineate, conceptually or physically, boundaries of archaeological cultures. We often see attempts to specify the extent of Shang political control, in other words, the territory of the Shang dynasty, either by textual description or by drawing boundaries directly on the map. In one of the first comprehensive reviews of archaeological data of the Anyang period, for example, Song Xinchao attempts to draw the cultural and political boundaries of the late Shang dynasty based on distribution of archaeological remains, mainly pottery.

Such reconstructions of "Shang territory" are strikingly similar to territorial maps for the later imperial dynasties, despite the fact that Shang political structure and territorial control were vastly different from those of Ming and Qing. They call to mind the long cartographic tradition of drawing territorial maps of past dynasties in China, the most recent project being *Zhongguo lishi ditu ji* (*The Historical Atlas of China*),[10] a monumental project begun in the mid-twentieth century. These territorial maps promote an artificial sense of unity, and they assert a kind and extent of territorial control that perhaps never existed in early Bronze Age China. Maps are clear and self-explanatory and are useful devices for conveying information—archaeologists and historians use them all the time—but they are by no means objective representations of the physical world.[11] They are interpretations—culturally and politically loaded artifacts.[12] Even a global map or a plain geographic map can be political, depending on the interpretation and the vantage point the viewers choose.[13]

Zhongguo lishi ditu ji commenced under state sponsorship in 1954, shortly after the establishment of the People's Republic of China, led by the eminent historian Tan Qixiang (1911–1992). The project was modeled on a Qing dynasty project conducted by Yang Shoujing (1839–1915); it mapped place-names and territories of the dynasties recorded in traditional historiography, starting with the Xia. Tremendous effort and much fine scholarship were invested in the project, but it certainly also had a political dimension. It was not unlike the writing of official historiography. The present claims and legitimates its place in history through its portrayal of the past.

Yet boundary maps are not easy to draw. Imagine trying to locate every place-name mentioned in historical texts on a map of China and then using the scatter of points to guess the borders of a political entity the size of the Han, Tang, or Qing dynasty. The task is daunting. It is not just a matter of connecting dots; we must first find enough information to place the dots. In the preface to *Zhongguo lishi ditu ji*, Tan Qixiang explains that a dynasty's boundaries were always in flux; when the project's scholars draw a territorial map, they are arbitrarily choosing one moment in time to represent an entire dynasty, and some dynasties lasted for hundreds of years. Interestingly, the maps for Xia, Shang, and Zhou, with the exception of the Eastern Zhou statelets, show only the location of place-names. The project did not attempt to draw borders for the Three Dynasties. There is not enough textual evidence. The first map in *Zhongguo lishi ditu ji* that shows a clear-cut border is in fact that of the Qin empire.

Distribution Map of Pottery Typology

Pottery analysis in Chinese archaeology is an art form. Chinese archaeologists devote enormous efforts to the analysis of potsherds and, most of all, to complete vessels. Anyone who has visited an archaeology field station in China has had the stunning experience of seeing shelves and shelves of complete and reconstructed vessels filling the rooms of the station (fig. 1). By focusing on whole vessels, Chinese archaeologists are able to establish very fine-tuned pottery typologies and relative chronology. The whole-vessel approach offers so many variables for analysis

10. *Zhongguo lishi ditu ji*, 8 vols. (Shanghai: Zhonghua ditu xueshe, 1975).

11. See Mark Monmonier, *Mapping It Out: Expository Cartography for the Humanities and Social Sciences* (Chicago: University of Chicago Press, 1993); Monmonier, *How to Lie with Maps* (Chicago: University of Chicago Press, 1996); Monmonier, *No Dig, No Fly, No Go: How Maps Restrict and Control* (Chicago: University of Chicago Press, 2010).

12. For instance, the Kuomintang government under Chiang Kai-shek never officially recognized the Mongolian People's Republic, whose independent status was maintained during the 1945 Sino-Soviet treaty at Yalta. After Chiang's retreat to Taiwan, the map of China published in Taiwan always included Outer Mongolia, whereas in the People's Republic of China, the territorial map of China includes only Inner Mongolia.

13. One of the most well-known examples is McArthur's Universal Corrective Map of the World, which shows an upside-down global map with the Australian continent positioned prominently at the center. The historic maps of Taiwan compiled in a 2005 calendar printed by the Ministry of Education of the pro-independence Democratic Progression Party government are another example. These maps place Taiwan in a horizontal position, with China lying underneath Taiwan. While their printing was politically motivated and controversial at the time, the maps in fact reflect European cartographic practices in the eighteenth and nineteenth centuries.

FIGURE 1. Pottery storage area in the Jiangxi Provincial Museum. Only the dark sections of the two vessels in the foreground are original pottery; the remaining sections are reconstructions in white plaster.

that in the view of some critics, Chinese archaeologists are tempted to spend too much time on typology, pushing it further than it can usually go.

Pottery typology is the *etic*, or outsider's, attempt, based in most cases not on the *emic* knowledge of the user or the maker but on intuition, to order material remains into classificatory systems that are designed to solve or explain specific problems.[14] In the case of Chinese archaeology, pottery typology is designed for the purpose of establishing the temporal and spatial, or historical and cultural, patterning of archaeological sites. In other words, archaeologists attempt to determine the temporal position and the cultural (archaeological) affiliation of a particular site by comparing its pottery with the pottery of other sites. The whole-vessel approach and the minute study of pottery morphology are well suited for such purposes.

However, pottery typology is given such emphasis in Chinese archaeology that it is often used independently of other considerations, such as function, technological choices, subsistence patterns, settlement patterns, inter-site relations, and regional settlement hierarchy. The situation is not too different from what Hayden describes in his review of the history of the use of typology in Western archaeology. It is typology for the sake of typology:

> [A]t some point in the elaboration of the world cultural-historical framework, it seems that archaeologists largely forgot why typologies were created. Instead of typologies being taught as tools for solving specific problems, they often became deified classifications. That is, they took on an existence of their own and were passed on from one generation of archaeologists to another in an unquestioning format. . . .[15]

Hayden points out that when archaeologists working on the American Southwest began to ask new and different questions in the 1950s—new questions concerning "artifact use, trade, socio-political organizations, evolution, and others"—they "rediscovered" the original purpose of typologies: establishing cultural-historical frameworks.[16] Typologies formulated to deal with such problems turned out not to be very useful for answering other types of inquiries. I must say, and I say this with empathy, not as criticism, that Chinese archaeology has yet to reach such a realization.

When political boundaries are drawn using pottery typology, without the use of other information such as settlement patterns, we are in fact making several

14. Definition adapted from Brian Hayden, "Are Emic Types Relevant to Archaeology?" *Ethnohistory* 31, no. 2 (1984): 79–92, and Carla Sinopoli, *Approaches to Archaeological Ceramics* (New York: Plenum Press, 1991).

15. Hayden, "Are Emic Types Relevant to Archaeology?" 81.

16. Ibid., 82.

inferential leaps, from a typology constructed by archaeologists and based mainly on pottery morphology, to the distribution mechanism of pottery, to the nature of the shared socio-cultural-political context of pottery use, to the ethnicity of the actual users, and then to the sociopolitical structure of past societies. This is all done without the support of empirical data or even any attempt to suggest causal relations. We have to ask ourselves whether the analysis of pottery morphology can really be expected to answer all these questions. The questions have wide-ranging implications that have yet to be fully investigated.

In what follows, I would like to take Anyang as a case study in the application of the dynastic model. I will try to explain why such models can mislead and to show that they have indeed misled research on Bronze Age archaeology in China.

ANYANG AS A HISTORICAL CONSTRUCT

Anyang archaeology began with a historical question. When Dong Zuobin (Tung Tso-pin; 1895–1963) and Li Ji (Li Chi; 1896–1979) first excavated at Anyang, their goal was to find what traditional historiography recorded as the last Shang capi-tal. Anyang archaeology, and therefore Chinese archaeology, from the time of its birth, inherited the historical scheme of political dynasties presented in transmit-ted texts. The polity that resided in Anyang became one of the lines of successive dynasties that ruled China from capitals usually located in north China. Many fea-tures of later polities that are embedded in the Chinese notion of "dynasty," such as well-defined borders, solid territorial control, monopoly over coercive force, and far-reaching political power over subordinates, are transferred to the archaeo-logical record without any scrutiny. Such assumptions are even more prevalent in the study of the Anyang oracle-bone inscriptions, in which ideas derived from traditional historiography are often freely used to help interpret the archaic texts.

Anyang with Solid Territorial Control and Far-Reaching Power
Modeled on traditional conceptions of much later dynasties, the late Shang state that resided at Anyang in the late second millennium BCE is often characterized as a feudal system with the Shang king holding paramount power. The king has the authority to extract tribute, summon military forces, wage wars, grant royal gifts and official titles, and, most of all, enfeoff feudal lords with estates and thereby expand territorial control over vast geographic areas. The Shang king is perceived as an early form of the imperial Son of Heaven, and he is imagined to possess almost equally extensive command over the geographic area of modern-day China. While some aspects of this characterization, such as the summoning of military forces and the granting of gifts, are recorded in contemporary texts, most of it—in particular the nature and extent of Shang political control—is assumed rather than empirically established.

Chen Mengjia and Song Xinchao
In his classic study of the oracle-bone inscriptions, *Yinxu buci zongshu*,[17] Chen Mengjia (1911–1966) outlined the boundaries of the late Shang dynasty by mapping the place-names designating the sites to which the Shang king traveled and the allied and enemy polities mentioned in the inscriptions, an approach pioneered by Wang Guowei (1877–1927) and further developed by scholars such as Dong Zuobin and Shima Kunio (1908–1977).[18] Chen argued that the territory of the late Shang dynasty covered much of the North China Plain in the modern-day provinces of Shandong, Hebei, and Henan and the northern part of Anhui and Jiangsu.[19] He also reconstructed a five-tier political geography of the late Shang dynasty on the evidence of terms related to political boundaries in oracle-bone inscriptions: the capitals (*Shang* 商 or *dayi* 大邑), the outskirts of the capitals (*dian* 奠), the extent

17. Chen Mengjia, *Yinxu buci zongshu* (Bei-jing: Kexue chubanshe, 1956).

18. See Wang Guowei, *Guantang jilin*, 2nd rev. ed. (Beijing: Zhonghua shuju, 1959); Dong Zuobin, *Yinli pu* (Nanxi, Sichuan: Guoli zhongyang yanjiuyuan lishi yuyan yanjiusuo, 1945); Shima Kunio, *Inkyo bokuji kenkyū* (Hirosaki, Japan: Chūgokugaku ken-kyūkai, 1958).

19. Chen Mengjia, *Yinxu buci zongshu*, 311.

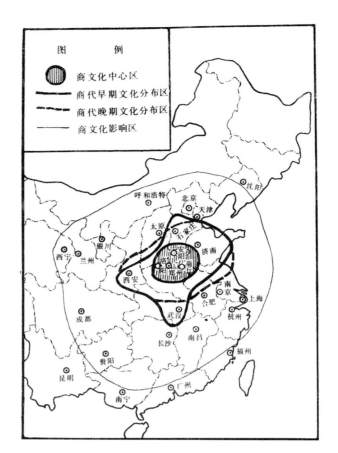

FIGURE 2. Map of the distribution of Shang culture as conceived by Song Xinchao. The shaded area marks the Shang central area, the heavy solid line marks the spread of early Shang culture, the dotted line marks the spread of late Shang culture, and the thin outer line marks the extent of Shang cultural influence.

of the Shang state (*situ* 四土 or *sifang* 四方), the borders of the Shang state (*sige* 四戈), and polities outside the Shang domain (*sifang* 四方, *duofang* 多方, and *bangfang* 邦方).[20] Similar approaches can be seen in the archaeological literature. In one of the earliest attempts to reconstruct the territory and sovereignty of the Shang dynasty from archaeological data, Song Xinchao drew a three-tier concentric map with Anyang at the center, its influence reaching outward from the Central Plain region (fig. 2).[21]

Drawing Boundary Maps

When maps are constructed in this way to show the territory or political influence of the Shang, Anyang becomes the seat of an imperial ruler who exerts power in the manner of later historical dynasties. Such reconstructions have prompted many scholars, consciously or unconsciously, to view other archaeologically defined bronze-using societies as being under the imperial rule of Anyang. Interactions between Anyang and other polities are therefore explained only in terms of political ties, and often within a scheme of ruler and ruled. The astonishing finds at Sanxingdui in Sichuan province, which clearly represent a radically different bronze-using culture, become just another polity referred to in oracle-bone inscriptions. The owner of the richly furnished tomb at Xingan in Jiangxi province becomes a military leader dispatched from Anyang despite the fact that his bronze assemblage is quite different from its Central Plain counterparts (see Steinke, ch. 7 in this volume). More sweepingly, it has been proposed that the distribution of bronze ritual vessels across China during the early Bronze Age identifies the domain of a common culture that became the foundation of the Central Plain–based Chinese civilization.[22] All these conceptualizations are built on an Anyang-centric view that sees the Shang state as the dominating and monopolizing political power, a view reflecting not the evidence supplied by archaeology but the perspectives of modern Anyang-centric archaeologists, as Bagley has forcefully pointed out.

20. Ibid., 325.

21. Song Xinchao, *Yin Shang wenhua quyu yanjiu* (Xi'an, Shaanxi: Shaanxi renmin chubanshe, 1991).

22. Xu Lianggao, "Wenhua yinsu dingxing fenxi yu Shangdai qingtong liqi wenhua quan yanjiu," in *Zhongguo Shang wenhua guoji xueshu taolunhui lunwenji*, ed. Zhongguo shehui kexueyuan kaogu yanjiusuo (Beijing: Zhongguo dabaike quanshu chubanshe, 1998), 227–36.

The dynastic model is extended beyond Anyang not only in space but also in time, for archaeologists apply it to two earlier Bronze Age civilizations, those of Erlitou and Erligang. Both are situated in the Central Plain region, and both predate Anyang, with Erlitou being the earliest of the three. And not surprisingly, these bronze-using civilizations are often characterized as Central Plain megacenters that were politically predatory and expansionistic, a characterization that conveniently equips them to fit into the traditional and linear dynastic scheme of Xia, Shang, and Zhou. Such a model emphasizes the Central Plain's monopoly on political legitimacy while downplaying the importance of polities in other regions, as it was originally designed to do. We see only the monolithic construct of the Central Plain regime and not the lively interaction between regions that must have been the reality on the ground in these early periods.

Although Erlitou, Erligang, and Anyang have evident similarities, they also differ significantly, not only in material culture, but also in the state of research on the sites. Anyang is by far the best understood of the three, and the only site where full writing has been found. When we compare Erlitou and Erligang with Anyang, we are in fact comparing two as yet "prehistoric" civilizations, one of them only sporadically excavated, with a civilization whose type site has been excavated continuously for eighty years, a civilization that has provided us with a first-person record of itself in the form of the oracle-bone inscriptions. While it is a valid intellectual exercise to compare the three centers, there is a danger that the apparent similarities, which may have to do mainly with the current state of research, will distract us from studying or lead us to overlook fundamental differences. We need to know a lot more—the nature and mechanism of political control exerted by the three megacenters and the relationship between them, their hinterlands, and the surrounding regions—if we are to reach any balanced understanding.

Must the basis of interregional interaction in early Bronze Age China be political domination by the Central Plain? Might it not instead be trade, whether reciprocal, administered, or down-the-line? Maybe sites in the south such as Wucheng in Jiangxi province engaged with the Central Plain not as subordinates but as partners in long-distance trade networks, once the "seeds of civilization" had been sown by contact with Erligang (see Steinke, ch. 7 in this volume). Must the Erlitou and Erligang presence in the Yuanqu basin of southern Shanxi have been of an expansionist nature?[23] Do the lack of fortifications at Gucheng Nanguan during the Erlitou period and the subsequent building of walls during the Erligang period indicate a change in the nature of the outlying settlement?[24] Perhaps in the Erlitou period, Gucheng Nanguan was a port of trade rather than a colony. Was Anyang a predatory state that extracted tribute from the fear-stricken fiefdoms, or simply a consumer of resources that it obtained by a variety of means?

We need to keep in mind that state-level societies such as Erlitou, Erligang, and Anyang are multifaceted, multiethnic, and metropolitan by nature. They interact with and influence their neighbors in a whole range of different ways. There are no simple one-to-one correlations between types of material remains and types of interaction. When we define political entities by using boundary maps based on pottery morphology, the past we are creating is a fiction.

THE ESSENCE OF SWISS CHEESE: NATURE OF INTERREGIONAL INTERACTION BETWEEN ANYANG AND ITS NEIGHBORS

David Keightley has presented a very different picture of the Shang state in his works. Unlike his Chinese colleagues, Keightley sees the late Shang state as consisting of "a series of nodal points" and as "a thin network of pathways and encampments" with only the "intermittent" or even "transitory" presence of state power.[25] He argues that "it is unlikely that the full Shang state, except at its center,

23. For a brief introduction to the Yuanqu basin during the Erligang period, see Wang, chapter 3 in this volume.

24. For the Gucheng Nanguan excavation report, see *Yuanqu Shang cheng 1: 1985–1986 niandu kancha baogao*, ed. Zhongguo lishi bowuguan kaogubu, Shanxi sheng kaogu yanjiusuo, and Yuanqu xian bowuguan (Beijing: Kexue chubanshe, 1996). For subsequent work on the Gucheng Nanguan site and a study of early settlements in the Yuanqu basin, see *Yuanqu pendi juluo kaogu yanjiu*, ed. Zhongguo guojia bowuguan kaogubu (Beijing: Kexue chubanshe, 2007).

25. David. N. Keightley, "The Late Shang State: When, Where, and What?" in *The Origins of Chinese Civilization*, ed. David N. Keightley (Berkeley: University of California Press, 1983), 548.

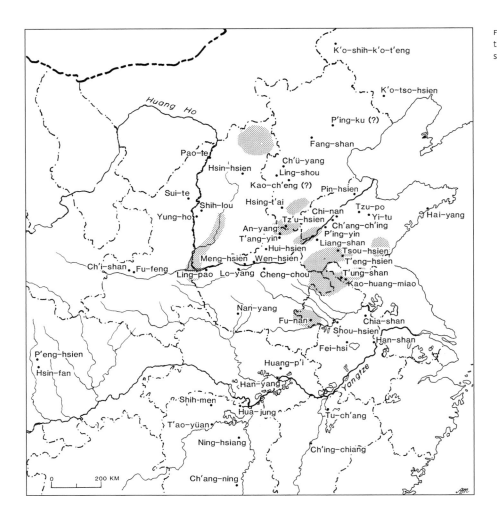

can be associated with a defined and bounded territory."[26] And it is in this sense that Keightley introduces his famous analogy: "the Shang state was gruyère, filled with non-Shang holes, rather than toufu, solidly Shang throughout."[27] Instead of drawing boundaries of the Shang state on the map, Keightley uses shaded areas to indicate pockets of Shang presence in areas defined by Chen Mengjia as Shang territory (fig. 3). For Keightley, the Shang king's frequent engagement in hunting trips and in warfare on behalf of himself and his allies exhibits not the power of the Shang state but the incipient and unstable nature of its political structure: the Shang king constantly needed to defend his domain against antagonistic neighbors, appease allies, and maintain alliances by his physical presence.[28]

Very few Chinese scholars are prepared to accept such a weak Shang kingship. However, Lin Yun, one of the most original and prolific of epigraphers and archaeologists, has also stressed the transient nature of Shang's political and military alliances. In Lin's view, Anyang was only one leader in a constantly changing network of political and military alliances: "Shang is deemed a dynasty in Chinese historiography, but it is in fact merely a dynasty of one statelet, or a dynasty of one of the stronger alliances of statelets. The main factor for the fall of the Shang dynasty . . . was the collapse of the alliance between Shang and the other important statelets."[29] Lin's characterization of Shang therefore parallels Keightley's view that the Shang state "functioned in part as an alliance of regional groupings."[30]

The discrepancy between traditional reconstructions of the Shang state and the views of scholars such as Bagley, Keightley, and Lin Yun is due mainly to the acceptance or rejection of the dynastic model that is embedded in traditional historiography. As Lin Yun points out sharply in his 1982 article, this model creates an apparent theoretical bias in the study of early states in China that is rarely empirically examined: "The study of the earliest state in China has long been affected by

26. David. N. Keightley, "The Shang State as Seen in the Oracle-Bone Inscriptions," *Early China* 5 (1979–80): 26.

27. Ibid.

28. Robert Bagley points out that Keightley's Swiss cheese model still gives absolute primacy to Anyang. "There is only one chunk of cheese: the Shang cheese. Everybody else is just holes." Personal communication, April 2010.

29. Lin Yun, "Jiaguwen zhong de Shangdai fangguo lianmeng," in *Lin Yun xueshu wenji* (Beijing: Zhongguo dabaike quanshu chubanshe, 1998), 83–84. See also Lin, "Guanyu Zhongguo zaoqi guojia xingshi de jige wenti," in *Lin Yun xueshu wenji*, 85–99.

30. Keightley, "The Late Shang State," 545.

FIGURE 4. Model of the spatial boundaries of a world-system.

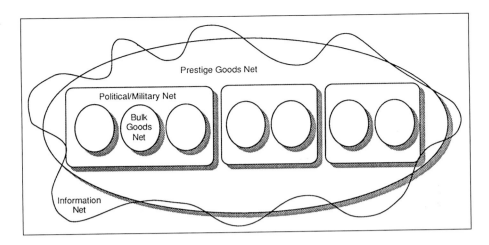

the traditional concept of 'the Grand Unity' (*Da yitong* 大一统). After the 1950s, we were given yet another theoretical dogma of Oriental Despotism. Till this day, the study of early states in China lacks concrete analyses based on empirical data."[31] Lin Yun was surprisingly blunt, not to mention courageous, since he even criticized the ubiquitous use of Marxist theory. His critique however, had no immediate impact on the field.

A politically weak Shang state undermines the application of the imperial dynastic model in which regional interaction is explained mainly in terms of political ties, tributes, and political subordination. But if Shang indeed could not extend direct control beyond its core area, how do we explain Anyang's diverse contacts, attested by its rich material culture, with its contemporaries in other regions?

A MULTILAYERED MODEL FOR INTERREGIONAL INTERACTION IN BRONZE AGE CHINA

In order to define the spatial boundaries of a world-system, Christopher Chase-Dunn and Thomas Hall propose a model with four forms of interaction and linkage between societies, each with its own set of boundaries: bulk goods, political/military, prestige goods, and information (fig. 4).[32] The bulk-goods interaction covers the smallest area; political/military interaction composes a larger net that may include more than one bulk-goods net; prestige-goods exchanges "link even larger regions composed of smaller conflict nets"; and the information net may be of the same size as the prestige-goods net, though its boundaries fluctuate with changes in the nature of the interaction. Though I do not wish to invoke world-systems theory in my discussion of Anyang and its contemporaries, Chase-Dunn and Hall's model does provide a useful starting point for looking at interactions that differ in nature and intensity, and their observation that different interaction nets can have different extents is important. Owen Lattimore proposed a similar model in his discussion of interaction between imperial China and its frontiers. Lattimore differentiated three levels, with decreasing geographic range, of China's regional control: unification by military action, centralization under a uniform civil administrative system, and economic integration.[33] Set next to these multi-level interaction models, the dynastic model that is standard in Chinese Bronze Age archaeology looks far too one-dimensional: for instance, it conspicuously ignores economic relationships.

The Diverse Contacts of Anyang Seen in the Archaeological Data
While Anyang's role as a political power has been overemphasized, its role as a major consumer of resources in Bronze Age China has yet to be fully recognized.

31. Lin, "Jiaguwen zhong de Shangdai fang-guo lianmeng," 69.

32. See Christopher Chase-Dunn and Thomas Hall, "Conceptualizing Core/Periphery Hierarchies for Comparative Study," in *Core/Periphery Relations in Precapitalist Worlds*, ed. Christopher Chase-Dunn and Thomas Hall (Boulder, CO: Westview, 1991), 5–44, and Chase-Dunn and Hall, "Comparing World-Systems: Concepts and Hypotheses," in *Pre-Columbian World-Systems*, ed. P. N. Peregrine and G. M. Feinman (Madison, WI: Prehistory Press, 1996), 11–25.

33. Owen Lattimore, "The Frontier in History," in *Studies in Frontier History: Collected Papers, 1928–1958* (London: Oxford University Press, 1962), 469–91.

The first generation of Anyang archaeologists had already noticed the diverse contacts implied by Anyang's material culture. Unlike his later Chinese colleagues, Li Ji recognized that Anyang was open to all kinds of external contacts and influences. He referred particularly to chariots, bronze technology, and raw materials such as seashells, turtles, metals, jade, marble, and exotic animals.[34] The mechanisms for importing these materials must have been as varied as the materials themselves. The exotic animals in the Anyang royal tombs may indeed represent diplomatic gifts from other regions. Seashells and turtles do not have to be tribute from political subordinates; they could be trade goods pure and simple. The bone refuse pits with tens of thousands of cattle bones at Huayuanzhuang[35] and Tiesanlu[36] call for an explanation both for the source of the livestock and for the supply mechanism, which must have been utterly different from the mechanism for importing seashells. Metals, on the other hand, are a resource that Anyang might have actively attempted to control through either trade, military expeditions, or diplomatic means. The Shang king may well have devoted a significant part of his state apparatus to ensuring the continuous flow of metal.

The current state of research in Anyang archaeology, however, does not permit any detailed discussion of trade and exchange in the context of regional interaction. The reasons are clear: an imbalance of research between Anyang and regions outside of Anyang, the lack of archaeological research in those other regions, and the lack of sourcing studies of local and exotic materials.[37] Archaeology outside of Anyang consists mainly of isolated stray finds of bronzes in either burial or stray contexts, with little or no information concerning the associated settlement. Without archaeological data to help us visualize settlements or regions outside Anyang, our imaginations are colored by these bronzes, which tend to reflect more the political and ideological aspects of interregional interactions.

Fortunately, we are at least beginning to see new Anyang projects that focus on regional surveys and sourcing. The recent discovery at Anyang of pottery types from Shandong, Shanxi, and Inner Mongolia has led Anyang archaeologists to begin thinking of Anyang not just as a dynastic capital but also as a Bronze Age metropolis,[38] a view that is as welcome as it is belated. Precisely because they present a simplified picture of the contemporary world of Bronze Age China, the transmitted texts also present a simplified picture of the central polity they chose to highlight. Archaeology gives us a way of enriching, rectifying, and going beyond the texts. Archaeologists may have taken a roundabout route, but they, or we, are now at least steering into the right direction. Eventually, perhaps, we will decide that Anyang is not the only metropolis worth studying.

Sections and early versions of this paper were also presented at the Seventy-Second Annual Meeting of the Society for American Archaeology, Austin, Texas, 25–29 April 2007, and the Fourth Worldwide Conference of the Society of East Asian Archaeology, Society for East Asian Archaeology, Beijing, China, 2–5 June 2008. Unless otherwise noted, all translations are my own.

34. Li Ji, "Anyang fajue yu Zhongguo gushi wenti," in *Li Ji kaoguxue lunwen ji (xia)* (Taipei: Lianjing, 1977), 825–66.

35. Zhongguo shehui kexueyuan kaogu yanjiusuo Anyang gongzuodui, "1986–1987 nian Anyang Huayuanzhuang Nandi fajue baogao," *Kaogu xuebao* 1992.1: 97–128.

36. He Yuling, personal communication, July 2009.

37. Recent research from Anyang on petrographic studies of pottery and clay molds and strontium analysis by Jing Zhichun, Tang Jigen, and their colleagues are among the increasing efforts by Chinese archaeologists to make up for the gap in sourcing studies. See Tang Jigen et al., "Ceramic Production in Shang Societies of Anyang," *Asian Perspectives* 48, no. 1 (2009): 182–203.

38. Wang Xuerong and He Yuling, "Anyang Yinxu Xiaomintun yizhi de kaogu xin faxian ji xiangguan renshi," *Kaogu* 2007.1: 54–63.

Erligang and the South

CHAPTER 7

Erligang and the Southern Bronze Industries

Kyle Steinke

SEVERAL OF THE CONTRIBUTORS to this volume discuss the problem of how to interpret the Erligang expansion (see Wang, ch. 3, and Baines, ch. 4, in this volume). In this chapter, I want to talk a little bit about what happened in its aftermath. The collapse of the Erligang state around 1300 BCE marks the beginning of a remarkable transformation in the archaeological record of China. When we turn a century later to the time of the Anyang kings, we are no longer looking at a landscape dominated by a single powerful state. Instead we find evidence for a variety of sophisticated cultures, some with artistic and technical achievements equal to those we know from Anyang. Though our archaeological knowledge of the south is still very spotty, the most impressive are in the south.

During the Erligang period, a period of roughly two centuries, bronzes found in the south, even as far south as Panlongcheng, are indistinguishable from bronzes found in the Central Plain. That changes after Erligang. About three hundred kilometers southeast of Panlongcheng, there is a major settlement site that is reasonably well excavated, a walled city at Wucheng on the Gan River in central Jiangxi (map 1). A large tomb found nearby at Xingan Dayangzhou (hereafter Xingan) contained a host of sophisticated bronzes, including weapons, ritual vessels, and large bells, and most are local in style.[1] Farther east, in the lower Yangzi River region, in Anhui, Jiangsu, and Zhejiang, archaeologists have found only small habitation sites and a handful of more modest tombs, but stray finds have turned up bells and ritual vessels no less impressive than those found in the Xingan tomb.

To the west of Panlongcheng in northern Hunan and southern Hubei, we also have stray finds of vessels and bells but again few large habitation sites. The greatest concentration of bronze finds is in Ningxiang county on the Xiang River. In the same county, a walled settlement at Tanheli is just beginning to be explored (see McNeal, ch. 8 in this volume).[2] Fragments of bronze vessels found in a few small burials suggest that the settlement may be connected with the other Ningxiang finds. But nothing in this region—west of Panlongcheng—seems to be as early as Xingan.

Farther west, in the upper Yangzi region, at the western edge of the Sichuan basin, archaeologists have explored the remains of a large walled city at Sanxingdui. Most of what we know about the Sanxingdui bronze industry we have learned from the contents of two spectacular sacrificial pits. The pits contained large bronze faces, masks, and statues, things that have no obvious prototypes anywhere else. They also contained a few bronze vessels imported from lower down the Yangzi, but no large bells.[3]

There is no doubt that a very complicated history lies behind the bronze industries of the Yangzi region—a history of interactions between the bronze-using cultures in the north and those spread across the south. However, if we look at

1. For the Wucheng excavation report, see *Wucheng: 1973–2002 nian kaogu fajue baogao*, ed. Jiangxi sheng wenwu kaogu yanjiusuo and Zhangshu shi bowuguan (Beijing: Kexue chubanshe, 2005). For the Xingan excavation report, see *Xingan Shangdai da mu*, ed. Jiangxi sheng wenwu kaogu yanjiusuo, Jiangxi sheng bowuguan, and Xingan xian bowuguan (Beijing: Wenwu chubanshe, 1997). Another settlement at Niutoucheng, a few kilometers from the Xingan tomb, is introduced in Zhu Fusheng, "Jiangxi Xingan Niutoucheng yizhi diaocha," *Nanfang wenwu* 2005.4: 4–7.

2. For a broad but not exhaustive selection of reports on early Bronze Age habitation sites and bronze finds in Hunan, see *Hunan chutu Yin Shang Xi Zhou qingtongqi*, ed. Hunan sheng bowuguan (Changsha, Hunan: Yuelu shushe, 2007). For the Ningxiang excavation report, see Xiang Taochu, "Hunan Ningxiang Tanheli Xi Zhou chengzhi yu muzang fajue jianbao," *Wenwu* 2006.6: 4–35.

3. For an introduction to the Sanxingdui finds and the early Bronze Age archaeology of Sichuan more generally, see Robert Bagley, ed., *Ancient Sichuan: Treasures from a Lost Civilization* (Seattle: Seattle Art Museum; Princeton: Princeton University Press, 2001). For the excavation report of the Sanxingdui pits, see *Sanxingdui jisi keng*, ed. Sichuan sheng wenwu kaogu yanjiusuo (Beijing: Wenwu chubanshe, 1999).

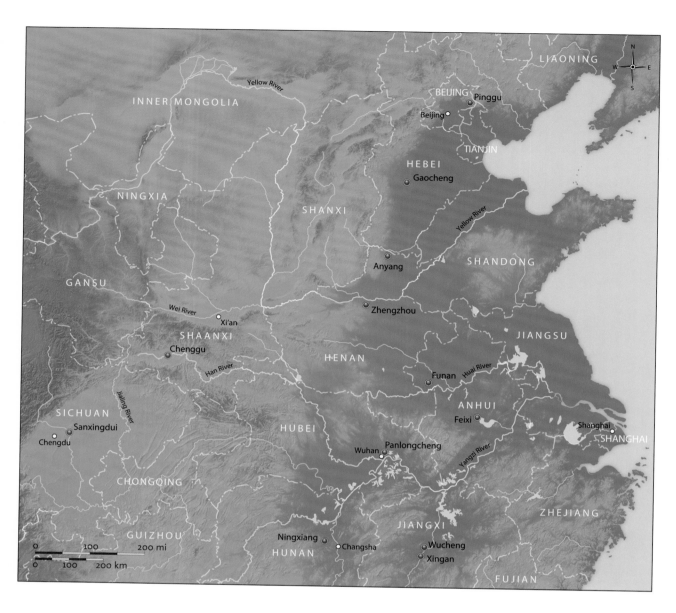

MAP 1. Early Bronze Age archaeological sites.

the archaeological record from the perspective of the Erligang civilization, it is clear that Erligang's major and immediate impact on the south was at Panlongcheng and points east. Only in these areas have bronzes been found that look like immediate descendants of Erligang. Bronzes found to the west of Panlongcheng in the middle and upper Yangzi region, in Hunan and Sichuan, seem to be later, and several sources, not just Erligang, feed into them. They are indebted to bronze industries downriver in the lower Yangzi region and also to post-Erligang sites in the north, including Anyang. In this chapter, I want to focus on the lower Yangzi region and on its response to the Erligang expansion. For this topic, we must begin in central Jiangxi, with Wucheng and Xingan.

Figure 1 shows a *fangding* from Zhengzhou, and figure 2 shows a *fangding* from the Xingan tomb. Except for the tigers on the handles, everything about the Xingan vessel suggests strong connections with Erligang. Both the basic shape and the decorative layout come directly from Erligang *fangding*. The proportions and the flanged high-relief masks on the legs might suggest a date slightly later than the Zhengzhou *fangding*, but they do not lie outside the vocabulary of Erligang casters. The casters who made the Xingan vessel had either worked in an Erligang foundry or learned their trade from someone who did. The tigers of course are another story. Erligang foundries did not cast bronze tigers, much less stick them on the handles of their vessels. Putting animals on vessel handles is a Xingan idea.

FIGURE 1. *Fangding*, 14th century BCE.
H. 87 cm. From the bronze hoard
at Zhangzhai Nanjie, Zhengzhou,
unearthed in 1974.

FIGURE 2. *Fangding* (M:8), 14th–13th
century BCE. H. 97 cm. From Xingan
Dayangzhou, Jiangxi, unearthed in
1989.

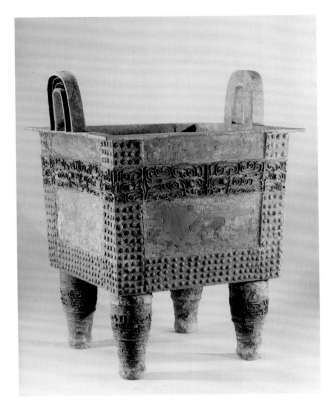

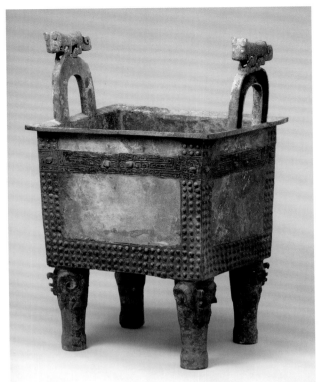

The bronzes in the Xingan tomb vary quite a bit in date. They seem to run from the end of Erligang to the beginning of Anyang—maybe about a century. (This century is sometimes called the "transition period.")[4] So this one tomb gives us an idea of how the Xingan bronze industry developed over a period of two or three generations.

Figure 3 shows a smaller and finer *fangding* from Xingan. This one belongs toward the end of the transition period, and here the hand of the Xingan caster asserts itself powerfully. We could never mistake this for something made in the north. Part of the vessel's distinctiveness comes from the use of local motifs—not just the tigers but also the bands of chevrons on the handles and the lip (see fig. 3b).[5] But the Xingan caster's originality did not stop with adding local motifs. He also transformed what he inherited. The *taotie* at the center of the wall is not far from Erligang versions, but the one-eyed creatures that surround it are new (see fig. 3c). The *taotie* is the static center of a buzzing swarm of ten little dragons. The Xingan caster has turned the one-eyed dragon into a symmetrical framing device for his Erligang-style *taotie*. Nothing quite like this rectangular composition ever occurs in the north.

Just as exciting is the vessel's technical sophistication. It shows off the full repertoire of techniques used by northern casters, including sequential casting—in other words, casting in a sequence of pours, each new part locking onto the previous one.[6] The tigers were joined to the vessel this way and so were the large hooked flanges. And the sharpness of the carving and the casting of the decor patterns are easily the equal of anything done in Erligang foundries, or at Anyang for that matter.

Consider the way in which Erligang decoration is executed. It has often been pointed out that modulated calligraphic lines like those on the Erligang *jia* in figure 4 probably came from first drawing the decoration in brush and ink. Now compare it to a bronze from Xingan (fig. 5), a tiny vessel, 11.4 centimeters high. The Xingan caster demonstrates the same love for sharp, deeply cut decoration as his Erligang predecessor but not the same enthusiasm for modulated line. Instead, he moves toward draftsmanship that gives equal weight to both raised and sunken

4. The term "transition period" has gained currency in Chinese archaeology as a way of referring to a gap of undetermined length between the Erligang occupation of Zhengzhou and the Shang occupation of Anyang. Here it denotes the time when bronzes typologically intermediate between the latest Erligang bronzes and the earliest Anyang bronzes were cast. A newly excavated portion of the Anyang site at Huanbei has recently been suggested as filling this gap. For a brief overview of the Huanbei excavations, see Robert L. Thorp, *China in the Early Bronze Age: Shang Civilization*, Encounters with Asia (Philadelphia: University of Pennsylvania Press, 2006), 131–33.

5. The same chevron motif appears on pottery from the tomb (see fig. 8b).

6. The repertoire of sequential casting techniques used by northern casters is succinctly introduced in Robert Bagley, *Shang Ritual Bronzes in the Arthur M. Sackler Collections* (Cambridge, MA: Harvard University Press, 1987), 42–44. Bagley also discusses a sequentially cast bronze from Panlongcheng in this volume (pp. 40, 42 fig. 51).

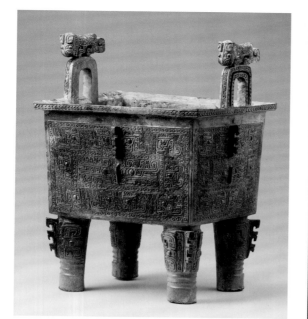
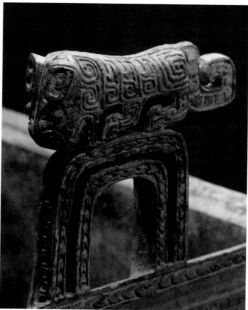

FIGURE 3. (a) *Fangding* (M:12), 13th century BCE. H. 39.5 cm. From Xingan Dayangzhou, Jiangxi, unearthed in 1989. (b) Detail of handle. (c) Detail of side.

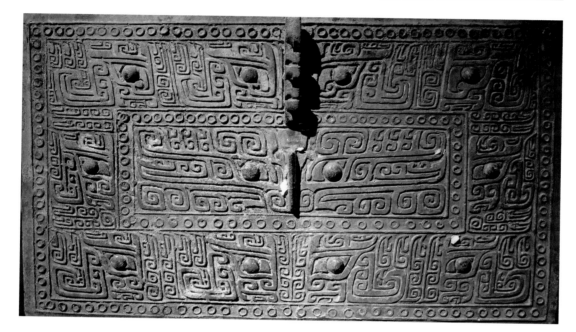

lines, a shift of emphasis that has a rather unexpected effect. Maybe we get something of the effect in the small ax from Xingan in figure 6. The casting is still razor sharp, but the sunken areas have opened up, giving a sense of cutting deep into a massive piece of metal. This is draftsmanship that makes even tiny objects look monumental.

The bronzes from the Xingan tomb show us a bronze industry freely innovating, over several generations, starting from an Erligang artistic and technical foundation that it had mastered completely. What about the patrons the Xingan casters served? Who were they? In order to explore that question, we need to step back and look at the tomb as a whole.

The Xingan tomb (fig. 7) was discovered in 1989 under a sandy mound on the east bank of the Gan River about twenty kilometers from the walled settlement at Wucheng. Like so many important archaeological discoveries in the south, it was found by accident, in this case, by workers moving sand to repair nearby dikes. The unstable, wet environment had destroyed most of the organic material in the tomb. There was little trace of coffins or skeletons. The excavators described the tomb as a rectangular shaft similar to tombs in the north, but its exact form

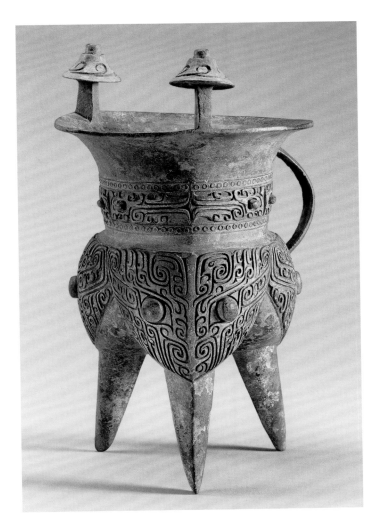

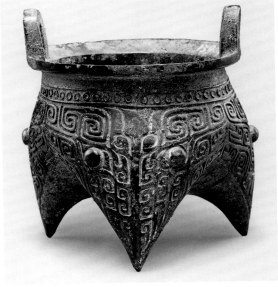

FIGURE 4. *Jia*, 14th century BCE. H. 31.1 cm. Shanghai Museum.

FIGURE 5. *Li* (M:33), 13th century BCE. H. 11.4 cm. From Xingan Dayangzhou, Jiangxi, unearthed in 1989.

FIGURE 6. Ax (M:338), 13th century BCE. L. 14.2 cm. From Xingan Dayangzhou, Jiangxi, unearthed in 1989.

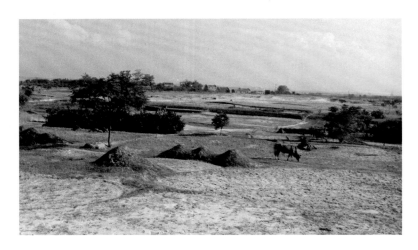

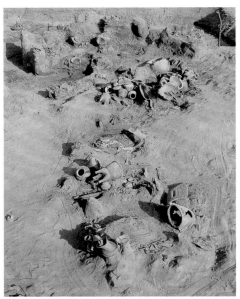

FIGURE 7. The Xingan Dayangzhou site. (a) Surrounding area. (b) During excavation.

7. Some scholars have used the absence of coffins and scarcity of human remains to argue that the Xingan find was not a tomb. The issue is difficult to resolve given the state of preservation of the deposit. Challenges to the identification as a tomb have highlighted differences between the Xingan find and northern elite tomb structures and inventories, but these differences may indicate only that the tomb occupant was not a northerner. For discussion, see Sun Hua, "Guanyu Xingan da mu de jige wenti," in *Shangdai Jiangnan: Jiangxi Xingan Dayangzhou chutu wenwu jicui* (Beijing: Zhongguo shehui kexue chubanshe, 2006), 337–52.

8. For a brief introduction to Fu Hao's tomb, see Robert Bagley, "Shang Archaeology," in *The Cambridge History of Ancient China: From the Origins of Civilization to 221 B.C.*, ed. Michael Loewe and Edward L. Shaughnessy (Cambridge: Cambridge University Press, 1999), 194–202.

9. For an overview of the development of high-fired stoneware in China, see Rose Kerr and Nigel Wood, *Science and Civilisation in China*, vol. 5, *Chemistry and Chemical Technology*, pt. 12: *Ceramic Technology* (Cambridge: Cambridge University Press, 2004), 122–32, 348–51. Potters in the south would seem to have had an inherent advantage over their northern counterparts in developing high-fired glazed stoneware. The rocks from which southern clays were refined tended to be surface features, easily encountered and prepared; they also contained a suitable mix of fine silt-grade silica and secondary potassium mica, the latter necessary as both a plasticizer in making the ceramic body and as a high-temperature flux in firing (Nigel Wood, personal communication, 1 December 2012).

"In north China, by contrast, common surface clays were largely fusible and loessic, and unsuitable bases for stoneware technology. True stoneware clays of the north tended to be more deeply buried, due to their much greater age of deposition, and mainly accessible where the loess beds thinned, such as the margins of mountains, or in the banks of deeper rivers. Even when identified and exploited these ancient clays were highly refractory and needed substantial kiln temperatures to mature them. To

has been much debated.[7] Poor preservation rules out any close comparison with northern tomb structures, but comparison with northern grave goods is easy and revealing. The tomb was amazingly rich—in fact, it is the second-richest tomb known from the early Bronze Age, second only to the Anyang tomb of Fu Hao.[8] It contained forty-eight bronze vessels, four large bells, several hundred bronze weapons and tools, 150 jades, and 356 pieces of pottery. This inventory has much to tell us about the tomb occupant and his culture, and different items tell us different things.

The pottery is important for several reasons. First, it matches pottery found at Wucheng, firmly connecting the tomb with the habitation site. Archaeologists found extensive evidence for bronze casting at Wucheng but few finished bronzes. A second point about the pottery is that there was a lot of it, more than is ever found in elite tombs in the north. A third is that it is not ordinary kitchenware. Though it may lack the visual splendor of the bronzes, Xingan pottery is very sophisticated. Much of it is high-fired, and some of it is even glazed. The pieces shown in figure 8 are full-fledged stoneware, referred to by the excavators as "proto-porcelain"; they are light-years ahead of anything made by Erligang or Anyang potters. Glazed high-fired stoneware was not produced in the north until the fifth century CE.[9] Ceramics like these were a southern luxury that northern aristocrats no doubt coveted.[10]

The tomb also contained many jades, some very unusual. Quite a few seem to be reworkings of Neolithic designs. Figure 9 recalls jades of the Liangzhu culture (ca. 3300–ca. 2000 BCE), the Neolithic of the area around modern Shanghai. Figure 10 reworks ideas taken from jades of the Shijiahe culture (ca. 2500–ca. 2000 BCE), the Neolithic of southern Hubei, the area around Panlongcheng.[11] Some show extraordinary technical virtuosity. The strange birdlike figure and its interlocking chain in figure 11 were carved from a single piece of jade. The jades in figure 12 look like the legs of a bronze *ding* (fig. 13). Perhaps the bowl of the vessel was made of some perishable material like lacquer. A lacquer *ding* with jade legs would be a remarkable object. There is no trace of such a thing anywhere else.

There were hundreds of weapons and tools (figs. 14–17) in the tomb. Bronze helmets and large axes are items found also in the north, but the Xingan helmet in figure 14 stands out for its exceptionally high quality. The ax in figure 17 has the same high quality, but its chevron-bordered jaws give it a definite local flavor. The arrowheads in figure 15 are ten centimeters long. Whether arrowheads like these

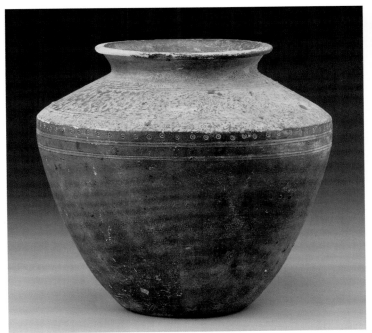

FIGURE 8. Ceramics from Xingan Dayangzhou, 13th century BCE. (a) Glazed stoneware *guan* (M:502). H. 18.8 cm. (b) Stoneware vase (M:569). H. 14.5 cm.

FIGURE 9. *Cong* (M:648), 13th century BCE or earlier. Jade, h. 7 cm. From Xingan Dayangzhou, Jiangxi, unearthed in 1989.

FIGURE 10. Pendant (M:633), 13th century BCE or earlier. Jade, h. 16.2 cm. From Xingan Dayangzhou, Jiangxi, unearthed in 1989.

FIGURE 11. Figure (M:628), 13th century BCE or earlier. Jade, h. 11.5 cm. From Xingan Dayangzhou, Jiangxi, unearthed in 1989.

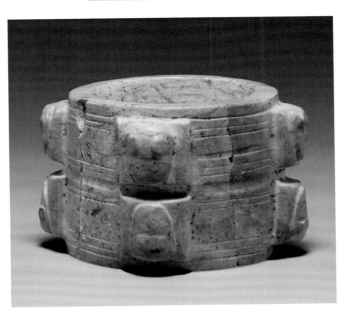

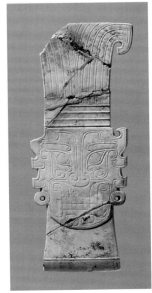

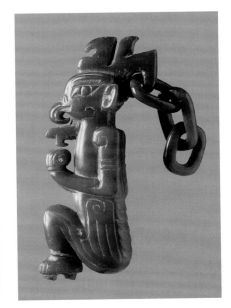

FIGURE 12. Tripod legs (M:634–6), 13th century BCE. Jade, h. 17.7–18 cm. From Xingan Dayangzhou, Jiangxi, unearthed in 1989.

FIGURE 13. *Ding* (M:16), 13th century BCE. H. 38.2 cm. From Xingan Dayangzhou, Jiangxi, unearthed in 1989.

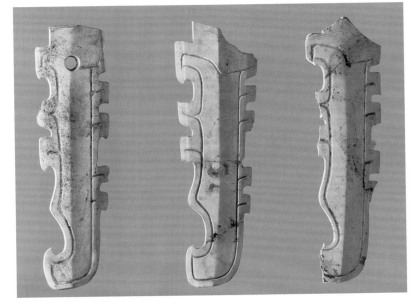

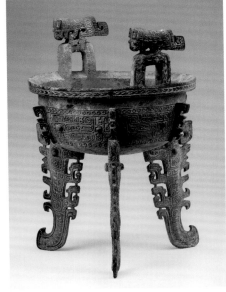

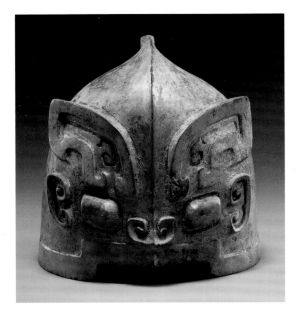

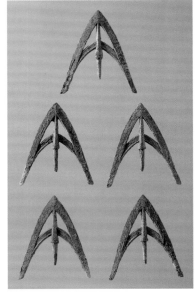

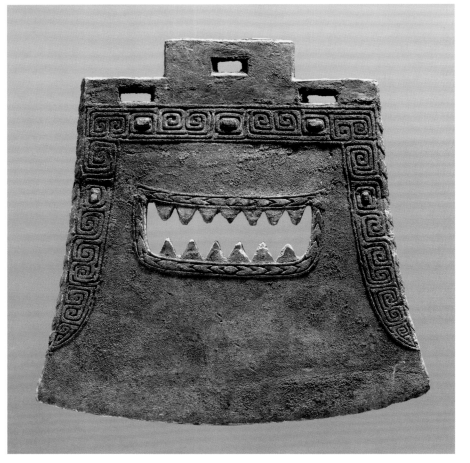

these problems can be added the high-alumina and low-flux natures of northern clays. Aluminous clays of this type would have given poor-quality glazes when mixed with wood ashes, the standard southern approach to glaze-creation. Thus, a combination of geological and technical factors may have inhibited the development of true glazed stoneware in the north." (Kerr and Wood, *Science and Civilisation*, 145)

Fine white-bodied ceramics were produced at Anyang from local kaolinitic clays. Firing estimates of samples have suggested temperatures as high as 1175 degrees Celsius, which is in the range used for southern stoneware but still well below the temperature required for the extremely refractory northern clays to reach full ceramic strength (ibid., 124). Kerr and Wood comment:

"Perhaps the oddest aspect of Shang dynasty whiteware was its failure to establish any substantial northern whiteware tradition and almost eighteen centuries elapsed before such clays again became significant materials in the manufacture of north Chinese ceramics. During this long interval loess remained the prime material for northern potters, and the potentials for high-firing kaolinitic clays were largely ignored." (ibid., 126)

Perhaps the fragility of Anyang whiteware in part deterred northern potters from further exploration of kaolinitic clays.

10. Archaeologists working on Erligang sites where small amounts of similar glazed, high-fired stoneware have been found have been reluctant to identify them as imports from the south. However, a study of the clay body composition of glazed wares from early Bronze Age sites found a close match between examples from Zhengzhou and from Wucheng. See Chen Tiemei et al., "Provenance Studies of the Earliest Chinese Protoporcelain Using Instrumental Neutron Activation Analysis," *Journal of Archaeological Science* 26, no. 8 (1999): 1003–15. Rose Kerr and Nigel Wood point out that

would ever have been used for anything besides display is hard to say, but they are certainly intimidating.

Tools and weaponry are seldom so prominent in northern burials, and as we have seen, other features of the Xingan tomb inventory, such as the wealth of fine ceramics, also set it apart from the north, but nothing tells us so much about the tomb occupant's relations with the north as the bronze vessels. By itself, the fact that the tomb was furnished with bronze vessels says something significant about the impact of the Erligang expansion. Both the ambition to own and produce ritual vessels and the expertise required to make them must have come from contact with Erligang cities like Panlongcheng.

FIGURE 18. Bronzes from Panlong-
cheng, 14th century BCE. Vessel types
(left to right): *gu*, *jia*, and *jue*.

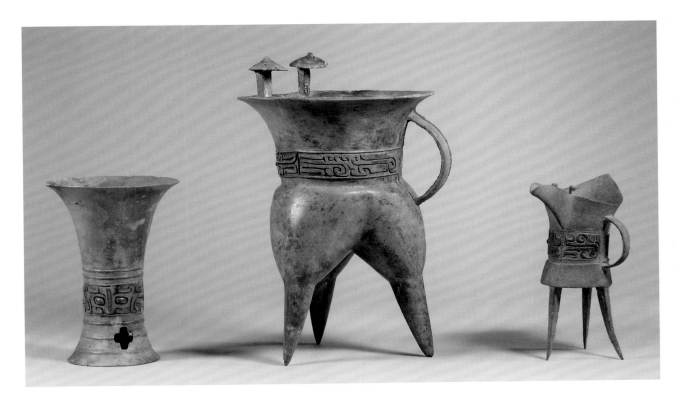

But ritual at Panlongcheng or any northern site required mostly wine vessels. Figure 18 shows three wine vessels from Panlongcheng.[12] These are the three types most common in northern burials: no self-respecting northern aristocrat could go into the grave without a supply of *gu*, *jia*, and *jue*. But while they account for more than half the bronze vessels in the Anyang tomb of Fu Hao—she had 105 *jia*, *jue*, and *gu*—the Xingan tomb contained not one.[13]

Instead, the tomb was filled with tripod and tetrapod cooking vessels. Of the forty-eight bronze vessels, thirty-eight belonged to the *ding*, *li*, and *yan* types. The *yan* in figure 19 is the largest bronze from the tomb: it is a little over a meter tall and weighs nearly eighty kilograms. It is the only known *yan* with four legs. Like the *fangding* in figure 3, it has all the marks of a local casting. There are animals on top of handles, this time a couple of male deer. There are also repeating chevron bands, a heavy molding, and large hooked flanges. The *li* in figure 5 is one of the smallest vessels from the tomb. Not just its decoration is local but also its shape, which copies a Wucheng pottery type (fig. 20).

The bronze vessels mentioned so far are all vessels for cooking food—the tripod and tetrapod types that dominate the inventory—but there was a scattering of other vessels, one-of-a-kind items that neither resemble the food vessel nor match up with the local pottery. They have none of the telltale features, like little tigers and chevron bands, that identify local castings. They look like imports. The smooth, undulating high relief and flat-edged flanges on the *lei* in figure 21 belong to a widespread transition-period style found at a variety of sites to the north.[14] It is hard to say where this vessel was cast, but nothing in its appearance suggests that Xingan casters were involved. The square-bodied wine container in figure 22, on the other hand, is a rare early Anyang type.[15] It is among the very latest bronzes found in the tomb.

Figure 23 shows another import. When it arrived at Xingan, it was a *pou*, a vessel something like the one in figure 24. But its new owner in Xingan did not want a *pou*; he ordered his bronze caster to convert it into a *ding*. The caster had to saw off the ring foot and then cast legs onto the bottom and handles onto the rim. The patron who gave those orders can hardly have been an émigré from the north. He must have belonged to a native elite that had different ideas about what

no sites from Zhejiang or Anhui provinces were included in the study, "so while a southern source is undoubted, Wucheng should not be assumed to be the sole source for all Shang dynasty glazed wares in the north." See Kerr and Wood, *Science and Civilisation in China*, 11–12, 129–30.

11. Later Bronze Age tombs have yielded fine jades from a variety of Neolithic cultures, including Hongshan, Liangzhu, and Shijiahe, suggesting that Neolithic jades were prized possessions collected and traded over a vast territory and passed down through many generations. A Western Zhou tomb, M:26, at Liangdaicun, Hancheng, Shaanxi, contains a jade from the Hongshan culture of northeastern China. For the initial excavation report, see Shaanxi sheng kaogu yanjiusuo, Weinan shi wenwu baohu kaogu yanjiusuo, and Hancheng shi wenwu lüyouju, "Shaanxi Hancheng Liangdaicun yizhi M26 fajue jianbao," *Wenwu* 2008.1: 4–21, esp. figs. 4 and 17. The carvers of the Xingan jades must have worked from knowledge of Neolithic models found in their patrons' collections, some no doubt acquired from contemporary looting of Neolithic tombs.

12. For the bronze assemblages of the tombs at Panlongcheng, see Zhang, chapter 2 in this volume, and the excavation report *Panlongcheng: 1963–1994 nian kaogu fajue baogao*, ed. Hubei sheng wenwu kaogu yanjiusuo, 2 vols. (Beijing: Wenwu chubanshe, 2001).

13. The Fu Hao excavation report is *Yinxu Fu Hao mu*, ed. Zhongguo shehui kexueyuan kaogu yanjiusuo, rev. ed. (Beijing: Wenwu chubanshe, 1984).

14. Cf. a *pou* vessel, M:112:4, recovered at Taixicun in Gaocheng county, Hebei, in 1972. See *Gaocheng Taixi Shangdai yizhi*, ed. Hebei sheng wenwu yanjiusuo (Beijing: Wenwu chubanshe, 1985), color plate 3.

15. For a discussion of the typology of northern *you* vessels, including square-bodied *you* similar to that of figure 22, see Bagley, *Shang Ritual Bronzes*, 355–59.

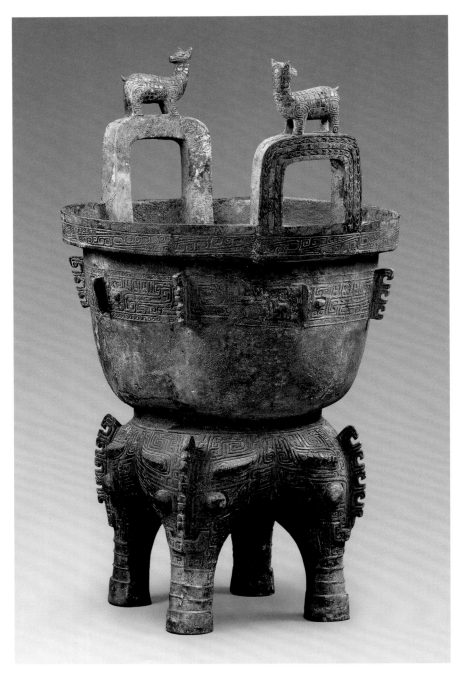

FIGURE 19. *Yan* (M:38), 13th century BCE. H. 105 cm., weight 78.5 kg. From Xingan Dayangzhou, Jiangxi, unearthed in 1989.

FIGURE 20. *Li* (M:625), 13th century BCE. Pottery, h. 11 cm. From Xingan Dayangzhou, Jiangxi, unearthed in 1989.

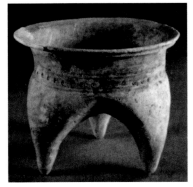

belonged in a ritual vessel set. He wanted cooking pots, preferably with chevron bands and little tigers.

It is hard to say what form of trade or exchange brought these imports to a court in central Jiangxi, but their presence suggests that the Xingan elite continued to have contacts reaching far to the north as late as the beginning of the Anyang period. They had other contacts as well. The upright clapperless bells in figures 25–28 are called *nao*. This type has a very wide distribution. The Xingan tomb had three, all different (figs. 25, 26, 28). Early examples just like them have been found throughout the lower Yangzi region.[16] The peculiar boxy shape of the bell in figure 25 is seen again in a bell from southern Jiangsu (fig. 27).[17] No bell of any kind has yet been found at an Erligang site, but these stemmed bells must descend from an Erligang ancestor.

The bell in figure 28 shows just how close the Xingan bells are to Erligang. At first glance, we do not detect a face in the patterns that surround the large pair of eyes, only a bilaterally symmetrical pattern of quills and swirls. If we break down the structure of this pattern, however, we find at the bottom of it an Erligang

16. For an extensive list of *nao* finds in the south, see Xiang Taochu, "Nanfang Shang Zhou tong nao de fenlei xulie he niandai wenti," in *Hunan chutu*, 718–43.

17. For a report of the discovery, see Nan Bo, "Jieshao yijian tong nao," *Wenwu* 1975.8: 87–88.

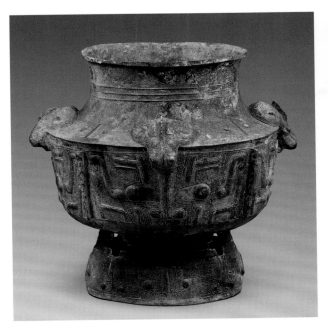

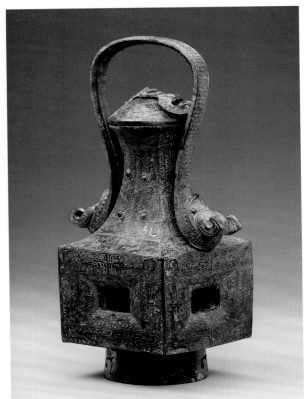

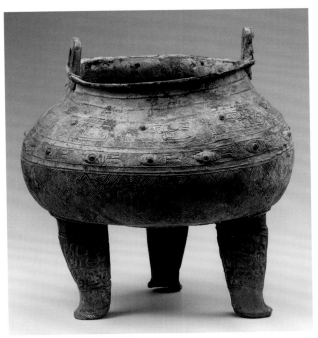

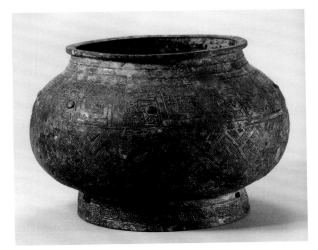

taotie (fig. 29). The quills lie on the back of the animal; the designer has omitted its head. This was the first creative step toward a design that soon returned the Erligang imaginary animal to abstract pattern. The next step, represented on bells found elsewhere in the lower Yangzi region, was to regularize all the spiraling elements and turn the eyes into bosses and then multiply them. A larger bell from Zhejiang (fig. 30a) shows how far bell casters in the lower Yangzi region took the idea (discussed below).

The wide distribution of these stemmed bells turns our attention to Xingan's connections with the lower Yangzi region. It requires us to move back from our close focus on central Jiangxi and the Xingan tomb and consider the impact of the Erligang expansion on a whole vast area of Anhui, Jiangsu, Jiangxi, and Zhejiang.

At Xingan, a local culture just beyond the limit of the Erligang expansion reacted to the impact of Erligang by leaping into the Bronze Age, and there is evidence that something similar happened throughout the lower Yangzi region (map 2). In the middle Yangzi region, the collapse of the Erligang presence at Panlongcheng is followed for a time by silence in the archaeological record. But to the

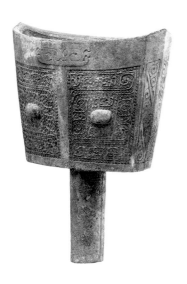

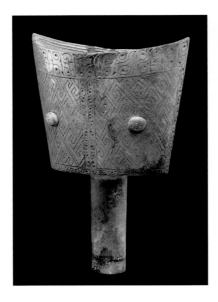

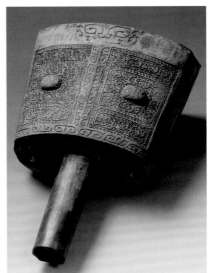

FIGURE 25. *Nao* (M:64), 13th century BCE. H. 41.5 cm. From Xingan, Dayangzhou, Jiangxi, unearthed in 1989.

FIGURE 26. *Nao* (M:66), 13th century BCE. H. 45.5 cm. From Xingan, Dayangzhou, Jiangxi, unearthed in 1989.

FIGURE 27. *Nao*, 13th century BCE. H. 46.5 cm. From Jiangning Hengxi, Jiangsu, unearthed in 1974.

FIGURE 28. *Nao* (M:65), 13th century BCE. H. 43.5 cm. From Xingan, Dayangzhou, Jiangxi, unearthed in 1989.

FIGURE 29. (a) Detail of figure 28. (b) Detail of the *fangding* in figure 3.

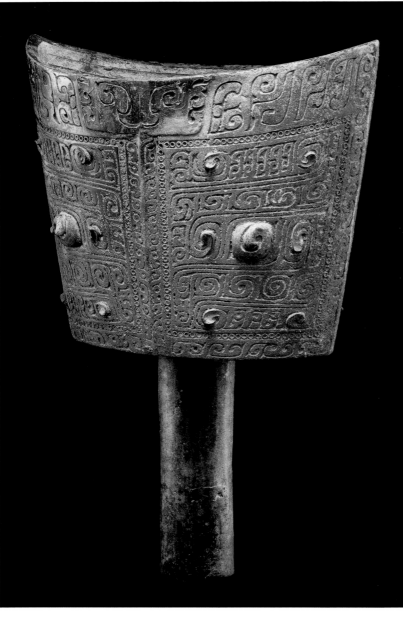

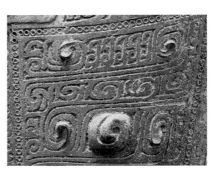

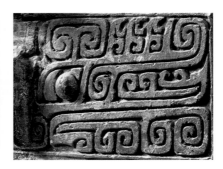

MAP 2. Early Bronze Age archaeological sites in the lower Yangzi River region.

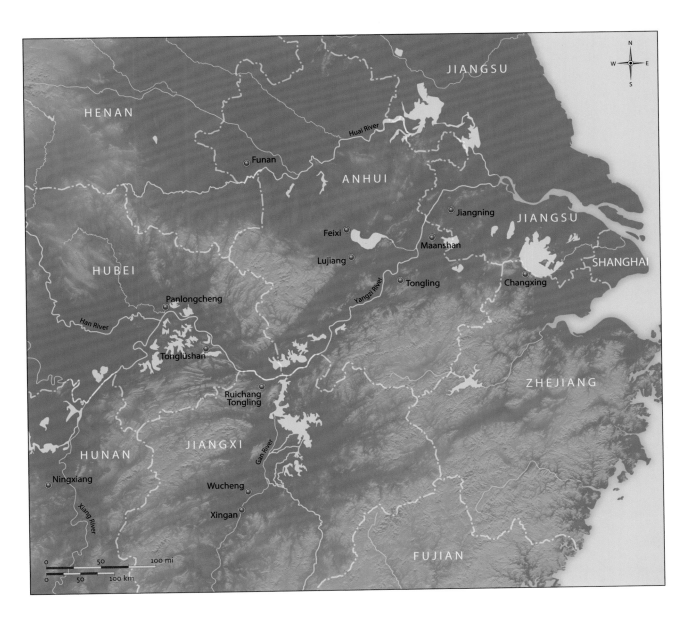

east, Anhui has provided important finds from just after the Erligang period—one from just north of the Huai River, in Funan, and one just south, in Feixi. And fairly standard Erligang bronzes have turned up in southern Anhui in Tongling (fig. 31).

The *zun* in figure 32 comes from an early transition-period burial at Funan.[18] The tiger reminds us immediately of Xingan; this caster had also mastered sequential casting. The dragon heads projecting from the shoulder were cast on, as were the tiger heads. But the bronzes found with this *zun* form a set that is perfectly northern in composition—it is all wine vessels: a second *zun*, a pair of *gu*, a pair of *jia*, and a pair of *jue*. Unlike the occupant of the Xingan tomb, this person seems to have followed the ritual traditions of the north.

The same might be said of the owner of the bronzes in figure 33, from a burial south of the Huai River at Feixi.[19] They are close to Erligang prototypes but larger and more imposing; the *jue* seems to be the largest on record. The number and high quality of early bronze finds in Anhui suggest that Panlongcheng was not the only Erligang city in the south. It is often assumed that Xingan got its knowledge of metallurgy from Panlongcheng, but Erligang casters in southern Anhui are also a possibility.

A few stray finds of standard Erligang bronzes (fig. 31) have been made in southern Anhui, in the area around Tongling (an area we will return to): Tongling has copper mines.[20] Anhui also produced stemmed bells. The one in figure 34 is from a site on the Yangzi in eastern Anhui.[21] Essentially the same pattern appears on

18. The discovery of the Funan bronzes is reported in Ge Jieping, "Anhui Funan faxian Yin Shang shidai de qingtongqi," *Wenwu* 1959.1: page preceding table of contents.

19. No report of the find was ever published. These bronzes are discussed in Robert Bagley, "The Appearance and Growth of Regional Bronze-Using Cultures," in *The Great Bronze Age of China: An Exhibition from the People's Republic of China*, ed. Wen Fong (New York: The Metropolitan Museum of Art, 1980), 121–22.

20. For illustrations of early bronze finds from southern Anhui, see *Wannan Shang Zhou qingtongqi*, ed. Anhui daxue and Anhui sheng wenwu kaogu yanjiusuo (Beijing: Wenwu chubanshe, 2006), 10–19.

21. For a report and discussion of the discovery of the bell, see Wang Jun, "Shi lun Maanshan qingtong da nao de niandai ji qi xingzhi," *Dongnan wenhua* 2006.3: 23–27.

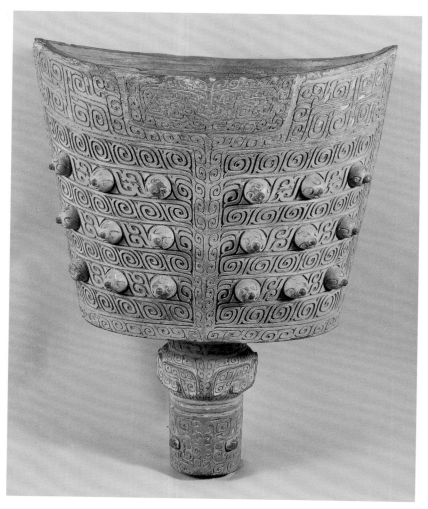

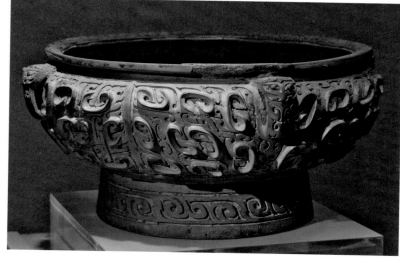

22. For the Xingan bronzes' connections with Sanxingdui and southern Shaanxi, relationships not discussed here, see Robert Bagley, "An Early Bronze Age City in Jiangxi Province," *Orientations* (July 1993): 169–85.

23. The discovery is reported in Zhejiang sheng wenwu guanli weiyuanhui, "Zhejiang Changxing xian chutu liang jian tongqi," *Wenwu* 1960.7: 48–49.

24. The discovery is reported in Zhejiang sheng wenwu kaogu yanjiusuo, et al., eds., "Zhejiang Ouhai Yangfushan Xi Zhou tudunmu fajue jianbao," *Wenwu* 2007.11: 25–35.

25. Whether any of the *nao* found in the Xingan tomb were actually cast in central Jiangxi is hard to say. Another site in the lower Yangzi region seems more likely. The Xingan *nao* carry none of the local decorative motifs, and slightly later relatives that seem to belong to the same foundry tradition, like figure 30a, match vessels quite different in appearance (e.g., fig. 30b) from Xingan castings. The Xingan tomb's occupant would seem to have been actively accumulating *nao* procured from his neighbors. The fourth bell found in the tomb belongs to the *bo* type and is clearly a local Xingan casting. It is the earliest example of its type yet found. The *bo* may be seen as a greatly enlarged version of a *ling*, a diminutive clapper bell with a very widespread distribution. Perhaps the enlargement was inspired by the *nao*, already a bell of substantial size.

26. The C-shaped elements seem to be derived from the high-relief elements of

one of the Xingan bells (see fig. 26). It is treated a bit more richly on the Anhui bell, but it is the same pattern (fig. 35).

Xingan was the home of a distinctive local culture: chevron borders and *ding* with little tigers on their handles are things known only from Xingan. But as we have seen already, the local culture of central Jiangxi had wide affiliations.[22] Stemmed bells are found all over the lower Yangzi region and, a little later, in the middle Yangzi region as well. The Zhejiang bell in figure 30a was found in 1959 together with the *gui* in figure 30b.[23] A very similar bell and *gui* turned up in another Zhejiang tomb in 2003.[24] Xingan was clearly not the only center in the lower Yangzi region that was casting both bells and vessels of very high quality.[25] The Xingan court must have been one of many, all with different histories, some more long-lived than others, linked by their fascination with bells.

The bell in figure 36 is from Anhui. Like the Zhejiang bell, it is later and larger than the Xingan bells. Its main decoration is different from that of the Zhejiang bell, but the two are connected by the *gui* found with the Zhejiang bell. Compare a detail of the *gui* (fig. 37) with the stem of the Anhui bell (fig. 36): the raised C-shaped elements are only the most obvious of several common features.[26]

The exact locations of the foundries that cast these bells and the courts they worked for are as yet unknown. So far, only central Jiangxi has provided a major tomb and a large settlement site clearly connected with it. But we cannot doubt that there were many such courts in the lower Yangzi region. Bronzes of this size and quality were major undertakings, and at least some of the polities that produced them survived long enough, and had connections distant enough, to affect developments far to the west, in the middle Yangzi region. Most of the major designs that later appear in Hunan are found on these early bells. The bell in

FIGURE 30. Bronzes from Changxing, Zhejiang, 13th century BCE. (a) Bell of the type *nao*. H. 52 cm. (b) *Gui*. H. 10 cm. Unearthed in 1959.

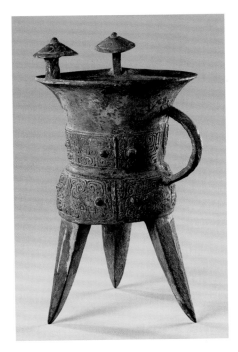
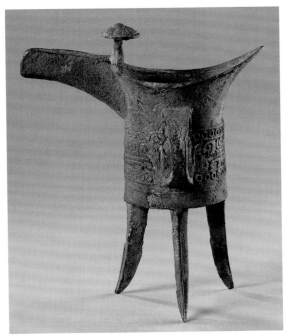
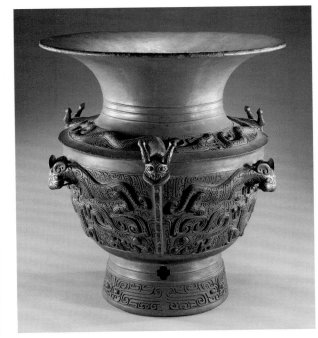

FIGURE 31. Bronzes from Tongling, Anhui, late 14th century BCE. (a) *Jia*. H. 33 cm. (b) *Jue*. H. 23 cm.

FIGURE 32. *Zun*, ca. 1300 BCE. H. 50.5 cm. From Funan, Anhui, unearthed in 1957.

FIGURE 33. Bronzes from Feixi, Anhui, ca. 1300 BCE. (a) *Jia*. H. 54 cm. (b) *Jue*. H. 38.4 cm. Unearthed in 1965.

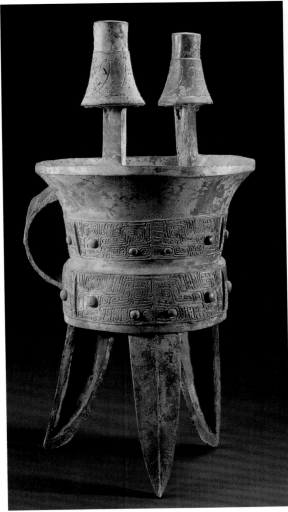
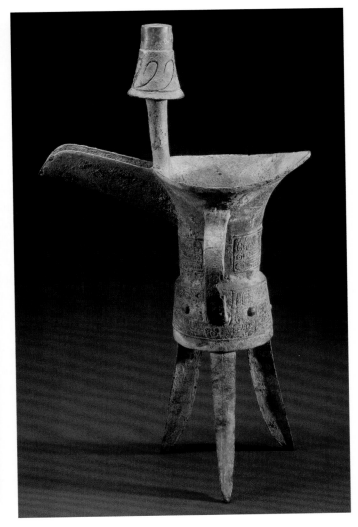

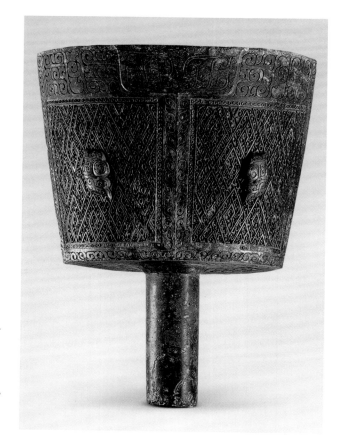

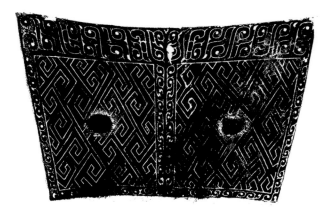

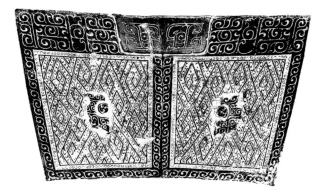

taotie designs on early transition-period vessels like the *zun* in figure 32. They occur in the context of a still recognizable *taotie* on the stem of the bell in figure 30a.

27. The bell, one of five found in 1959 on a mountaintop in Ningxiang, was first reported in Hunan sheng bowuguan, "Hunan sheng bowuguan xin faxian de jijian tongqi," *Wenwu* 1966.4: 2.

28. For an illustrated overview of *nao* found in Hunan, see Gao Zhixi and Xiong Chuanxin, eds., *Zhonguo yinyue wenwu daxi II: Hunan juan* (Zhengzhou, Henan: Daxiang chubanshe, 2006). While a case could be made that a few of the *nao* found in Hunan are as early as those found in the lower Yangzi region (e.g., Gao and Xiong's nos. 5, 16, and 24), the majority are clearly later. None of the examples so far found in and around Ningxiang can be as early as the ones found at Xingan. Most are larger than their lower Yangzi predecessors, and many incorporate elements related to later bronze designs, including designs from Anyang, an influence not so far seen in bells found in the lower Yangzi region.

29. The Pinggu tombs were first reported in Beijing shi wenwu guanlichu, "Beijing Pinggu xian faxian Shangdai muzang," *Wenwu* 1977.11: 1–8. Bronze finds in Shanxi are discussed in Bagley, "Shang Archaeology," 225–26. For illustrations, see Cao Wei, ed., *Shanbei chutu qingtongqi*, 5 vols. (Chengdu, Sichuan: Ba Shu shushe, 2009).

30. For a discussion of the Chenggu bronzes, see Bagley, "Shang Archaeology," 178–79. For illustrations, see Cao Wei, ed., *Hanzhong chutu Shangdai qingtongqi*, 3 vols. (Chengdu, Sichuan: Ba Shu shushe, 2006).

31. The discussion that follows is indebted to Peter J. Golas, *Science and Civilisation in China*, vol. 5, *Chemistry and Chemical Technology*, pt. 13: *Mining* (Cambridge: Cambridge University Press, 1999).

32. Ibid., 72, 98–99.

33. Guo Moruo presented the idea in his "Qingtongqi shidai," in *Qingtong shidai* (Beijing: Kexue chubanshe, 1957), 297–308, esp. 300–301. See also the discussion by Amano Motonosuke in "Indai sangyō ni kansuru jakkan no mondai," *Tōhō Gakuhō* 23 (1953): 231–32.

34. For a discussion of the issue, see Mei Jianjun, "Cultural Interaction between China and Central Asia during the Bronze Age," *Proceedings of the British Academy* 121 (2003): 1–39.

figure 38 comes from Ningxiang in northern Hunan.[27] It is clearly a direct descendant of bells from the lower Yangzi region, bells like the one from Anhui.[28]

I began this chapter by pointing out that the period immediately following the collapse of the Erligang state—in other words, the transition period—coincides with the widespread flourishing of advanced bronze-using cultures. Some of these newly emerging cultures are found in the north. Transition-period bronzes have turned up in burials in the Pinggu district of Beijing and also in Shanxi (see map 1).[29] Farther west, finds are scarcer in the Wei River valley of Shaanxi, the homeland of the Zhou, but in Chenggu, in southern Shaanxi on the Han River, there is a large concentration of often very impressive stray finds.[30]

It seems that, as in the south, the Erligang periphery in the north was home to local bronze-using cultures. But a close look at bronzes from northern sites reveals that the ones that look impressive do not look local, and the ones that look local mostly do not look impressive. The items of distinctly local character seldom go beyond small things like weapons and plaques cast in simple two-part molds. By comparison with the south, societies on the northern periphery look simple.

In the south, the first large-scale bronze industries seem to emerge in areas east of Panlongcheng. But by the Anyang period, monumental local castings are found throughout the entire Yangzi region, all the way from the western edge of the Sichuan basin to the Yangzi delta. A belt of flourishing civilized cultures stretched all the way across China. The Bronze Age may not have begun in the south, but it caught on and took root there very quickly. Why?

Today most of China's tin and copper comes from the south.[31] The major ore deposits are in the Yangzi region and farther south in Guangxi and Yunnan.[32] There was a time not too long ago when prominent scholars speculated that the early development of bronze metallurgy in China was connected with these rich southern copper deposits.[33] The growing number of early metal finds in Gansu and farther west seems to point instead to regions in contact with the Near East.[34] Nevertheless, the copper deposits at southern mining sites like Tonglüshan (銅綠山

FIGURE 34. Bell of the type *nao*, 13th century BCE. H. 50.6 cm. From Maanshan, Anhui, unearthed in 2002.

FIGURE 35. (a) Rubbing of Xingan bell (fig. 26). (b) Rubbing of Maanshan bell (fig. 34).

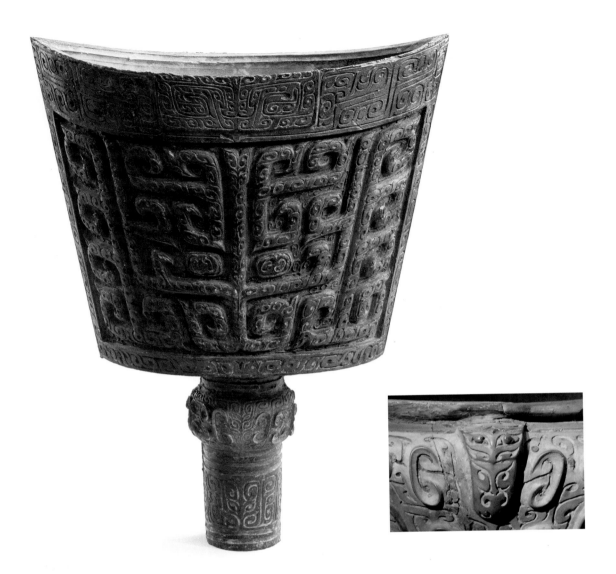

Copper-Green Mountain) in southeastern Hubei seem to have been worked very early.[35] Jessica Rawson suggested thirty years ago that Panlongcheng could have been an Erligang outpost set up to manage a trade in southern copper.[36] Panlongcheng is just northwest of Tonglüshan (see map 2). Some 120 kilometers southeast of Tonglüshan, at Tongling (銅嶺 Copper Ridge), near Ruichang in northern Jiangxi, there is another ancient copper mine with evidence for mining that goes back to the Erligang period.[37] The Erligang bronzes in figure 31 are from yet another ancient mining center named for its copper resources, Tongling (銅陵 Copper Hill), in southern Anhui.[38]

The deposits in this zone of ancient copper mines share some features that made them especially attractive to miners.[39] The first is access to good transportation. The Ruichang Tongling mines lie only a few kilometers from the Yangzi, and the other mining sites are similarly close to open waterways. Easy access to river transport meant greater ease in moving supplies to the mines and in moving metals to users. The second was access to abundant timber and food supplies. Mining sites in the Yangzi region are close to rich forests and lie in areas that could support intensive agriculture. Good timber is needed for building mine galleries and shafts, copper smelting requires vast quantities of firewood, and the labor forces necessary for large-scale mining had to be fed. The third has to do with the nature of the ore deposits themselves. The deposits in the Yangzi region are particularly rich in secondary ores, copper carbonates such as malachite and azurite. Extracting copper from a secondary ore is a straightforward one-step process of heating

35. See Golas, *Science and Civilisation in China*, 79–83. For the excavation report, see *Tonglüshan gu kuangye yizhi*, ed. Huangshi shi bowuguan (Beijing: Wenwu chubanshe, 1999).

36. Jessica Rawson, review of *The Great Bronze Age of China: An Exhibition from the People's Republic of China*, ed. Wen Fong, *Ars Orientalis* 13 (1982): 193–95.

37. The finds at Ruichang Tongling are briefly discussed in Thorp, *China in the Early Bronze Age*, 92. For a report of the excavations, see Liu Shizhong and Lu Ben-shan, "Jiangxi Tongling tongkuang yizhi de fajue yu yanjiu," *Kaogu xuebao* 1998.4: 465–96.

38. Golas, *Science and Civilisation in China*, 84–85.

39. For the discussion that follows, see ibid., 78–85.

FIGURE 38. Bell of the type *nao*, 12th–11th century BCE. H. 71 cm. From Ningxiang Shiguzhai, Hunan, unearthed in 1959.

the ore in an oxygen-starved environment and requires only a well-designed furnace and lots of charcoal. Primary ores—sulfides of copper—are much harder to smelt. A last key feature of these sites is that their ore deposits were easy to find. The deposits at Tongling in Anhui are advertised by iron caps and brightly colored blue flowers that bloom in the copper-rich soil.[40] At Tonglüshan, even a light rain stains the hillsides with verdigris. Southerners were sitting on some of the richest copper deposits in the world.

Now imagine a scenario in which Erligang soldiers and settlers came to the south. They may not have come south in search of copper, but they did bring their bronze industry with them, and it had to be supplied. Erligang prospectors who had learned their skills in the metal-poor north would have had no difficulty finding the far richer deposits in the south. But the southern deposits were not in the middle of nowhere. Erligang experts found themselves dealing with indigenous local societies. The labor and other resources necessary for mining, smelting, and transport could have been secured by trade and collaboration with the locals. Whatever form these interactions took, they cannot have been one-sided. Local elites would have acquired a taste for the Erligang ritual apparatus and Erligang forms of elite display, along with the means to satisfy it—Erligang

40. Ibid., 84.

FIGURE 39. Inscribed ceramics from Xingan, Dayangzhou, 13th century BCE, with rubbings of the inscriptions. (a) *Guan* (M:517). Glazed stoneware, h. 13.2 cm. (b) *Zun* (M:537). Stoneware, h. 47.2 cm.

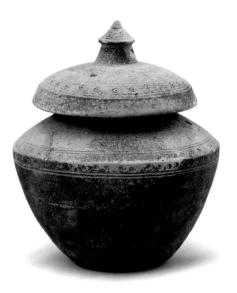
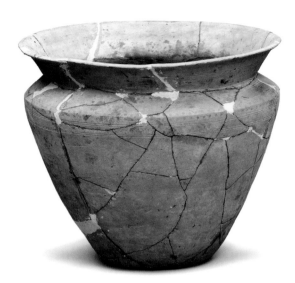

metallurgical expertise and perhaps actual Erligang casters. Thus when the Erligang state retreated from the south, it left in its wake cultures that were not only fully capable of operating mines and smelting metals but also in full possession of Erligang's casting technology and artistic tradition.

This kind of technology transfer would not have been possible if the local cultures had not been fairly sophisticated even before their encounter with Erligang. And we have good evidence that they were: they had some remarkable technical achievements of their own. The stoneware from the Xingan tomb and the Wucheng site is the ancestor of Chinese porcelain (figs. 8, 39). It was fired to 1200 degrees Celsius and carries the first high-fired glazes of the Chinese ceramic tradition.[41] We know northerners admired it; examples have been found at the Erligang capital at Zhengzhou.[42] The presence of southern stoneware at Zhengzhou is actually the most concrete evidence that Erligang was trading with cultures in the lower Yangzi region.

The pots in figure 39 are inscribed. More than 120 different symbols have been found incised into the surfaces of ceramics at Wucheng and Xingan.[43] Some of them appear in long strings.[44] This argues that the symbols are not just pot marks but the signs of a writing system, and hence that the Wucheng culture was in possession of a writing system. The writing remains undeciphered; perhaps it is difficult to read because it is not based on the Anyang writing we are familiar with but is a local adaptation of Erligang writing.

Like metallurgy, writing is a technology that only a society of some sophistication could have adopted. If the early and sudden appearance of advanced bronze-using civilizations in the south seems surprising, we should ask ourselves whether an archaeologist looking at China in the mid-third millennium BCE and unaware of later developments would have predicted that the first large-scale states would arise in the north. In the third millennium, the richest societies by far were in the lower Yangzi region. In northern Zhejiang, the Liangzhu culture shows evidence

41. The Wucheng site is also the source for one of the earliest dragon kilns. The stoneware from Xingan represents a whole suite of sophisticated technologies, from clay prospecting to kiln design, that laid the foundation for the later Chinese porcelain tradition. See Kerr and Wood, *Science and Civilisation in China*, 348–51.

42. See *Zhengzhou Shang cheng: 1953–1985 nian kaogu fajue baogao*, ed. Henan sheng wenwu kaogu yanjiusuo (Beijing: Wenwu chubanshe, 2001), 2:790–93 and vol. 3, black-and-white plate 208.

43. For a table listing the pottery inscriptions found at Wucheng, see *Wucheng*, 465–85.

44. For an example of one of the longest pottery inscriptions found at Wucheng, see ibid., 224–25 and plate 19.6.

of a highly stratified society that invested vast amounts of labor in the production of elite goods and imposing tombs. A large walled Liangzhu city has recently been located.[45] Though we are only just beginning to know the Neolithic south, for much of the millennium leading up to the Bronze Age, it already looks far more impressive than the north.

For the archaeologist, the question of why writing and bronze metallurgy emerged in the Yellow River valley rather than the south is puzzling indeed. Might the Yellow River valley have owed its technological head start to its proximity to the Near East? Certainly, once the cultures of the south were introduced to northern technologies, they had no trouble catching up. The Bronze Age spread like wildfire: within a century of the Erligang collapse, the entire Yangzi valley had become a region of high civilization. This would never have happened if Erligang had expanded into a vacuum. The Erligang expansion brought northern ideas into contact with southern cultures that were fully prepared to exploit them. Perhaps the civilizations of the Yangzi valley were the product of something close to a meeting of equals.

45. For a report of the excavation, see Zhejiang sheng wenwu kaogu yanjiu-suo, "Hangzhou shi Yuhang qu Liangzhu gu cheng yizhi 2006–2007 nian de fajue," *Kaogu* 2008.7: 3–10.

CHAPTER 8

Erligang Contacts South of the Yangzi River

The Expansion of Interaction Networks in Early Bronze Age Hunan

Robin McNeal

IN CHAPTER 7 in this volume, Kyle Steinke has provided a nuanced picture of how interactions among people from north and south China in the second millennium BCE are apparent to us in the spread of Erligang technologies and artistic repertoires in regions south and east of the Erligang site at Panlongcheng, primarily in modern-day Jiangxi, Anhui, and Zhejiang provinces. We turn now to modern-day Hunan province, immediately southwest of Panlongcheng, where understanding the Erligang influence and indeed the historical role of north-south interactions more generally has been more difficult. Archaeological discoveries from the past several decades are explored here, particularly those clustered around two sites in northern Hunan that allow us to reconstruct a rudimentary picture of how contact between the Erligang culture of the north and indigenous cultures in Hunan is likely to have begun. I will describe this contact as the expansion of interaction networks that primarily followed river valleys, highlighting the importance of such networks in the rise of civilization in early China.[1]

THE PERPETUAL FRONTIER

I am an intellectual historian of early China by training, and in the broadest terms, my interest in the early Bronze Age is related to my interest in the emergence of civilization and the state in China, issues that I find insinuated into almost every other problem I look at in my work. In trying to get a handle on such a complex conglomeration of questions, I find it useful to focus some of my attention on the peripheries and edges (real political and cultural boundaries as well as intellectual and imaginative peripheries), where perhaps there will be unique configurations of data, or where there are at least unique points of entry. Hunan province turns out to have been something of a "perpetual frontier" throughout early Chinese history and, indeed in many respects, right down through the entire imperial era.[2] As a geographic focus of research, it provides distinctive perspectives on many of the questions that plague inquiries into the rise of civilization in China. In this brief essay, I will try to set the stage for this sort of "pericentric" inquiry by attempting to present what can now be seen or surmised concerning the emergence of the Bronze Age in this region, which comes with the arrival of sustained contact with the Erligang culture to the north at Panlongcheng.[3]

Before we turn to the Erligang evidence itself, a few words about later developments in Hunan's Bronze Age are in order. Throughout most of the twentieth century, spectacular and sometimes idiosyncratic bronzes apparently dating from the eleventh and tenth centuries BCE (that is, corresponding to the late Anyang [ca. 1200–ca. 1050 BCE] and early Western Zhou [ca. 1050–771 BCE] periods in the north) were uncovered throughout much of the Xiang River drainage basin,

1. Delimiting the scale of inquiry to the modern-day administrative boundaries of the province is of course largely a convenience, since archaeological data in China are for the most part generated, published, and even often theorized at the provincial level. In the case of the early Bronze Age in this region, the provincial scale turns out to be a fairly suitable one, though there are inevitably areas of Hunan that are not part of the discussion and other areas of importance that fall outside the modern provincial borders.

2. I understand a perpetual frontier to consist of a series of geographic conditions, cultural formations, and ethnic or linguistic populations that coincide or overlap and endure over a long period. A quick survey of English-language scholarship on Hunan during the historical era easily bears out this portrayal as a problematic and long-standing frontier: see, inter alia, Donald S. Sutton, "Violence and Ethnicity on a Qing Colonial Frontier: Customary and Statutory Law in the Eighteenth-Century Miao Pale," *Modern Asian Studies* 37, no. 1 (February 2003): 41–80, and John W. Haeger, "Between North and South: The Lake Rebellion in Hunan, 1130–1135," *Journal of Asian Studies* 28, no. 3 (May 1969): 469–88. The latter includes a discussion of the difficult terrain of the Dongting Lake region as late as the twelfth century. In chapter 6 of David W. Anthony, *The Horse, the Wheel, and Language: How Bronze-Age Riders from the Eurasian Steppes Shaped the Modern World* (Princeton: Princeton University Press, 2007), Anthony uses the term "persistent frontier," which he describes as often resulting from the coinciding of a material-culture border, perhaps an ecological border, and, importantly, a linguistic border. He argues that persistent frontiers are understudied and often not fully recognized. The full application of his notion of persistent frontiers to southwest China would perhaps show that the mountainous Xiangxi region running the length of Hunan north to south has long been part of a much larger frontier that to this day is visible in terms of material culture, linguistic groups, and ecological conditions. My thanks to Rowan Flad for drawing my attention to the similarities between my use of the term "perpetual frontier" and Anthony's terminology.

3. On the term "pericentric," that is, archaeological studies that take as their main concern peripheral regions, see Prudence M. Rice, "Contexts of Contact and

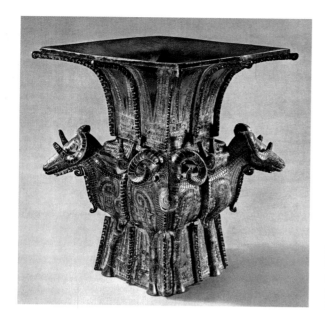
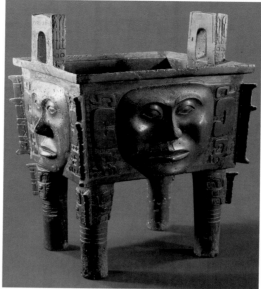
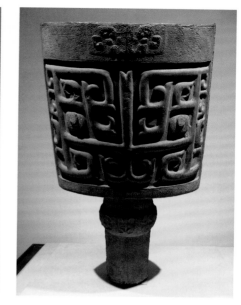

with by far the biggest concentration coming from the narrow Wei River valley in Ningxiang county, west of modern-day Changsha. Some of the best-known of all early Chinese bronzes come from this area, including the famous four-ram *fangzun* and a *fangding* with a human face cast on each of its four sides (figs. 1, 2). The very same region has yielded numerous massive bronze bells, some of them buried as sets (fig. 3). As a rule, these bronzes have not been found in tombs, as is most frequently seen in the north, but have been deposited in simple pits along mountainsides or near rivers, leaving little or no archaeological context. Frustratingly little can be said about these bronzes, but most scholars agree that they were likely produced or imported by a local, probably indigenous polity. With neither archaeological data nor later historiographical traditions to guide our inquiries, the Hunan bronzes have remained one of the great mysteries of early China.

Only in the opening years of this century did this begin to change. From 2002 to 2004, Xiang Taochu led a team of archaeologists from the Hunan Provincial Institute of Cultural Relics and Archaeology in excavating a site at Tanheli in Ningxiang county, deep in the heart of the Wei River valley, that turned out to be the remnants of a walled complex dating from the very end of the Anyang period and into the early Western Zhou period, that is, from no earlier than the eleventh century BCE (map 1). Most of the site had been badly eroded by the changing course of the Wei River, but palace foundations were uncovered within the remaining walled area. In the hills just outside the walled area, a small number of elite tombs furnished with a few bronze blades and some broken fragments of bronze vessels were also excavated. Neither these excavations nor the many chance finds of bronzes from the region, many of them literally made within a stone's throw of the walled compound, have provided a rich enough material record to allow for a robust understanding of the possible relationship between the settlement here and the vessels and bells scattered across the landscape, much less possible links to cultures or sites beyond the Wei River valley, so while the Tanheli finds are promising and intriguing, they raise many more questions than they solve. Understanding more about Hunan during the Erligang period (ca. 1500–ca. 1300 BCE) would presumably take us some way toward formulating better hypotheses about the origins and nature of the Tanheli site and the many Anyang- and Western Zhou–period bronzes found across much of Hunan province.[4]

From the perspective of our inquiry, three main regions define the Hunan landscape during the early Bronze Age: the Xiang River drainage system, running along the eastern half of the province from the south to the north; the mountainous

Change: Peripheries, Frontiers, and Boundaries," in *Studies in Culture Contact: Interaction, Culture Change, and Archaeology*, ed. James G. Cusick, Occasional Paper No. 25 (Carbondale: Center for Archaeological Investigations, Southern Illinois University, 1998), 44–66. My ultimate concern is not with peripheries and frontiers *themselves*, although they are inherently interesting, but with the broader question of how overlapping and shifting interaction networks of various kinds were slowly integrated into more complex social, economic, and political formations. Beginning such inquiries in peripheral regions serves to highlight some of the features of these networks, in part by making the existence of distinct networks more easily visible. For an example of the cultural diversity of Hunan province visible in the archaeological record, see, inter alia, Luo Renlin, "Yueyang diqu Shang shiqi de wenhua xulie ji qi wenhua yinsu de fenxi," *Hunan kaogu jikan* (1999): 223–51, esp. 237–38, which focuses solely on the Yueyang region. Farther south and west into Hunan, understanding of the cultural landscape in the pre-imperial era becomes increasingly spotty, but what is known suggests increasing cultural (and presumably ethnic) diversity. For an example of a site from deep in the Xiangxi region, see Hunan sheng wenwu kaogu yanjiusuo and Xiangxi zizhizhou wenwu guanlichu, "Xiangxi Yongshun Buermen fajue baogao," in *Hunan kaogu 2002: Shang* (Changsha, Hunan: Yuelu shushe, 2002), 72–125.

4. For details on the Tanheli discoveries, see Xiang Taochu, "Hunan Ningxiang Tanheli Xi Zhou chengzhi yu muzang fajue jianbao," *Wenwu* 2006.6: 4–35. The four-ram *fangzun* (fig. 1) was discovered in the mountains immediately to the north of the site, and the *fangding* in figure 2 was found along the bank of the Wei River just adjacent to the Tanheli site.

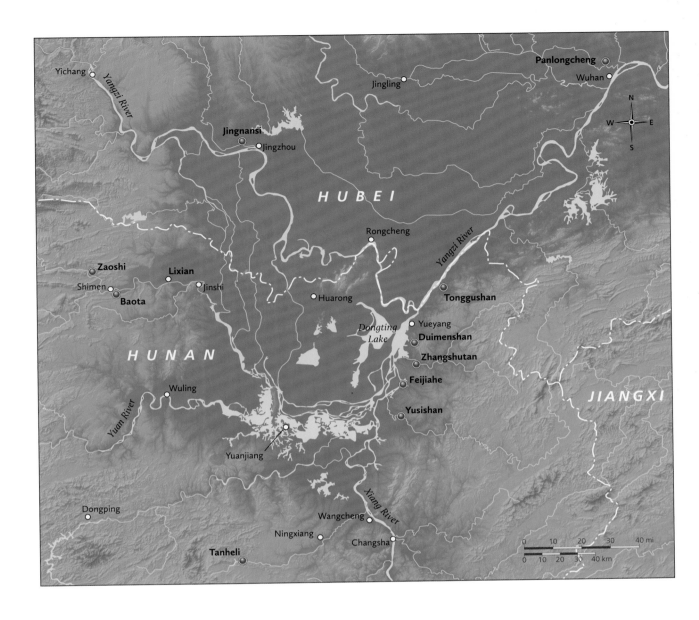

MAP 1. Early Bronze Age sites in northern Hunan province.

Xiangxi (West of the Xiang) region, covering the western half of the province; and the broad plain in the north where these two regions butt against the Li River and Dongting Lake, just before the many waterways that converge in that massive lake enter the Yangzi. The human and physical geographies of these three regions remain diverse to this day and likely made Hunan a challenging region to outsiders as far back as the Erligang era. There seem to have been two main trajectories of northern influence across the region that is now Hunan province during the Bronze Age, one running from east to west across the northern end of the province, just to the south of the Yangzi and along the Li River plain, and then a second trajectory running from the northeastern tip of the province down along the Xiang River to the deep south. On available evidence, it seems likely that this second route of north-south interaction, which was to become quite important by the Anyang period, was largely inactive during the Erligang period.

THE EAST-WEST ROUTE

It now appears that the first arrival of Bronze Age technology in Hunan, and of whatever political and cultural influences attended its arrival, came from Panlongcheng to the northeast. This is itself unsurprising, but the evidence for this contact has been difficult to discern, and the direct impact made by Erligang civilization in Hunan appears on first assessment rather minimal. What looks to be the site

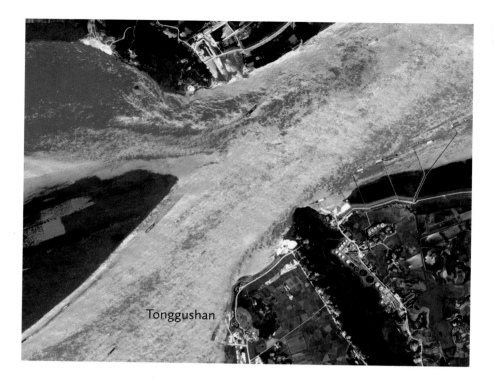

FIGURE 4. Satellite image of Tonggushan site.

Tonggushan

of the first entrance into and sustained presence of Erligang culture in Hunan is located at Tonggushan, directly upriver of the Panlongcheng site, near modern-day Yueyang, where the Yangzi is joined by the Xiang River at the northeastern-most tip of the province (map 2).

The Tonggushan settlement is situated quite strategically, on the southern bank of the Yangzi, at what must have been an excellent spot for monitoring the surrounding landscape and the traffic moving up- or downriver (fig. 4). The Yangzi passes through low mountains that run perpendicular to the course of the river, which widens slightly just before it breaks through them, then becomes constricted again on the other side. A wide, low island has formed in the middle of the river where it widens, and thus this was likely a very good point for crossing the river as well. Just upstream of the line of mountains, on the southern bank, a separate hill rises up from the surrounding plain, just at the edge of the bay that likely formed when the river widened out, presumably as it pushed its way through the mountains. The top of this hill is relatively flat and broad and is littered to this day with potsherds and the occasional broken stone implement. As with the Panlongcheng site north of modern-day Wuhan, we are fortunate here, at Tonggushan, that the site is now rather remote, far enough north of metropolitan Yueyang to remain fairly well preserved.[5] We cannot be sure that there were not other important sites nearby that are now inaccessible, buried under modern cities, but the evidence we do have suggests that Tonggushan was an important post along a route linking the Panlongcheng area to the upper Yangzi and the plain of northern Hunan delineated by Dongting Lake and the Li River.

The broad region east of Dongting Lake, defined by the drainage of the Xin-qiang, Feijia, and Mi-Luo Rivers into the lake, has produced numerous Anyang-period sites, but thus far, Tonggushan alone appears to have been occupied as early as the Erligang.[6] The initial reports from excavations done here in 1987 note the discovery of two distinct assemblages of pottery: one that can be linked to local pottery known from elsewhere in Hunan and the central Yangzi region, and one that is clearly a part of the Erligang culture of Zhengzhou and of course Pan-longcheng.[7] What has become clear only after further analysis is that these two assemblages can be demonstrated to represent two distinct phases of occupa-tion at Tonggushan. Guo Shengbin, a local archaeologist who has worked in the

5. The area immediately surrounding the Tonggushan site is still relatively undevel-oped, although the hill itself is now a pop-ular location for new tomb construction. It must be noted, however, that all archaeo-logical strata at the site dating from the early Bronze Age were badly damaged by Eastern Zhou–period (770–221 BCE) settle-ments, making the job of archaeologists here much more difficult than would oth-erwise be the case.

6. The Anyang-period sites are treated in detail below.

7. Archaeologists have identified the pot-tery at Tonggushan as a very close match to Erligang pottery, "especially as known from Panlongcheng"; see Guo Shengbin, "Tonggushan Shangdai yicun wenhua yinsu fenxi," *Jiang Han kaogu* 2001.4: 47 (Guo also discusses a nearby site at Jingnansi, Hubei, which I describe briefly below). The same observation is made in Xu Weihua, "Hunan Yueyang shi Tonggushan yizhi chutu Shangdai qingtongqi," *Kaogu* 2006.7: 90–91. While such conclusions about affiliations of pottery types are always to some extent impressionistic, early Bronze Age pottery from northern Hunan is by now familiar enough to local scholars that they can make meaningful comparisons of design and decor, and the overall picture that emerges from detailed studies of pottery agrees with the other archaeological data (e.g., con-cerning rammed-earth foundations, burial practices, and other artifacts such as bone or bronze) and makes good historical sense as well.

MAP 2. Yueyang area and Dongting Lake.

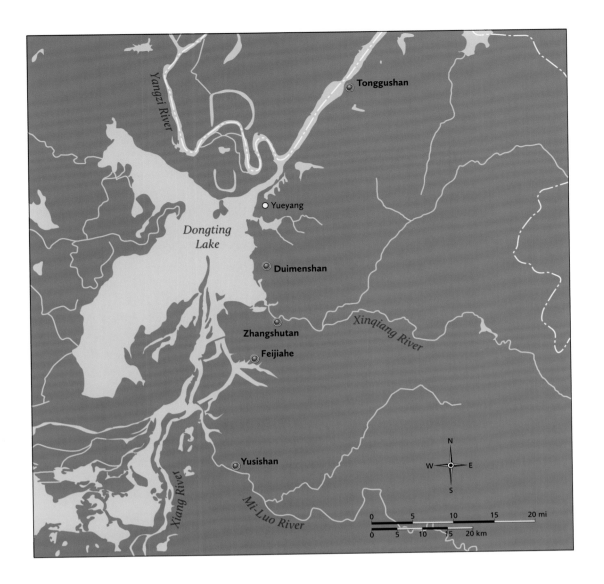

Yueyang area for decades, has described five archaeological strata at Tonggushan, the first four corresponding to the Erligang period and dominated by a pottery assemblage recognizable from Panlongcheng and Erligang culture more broadly. The final stratum can be dated to the early Anyang period, but this last layer represents a local culture and clearly marks a change in the occupants of the site; we will address this issue in a moment.[8]

The occupation of Tonggushan throughout Guo's first four periods by a group of people using Erligang pottery types and assemblages, who then left or were driven out of the area just as the site at Panlongcheng downstream seems to have been abandoned, is telling. While no ritual bronze vessels were uncovered here that can be dated to the Erligang period, a few bronze arrowheads and other implements were found, and the pottery is unquestionably directly linked to the Erligang culture. Guo and other archaeologists working on this region describe this as a local culture strongly influenced by the Erligang settlement at Panlongcheng, perhaps stopping just short of identifying it as an Erligang outpost because of the absence of ritual bronzes and small differences in the full range of pottery types found here and at Panlongcheng. These differences, I suspect, must actually arise from the different social status of the occupants at Panlongcheng and Tonggushan.[9] Panlongcheng was clearly an important political and ritual center. The likelihood that it served as an important site along a route connecting Zhengzhou to rich sources of copper in the lower Yangzi region has been discussed in detail by scholars in China and the West and is noted by Steinke in chapter 7 in this volume.[10] This focus on Panlongcheng's role in large-scale interregional interaction is

8. See Guo Shengbin, "Tonggushan Shangdai yicun wenhua yinsu fenxi," 40–48, 22.

9. In his new, book-length synthetic treatment of the Bronze Age in Hunan (specifically, along the Xiang River basin), Xiang Taochu comes to basically the same conclusion; see *Xiangjiang liuyu Shang Zhou qingtong wenhua yanjiu* (Beijing: Xianzhuang shuju, 2008), 51.

10. In the English-language literature, Jessica Rawson was the first to suggest the link between Panlongcheng and the copper mines of southeastern Hubei, in Jessica Rawson, review of *The Great Bronze Age of China: An Exhibition from the People's Republic of China*, ed. Wen Fong, *Ars Orientalis* 13 (1982): 193–95. The idea is given prominence in Li Liu and Xingcan Chen, *State Formation in Early China* (London: Duckworth, 2003), ch. 3.

appropriate, but, as I will argue below, we would be mistaken to understand Panlongcheng only as a stop on a string of trade routes that moved metal to a political center in Henan. Such a drastic simplification of interregional interactions in Bronze Age China obscures more than it brings into focus. Panlongcheng was likely a hub of many different intersecting and overlapping networks. It not only helped conduct the movement of goods inward toward the political center(s) but also acted as a conduit for the movement of power, ideas, goods, people, and practices outward, and not simply from the center to the periphery, but in multiple directions across diverse landscapes, to and through various types of "centers"— some political, others perhaps important for religious or cultural reasons, still others important for crucial resources such as salt or copper.

When we try to reconstruct the role of Panlongcheng as an outpost of Erligang civilization, we need to be aware of its position in this broader web of overlapping networks of various kinds. Some of this is clearly evidenced in the rich and diverse material remains at Panlongcheng; other aspects of this vision of the walled compound need to be teased out of the broader archaeological landscape, from a careful analysis of aesthetic sensibilities at neighboring sites or the appearance of luxury items from far afield.[11]

The Tonggushan site, in contrast, does not appear to have been of comparable size, complexity, or importance. There is no sign that any rammed-earth walls were ever built here, nor that the settlement was home to anyone of particularly high status. No jades or ritual bronze vessels are known from the Erligang occupation. The Tonggushan site may be modest in comparison with Panlongcheng, yet the settlement was maintained throughout the Erligang period, and its inhabitants are likely to have been an important force in transforming the cultural landscape of northern Hunan.

The Tonggushan site seems not to have been occupied before the Bronze Age. This is a somewhat remarkable fact, since northern Hunan was almost certainly a densely populated area in the late Neolithic (the Qujialing [ca. 3300–ca. 2600 BCE] and the Shijiahe [ca. 2600–ca. 1900 BCE] periods). This fact strengthens the likelihood that the settlement here was established as an outpost by interlopers from downstream at Panlongcheng, as part of a push westward along the Yangzi. We need to explore the legacy of the site in two respects: its role as a catalyst for cultural change in the immediately surrounding landscape, and its role as part of a longer westward trajectory of Erligang influence reaching deeper into Hunan province.

Throughout the Erligang occupation at Tonggushan, that is, the first four strata identified by Guo, one cannot directly discern any cultural influence from it on the broader region east of Lake Dongting, but this may simply reflect our imperfect understanding of the archaeological record of this area in the late Neolithic and early Bronze Age. By the time of the fifth stratum, the Tonggushan site, now no longer an outpost of the Panlongcheng settlement downstream, is suddenly part of a broader regional culture with sites scattered along the many rivers that drain into the eastern banks of Lake Dongting. These sites have a distinctly local pottery profile and exhibit burial practices at variance with those at Panlongcheng and other Erligang sites.[12] Ritual bronze vessels suddenly enter the archaeological record in this period, though they seem never to become common in the Yueyang region at any time during the Anyang or early Western Zhou periods, in spite of the fact that, farther south along the Xiang River, they clearly become an important feature of elite material culture by the eleventh century BCE. And aside from small, simple, locally produced bronze implements such as arrowheads, most or all cast bronzes in this region appear to be imports. Thus, we discover the somewhat counterintuitive fact that during the Erligang occupation itself, a

11. A more careful and comprehensive study of the finds from Jingzhou Jingnansi, in southern Hubei, would make a good case study for this sort of analysis; the site report makes clear that the repertoire of regional pottery styles from this single site is varied and complex, probably revealing long- and short-range interactions with both Panlongcheng and the Erligang type site in Zhengzhou, as well as with the Zaoshi site in Hunan and sites in both Sichuan and Jiangxi; see *Jingzhou Jingnansi*, ed. Jingzhou bowuguan (Beijing: Wenwu chubanshe, 2009), and note 34 below, in which I discuss this site and also suggest that the region just east of Dongting Lake would make another good case study for the Anyang period.

12. For a synthetic treatment of these sites, see Guo Shengbin, "Yueyang Shangdai kaogu shulüe," *Jiang Han kaogu* 2005.3: 63–69; by no means are all the sites completely culturally uniform.

FIGURE 5. *Gu*, 13th–12th century BCE. H. 22.2 cm. From Tonggushan, Hunan.

FIGURE 6. *Ding*, 13th–12th century BCE. H. 25.6 cm. From Tonggushan, Hunan.

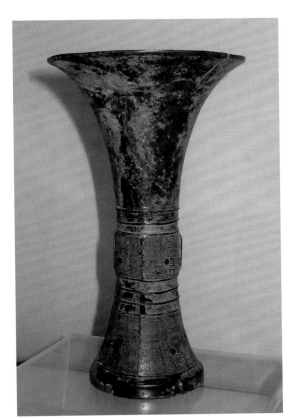

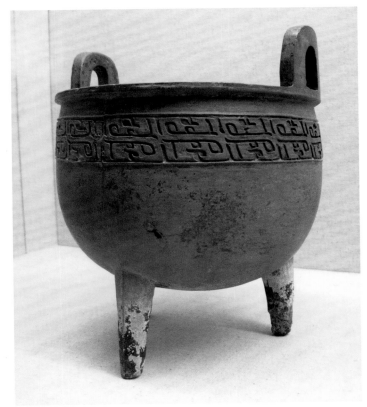

time of direct sustained contact between Tonggushan in northern Hunan and the bronze-rich city at Panlongcheng in southern Hubei, there seem to be no bronze ritual vessels made in or imported into Hunan. It is only after the Erligang abandonment of the Tonggushan site and apparent retreat from the central Yangzi region, sometime during the Anyang period, that ritual bronze vessels and, eventually (and prominently), bells arrive.

Though the excavations at Tonggushan did not turn up any ritual bronze vessels, in 1997 local residents laying the foundation for a new home in the area uncovered two; by the time archaeologists had been called in, it was impossible to determine precisely the conditions of their interment, but the modern construction may have disturbed an elite tomb or other deposit from the latest phase of occupation. Both vessels, a bronze *gu* (fig. 5) and a thickly cast *ding* (fig. 6), can be dated on stylistic grounds to the Anyang period and must have been imported into Hunan only after the abandonment of the Yueyang region by its Erligang settlers.[13]

Before speculating about the role of these settlers in stimulating the development of more complex social formations in the region, we need to explore the links between Tonggushan and sites farther west, particularly the only other known bronze-using Erligang site in Hunan, the settlement at Zaoshi, near Shimen, west of Dongting Lake (see map 1). The broad floodplain west of the lake defined by the Li River, running through the far northern end of the province, was an important region throughout the Neolithic and is probably crucial to understanding early interaction patterns in the middle Yangzi well into the Bronze Age as well. Bronzes have been discovered scattered along this route, from Huarong, across the Yangzi from Yueyang, to Jinshi, just west of Dongting Lake. As with the two pieces known from Tonggushan, these all seem to date later than the Erligang period, and very little is known about their burial conditions or their relationship to local settlements.[14] At the western end of the region, however, a series of sites near modern-day Shimen have come to light, including an Erligang-period settlement at Zaoshi.

13. See Yueyang shi Yunxi qu wenwu guanlisuo, "Yueyangshi shijiao Tonggushan yizhi xin chutu de qingtongqi," *Hunan kaogu* (2002): 455–59. The vessels were reportedly discovered along with some stone implements and numerous pottery vessel fragments. Xu Weihua discusses the pottery, although he seems not to observe the distinctions between the Erligang occupation and the later occupation posited by Guo. See Xu Weihua, "Hunan Yueyang shi Tonggushan yizhi chutu Shangdai qingtongqi," *Kaogu* 2006.7: 90–91. In comments on an earlier draft of this chapter made in 2010, Robert Bagley pointed out to me that a similar *gu* and *ding* were unearthed together in 1966 from a tomb roughly one thousand kilometers to the north, in Xin xian (now Xin zhou), Shanxi. See Shen Zhenzhong, "Xinxian Liansigou chutu de qingtongqi," *Wenwu* 1972.4: 67–69.

14. There are a few other bronzes known from the Yueyang area, including two *nao* bells discussed below (see n. 33), a *zun* from the Feijiahe area, and a *lei* (originally described as a *zun*); on the latter, see Yueyang shi wenwu guanlisuo, "Yueyang shi chutu de Shang Zhou qingtongqi," *Hunan kaogu jikan* 2 (1984): 26–28. The Huarong *zun* and Feijiahe *zun* are discussed briefly in Xiang, *Xiangjiang liuyu Shang Zhou qingtong wenhua yanjiu*, 269–71. For the Jinshi bronzes, see Tan Yuanhui, "Hunan Cendan nongchang faxian Shangdai tongqi mu," *Huaxia kaogu* 1993.2: 54–56. Overall, bronze finds from northern Hunan are sparse when compared to those from the Xiang and Wei River valleys in the interior.

15. The Pengtoushan site is treated as the type site for the earliest Neolithic culture recognized in northern Hunan, dating from as early as 7500 BCE. It is followed in the currently understood chronology by another local culture with a type site at Shimen Zaoshi (the Lower Zaoshi culture [ca. 6000–ca. 4800 BCE]) and the Daxi culture (ca. 4300–ca. 3300 BCE), which covered a much larger area reaching across parts of Hubei, Hunan, and Sichuan. The Chengtoushan walled settlement was occupied first during the Daxi period and continued to be important during the following Qujialing culture (ca. 3300–ca. 2600 BCE). The Shijiahe culture (ca. 2600–ca. 1900 BCE) completes the standard chronology of the Hunan-Hubei central Yangzi region, perhaps not quite closing the historical gap with the Bronze Age.

16. Results of these surveys have not been systematically published, although they are summarized in the maps and brief descriptions provided in *Zhongguo wenwu ditu ji: Hunan fence*, ed. Guojia wenwuju (Changsha, Hunan: Hunan ditu chubanshe, 1997), esp. 108–15 and 204–38. In the fall of 2008, I traveled with Gao Chenglin of the Hunan Provincial Archaeology Institute and, for various legs of the trip, several local archaeologists, starting from Yueyang and the Tonggushan site in the northeastern corner of Hunan and moving west across the Li River plain to the site at Zaoshi. Along the way, we stopped at the sites of numerous Neolithic and early Bronze Age settlements identified in recent years by surveys. In the heart of the fertile plain, around modern-day Lixian, the Neolithic settlements were so dense that they seemed literally to overlap.

17. Hunan sheng wenwu kaogu yanjiusuo, "Hunan Shimen Zaoshi Shang dai yicun," *Kaogu xuebao* 1992.2: 185–219, reports three periods of occupation at Zaoshi: finds from the first period were very limited and may have been as early as lower Erligang; the majority of the finds were from the second period, coinciding with the upper Erligang period; the third and final stage of occupation was dated to the first and second phases at Yinxu. The archaeologists describe this final stage of occupation as a time of "continued development of the local culture, with diminishing influence from the Shang." Guo Shengbin has somewhat refined this stratigraphy, arguing that it closely matches the finds at Tonggushan; even without turning to his more refined study, the broad outlines of the history of the Zaoshi occupation support an understanding of the two sites as related to each other. See Guo, "Yueyang Shangdai kaogu shulüe." None of the archaeological chronologies that typically are employed accounts very well for what is now sometimes referred to as the "transition period" between the end of the Erligang and the start of the Anyang phase. This is symptomatic of the reliance on a chronology tied to developments in north China. In the case of northern Hunan, the transition from the Erligang-period occupation at Shimen to the early Anyang-period occupation has actually been carefully worked out, and the gradual ascendancy of the local Bronze Age cultures in the wake of the Erligang retreat from the region suggests that in this area, the term "transition period" is perfectly accurate.

Between the eastern and western limits of this plain, the sites of the important Neolithic settlements at Pengtoushan and Chengtoushan are found, testimony to the long history of settlement in the region, and the Zaoshi site itself is the type site of the Neolithic Lower Zaoshi culture.[15] Clearly, the entire Li River plain was densely populated through much of the Neolithic and the Bronze Age as well, although only cursory surveys of the region have been conducted. A comprehensive account of cultural interactions among sites along the Yangzi and cultures farther north would have to take into account the rich interactions already evident in northern Hunan during the Neolithic, especially the late Neolithic at the height of the Qujialing and Shijiahe cultures.[16]

For the Bronze Age, however, the Zaoshi site, nestled tightly between two close mountain ranges just to the west of the broad Li River plain, is crucial, since it provides what is to date the only solid evidence of bronze workshops in Hunan outside the Yueyang region during the Erligang period in the form of a handful of bronze tools, a few fragments of stone and pottery molds, and some bits of copper dross at the site. Such finds on their own do not allow us much insight into the early Bronze Age in Hunan, but here it is clear that the evidence for metallurgy accompanies Erligang pottery assemblages just like those at Tonggushan, so that we can link the use of bronze at Zaoshi to persistent technological exchange and interaction with the inhabitants of the Erligang settlements farther east, at Tonggushan and perhaps Panlongcheng itself.[17]

The pottery at Zaoshi, like that known from the Yueyang Tonggushan site, is a diverse mix. Most notably, there is a group of items closely related to Erligang pottery and a second group that can be understood as local products. However, unlike the Tonggushan finds, here the two groups seem to coexist in time, and there is clearer evidence than at Tonggushan of the gradual shift away from Erligang assemblages and toward complete dominance of what archaeologists call the indigenous culture.

While the Tonggushan site was clearly chosen in large part for its location along an important traffic route, the settlement at Zaoshi is somewhat isolated and may have been located primarily for strategic reasons, as discussed below (map 3). After forming in the mountains at the far northern end of the Xiangxi region, the Li River drops down to the broad floodplain and flows east toward Dongting Lake. It is joined by the small Xie River, which winds through a series of steeply rising mountain chains to the northwest of the Li River floodplain. The Zaoshi site is located on the northern bank of the Xie, in a narrow valley formed between two parallel mountain ranges, roughly 9 kilometers upstream, as the crow flies, from the confluence with the Li River (but following the twisting course of the Xie, the distance is about 14.5 kilometers). Unlike the Erligang type site at modern-day Zhengzhou, and the sites at Panlongcheng and Tonggushan, the Zaoshi site is in a particularly mountainous region (fig. 7). The settlement itself, located on a broad bank where the river cuts sharply to the east on its southern journey through the valley to join the Li River, is a mere 85 meters above sea level, but the mountains immediately behind the site, to the north, rise to more than 425 meters, and the sharply rising peaks to the south reach over 500 meters. Once the Xie cuts through these mountains, the elevation of the surrounding terrain drops off immediately, and following the Li River eastward past Shimen, the broad plain stretching some 56 kilometers to Jinshi, where the river twists to the south again, runs roughly between 46 and 36 meters above sea level.

In 1984, another important site was excavated a mere 2.4 kilometers downriver of Shimen, at Baota, on the southern bank of the Li River (map 3). The pottery at the Baota site matches that at Zaoshi: there are two distinct groups, one matching Erligang assemblages and a second local group that overlaps with and then

MAP 3. The Zaoshi and Baota sites.

FIGURE 7. Looking south across the Xie River from the Zaoshi site.

18. See He Jiejun and Cao Chuansong, "Hunan Lixian Shang Zhou shiqi gu yizhi diaocha yu tanjue," *Hunan kaogu jikan* 4 (1987): 1–10.

19. But the Zaoshi site seems also to have been integrated into other networks not centered on Panlongcheng. For example, its occupiers may have been in regular contact with the settlement near modern-day Jingzhou at Jingnansi in southern Hubei; see note 21 below.

20. Just across the Xie River from the Zaoshi site, locals unearthed what seems to have been a grave furnished with pottery and a few jades, all recognizably belonging to the Erlitou culture that spread from the North China Plain in the centuries preceding the Erligang expansion. See *Hunan kaogu manbu*, ed. Hunan sheng wenwu kaogu yanjiusuo (Changsha, Hunan: Hunan meishu chubanshe, 1999), 32. It is unclear what impact the Erlitou culture had this far south, and the nature of the transition from the Shijiahe culture of the late Neolithic to the Erligang sites discussed in this chapter remains uncertain. Archaeologists working in Hubei and Hunan have begun to formulate the notion of a "post-Shijiahe culture" to describe changes in the region that are as yet discernible only in vague outline.

21. Jingzhou diqu bowuguan and Beijing daxue kaoguxi, "Hubei Jiangling Jingnansi yizhi diyi, erci fajue jianbao," *Kaogu* 1989.8: 679–92, 698; *Jingzhou Jingnansi*. The earliest occupation is categorized as part of the Daxi culture, which is followed by a period of Longshan occupation (the exact identification of cultures in this era is problematic, but generally the Shijiahe culture is dominant), and then Erlitou and Erligang strata. The Bronze Age occupation seems to be continuous from the Erligang through roughly the first phase of Yinxu (the early occupation at Anyang), and then there may be a break before occupation resumes in the late Western Zhou and continues through the Eastern Zhou; this entire region was a central part of the Chu state. The site was occupied again in the Western Han (206 BCE–24 CE). In addition to pieces closely related to vessels characteristic of the indigenous culture at Shimen Zaoshi, pottery from the Erligang-period occupation at Jingnansi includes styles prominent at Zhengzhou but rare at Panlongcheng as well as styles that figure prominently at Panlongcheng but are rare at Zhengzhou, suggesting to some that the Jingnansi site was in direct, independent contact with each of these Erligang political centers. On the basis of this, *Hunan kaogu manbu* (32) posits two major routes of southern expansion out of Zhengzhou: one that moved south through modern-day Nanyang, in Henan, and then directly down to the Jingzhou region, and another that split off from this route near modern-day Xiangfan or Zaoyang, in northwestern Hubei, and then passed through modern-day Suizhou to Xiaogan and finally arrived at the Panlongcheng settlement. The latter is the better documented. Liu and Chen, *State Formation in Early China*, 51–53, 118–19, discusses yet another route, which moves almost directly south from Zhengzhou to Panlongcheng. On paper, this last route seems the most direct, but it was by no means the easiest to traverse.

replaces the Erligang set.[18] The Baota site was occupied from sometime during the Erligang period down through the transition period (ca. 1300–ca. 1200 BCE) and into Yinxu phases 1 and 2, contemporary with the last stage of occupation at Zaoshi (roughly the twelfth century BCE). The Baota site sat on the edge of the Li River plain, at the gate, so to speak, between the Zaoshi site and the rest of northern Hunan. Keeping in mind that survey data suggest that the Li River plain was densely populated and must have been an important area for farming (the walled Neolithic settlement at Chengtoushan, in the middle of this floodplain, is one of the earliest known sites of domesticated rice cultivation), the Zaoshi site appears to have been located defensively, behind a protective wall of mountains on the edge of this important fertile plain. Perhaps from this vantage point at the border between the broad Li River floodplain and the northern tip of the mountainous Xiangxi region, the occupants of the Zaoshi site exercised some form of control over the vast fertile plains of northern Hunan.

On current evidence, then, this site at Zaoshi can best be understood locally in relation to the broad fertile plain of the Li River and the neighboring site at Baota. It does not appear to have been an outpost of the Panlongcheng site. Zaoshi residents were the bearers of a largely independent, indigenous culture with considerable influence from the Erligang culture, with which they maintained regular contact through a vast network linked via the settlement at Tonggushan to the major political and ritual complex downriver at Panlongcheng.[19] Panlongcheng was itself undoubtedly integrated with many larger-scale political, economic, and social networks reaching farther east down the Yangzi and north to Zhengzhou and the Yellow River valley. Thus, in examining the Erligang sites in northern Hunan, we are looking at evidence of settlement patterns and cultural interaction centered on or, in the case of Zaoshi, integrated with political and ritual centers quite far away. We will return to the question of what exactly justified and sustained these large-scale networks in the conclusion.

THE ERLIGANG LEGACY IN HUNAN

I have reconstructed what I believe to be the primary route by which the Erligang civilization came into direct contact with the natural and human landscape of northern Hunan during the last half of the second millennium BCE. That route moved from north China through the regional hub of Panlongcheng, then followed the Yangzi upstream to the settlement at Tonggushan, just inside the border of modern-day Hunan province, which I identify as an outpost of the Erligang city at Panlongcheng.

Moving beyond this outpost, the archaeological evidence suggests, also takes us beyond the realm of northern cultural dominance and into a peripheral region where that influence was important but coincided with other powerful regional cultures. This seems to be the case in the area around Shimen, in northwestern Hunan, where we find signs that the Erligang presence, while surely an important catalyst (it brought the region into the Bronze Age), was but one among many overlapping regional powers.[20] The possibility that the Zaoshi and Baota sites were culturally and perhaps even politically diverse finds support from a look at a neighboring site at Jingnansi, Hubei, just outside of modern-day Jingzhou, on the banks of the Yangzi farther upstream from the Tonggushan settlement (map 1). The site was occupied from the late Neolithic to the end of the Anyang period, and as at Zaoshi, the Erligang influence is apparent but not dominant in pottery assemblages. Equally important are influences from upriver, in the Sichuan basin, and farther afield. And the same local pottery types seen at Zaoshi are found here at Jingnansi as well. Unlike at Tonggushan, there is no clear archaeological indication that northern culture ever dominated either the Zaoshi or Jingnansi sites.[21]

The legacy of the Erligang arrival in Hunan comes into much clearer focus when we turn our attention to the Yueyang region. As noted above, unlike the Zaoshi site, the Tonggushan settlement seems to have been established on virgin ground and was inhabited by a single group with a unified culture for a long period. In spite of this long occupation, it has been difficult to find evidence of the gradual influence of Erligang civilization on indigenous cultures in the Yueyang area. Nevertheless, the proliferation here of sites that were roughly contemporaneous with or just followed the last period of occupation at Tonggushan, after the Erligang influence there disappears, and that share distinct cultural features with it (discernible primarily through analysis of pottery) makes this region an excellent case study of how the arrival of the Erligang culture transformed the local cultural landscape.

There are now a handful of sites known from the Yueyang area that were occupied during all or part of the Anyang period. They are clustered primarily along the banks of the Xinqiang River, which flows westward into Dongting Lake just south of Yueyang city, roughly forty-eight kilometers south of the Tonggushan site, but stretch south to the banks of the Mi-Luo River (map 2). The most important are the Duimenshan site, located north of the mouth of the Xinqiang; the Feijiahe site, just to the south of the Xinqiang; the Zhangshutan site, on the southern bank of the Xinqiang River, close to where it empties into Dongting Lake; and the Yusishan site, on the banks of the Mi-Luo River. There are five other sites in the same region that are all related, but the first three listed here are clearly the most important and, together with the fourth, indicate well the geographic range of this local culture.[22]

The pottery at these sites is distinct from Erligang assemblages, though not untouched by Erligang influence. As the sites have come to light over the past two decades or so, their relationships to one another and to the final stage of occupation at Tonggushan have only slowly and tentatively been worked out.[23] Of the nine that have been excavated in the greater Yueyang area, the Zhangshutan site was occupied for the longest time, beginning as early as late Erligang, contemporaneous with the later occupation of the Tonggushan site and perhaps even overlapping with the last stage of occupation there. The Zhangshutan site was continuously occupied down through the end of the Anyang period, roughly from sometime in the thirteenth century through much of the eleventh century BCE. Pottery remains from this site are particularly rich (it seems to have been a major pottery production site), so it is now increasingly treated as the type site for an archaeological culture shared by all the Anyang-period sites in the Yueyang region.[24] Guo Shengbin has described a pottery assemblage defining this culture that comprises *ding* cauldrons, *fu* pots, and a large jar made of hard, high-fired pottery of a style that seems to be unique to this area.[25]

This local culture emerged approximately as the Erligang occupation at Tonggushan was ending and spread out across the floodplains of the Mi-Luo and Xinqiang Rivers and north as far as Tonggushan, where it replaced the Erligang occupation. Pottery production is well attested at several of these sites. At the Feijiahe site, an astonishing sixty-three kilns were discovered, laid out in neat, dense rows. Pottery workshops have also been identified at some sites.[26] A few bronze weapons or implements are known from some of the sites, and at Wenjiashan, just south of the Zhangshutan site, stone molds for simple bronze implements were found. Bronze dross was found at Zhangshutan and Yusishan, and fragments of molds for bronze implements were also discovered at Zhangshutan.[27] At another site, Laoyazhou, east of Zhangshutan on the banks of the Xinqiang River, a single bronze fragment and several pottery crucibles likely used in the melting of bronze were uncovered.[28]

22. The sites are treated in detail, with comprehensive bibliography, in Xiang, *Xiangjiang liuyu Shang Zhou qingtong wenhua yanjiu*, 52–90. Broadly speaking, these sites can probably be considered constitutive of a single archaeological culture. There are, however, some cultural differences from site to site, and it is by no means certain that there was any political unity across any of these settlements.

23. See Luo, "Yueyang diqu Shang shiqi"; Guo, "Yueyang Shangdai kaogu shulüe," 63–69; Xiang, *Xiangjiang liuyu Shang Zhou qingtong wenhua yanjiu*, 52–90.

24. Earlier publications sometimes refer to the sites of the Yueyang region in the Anyang period as the "Feijiahe" phase, still considering it a local variant of Shang culture, but as the Zhangshutan site and others came to light, it became clear that this is an independent archaeological culture. Guo Shengbin argues that Zhangshutan is more representative than Feijiahe of this culture, while Xiang Taochu now argues for keeping the term "Feijiahe culture" while recognizing that this is not a local variant of Shang culture. See Guo, "Yueyang Shangdai kaogu shulüe," 66–67; Xiang, *Xiangjiang liuyu Shang Zhou qingtong wenhua yanjiu*, 52–53.

25. The most detailed argument is presented in Guo, "Yueyang Shangdai kaogu shulüe."

26. Xiang, *Xiangjiang liuyu Shang Zhou qingtong wenhua yanjiu*, 82.

27. Ibid., 64–66, 82–83; Guo, "Yueyang Shangdai kaogu shulüe," 68.

28. Xiang, *Xiangjiang liuyu Shang Zhou qingtong wenhua yanjiu*, 82.

29. Guo, "Yueyang Shangdai kaogu shulüe," 68.

30. In addition to the Huarong *zun* discussed briefly in note 14 above, the Yueyang Museum also houses a *ding* found at Huarong, but no information is currently available on its discovery, and no mention of the vessel has been made in any publication yet. The piece resembles the Tonggushan *ding* in shape, size, and decor.

31. See Tan, "Hunan Cendan nongchang." The pairing of a *gu* and a *jue* is typical of small-scale graves in the north at this time. The existence here of a tomb furnished in this way suggests an important settlement nearby, but no archaeological work has been done in the area since the salvage team's initial visit in 1991.

32. See Robert Bagley, "The Prehistory of Chinese Music Theory," *Proceedings of the British Academy* 131 (2005): 41–90, esp. 72–83, for a discussion of the role of bells in early Chinese music; see Li Ling, *Rushan yu chusai* (Beijing: Wenwu chubanshe, 2004), 3–10, for a discussion of the Ningxiang bronzes in the broader context of ritual burials in early China.

33. For a discussion of the discovery, see Xiang, *Xiangjiang liuyu Shang Zhou qingtong wenhua yanjiu*, 53. The bell is pictured in Gao Zhixi and Xiong Chuanxin, eds., *Zhongguo yinyue wenwu daxi II: Hunan juan* (Zhengzhou, Henan: Daxiang chubanshe, 2006), 27 fig. 1.1.12. The other *nao* bell from the Yueyang area is somewhat problematic. It was discovered in 1990 near Zhongzhou xiang, just north of the Feijiahe site, but was reportedly found buried with two pieces of bronze inscribed with the graph 金 (*jin*, "metal"), a practice reportedly known from the Han period (206 BCE–220 CE). There is some speculation that the bell, which probably dates from the Western Zhou period, may have been buried in the Han. It is a rather crude piece compared to the Feijiahe *nao* and others like it from the Ningxiang region. For the illustration and description of the discovery, see ibid., 46 fig. 1.1.36; the location is erroneously given as Jingzhou xiang. The same work (80 fig. 1.3.12) lists a *bianzhong* bell collected in 1982 from Xitang xiang in Yueyang county (presumably this is Xitang zhen). Virtually nothing is known about this piece.

34. The mix of cultural influences identified at the Jingnansi site, directly upriver from the Tonggushan site on the banks of the Yangzi, can be fruitfully compared to the complex situation in the Yueyang area. In the full site report, six archaeological cultures are identified for the early Bronze Age settlement at Jingnansi (although not all six overlap in time). An Erlitou pottery assemblage is followed by a group of Erligang vessels that coincides with several other assemblages representative of regional cultures: one is identified as local; one is linked to the local culture at Shimen, Hunan; one is identified as the Ba-Shu culture of neighboring Sichuan; and some influence from Jiangxi is discerned. See *Jingzhou Jingnansi*, 148.

The emergence in northeast Hunan of an indigenous culture able to cast bronze is an indication of the impact that the Erligang settlement at Tonggushan must have had on the region, even if the details of the interactions between the Tonggushan occupants and local inhabitants are not otherwise apparent. Still, bronze does not appear to have been a very important feature of Zhangshutan-Feijiahe culture. For that matter, as noted above, it does not seem to have figured prominently at the Erligang occupation of Tonggushan either. As far as we know, it would have been quite a scarce commodity locally. Nor do jades appear to have been culturally important. Pottery is the single most important cultural relic visible in the archaeological record, and it seems to have figured prominently in the economy of the region; Guo Shengbin suggests that high-fired pottery made in the Yueyang region was exported to Anyang.[29] In the few instances in which bronze vessels are found, however, it is unclear how or even if they were integrated into local cultural practices and beliefs and whether they were anything more than magnificent anomalies in the local economy.

At none of these sites have bronze vessels been excavated in association with settlement remains; they have thus far only been discovered by local residents in proximity to excavations. The two bronze vessels found at Tonggushan along with stone implements and potsherds are likely to have been grave furnishings, but the answer to whether they were buried in a manner that suggests close ties to northern practices or served some other purpose is forever lost to us. Almost nothing is known about the context of two bronzes from across the Yangzi at Huarong that are both early Anyang-period pieces.[30] Farther west, near Jinshi, locals removing soil for a project discovered a *gu* and a badly damaged *jue* in 1991, both also dating from the Anyang period. Archaeologists called in to examine the site describe finding remnants of a crudely executed tomb with two chambers and a ramp, but absolutely nothing else is known from the region, perhaps because of thick soil deposits resulting from centuries of flooding.[31] At Feijiahe, we have the most intriguing of all the bronze discoveries in the Yueyang region. In 1972, local residents digging a fish pond discovered a single, massive *nao* bell. This was the discovery of the Feijiahe site. Archaeologists from the provincial museum were dispatched and discovered numerous pottery kilns in the area, but proper excavations did not come until 1981 and 1982. We take notice of this find because of the huge importance of *nao* bells in Hunan in the Anyang and early Zhou periods. Xiang Taochu lists seventy-two such *nao* bells from Hunan. Their role in the Bronze Age cultures of Hunan, while undeniably important, is still unknown to us. They seem never to have been interred in graves but rather to have been buried singly or occasionally in groups along mountainsides or near rivers in shallow pits.[32] This practice, so common elsewhere in Hunan, is exceedingly uncommon in the Yueyang region, the Feijiahe bell being one of only two possible exceptions.[33]

Careful attention to the pottery remains and burial practices of the Zhangshutan-Feijiahe culture points to much more than Erligang influence. The hard-fired pottery noted above is generally understood to be a hallmark of the so-called Yue culture from southeast of Yueyang, in Jiangxi particularly. Some of the pottery styles that compose the full Zhangshutan-Feijiahe assemblage can be traced to Jiangxi as well. The two regions are adjacent, and narrow river valleys that cross the mountains dividing Hunan from Jiangxi allow for direct contact without the need to travel north to the Yangzi first. Other features of the pottery here show distinct influences from the so-called Ba culture of the upper Yangzi as well. Thus, it is fair to say that by the thirteenth century BCE, the Yueyang region had become a hub for multiregional interaction.[34] Given the relatively sparse record of occupation in this area during the late Neolithic, it is also likely that the Erligang arrival to the region served as a catalyst to this interregional interaction, increasing traffic to and through the region and propelling it to regional prominence.

When we turn our attention to the Erligang legacy at Zaoshi, we find less conclusive evidence but some hints of more important linkages. There is still a great deal we do not understand about the Zaoshi site; it is clear now that excavations there were not carried out on a scale matching this region's probable importance. In spite of this, it is now widely acknowledged among archaeologists in Hunan that the Zaoshi site is probably a very important piece of the larger Hunan Bronze Age puzzle, perhaps even key to understanding developments after the Erligang period, when the archaeological record of all of Hunan quickly becomes far more diverse and complex. While the direct impact of Erligang culture on Hunan appears to have been limited to the area reaching from modern-day Yueyang west along the northern banks of Dongting Lake and as far as Shimen and Zaoshi, the long-term impact of its arrival in northern Hunan is likely to have been of major significance. We would like to understand the Erligang contacts with Hunan in a broader context. On the one hand, as we have seen above, there are questions concerning the long-term impact of these early settlements at Tonggushan and Zaoshi on other developments within Hunan. At both sites, and reaching throughout the regions in which they are situated, it is clear that occupation continued well into the Anyang phase and beyond. On the other hand, the evidence available suggests that links to the Shang capital at Anyang may not have been quite as direct or strong as the initial links to the culture of the Panlongcheng site. So far, the archaeological record falls just short of allowing us to trace direct cultural affiliations from the Yueyang or Zaoshi areas south to what would become the most important region of Bronze Age civilization in Hunan province, the Xiang River valley generally and the Wei River valley in modern-day Ningxiang county in particular. Yet understanding the relationship, whatever it might be, between early Hunan bronze-producing cultures on either side of Dongting Lake and the spectacular bronzes found in and around the Wei River valley must be one of our most pressing goals. In spite of considerable progress in recent years in understanding the archaeological context of the Ningxiang bronzes, many questions remain, and the civilization based in the narrow Wei River valley during the eleventh century BCE still appears so unprecedented that one of the leading archaeologists of the region has described it as entirely intrusive.[35]

Farther afield, we need to understand the role of early Bronze Age sites in Hunan as nodes along a larger network of communication routes linking the middle and upper Yangzi east to west and, to the south, linking the cultures of north and eastern China to the far southwest via the Xiang River. Erligang bronzes are negligible or nonexistent in Hunan and south into Guangxi, but the initial contacts made during the Erligang era appear to be the start of increasingly long-range interactions north-south along the Xiang River valley. Anyang bronzes, that is, pieces almost certainly cast at the Anyang site, are found scattered across Hunan and even deep into Guangxi province, as are vessels and other pieces that clearly employed Anyang technology and the Anyang repertoire but are likely products of regional foundries. Whether or not some of these foundries were located within Hunan itself—and if so, where—is still surprisingly unclear. If we are to understand the important developments of the Anyang and later periods, we need a better knowledge of what Hunan looked like before the explosion of interaction that came at the end of the second millennium BCE.

CONCLUDING REMARKS: INTERACTION NETWORKS AND THE EMERGENCE OF THE STATE

A prominent goal of this study has been the reconstruction not just of simple routes of contact, which are certainly important, but of nested clusters of interaction that form large-scale networks of political, cultural, and social interaction.

35. Xiang Taochu maintains that the Tanheli site in the upper Wei River valley represents a remnant of the Shang culture driven out of southern Hubei at the time of the Zhou conquest of the Shang (see, inter alia, Xiang, *Xiangjiang liuyu Shang Zhou qingtong wenhua yanjiu*). I do not believe that the current archaeological data support his hypothesis.

These networks usually took as their basic structure the existing networks of the physical environment, that is, river systems, along with other important considerations of topography, such as defensive positioning and flood patterns. Across such networks, at both the local level on a relatively limited scale (e.g., among the handful of sites within the Yueyang region itself) and across a much larger geographic scale, human beings moved, carrying with them luxury items and staples, cultural innovations and ideas, beliefs and practices, techniques and skills. Such networks of interaction were certainly already important in the late Neolithic period, but they required regular maintenance and renewal. Beyond the establishment and maintenance of physical infrastructure such as roads and outposts, interaction networks required regular social maintenance, the renewing of human relations that must have been their mainstay.

The Erligang expansion that figures so prominently in this volume can perhaps be understood as the single most important increase in the scale and complexity of interaction networks across the early Chinese landscape up to that time in history. The massive movement outward from Zhengzhou to new regional hubs such as Panlongcheng and then, radiating out again, to new frontiers integrated numerous local interaction networks and increased the complexity of the interactions by introducing new technologies and new ideologies, new ways of interacting, and new motivations for interaction. And the flow of people, goods, and ideas was never unidirectional. Investigations into the origin of the state in early China have been concerned largely with bounded territories, even if conceived of in novel ways. Shifting our attention to the unbounded networks that were the framework of state and civilization will likely provide insights heretofore unavailable to us.

The importance and complexity of interregional interactions across much of China proper by the Erligang era is abundantly apparent in the archaeological record, and this fact allows us to conceive of interaction networks in ways that substantially complicate and deepen our understanding of the rise of the state and civilization in China. It may be that the Erligang expansion to the south was motivated at least in part by the need to create and sustain routes of access to and means of control over natural resources. The copper-rich region of southeastern Hubei and northern Jiangxi must have been attractive to the Erligang settlers at Panlongcheng, and in this case, we can imagine metal ore as a sufficient motivation for the establishment and maintenance of the long-distance trade route that followed the Yangzi east from Panlongcheng to the Gan River. But no such easily identifiable justification is evident for the Erligang movement upriver from Panlongcheng into modern-day Hunan province.

One possible explanation is that there may have been movement of important resources out of northern Hunan that left little or no trace in the archaeological record; given the evidence that the region was densely populated, it is entirely possible that human beings were among the most important resources to be found here. At the same time, it may be that when Erligang agents moved into Hunan and established a permanent base at Tonggushan, they had no specific objective in mind. In fact, an intriguing possibility is that in the minds of the Erligang elite, active, robust interaction networks may have been not a means to an end but an end in themselves—that is to say, cultural and political power may have been understood to be created and sustained precisely by maintaining a dynamic and visible presence in such networks and by actively expanding or strengthening such networks whenever possible. Material resources, then, were but one in a broad range of cultural, political, and economic concerns that were pursued or articulated through interregional networks of varying scales. Another way to formulate this perspective is to argue that a defining feature of the rise of civilization, in China or elsewhere, was active participation in the creation, maintenance, and

expansion of vast, complex interaction networks. If this understanding holds any merit, then the Erligang civilization appears to us all the more fascinating and important in reconstructing the rise of state and civilization in early China.

Special thanks are due to my many colleagues at the Hunan Provincial Archaeology Institute, in Changsha, who have provided logistical assistance and/or accompanied me on numerous trips across Hunan province over the past seven years, particularly Xiang Taochu (now at Yuelu Academy, Hunan University), for his continued generosity and encouragement, and Gao Chenglin, who traveled with me for several days across northern Hunan in the fall of 2008 to retrace the route of Erligang penetration into the area that I describe in this study, and to the two directors of the institute over the time I have been visiting, first, Yuan Jiarong and, more recently, Guo Weimin, for their enlightened approach to collaboration and cooperation. Funding for various stages of the broader research project out of which this study has grown has been generously provided at Cornell University by the Jeffrey Sean Lehman Fund for Scholarly Exchange with China, the Department of Asian Studies, and the East Asia Program's L. T. Lam Fund for East Asian Studies. Finally, thanks are due to Robert Bagley and Rowan Flad for thoughtful suggestions on earlier drafts of this chapter, and above all to Kyle Steinke, for organizing the conference and this volume. His support and patience as I found a way to extract the Hunan Erligang material from a larger study of the rise of civilization in the middle Yangzi region were especially helpful.

Parting Thoughts

Bronzes and the History of Chinese Art

Maggie Bickford

I WAS BROUGHT into the Erligang project as an art historian, to speak from my perspective "as a non-specialist who has thought about and taught Chinese bronzes in the context of [my] engagement with the field of Chinese art history as a whole"—to quote Kyle Steinke's invitation to me. And this I am pleased to do, because I have been thinking about bronzes for a long time. A Chinese ink painting (fig. 1) brought me my vocation, but bronze studies (fig. 2) taught me how to think, to think in a new way for me—that is, to engage with objects through visual thinking. I shall begin with my formative experiences (including my art historical life before bronze studies) and recount what I believe bronze studies has given to me; I shall try to explain what it offers to my students in ways that go beyond the particularity of that specialty and inform all good art historical practice; and, finally, I shall raise the issue of our common challenge: What do we do when our findings profoundly disrupt an entrenched, useful, and much-loved master narrative?

Bronzes are fundamental to the history of the arts of China: literally, because they enter the material record early (if not as early as do pots and jades), and fundamental to the *practice* of the history of art because their study calls for the fundamental skills of the art historian—sustained, directed observation, rigorous visual thinking, precise articulation—points that I shall have cause to revisit throughout this essay.

For the education and training of historians of Chinese painting, the best thing about Chinese bronzes is what they are not. Bronzes are not paintings! Typically, they do not overtly display subject matter drawn from the observable natural world. A bronze ritual vessel is not the work of a named individual and so does not derive its value in whole or in part from its connection with a named hand. Unlike paintings, bronzes are not ensnared in a web of texts as is, for instance, figure 3, which bears a title inscription (*Early Spring* [*Zao chun* 早春]) and an artist's signature (Guo Xi 郭熙), as well as legible relations with extensive subtexts: landscape texts, philosophical and religious texts, biographical and critical texts, institutional and political texts.

Further to my point, for historians dedicated to Chinese scholar-amateur ink painting—as I have been for a good part of my practice—the best thing about early bronzes is that they are not covered with writing by a person whose name we know (as in fig. 4). In the case of this fourteenth-century painting, the artist wanted to speak to us both through the object he depicts and through the texts he inscribed. At the same time, and by design, the texts are his "instructions for viewing" the image. A multitude of conventions exists for reading his subject matter. His texts guide the viewer toward particular readings by describing circumstances (such as the occasion on which the painting was done) or by juxtaposing the image

FIGURE 1. Unidentified artist, Qing dynasty (1644–1911). *Ink Plum*. Ink on paper mounted on panel, 66 × 134.6 cm. Private collection, Providence, Rhode Island.

with a poem that selectively alludes to literary, historical, or cultural associations that adhere to the subject matter.

At the same time, he also communicates reliably by means of his choices of style and brushwork in his calligraphy and painting, that is, by means of visual allusion to the styles of old masters and the associations adhering to their received personae. After he has made his work, the understanding of his work will be further shaped by "life-and-times" textual accretions attaching to the artist and *his* received persona. For the beginner at the start of basic training as an art historian, this situation offers, as one of my students might put it, "way too much information!"

As an agent of art historical training, Chinese bronzes are not impoverished but empowered by the absence of this deluge of textual and contextual data. The student is thrown back upon the object. The object is your only friend. It will tell you a lot if you look at it carefully and patiently, ask it sensible questions, seek sensible answers.

EXPERIENCES IN PAINTING AND BRONZE STUDIES

A Mysterious Ink Plum

Some forty years ago, I met the painting that made me into a historian of Chinese art (fig. 1), a battered ink-plum painting on paper—a roughly scrubbed horizontal bough, from which spiky, blossoming branches stick up and penetrate the irregular interstices of columns of blunt black calligraphy. The ink was thick and abraded; the paper was cracked; glue applied long before to its mounting and rigid supports had seeped through the paper and stained its surface. The sellers' attribution proved to be wrong; their transcription and translation of the inscription also turned out to be wrong. Notwithstanding the painting's damaged state and the state of my ignorance, I knew that I had to have it and needed to understand it. We brought it home.

The inscription on this mysterious object ran all the way along its top edge. I did not know how to read Chinese. Ink-plum continued to work on me. At length, I quit my job and began to study double-intensive Chinese at Connecticut College in 1972. Charles Chu was my first teacher of Chinese language and of the history of Chinese art. As a volunteer, he taught a course on Chinese art with all the engagement and love for painting of a practicing painter. That year brought

FIGURE 2. *Fangyi*, provenance unknown, 12th century BCE. H. 29.8 cm. Winthrop Collection, Harvard University Art Museums (1943.52.109).

another transforming encounter—Tseng Yu-ho Ecke's *Chinese Calligraphy* exhibition at The Metropolitan Museum of Art, installed by Mike Hearn in the old "bowling alley" gallery.[1] I still remember the long approach, circumambulating the balcony above the Great Hall. Around the balcony, case after case was filled with the seductive forms, dazzling colors, and lustrous surfaces of the Altman porcelains; then, just before the exhibition entrance, Ogata Korin's *Iris* screens—lush, deep purple, malachite green, gleaming gold leaf. And then, nothing but black and white—acres of it, it seemed to me. There was ink on paper, ink on silk and satin, white-on-black ink rubbings, inks of every density and tonality. There were monumental hanging scrolls, whirling-dervish handscrolls, prim small standard script, dashing gestural cursive, rich round seal script, rubbed bronze and stone inscriptions. (Of course, I did not know the names of script types then.) This amazing monochrome world stretched out before me. "Tell me more!"

The next year, I entered Yale University's Chinese Studies MA program, designed for people like me with little or no previous training. I had not studied art history in college and began with Chinese painting, which I studied with Dick Barnhart. We talked about my mysterious ink-plum painting. Eventually, I brought it to school, and we looked at it together. "You know, Maggie, that's a self-portrait," said Dick.

1. The "bowling alley" (also known as the "airplane hangar") is now devoted to Chola bronzes and medieval Indian sculpture. At the time of the calligraphy exhibition, Maxwell K. (Mike) Hearn was a curatorial assistant; he currently serves as the Douglas Dillon Curator in Charge of the Department of Asian Art at The Metropolitan Museum of Art. The installation was his first assignment working with an in-house designer.

FIGURE 3. Guo Xi (ca. 1000–ca. 1090). *Early Spring*, signed and dated 1072, with detail of inscription. Hanging scroll; ink and color on silk, 158.3 × 108.1 cm. National Palace Museum, Taipei.

I was astonished. If the painter was portraying himself in the guise of a branch of plum, the branch gnarled and the blossoms few and clinging, what was he saying about himself? I asked: "Is he OK?"

"Yes, he's OK." Dick said.

"All right, then."[2]

Now, because as a college student I had been formed by the New Critics and had cut my analytic baby teeth on Joyce's *Portrait of the Artist as a Young Man*, this situation seemed tailor-made for me. I confidently set out on close readings of inscriptions and texts of various kinds (technical, historical, and literary) and more clumsily applied these methods to visual structures—often resorting to metaphor. My first art history paper of any kind was on an ink-plum master (fig. 4), who was amply attested in the textual and material record. A good result.

The next year, I discovered a forgery among the objects in a private calligraphy collection that our seminar was working up. If I had read about stylistic analysis before, the term did not stick in my mind, nor did the deployment of its methods as such. To me, it was just a matter of visual common sense (a vastly undervalued quality, in my view). The putative calligrapher (Jin Nong, 1687–1764+) had a highly

2. The painting leaned against a wall in Dick Barnhart's office for nearly two years. Chinese painting specialists came and went, proposing dates that ranged from the fourteenth to the seventeenth to the nineteenth century. Fu Shen's assignment of the painting to a minor eighteenth-century Yangzhou artist seemed to be the most satisfactory of these suggestions at the time. But in fact I still do not know the painting's maker or its date of execution.

idiosyncratic style, employing thick strokes that he made with a blunted brush.[3] Throughout a sample comprising hundreds of reproduced examples of his writing, he consistently formed the radical □ *kou* (mouth) the same way: the open space in the center left by his long, broad horizontal brushstrokes was only a horizontal slit. Of the hundreds that I examined, only the work that I was studying in seminar exhibited a *kou* in which long, thick vertical strokes consistently left a vertical slit [|] as the center of the *kou* element. More, in my Jin Nong sample, the calligrapher varied his generally squat forms by selectively making scythelike strokes. The imposter, in contrast, used these strokes in every instance that the form of a character permitted it—no doubt because it was a mannerism associated in his mind with the master he was impersonating. Less evidential, but nonetheless suggestive, was how charmingly the fake work was assembled: the black characters inscribed on cinnamon-colored paper impressed with gold flowers, and the whole in a turquoise mount. A pleasure to look at. After turning many more pages, I found, in a book devoted to Jin Nong's calligraphy, a reproduction of the Jin Nong

3. The model on which he based his hand is the Heavenly Omen Stele (*Tianfa Shenzhen bei* 天發神讖碑), dated 276; he is known to have had a rubbing of this stele. For discussion and reproduction, see *Shodō zenshū*, vol. 3 (Tokyo: Heibonsha, 1965), 12–23, 77–82.

BULLETIN OF THE MUSEUM OF FAR EASTERN ANTIQUITIES

I divide the regularly occurring décor elements into three groups, which I call groups A, B and C. In the table below I place group C between groups A and B. This division and this arrangement of the table are indeed an anticipation of the results of my enquiry, for, as the reader will find presently, A elements regularly go together with A elements and with C elements, and B elements combine with B elements and with C elements, but A and B elements do not as a rule occur together on the same vessel:

A Elements:	C Elements:	B Elements:
1. Mask t'aot'ie.	1. Deformed t'aot'ie.	1. Dissolved t'aot'ie.
2. Bodied t'aot'ie.	2. Dragonized t'aot'ie.	2. Animal triple band.
3. Bovine t'aot'ie.	3. Trunked dragon.	3. De-tailed bird.
4. Cicada.	4. Beaked dragon.	4. Eyed spiral band.
5. Vertical dragon.	5. Jawed dragon.	5. Eyed band with diagonals.
6. Uni-décor.	6. Turning dragon.	6. Circle band.
	7. Feathered dragon.	7. Square with crescents.
	8. Winged dragon.	8. Compound lozenges.
	9. S dragon.	9. Spikes.
	10. Deformed dragon.	10. Interlocked T's.
	11. Bird.	11. Vertical ribs.
	12. Snake.	
	13. Whorl circle.	
	14. Blade.	
	15. Eyed blade.	
	16. Spiral band.	

Let us first comment briefly upon the details of these elements.

A 1, A 2 and *A 3.* It was, as a matter of fact, not necessary, in order to establish the thesis of the present paper, to subdivide the true, realistic t'aot'ie into three variants, the mask t'aot'ie, the bodied t'aot'ie and the bovine t'aot'ie. Functionally they are interchangeable. However, since I have gone to the trouble of describing, though of course very summarily, nearly 1300 bronze vessels, I have thought it useful to bring a certain amount of detailed description into my definitions. Even so, although I distinguish three kinds of realistic t'aot'ie, this is, of course, an enormous simplification. The variations in the execution of the t'aot'ie are innumerable. There is a vast difference between the primary, simple and forceful t'aot'ie of our pl. II: 53 and the elegantly, almost playfully drawn and richly embellished t'aot'ie of pl. XVII: 591. It is not the aim of the present paper to follow up all these variations and shades, but to bring out some fundamental points, and I confine myself to three principal types of the realistic t'aot'ie:

A 1, the mask t'aot'ie, is well exemplified by pl. VII: 186 and IX: 214, VIII: 202.

14

original on which the fake was modeled. The original consistently displayed *kou* with horizontal centers and used extravagantly combed strokes only selectively. Today, I can recognize my findings as the outcome of stylistic analysis; back then, they were just common sense. Beginner's luck.

FIGURE 5. Reading lists, typescript with pencil and ink annotations, 1978.

FIGURE 6. List of Bernhard Karlgren's A, B, and C elements.

Bronze Studies and Graduate Training in Chinese Art and Archaeology

It would take another three years before I began to engage substantially with bronze studies. My previous exposure to Chinese ritual bronzes came to but a few lectures near the start of survey courses and quick marches through ancient China installations at the Museum of Fine Arts, Boston, The Metropolitan Museum of Art, and the Freer Gallery of Art in Washington, D.C, for the business of those days was painting and calligraphy. That focus tightened further as I entered Princeton University's PhD program in Chinese art and archaeology.

I began to study Chinese bronzes in earnest in the course of preparing for general exams at Princeton. The operative word is "general." These really were general exams—at a time when it actually was possible to read most of the major works on a wide range of topics—not like today. No one at Princeton was teaching early Chinese art and archaeology. But "The Problem of Ancient Chinese Bronze Vessels" was a classic Princeton generals topic, and I prepared for it by myself, although I was not entirely on my own. I was aided by the preparations of previous generations of graduate students who had compiled cumulative bibliographies (fig. 5) and who also left behind their collective wisdom through accretions of marginalia,

hastily or thoughtfully inscribed on the pages of books and articles. This probably was the only time in my life when I was up to speed on the scholarly literature. And, as far as the literature on Chinese painting went, it was deeply depressing to me. Much of the modern scholarly corpus seemed to be simply a sinologically informed literature of art appreciation: swollen with rhapsodic language, rich in translated classical texts, lively with tenuously supported speculation, replete with essentialist generalizations, and illustrated with paintings (purportedly the subject of the article) that even to my beginner's eye stood little chance of being authentic works.

Studies of stylistic development (of genres or the oeuvres of individuals) were ostensibly more objective. These often seemed strained in their authors' choice among available works of those that best fitted into their sequences (that is to say, outcome-driven selections). Most off-putting was the tendency among these authors to present theoretical structures as if they were factual history.

In this situation, the literature on bronzes came as an enormous relief. Not that it was necessarily more objective, or lacked in pompous rhetoric and authoritarian pronouncement, or was more frequently persuasive in its findings, but I could follow the overt dialectic among stakeholders, understand what was at stake, and, best of all, see what these writers were writing about!

I could see for myself (as my students, uncoached, still do) that Bernhard Karlgren's lateral classificatory and combinatory ABC scheme (fig. 6)—what Alexander Soper called "Karlgren's cryptic 'rules and prohibitions'"[4]—is incapable of producing a plausible developmental sequence: it is incapable of accounting for change. In contrast, I could follow—in three dimensions—the internal logic of Max Loehr's five styles.[5] As these powerful voices drew allies and detractors, bronze studies and its context widened. One could see why lobed forms asked for ornaments different from those cast into continuous, smoothly curved forms. The implications of Orvar Karlbeck's study of molds found new uses in small studies and large, such as Wilma Fairbank's "Piece-Mold Craftsmanship and Shang Bronze Design" and John Gettens's *Technical Studies*.[6] And the history of style and the history of facture were made to come together in accounts of characteristic vessel features such as compartmented decoration and flanges. The embrace of facture—particularly in the development of mold making—as a formative force would give Loehr's five styles a new level of satisfying plausibility.

Most exciting, of course, were the new archaeological discoveries and their fallout in bronze scholarship. The Erligang site at Zhengzhou materially confirmed the early stages of Loehr's theoretical sequence. (Imagine a sequence built from unprovenanced vessels that is substantially confirmed by archaeologically excavated material evidence!) Given their location, their level of casting and design, and the complement of pottery forms found along with them, the pre-Anyang bronze vessels delighted the nativist proponents of indigenously developed bronze technology. Energized by fine bronzes and impressive urban remains, scholars redoubled their efforts to correlate sites with textually recorded pre-Anyang capitals, thus reinforcing a linear dynastic narrative of Xia and Shang with Anyang as its climax: Chinese civilization fully formed.

But there were awkward loose ends. First came the finds at Panlongcheng, Zhengzhou's sister city located an astonishing 450 kilometers to the south, and then the animal-form vessels of the south, found not in tombs but by rivers and in the mountains. These evaded monolithically Anyang-centric explanations. Then, finally—just before my exams—came the archaeological reports of the 1976 discovery of Anyang Tomb 5, the unplundered tomb of Fu Hao, consort of the Shang king Wu Ding (ca. 1200 BCE). Unimaginable riches! Now my problem (not faced by the previous general exams cohort) was how to assimilate this treasure house and understand its implications for previous scholarship—quickly. Well, the finds

4. Alexander Soper, "Early, Middle, and Late Shang: A Note," *Artibus Asiae* 28 (1966): 33.

5. Max Loehr, "The Bronze Styles of the Anyang Period," *Archives of the Chinese Art Society of America* 7 (1953): 42–53. If Robert Bagley's book, *Max Loehr and the Study of Chinese Bronzes: Style and Classification in the History of Art* (Ithaca, NY: Cornell University East Asia Program, 2008), had been available back then, I could have understood Loehr and Karlgren more efficiently and deeply; but then again, that would have deprived me of the small self-discoveries that made for later changes in my practice. See the bibliography in Bagley's *Max Loehr* for works by Karlgren and Loehr.

6. Orvar Karlbeck, "Anyang Moulds," *Bulletin of the Museum of Far Eastern Antiquities* 7 (1935): 39–60. Wilma Fairbank, "Piece-Mold Craftsmanship and Shang Bronze Design," *Archives of the Chinese Art Society of America* 16 (1962): 8–15, reprinted in her *Adventures in Retrieval: Han Murals and Shang Bronze Molds* (Cambridge, MA: Harvard University Press, 1972), 183–201. Rutherford John Gettens, *The Freer Chinese Bronzes*, vol. 2, *Technical Studies* (Washington, DC: Smithsonian Institution, 1969).

FIGURE 7. Painting in figure 1, altered, inscription removed.

preserved Loehr's relative chronology but pushed his fourth and fifth styles back in time to the reign of Wu Ding. So, too, with ancestor inscriptions, which had been thought to have begun later in the Anyang occupation. There were also Anyang vessels and perhaps tribute vessels that came from elsewhere. The variety of vessel forms, scale, and ornament was impressive. And most thought-provoking was the knowledge that all of this material (including also jade and stone) had been brought to one place at one time.

"The Problem of Ancient Chinese Bronze Vessels" did indeed appear as a topic on my general exam sheet. And although I scorn those Princeton diehards who consider their exams to have been a religious experience, I admit that writing my exam essay on the topic—a historiographic and bibliographic task in the circumstances—was the closest that I have ever come to automatic writing, straight from my brain to my typing fingers!

The experiences that my earliest engagement with bronze studies brought to me are what I want to transmit to my students:

First of all is the primacy of the object—that is, the test of any theory is the object that it seeks to explain. However firm the voice of authority, if its words do not conform to the visual evidence before one's eyes, the theory fails. At Princeton, our teacher Wen Fong had told us many times, "The object is always right." That seemed to me in my student days to be words only. No longer.

I want them to understand the materiality of the object under study, even though they mostly see objects in two-dimensional projections, and in one view only. I want them to understand facture: how the object at hand is the outcome of the meeting of material and technology, of designers, mold makers, and foundrymen who all work upon one another and change together.

I want my students to understand that visual thinking as method does not come naturally to most of us, and that often it comes hardest to those with a talent for quick-witted articulation. It requires patience and the discipline to resist the urge to flee from the reticent object and indulge in verbal improvisations.

I want them to understand that knowledge is not static but changes through scholarly conversation—assertive, divisive, defensive, conciliatory or not—and, decisively, through confronting new material evidence that does not fit and will not go away. In this regard, bronze studies is an exemplary case in point. What must one do when an established and serviceable picture of Bronze Age China and

its development cannot accommodate new archaeologically excavated material evidence— at not merely one exceptional site but many?

In line with this, I need my students to understand that all developmental theories and schemes are provisional constructions built in the eyes and minds of people. A scholar looks and looks, and lumps and splits for a long, long time, and then takes her best shot at a plausible account of change over time. However attractive, and however congruent with the received textual record, at the point that the "exceptions" cannot be brushed aside, the cerebral theory must be adjusted to accommodate the new material evidence. Sometimes the changes required are small ones—an absolute chronology becomes a relative one; sometimes accumulated "exceptions" demand that we rethink the very foundations of Bronze Age civilization in China, as we are doing now.

Today, the irony is not lost on me that I learned these goals from bronze studies instead of from my Princeton training in Chinese painting, for, surely, nowhere were the methods and deployment of visual inspection and analysis more keenly and intensively demonstrated than they were at Princeton by Wen Fong. Maybe (like some of my own graduate students) I simply suffered from mother-deafness, that is, the inability to learn from one's own teacher, concomitant with a (maddening) avidity for learning from anyone else. I think also that it was my upbringing in text and my focus on the individual behind the text, who produced it, because he had something to say to me. For me, then, stylistic analysis as an end in itself, rather than as a tool, did not make sense—especially when the maker of a work such as the one in figure 1 was pressing upon me so much textual content as well as visual information. Sometimes it seemed that a blinkered focus on formal particulars was blocking out everything else, and the paintings, I felt, could have been made by Eskimo. Sometimes, I felt, the inscribed work of art (I've long thought that we are guilty of a misnomer in calling these word-and-image objects "paintings") was threatened with mutilation (fig. 7), the artist's "text" being cut down to leave little besides its formal features and its stylistic models. Bronzes did not suffer from these problems. If they were inscribed, the inscription was discreetly placed on the underside or interior. I could concentrate on the visual and material evidence of the object undistracted by the elephants in the room that we were not talking about.[7]

There were lots of things that I did not understand then. And I must have learned more from Professor Fong's painting training than I thought I had, because I use his methods every day. Nevertheless, for me—and I think for my students—the clearest, most developed, and most accessible beginning in object-centered practice is bronze studies.

Chinese Bronze Studies in the Liberal Arts Classroom
At the start, when I began to teach the Chinese art survey, I taught what I had been taught: a master narrative embodied in a procession of monuments, hundreds of which were to be memorized and recalled on exams, the whole intended to build foundations for further study in the history of Chinese art. But foundations for whom? My beginners' classes have the most heterogeneous group of students I teach. There are freshman and seniors; art history majors who know nothing about China and East Asian studies majors who are visually illiterate; American-born Chinese students dipping their toes into their remote heritage and students from China for whom antiquity is just as much a revelation as it is for their American-born classmates. And then there are those who are simply homesick. For some of my students, my course is a form of academic tourism: computer science students and economics students and premed students make use of Brown's pass/fail option to try out something different (my course often

7. Is it just my students and I who, given simultaneous exposure to words and images, will read the text first?

FIGURE 8. Unidentified artist, late 12th century. *Sparrows, Plum Blossoms, and Bamboo*. Fan mounted as an album leaf; ink and color on silk, 25.7 × 26.8 cm. Bequest of Mary Clark Thompson, 1927. The Metropolitan Museum of Art (24.80.487).

FIGURE 9. Sources for an analysis of figure 8. (a) *Birds in a Thicket of Bamboo and Plum*, early 12th century? Detail as reproduced in Cahill, *Chinese Painting*, 69. Hanging scroll; ink and colors on silk, 258.4 × 108.4 cm. National Palace Museum, Taipei. (b) Emperor Huizong (Zhao Ji, 1082–1135, r. 1101–1125). *Finches and Bamboo*. Handscroll; ink and color on silk, 27.9 × 45.7 cm. The Metropolitan Museum of Art, Purchase, Douglas Dillon Gift, 1981. John M. Crawford Jr. Collection (1981.278).

is their fifth course), and usually they are among the best beginners in my class. What can I teach them?

Whatever else I am teaching them—and my priorities and distribution of topics change from year to year—I must teach them how to look closely at objects and to articulate what they learn from them, because they do not know how to do it. My students are smart, intellectually adventurous (usually), and willing. But one thing that most of them share is a fear of objects. (The pre-professional art historians among them instinctively shy away from what they fear, giving priority to iconography or to social and economic context, or putting theory at the center and pushing the serious study of objects to the unfruitful margins.)

Like many of us, they most enjoy doing what they already know how to do. They are programmed for success, they have a low tolerance for uncertainty, and they are more vulnerable than we are. Left to their own devices in a written viewing exercise, many of them will circle the object warily; they will write all around the object; they will write about everything except the object. Thus, in many of the papers I receive in response to a short essay assignment that asks them to compare two sets of bronze felines, half-baked, error-ridden accounts of Zhou (ca. 1050–221 BCE) and Han (206 BCE–220 CE) culture account for a good two-thirds of the content.

Faced with a viewing exercise, a measure of their anxiety and fear of failure is the way in which those rare students who cheat approach their work. (It is always a perfect-GPA student; as far as I know, I have never had a foundering student cheat.) If they plagiarize, what do they copy? They don't copy ideas. They have plenty of ideas of their own. If they plagiarize, they lift visual characterizations of objects.

To take an extreme example from real life, in one viewing assignment, I asked students to analyze an anonymous, late-twelfth-century bird-and-flower fan painting, *Sparrows, Plum Blossoms, and Bamboo* (fig. 8). Given this task, a resourceful overachiever turned to James Cahill's treatments of two near-contemporary paintings in the same genre but in different formats: the anonymous, twelfth-century *Birds in a Thicket of Bamboo and Plum* (fig. 9a) and Emperor Huizong's (1082–1135) *Finches and Bamboo* (fig. 9b), both discussed in Cahill's book *Chinese Painting*.[8] These she combined and plugged into her essay, which she presented as her own analysis. She went about her work fastidiously: she adjusted the number and species of birds to match the fan; she rearranged Cahill's paragraphs, the better to blend the two source characterizations; and she did some copyediting that actually improved Cahill's prose, no mean feat. Her essay was a notably well-crafted one. It must have taken considerable time and thought to tailor her unacknowledged borrowings to the case at hand. Expending the same time and thought, she probably could have devised her own visual analysis. Why did she not do that? I think it was fear of failure. She didn't know how to engage with visual situations, and she feared to try where she might not succeed. Now this was a rare, extreme case of adaptive plagiarism. What is not at all rare is the timid student who will put his or her borrowed insights within quotation marks and carefully acknowledge their authoritative sources by means of notes and bibliography. These honest students also are afraid to trust their own eyes and their ability to articulate usefully what they understand.

In this situation, my job is clear to me. I must push my students toward objects. I must hold them to questions that make them linger there. And I must help them to build their confidence and competence through their success in thinking and explaining in ways that are more foreign to them than are the non-Western objects that they study with me. Here, the objects of ancient China are the best instruments at hand.[9]

8. James Cahill, *Chinese Painting* (Geneva: Skira, 1960), 69 and 73 (plates only), 74–76.

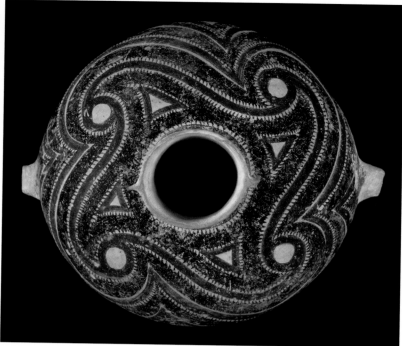

I find it good to begin with Neolithic painted pottery (fig. 10). The person who painted this pot was not painting a picture—in fact, if we judge by excavated material evidence, people in ancient China showed little interest in making pictures for a long, long time. The person who painted this pot was not translating a verbalized idea or her personal feelings of the moment into visual form. She was thinking visually and three-dimensionally about appropriately decorating a particular pot—the blank pot in front of her. Like the pot form itself, the pattern that she painted on it was most likely a conventional type. It had been developed (during the course of who knows how long a period) to enhance the great bulging body of special storage jars and their effect of near-bursting plentitude. But if the pattern elements—principally the running spiral—are generic, the painter's performance is specific to the particular pot under her hands.[10]

She marks four nuclei (which she forms by reserving the clay body against applications of slip rich in iron oxide) equidistantly along the circumference midway between the pot's point of greatest girth and its narrow neck. (If the pot were smaller, the nuclei would be closer together.) From these, she freely swings the spirals: up and around the retreating surface toward the neck; swooping down, diagonally, over the expanding surface of the shoulder; winding up into the next nucleus, whence the spiral recommences.

All this application takes place in three dimensions and three colors (although the colors will not be as we see them until after the pot has been fired). Echoing the contours of the spiral arms is a sequence of unpainted clay body, manganese-black strokes with toothed upper edges, unpainted body, and iron-red strokes, with the whole repeated twice more as the painter works her way down the pot. The unpainted clay body between the colored strokes not only adds a third color but unobtrusively insists on the material of the form beneath the painting. The swelling strokes that accumulate around each nucleus cradle the form and emphasize its swelling convexity. As the strokes rise and fall, they develop the triangular negative space between the spirals, making angular, hooked peaks, shrinking into crisp triangles beneath the banded neck, devolving into bowed chevrons above the banded and scalloped belly. Above, the band marks the boundary between the globular, convex body and the cylindrical, straight-sided neck; below, the banding demarcates the painted belly from the unpainted, severely tapered lower pot. A

FIGURE 10. Narrow-necked jar with vertical handles, Majiayao culture, mid-3rd millennium BCE. Buff earthenware painted in black and red; h. 35.9 cm, diam. at mouth 10.4 cm, diam. of foot 13 cm. Museum of Fine Arts, Boston, Frederick Brown Fund, 1929 (29.1038).

9. I now am going to focus on my use of ancient vessels as a means of fostering visual thinking. The reader should not take this to imply that, in my teaching, I deprive the objects under study of their archaeological, historical, or cultural contexts. For distinctions and commonalities between the interests of art historians and archaeologists, see Bagley's discussion in *Max Loehr*, 77–80.

10. On visual thinking, see Ruth Bunzel, *The Pueblo Potter: A Study of Creative Imagination in Primitive Art* (1929; repr., New York: Dover, 1972). My discussion of the running spiral pattern follows Robert Bagley, "Chapter One. The Neolithic. 1.2. The Majiayao Culture," undated typescript. I am grateful to Bagley for introducing me to Bunzel and for sharing his manuscript with me.

pair of lugs—probably a feature of the everyday, practical prototype for this special pot—may suggest presentation faces, but the spirals and their elaborations pay them no mind as they circulate around and around.

The ideal view of this pot and others like it is thought to be from a point above it. In Neolithic burials, they are often found sunk into the ground of the grave, which may account for the unpainted lower zone. In my classroom, after we examine such a pot on the table, we put the pot on the floor, stand looking down at it, and get a second reading from that point of view (fig. 10, right). Now the bulging upper surface rises to meet us. The cylindrical neck collapses into the body and disappears, leaving only its plain, ringed mouth, forming another kind of nucleus, banded and cornered with triangles. From this vantage point, the pulse of the running spiral is more dramatic, its continuous motion tighter, less relaxed, nearly hypnotic.

Globular pots with unitary decorations will have a long history in Chinese material culture. But does that mean that every day, in every way, they will get better and better? Comparisons between the Neolithic pot (fig. 10) and an eighteenth-century CE vessel (fig. 11) resist an art historically Positivist "yes." If our basic investigative question is "Better compared to what?" we had better ask "Compared to what in what way(s)?" It is readily seen that there have been numerous technical improvements: the Neolithic potter achieved rough symmetry and smooth surface by paddling, scraping, and burnishing her coil-built pot while turning it on a mat; the Qing dynasty (1644–1911) imperial potter produced her symmetrical, continuous form by extruding fine, white porcelain clay on her spinning potter's wheel. The low-fired earthenware vessel is soft and porous; the high-fired porcelain vessel is vitreous, hard, and waterproof.

What about their ornament? The Neolithic pot relies on slips (liquid clay) colored with iron and manganese oxides that yield dry, rusty reds and black on

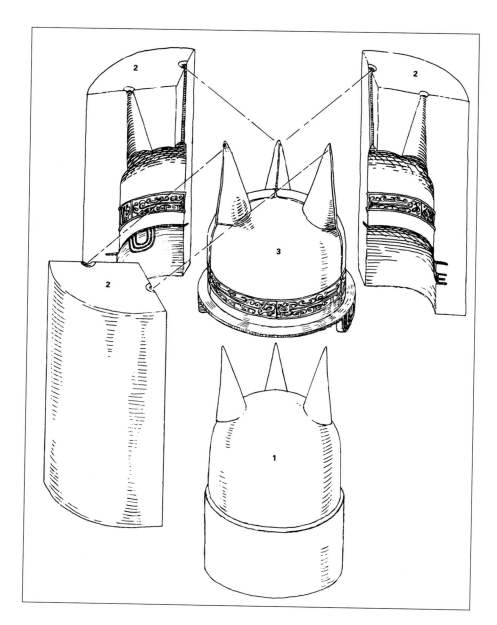

FIGURE 12. Diagram of piece-mold casting assembly for a *ding* vessel. (1) Clay core. (2) Clay mold sections (formed on an undecorated model and the decoration then carved into them). (3) Finished bronze, showing mold marks along the lines where the mold sections met.

firing. The porcelain pot is decorated with luminous enamels in brilliant color. If we focus on the relationship between form and decoration, however, advance in design is not as clear-cut as are the technical advances. The enamel decoration on the porcelain vessel takes the form of peach tree branches that rise from its base and, displaying all growth stages, wrap around its belly, shoulders, and neck. Like the running spiral and its elaborations on the Neolithic pot, a cluster of three ripe peaches draws attention to the porcelain vessel's assertive convexity. But to what end? In the case of the running spiral, the integrated ornament is developed to enhance the particular three-dimensional pot underlying it—that is to say, the ornament serves the form. In the case of the fruitful peach tree, the porcelain pot lends its convex form to the illusionistic three-dimensional volume of the painted ripe fruit—that is to say, the form serves the ornament. Viewed from this perspective, we might consider that we witness alienation, or at least a shift in partnership, between form and decoration. The lateral peach branches languidly extend along the arced surface; the fragile, topmost flowering twigs seem an effete finish to this robust form. And nowhere does the pictorial decoration find the energy and dynamic movement of the spirals. We might decide that in regard to the integration of form and unitary ornament, this Neolithic pot is a mature exemplar, more successful, if less sophisticated, than the Qing dynasty imperial porcelain vessel. Food for thought.[11]

11. In this connection, it is useful to reread Max Loehr, "The Fate of the Ornament in Chinese Art," *Archives of Asian Art* 21 (1967–68): 8–18.

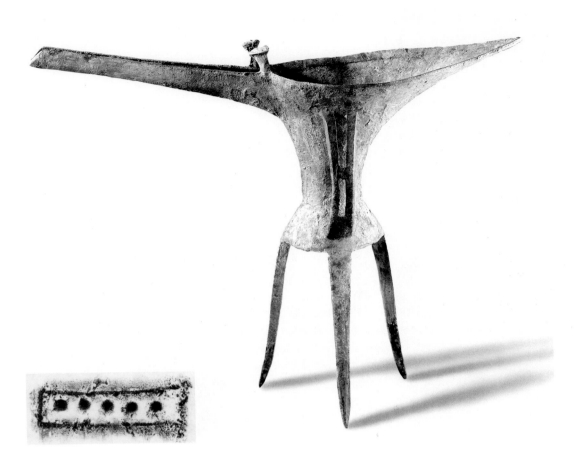

FIGURE 13. *Jue*, 16th century BCE, with rubbing of decoration on the side opposite the handle. H. 22.5 cm. From Yanshi Erlitou, Henan, discovered in 1975.

Given that the subject of my essay is bronze studies, the reader might wonder at this point why I have expended so much space on pots. One response is that pots occur much earlier in the archaeological record and, therefore, earlier in my syllabus and in laying the foundations for the work of the course. A more honest response might be that I, like my students, tend to do what I am most comfortable doing. I am a trained potter. I rely on my experience as a maker to draw my students closer to object-centered study, to thinking with their eyes and hands and to considering ideas that are unlikely to come to them otherwise. Entering the material and methodological richness of the Bronze Age, I rely more on the experience of others, tempered by our close viewings and critical readings of argumentation.

In my entry-level survey I must compress the Bronze Age severely. We study pre-Zhou bronzes in one fifty-minute lecture and two discussion sessions (keep in mind that my syllabus promises to deliver my students to modern Shanghai before Christmas).[12] Under these constraints, it comes down to Anyang and the development of bronze styles and piece-mold casting. The Anyang part is easy: a stirring narrative of excavations carried out in turbulent times; the location of Shang in a newly discovered material record alongside its sacrosanct, but unproven, place in the traditional textual record; giant tombs piled with human remains and great objects in a wide range of mediums.[13] Understanding the objects—including bronze vessels from other sites—is a different matter. It requires asking new questions, developing new skills through directed close viewing, and engaging with technology as a formative element of style.

Max Loehr's 1953 "The Bronze Styles of the Anyang Period" is a powerful example of visual thinking through close viewing *with a purpose*, a relentless exploitation of the art historian's basic strategy of comparison. The story is of course familiar to readers—how, while Chinese archaeology was still in its infancy, Loehr worked with his eyes, mind, and sympathetic imagination to understand the historical development of mostly unprovenanced ancient bronze vessels. He carried

12. In my more expansive ancient China course, there are some nine lectures and four or five discussion groups on pre-conquest sites, objects, and issues.

13. For Anyang site photographs and finds, see Bagley, chapter 1 in this volume.

out his work by paying close attention to forms and ornaments and, importantly, by putting himself in the place of the maker and positing the cumulative decisions of a series of makers. From this, he devised a hypothetical sequence that, proceeding with structural logic, accounts for change over time and that successfully accommodates the objects of study. What is more, it is a sequence supported by later archaeology. Even the most blasé consumers of elite education come away amazed to learn that a sequence made in the mind was proved to be essentially correct in real life by comparable sequences of bronze vessels recovered later by excavations in China.

Yet my students' engagement with Loehr seems to be confined to memorizing each of his five rubrics and their defining features with a view to applying them to images of unknown vessels on a midterm exam. Questions remain that most of us are too ashamed to ask: How did Loehr know what to look for? How did he decide what elements were significant? How did he get from one early stage to the next? How are my students, as beginners, and I, as a nonspecialist teacher, to know that our lack of understanding arises not only from our ignorance but also from Loehr's reticence? Robert Bagley's recent book *Max Loehr and the Study of Chinese Bronzes* opens up Loehr's creative visual thinking.[14] Now students new to bronze studies will be able to engage more fully with Loehr's processes as well as his outcomes. And they can ask new questions of him: Why do these bronze vessels look the way they do? Why did bilateral symmetry, emphatic segmentation, and flanges appeal so much to their makers? We now approach the question of "Why do the bronze vessels look the way the do?" by asking another question: "How were they made?" (fig. 12).

We know that the evidence of piece-mold production of bronze vessels in China was available as early as Karlbeck's 1935 article and that, in 1937, J. Leroy Davidson raised the possibility that the earliest thread-relief bronze decorations were produced by incision in the inner surface of the mold.[15] Earlier I mentioned the technical studies of Fairbank and Gettens, who drew facture, form, and ornament closer together in dynamic, consequential relationships. Building on these, bronze studies of our generation has opened up so much more fully the fundamental importance of those relationships, and, in doing so, it has dismantled the shallow paradigm that presumed that facture *influences* style.

Consider this passage from Bagley's 1990 "Shang Ritual Bronzes: Casting Technique and Vessel Design":

> Shang bronzes confront us inescapably with the problem of understanding how technique and design interacted, and a first step toward solving this problem is perhaps to recognize that we are formulating it in terms that no Shang caster would have understood. The distinction we make between technique and design is a construct inherited from our own intellectual tradition; the Shang caster learned the two things together. The firm line we draw between art history and the history of technology has more to do with the structure of our universities than with the making of Shang bronzes.[16]

Now we proceed together, in integrated approaches to understanding facture, form, and ornament. Whatever dark suspicions my (more advanced) students may have harbored of an ineluctable stylistic force driving the bronze decor to develop gives way to the pleasure of comprehensible, human, imaginative processes that proceed from many decisions and innovations. They can understand how the earliest bronze ornaments on an Erlitou *jue* (fig. 13) plausibly could begin with five pokes of a tool pushed into the inner surface of a clay mold section and end as five bumps on the outer surface of the bronze vessel that was cast in that mold. They can understand the full-blown ornament of the Ge *you* (fig. 14): how segmentation

14. For a reconstruction of Loehr's project and a glimpse of his process, see also Bagley, chapter 1 in this volume, pp. 35–38.

15. Karlbeck, "Anyang Moulds." J. Leroy Davidson, "Toward a Grouping of Early Chinese Bronzes," *Parnassus* 9, no. 4 (April 1937): 29–34, 51.

16. Robert Bagley, "Shang Ritual Bronzes: Casting Technique and Vessel Design," *Archives of Asian Art* 43 (1990): 7.

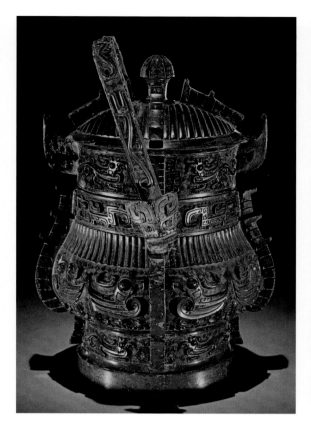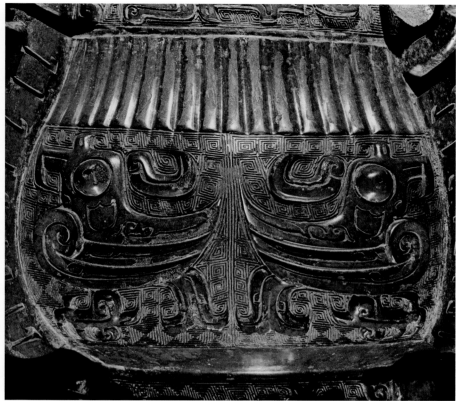

and symmetry effectively enforce order on the exuberant decor; how minutely adjusted *leiwen* enliven the space between the birds' addorsed tails, how they separate back from crest, how a single spiral fills the crook of the beak; how the corrugated concave and convex segments raise the vessel and lid, adding repose and visual gravitas; how the deeply engraved flanges keep the energetic ornament from flying off the form. In these two vessels and in the long development that separates them, and in other vessels that use the same foundry techniques for making different forms and different ornamental systems, we observe an underlying physical relationship: cast in the piece-mold process, form and ornament are made simultaneously. The exterior ornament *is* the bronze form—that very form (not yet made of bronze) as prefigured in the clay mold—at a point in the process when it is available to the makers, before the assembly is closed up and made ready for the pour.

Equipped with these experiences, my students surely will be ready for the magnificent and monstrous productions of the later Houma foundry, excavated in modern Shanxi province. Dating to the sixth and fifth centuries BCE, this foundry site has left for the archaeologist's spade an abundance of pattern blocks and mold fragments.[17] All too soon, I must withdraw myself and my students to worlds of only two dimensions—painting and calligraphy, for the most part. But the lessons of the Bronze Age are not lost on me or on them. After my course is over, my students, like me, can bring their habits of trained observation and their active command of bronze studies' analytic tools to whatever spheres of visual inquiry their imaginations take them to.

DISTURBING THE PEACE: DESTABILIZING THE MASTER NARRATIVE

As I read the Erligang conference papers, listened to discussions of bronze cultures, and reviewed the sites whence my classroom bronzes come, I could not but think on the kindred disjunctions between material evidence and text-driven paradigm

17. For further bibliography, see the Bibliographic Note section in Bagley, ch. 1 in this volume.

in my own field, Chinese painting. That is what I had on my mind at this essay's outset, when I wrote of the challenge we share: What do we do when our findings profoundly disrupt an entrenched, useful, and much-loved master narrative?

In this regard, I am afraid that we painting historians find ourselves more constrained and more compromised by our dominant paradigm than do bronze specialists. Your challenge arises from confronting the disturbance that new material evidence inflicts upon old understandings of Bronze Age China. Our challenge arises from the consequences of *refusing* to confront long-standing contradictions between our material evidence—that is, extant paintings—and the reigning art historical narrative that they are made to illustrate. This takes a bit of explaining.

Most art historians agree that many of our key monuments, among them some of our most beloved paintings in our master narrative of early Chinese art, are observably the work of later hands. We also agree that many of these paintings probably were made during the Song dynasty (960–1279), especially during the twelfth century, when the emperors Huizong (r. 1100–1125) and Gaozong (r. 1127–1162) made strenuous efforts to enlarge and rebuild imperial collections so that they would comprise a historically comprehensive visual patrimony. In the service of maintaining the traditional history of what Loehr honestly called "the great painters of China,"[18] we twenty-first-century historians of Chinese painting continue to insert fine Song paintings made by unnamed Song artists into slots long ago reserved for the famous named masters of the more distant past.

Among the paintings most ill used by the practices of art-historians-in-denial is a famous handscroll in the Museum of Fine Arts, Boston, that is certified by the Jin emperor Zhangzong's (1168–1208) title inscription "Copied by Tianshui [Emperor Huizong] after Zhang Xuan's [act. 714–741] *Silk Beating Picture*" (*Tianshui mo Zhang Xuan "Daolian tu"* 天水摹張萱搗練圖) (fig. 15).[19] Whether this work was personally copied by the emperor from an authentic Zhang Xuan painting, or copied by his corps of court artists,[20] or re-created by them from a later recension, or created from whole cloth, the *Silk Beating Picture* is a Song-period court painting. It is not a Tang-period painting. Yet in our history of Chinese painting, in which this handscroll appears again and again as a favorite of specialists and amateurs alike, Huizong's painting inevitably ends up in the annals of the Tang dynasty, where it is made to illustrate the work of the great Tang dynasty figure painter Zhang Xuan,

18. Max Loehr, *The Great Painters of China* (London: Phaidon; New York: Harper & Row, 1980).

19. Reproduced and discussed in Wu Tung, *Tales from the Land of Dragons: 1,000 Years of Chinese Painting* (Boston: Museum of Fine Arts, Boston, 1997), no. 14.

20. The *Xuanhe huapu* catalogue of Huizong's painting collections records a *Silk Beating Picture* by Zhang Xuan. See ibid., 143n1.

FIGURE 15. Attributed to Emperor Huizong (Zhao Ji, 1082–1135, r. 1101–1125). *Silk Beating*, Northern Song period (960–1127), datable to the 1110s, with detail of label. Handscroll; ink and color on silk, 37 × 145.3 cm. Museum of Fine Arts, Boston, Chinese and Japanese Special Fund (12.886).

instead of taking its rightful place as a great Song retrospective painting and as primary evidence of the Song emperor's engagement with his imperial visual heritage.

How do we remedy this situation? The field's understanding changes slowly and reluctantly. Although I am sorely tempted to throw out the whole thing and self-righteously begin anew, that is both futile and, in its own way, dishonest, because there is no doubt that the old-master works that I reject as later creations, were indeed considered by connoisseurs and, most importantly, by later painters to be original works by Loehr's great painters of China. The evidence of their profound influence on the history of later Chinese painting cannot be minimized: it is to be found everywhere in the textual record and in the archaizing works of later artists. And not even I am willing to give up the delicious story of Gu Kaizhi explaining that he sucked sugarcane from the wrong end "in order to enter paradise slowly."

We can introduce change incrementally. We can clearly distinguish between the secondary textual record and the primary material evidence at hand. We can make datable pictorial evidence our primary focus for the study of early painting. And we can write new chapters in the history of art, in which our vision of the early great painters of China can be shown in art (as has been demonstrated already in literature) to have been formed by the knowledge, desires, and imaginations of Song persons.

It has become my mission to rescue Song retrospective paintings by artists whose names we shall never know from their scatter-shot disposition throughout the history of early painting in China and make a new corpus of Song retrospective paintings. My intention is to free these wonderful paintings to be used in their own right, without the apologies, special pleading, fudging, and wishful thinking that has characterized their employment as mere "placeholders" for the past.[21]

These being the conditions of my field and of my work, I find myself sympathetic to your challenge and to your exertions in building a better account of early civilization in China. It is now clear to me that the Erligang culture must alter our understanding of the beginning of civilization in China. This is one of the BIG questions and one beyond both my expertise and my mental equipment. What are we to do with the beloved Anyang narrative and all those earlier sites and objects that have hitherto been treated as mere preamble to the glorious Anyang chapter?

21. See Maggie Bickford, "Making the Chinese Cultural Heritage at the Courts of the Northern Sung," in *Conference on Founding Paradigms, Papers of the Art and Culture of the Northern Sung Dynasty* (Taipei: National Palace Museum, 2008), 499–535.

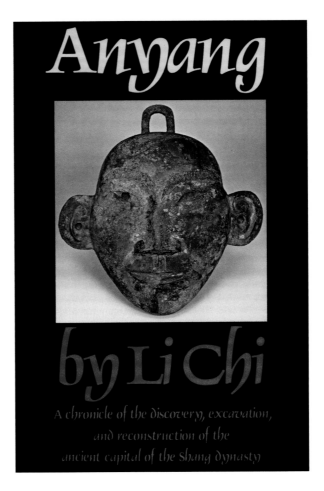

FIGURE 16. Dust jacket of *Anyang*, by Li Chi (Seattle: University of Washington Press, 1977).

As an undergraduate teacher, I don't want to abandon Anyang. The story is simply too good (fig. 16).[22] There are the pioneers of the study of oracle bones, Wang Yirong (1845–1900), who committed suicide in the aftermath of the siege of the Western legations, and Liu E (1857–1909), who died in exile.[23] There is writing to be deciphered. There are plastrons and carapaces and scapulae on which that writing appears. There is the Japanese invasion, the postwar flight of scholars and excavated objects to Taiwan, the resumption of systematic digging after the establishment of the People's Republic of China, and the spectacular Anyang payoff in the discovery of Fu Hao's unplundered royal tomb. Since my primary teaching vehicle is the illustrated lecture, I need those Anyang visuals. What am I to do now that Anyang is not the whole story or even, it seems, the most important part of the story? Within the confines of the nonspecialist, liberal arts classroom, is it possible to make Anyang-centered presentations without perpetuating an Anyang-centric worldview? I should like to think so.

We all are aware of the gap in time and readership between findings published in scholarly, specialist literature and the stories retold in textbooks short of space and classrooms pressed for time. But it is not enough for Erligang sites simply to be given an honorable mention slipped into otherwise unrevised comprehensive accounts. Change will not come if the most fruitful discussions are isolated inside the specialized volumes through which experts speak mainly to one another. Before generalist art historians (and their students) can comfortably proclaim the priority of the Erligang civilization, we need to have in our hands a new, bold account of ancient China—an account that is mounted as a fully integrated part of an accessible, comprehensive history of Chinese art (yes, up to the present time). That work is not for me to do. I offer instead, in conclusion, a modest contribution: my revised handout (fig. 17) for the next offering of my Chinese art survey course.

22. For a lively (if somewhat outdated) narrative of the discovery of the oracle bones and the Anyang excavations, see John Hay, *Ancient China* (London: Bodley Head, 1973), chs. 4 and 5.

23. Ibid., 50.

FIGURE 17. Revised course handout, after Kyle Steinke's Erligang conference announcement.

HIAA0400/CHINESE ART/STUDY 3/GREAT BRONZE AGE I
Erligang Civilization

Named after a type site discovered in Zhengzhou in 1951, the Erligang civilization arose in the Yellow River valley around the middle of the second millennium BCE. Shortly thereafter, its distinctive elite material culture spread to a large part of China's Central Plain, in the south reaching as far as the banks of the Yangzi River. Source of most of the cultural achievements familiarly associated with the more famous Anyang site, the Erligang culture is best known for the Zhengzhou remains, a smaller city at Panlongcheng in Hubei, and a large-scale bronze industry of remarkable artistic and technological sophistication. Bronzes are the hallmark of Erligang elite material culture. They are also the archaeologist's main evidence for understanding the transmission of bronze metallurgy to the cultures of southern China.

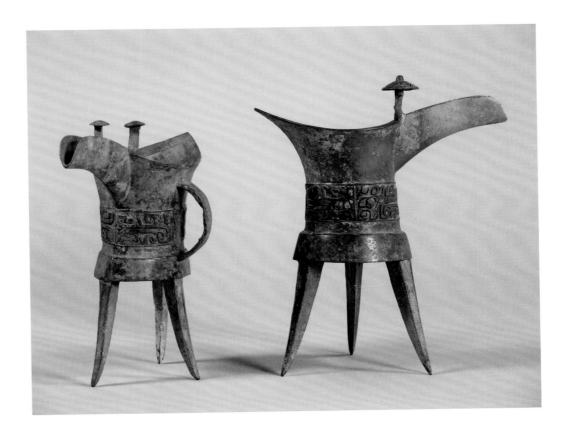

References

Agrawal, D. P. *The Indus Civilization: An Interdisciplinary Perspective*. New Delhi: Aryan Books International, 2007.

Akkermans, Peter, and Glenn Schwartz. *The Archaeology of Syria: From Complex Hunter-Gatherers to Early Urban Societies (ca. 16,000–300 BC)*. Cambridge: Cambridge University Press, 2003.

Alcock, Susan E., Terence N. D'Altroy, Kathleen D. Morrison, and Carla M. Sinopoli, eds. *Empires: Perspectives from Archaeology and History*. Cambridge: Cambridge University Press, 2001.

Algaze, Guillermo. *Ancient Mesopotamia at the Dawn of Civilization: The Evolution of an Urban Landscape*. Chicago: University of Chicago Press, 2008.

———. *Mesopotamian Expansion and Its Consequences: Informal Empire in the Late Fourth Millennium B.C.* PhD diss., University of Chicago, 1986.

———. "The Prehistory of Imperialism: The Case of Uruk Period Mesopotamia." In *Uruk Mesopotamia & Its Neighbors: Cross-Cultural Interactions in the Era of State Formation*, ed. Mitchell Rothman, 27–84. Santa Fe, NM: School of American Research Press, 2001.

———. *The Uruk World System: The Dynamics of Expansion of Early Mesopotamian Civilization*. 2nd rev. ed. Chicago: University of Chicago Press, 2005.

Allan, Sarah. "Erlitou and the Formation of Chinese Civilization: Toward a New Paradigm." *Journal of Asian Studies* 66 (2007): 461–96.

Amano Motonosuke 天野元之助. "Indai sangyō ni kansuru jakkan no mondai" 殷代産業に関する若干の問題. *Tōhō Gakuhō* 東方学報 23 (1953): 231–58.

An Jinhuai 安金槐. *An Jinhuai kaogu wenji* 安金槐考古文集. Zhengzhou, Henan: Zhongzhou guji chubanshe, 1999.

An Zhimin 安志敏. "Gudai de caomian taoju" 古代的糙面陶具. *Kaogu xuebao* 考古學報 1957.4: 69–77. Reprinted in An Zhimin, *Zhongguo xinshiqi shidai lunji* 中國新石器時代論集, 195–203. Beijing: Wenwu chubanshe, 1982.

Andersson, Johan Gunnar. *Researches into the Prehistory of the Chinese. Bulletin of the Museum of Far Eastern Antiquities, Stockholm* 15 (1943).

Anhui sheng bowuguan cang qingtongqi 安徽省博物館藏青銅器. Edited by Anhui sheng bowuguan 安徽省博物館. Shanghai: Shanghai renmin meishu chubanshe, 1987.

Anthony, David W. *The Horse, the Wheel, and Language: How Bronze-Age Riders from the Eurasian Steppes Shaped the Modern World*. Princeton: Princeton University Press, 2007.

Arkell, A. J. "Varia Sudanica." *Journal of Egyptian Archaeology* 36 (1950): 24–40.

Asselberghs, Henri. *Chaos en beheersing: Documenten uit het aeneolitisch Egypte*. Documenta et Monumenta Orientis Antiqui 8. Leiden: E. J. Brill, 1961.

Bagley, Robert. "Anyang Mold-Making and the Decorated Model." *Artibus Asiae* 69, no. 1 (2009): 39–90.

———. "Anyang Writing and the Origins of the Chinese Writing System." In *The First Writing: Script Invention as History and Process*, ed. Stephen D. Houston, 190–249. Cambridge: Cambridge University Press, 2004.

———. "The Appearance and Growth of Regional Bronze-Using Cultures." In *The Great Bronze Age of China: An Exhibition from the People's Republic of China*, ed. Wen Fong, 111–33. New York: The Metropolitan Museum of Art, 1980.

———. "Chapter One. The Neolithic. 1.2. The Majiayao Culture." Undated typescript.

———. "An Early Bronze Age City in Jiangxi Province." *Orientations* (July 1993): 169–85. Reprinted in *Chinese Bronzes: Selected Articles from "Orientations" 1983–2000*, 169–85. Hong Kong: Orientations Magazine, 2001.

———. "Interpreting Prehistoric Designs." In *Iconography without Texts*, ed. Paul Taylor, 43–68. Warburg Institute Colloquia 13. London: Warburg Institute, 2008.

———. *Max Loehr and the Study of Chinese Bronzes: Style and Classification in the History of Art*. Ithaca, NY: Cornell University East Asia Program, 2008.

———. "Ornament, Representation, and Imaginary Animals in Bronze Age China." *Arts Asiatiques* 61 (2006): 17–29.

———. "P'an-lung-ch'eng: A Shang City in Hupei." *Artibus Asiae* 39, no. 3 (1977): 165–219.

———. "The Prehistory of Chinese Music Theory." *Proceedings of the British Academy* 131 (2005): 41–90.

———. "Replication Techniques in Eastern Zhou Bronze Casting." In *History from Things: Essays on Material Culture*, ed. Steven Lubar and W. David Kingery, 234–41. Washington, DC: Smithsonian Institution Press, 1993.

———. "Shang Archaeology." In *The Cambridge History of Ancient China: From the Origins of Civilization to 221 B.C.*, ed. Michael Loewe and Edward L. Shaughnessy, 124–231. Cambridge: Cambridge University Press, 1999.

———. "Shang Ritual Bronzes: Casting Technique and Vessel Design." *Archives of Asian Art* 43 (1990): 6–20.

———. *Shang Ritual Bronzes in the Arthur M. Sackler Collections*. Cambridge, MA: Harvard University Press, 1987.

———. "What the Bronzes from Hunyuan Tell Us about the Foundry at Houma." In *Chinese Bronzes: Selected Articles from "Orientations" 1983–2000*, 214–22. Hong Kong: Orientations Magazine, 2001.

———, ed. *Ancient Sichuan: Treasures from a Lost Civilization*. Seattle: Seattle Art Museum; Princeton: Princeton University Press, 2001.

Baines, John. "Aesthetic Culture and the Emergence of Writing in Egypt during Naqada III." *Archéo-Nil* 20 (2010): 134–49.

———. "Communication and Display: The Integration of Early Egyptian Art and Writing." *Antiquity* 63, no. 240 (1989): 471–82. Reprinted in John Baines, *Visual and Written Culture in Ancient Egypt*, 281–97. Oxford: Oxford University Press, 2007.

———. "The Earliest Egyptian Writing: Development, Context, Purpose." In *The First Writing: Script Invention as History and Process*, ed. Stephen D. Houston, 150–89. Cambridge: Cambridge University Press, 2004.

———. "Early Definitions of the Egyptian World and Its Surroundings." In *Culture through Objects: Ancient Near Eastern Studies in Honour of P. R. S. Moorey*, ed. Timothy Potts, Michael Roaf, and Diana Stein, 27–57. Oxford: Griffith Institute, 2003.

———. "Modelling the Integration of Elite and Other Social Groups in Old Kingdom Egypt." In *Élites et pouvoir en Égypte ancienne*, ed. Juan Carlos Moreno García, 117–44. *Cahiers de Recherches de l'Institut de Papyrologie et d'Égyptologie de Lille* 28 (2009–10). Lille: Université Charles-de-Gaulle, 2010.

———. "Sources of Egyptian Temple Cosmology: Divine Image, King, and Ritual Performer." In *Heaven on Earth: Temples, Ritual, and Cosmic Symbolism in the Ancient World*, ed. Deena Ragavan, 395–424. *Oriental Institute Seminar 9*. Chicago: Oriental Institute, University of Chicago, 2013.

———. "Travel in Third and Second Millennium Egypt." In *Travel, Geography and Culture in Ancient Greece, Egypt and the Near East*, ed. Colin Adams and Jim Roy, 5–30. Leicester Nottingham Studies in Ancient Society 10. Oxford: Oxbow, 2007.

Baines, John, and Norman Yoffee. "Order, Legitimacy, and Wealth in Ancient Egypt and Mesopotamia." In *Archaic States*, ed. Gary M. Feinman and Joyce Marcus, 199–260. Santa Fe, NM: School of American Research Press, 1998.

Barnard, Noel, and Satō Tamotsu. *Metallurgical Remains of Ancient China*. Tokyo: Nichiōsha, 1975.

Beijing gongshang daxue Mingdai taijian mu 北京工商大學明代太監墓. Edited by Beijing shi wenwu yanjiusuo 北京市文物研究所. Beijing: Zhishi chanquan chubanshe, 2005.

Beijing shi wenwu guanlichu 北京市文物管理處. "Beijing Pinggu xian faxian Shangdai muzang" 北京平谷縣發現商代墓葬. *Wenwu* 文物 1977.11: 1–8.

Benson, Elizabeth, and Beatriz de la Fuente, eds. *Olmec Art of Ancient Mexico*. Washington, DC: National Gallery of Art, 1996.

Bickford, Maggie. "Making the Chinese Cultural Heritage at the Courts of the Northern Sung." In *Conference on Founding Paradigms, Papers of the Art and Culture of the Northern Sung Dynasty*, 499–535. Taipei: National Palace Museum, 2008.

Binford, Lewis. "Mortuary Practices: Their Study and Their Potential." In *Approaches to the Social Dimensions of Mortuary Practices*, ed. James A. Brown, 6–29. Memoirs of the Society for American Archaeology 25. Washington, DC: Society for American Archaeology, 1971.

Bothmer, Bernard V. "A New Fragment of an Old Palette." *Journal of the American Research Center in Egypt* 8 (1969–70): 5–8.

———. "On Photographing Egyptian Art." *Studien zur Altägyptischen Kultur* 6 (1978): 51–53.

Braun, Eliot. "South Levantine Early Bronze Age Chronological Correlations with Egypt in Light of the Narmer Serekhs from Tel Erani and Arad: New Interpretations." *British Museum Studies in Ancient Egypt and Sudan* 13 (2009): 25–48.

Brown, James A. "The Search for Rank in Prehistoric Burials." In *The Archaeology of Death*, ed. Robert Chapman, Ian Kinnes, and Klavs Randsborg, 25–39. Cambridge: Cambridge University Press, 1981.

Bunzel, Ruth. *The Pueblo Potter: A Study of Creative Imagination in Primitive Art*. 1929; repr., New York: Dover, 1972.

Bussmann, Richard. *Die Provinztempel Ägyptens von der 0. Bis zur 11. Dynastie: Archäologie und Geschichte einer gesellschaftlichen Institution zwischen Residenz und Provinz*. Probleme der Ägyptologie 30. Leiden: Brill, 2010.

Cahill, James. *Chinese Painting*. Geneva: Skira, 1960.

Campagno, Marcelo. "Ethnicity and Changing Relationships between Egyptians and South Levantines during the Early Dynastic Period." In *Egypt at Its Origins II: Proceedings of the International Conference "Origin of the State: Predynastic and Early Dynastic Egypt," Toulouse, 5th–8th September 2005*, ed. Béatrix Midant-Reynes and Yann Tristant, 689–705. Orientalia Lovaniensia Analecta 172. Leuven: Peeters, 2008.

Campbell, Rod. *Blood, Flesh and Bones: Kinship and Violence in the Social Economy of the Late Shang*. PhD diss., Harvard University, 2007.

———. "On Humanity and Inhumanity in Early China." In *Violence and Civilization: Studies of Social Violence in History and Prehistory*, ed. Rod Campbell. Joukowsky Institute Publication Series. Oxford: Oxbow Books, forthcoming.

———. "Toward a Networks and Boundaries Approach to Early Complex Polities: The Late Shang Case." *Current Anthropology* 50, no. 6 (December 2009): 821–48.

Campbell, Rod [Jiang Yude 江雨德]. "Guo zhi da shi: Shangdai wanqi zhong de lizhi gailiang" 國之大事: 商代晚期中的禮制改良. In *Yinxu yu Shang wenhua: Yinxu kexue fajue 80 zhounian jinian wenji* 殷墟 與商文化: 殷墟科學發掘 80 週年紀念文集, ed. Zhongguo shehui kexueyuan kaogu yanjiusuo 中國 社會科學院考古研究所, 267–76. Beijing: Kexue chubanshe, 2011.

Cannon, Aubrey. "The Historical Dimension in Mortuary Expressions of Status and Sentiment." *Current Anthropology* 30 (1989): 437–58.

Cao Nan 曹楠. "Sandai shiqi chutu bingxing yuqi yanjiu" 三代時期出土柄形玉器研究. *Kaogu xuebao* 考 古學報 2008.2: 141–74.

Cao Wei 曹瑋, ed. *Hanzhong chutu Shangdai qingtongqi* 漢中出土商代青銅器. 3 vols. Chengdu, Sichuan: Ba Shu shushe, 2006.

———, ed. *Shanbei chutu qingtongqi* 陝北出土青銅器. 5 vols. Chengdu, Sichuan: Ba Shu shushe, 2009.

Chang, Kwang-chih. *The Archaeology of Ancient China*. 4th ed. New Haven, CT: Yale University Press, 1986.

———. *Shang Civilization*. New Haven, CT: Yale University Press, 1980.

Chase-Dunn, Christopher, and Thomas Hall. "Comparing World-Systems: Concepts and Hypotheses." In *Pre-Columbian World-Systems*, ed. P. N. Peregrine and G. M. Feinman, 11–25. Madison, WI: Prehistory Press, 1996.

———. "Conceptualizing Core/Periphery Hierarchies for Comparative Study." In *Core/Periphery Relations in Precapitalist Worlds*, ed. Christopher Chase-Dunn and Thomas Hall, 5–44. Boulder, CO: Westview, 1991.

Chen Mengjia 陳夢家. *Yinxu buci zongshu* 殷墟卜辭綜述. Beijing: Kexue chubanshe, 1956.

Chen Peifen 陳佩芬, ed. *Xia Shang Zhou qingtongqi yanjiu: Shanghai bowuguan cangpin* 夏商周青銅器研 究: 上海博物館藏品. 6 vols. Shanghai: Shanghai guji chubanshe, 2004.

Chen Tiemei, George Rapp Jr., Jing Zhichun, and He Nu. "Provenance Studies of the Earliest Chinese Protoporcelain Using Instrumental Neutron Activation Analysis." *Journal of Archaeological Science* 26, no. 8 (1999): 1003–15.

Chen Zhida 陳志達 and Fang Guojin 方國錦, eds. *Zhongguo yuqi quanji: 2 Shang, Xi Zhou* 中國玉器全集: 2 商, 西周. Shijiazhuang, Hebei: Hebei meishu chubanshe, 1993.

Chengdu Institute of Cultural Heritage and Archaeology, comp. *The Jinsha Site: A 21st Century Discovery of Chinese Archaeology*. Translated by Wang Pingxing. Beijing: China Intercontinental Press, 2006.

Childe, V. Gordon. *The Danube in Prehistory*. Oxford: Oxford University Press, 1929.

———. *Social Evolution*. New York: Schuman, 1951.

———. "The Urban Revolution." *Town Planning Review* 21, no. 1 (1950): 3–17.

Chūka Jinmin Kyōwakoku kodai seidōki ten 中華人民共和國古代青銅器展. Tokyo: Nihon Keizai Shinbunsha, 1976.

Claessen, Henri. "Internal Dynamics of the Early State." *Current Anthropology* 25, no. 4 (1985): 365–79.

Clark, John, and Mary Pye, eds. *Olmec Art and Archaeology in Mesoamerica*. Washington, DC: National Gallery of Art, 2000.

Cohen, David. *The Yueshi Culture, the Dong Yi and the Archaeology of Ethnicity in Early Bronze Age China*. PhD diss., Harvard University, 2001.

Cooper, Jerrold S. "Babylonian Beginnings: The Origin of the Cuneiform Writing System in Comparative Perspective." In *The First Writing: Script Invention as History and Process*, ed. Stephen D. Houston, 71–99. Cambridge: Cambridge University Press, 2004.

Crawford, Harriet. *Sumer and Sumerians*. Cambridge: Cambridge University Press, 1991.

D'Altroy, Terence N. *The Incas*. Malden, MA: Blackwell, 2002.

Davidson, J. Leroy. "Toward a Grouping of Early Chinese Bronzes." *Parnassus* 9, no. 4 (April 1937): 29–34, 51.

Deng Tongde 鄧同德. "Henan Xiangcheng chutu Shangdai qianqi qingtongqi he kewen taopai" 河南項城 出土商代前期青銅器和刻文陶拍. *Wenwu* 文物 1982.9: 83–84.

Dey, Hendrik W. *The Aurelian Wall and the Refashioning of Imperial Rome, AD 271–855*. Cambridge: Cambridge University Press, 2011.

Di Cosmo, Nicola. *Ancient China and Its Enemies: The Rise of Nomadic Power in East Asian History*. Cambridge: Cambridge University Press, 2002.

Diego Espinel, Andrés. *Abriendo los caminos de Punt: Contactos entre Egipto y el ámbito afroárabe durante la Edad del Bronce [ca. 3000 a.C.–1065 a.C.]*. Barcelona: Bellaterra, 2011.

Diehl, Richard A. *The Olmecs: America's First Civilization*. London: Thames and Hudson, 2004.

Dong Zuobin 董作賓. *Yinli pu* 殷曆譜. Nanxi, Sichuan: Guoli zhongyang yanjiuyuan lishi yuyan yanjiusuo, 1945.

Dreyer, Günter. "Ein Siegel der frühzeitlichen Königsnekropole von Abydos." *Mitteilungen des Deutschen Archäologischen Instituts, Abteilung Kairo* 43 (1987): 33–43.

Dreyer, Günter, Eva-Maria Engel, Ulrich Hartung, Thomas Hikade, Eva Christiana Köhler, and Frauke Pumpenmeier. "Umm el-Qaab: Nachuntersuchungen im frühzeitlichen Königsfriedhof, 7./8. Vorbericht." *Mitteilungen des Deutschen Archäologischen Instituts, Abteilung Kairo* 52 (1996): 11–81.

Dreyer, Günter, Ulrich Hartung, Thomas Hikade, Eva Christiana Köhler, Vera Müller, and Frauke Pumpenmeier. "Umm el-Qaab: Nachuntersuchungen im frühzeitlichen Königsfriedhof, 9./10. Vorbericht." *Mitteilungen des Deutschen Archäologischen Instituts, Abteilung Kairo* 54 (1998): 77–167.

Dreyer, Günter, Ulrich Hartung, and Frauke Pumpenmeier. *Umm el-Qaab I: Das prädynastische Königsgrab U-j und seine frühen Schriftzeugnisse.* Deutsches Archäologisches Institut, Abteilung Kairo, Archäologische Veröffentlichungen 86. Mainz: Philipp von Zabern, 1998.

Du Jinpeng 杜金鵬 and Wang Xuerong 王學榮, eds. *Yanshi Shang cheng yizhi yanjiu* 偃師商城遺址研究. Beijing: Kexue chubanshe, 2004.

Earle, Timothy. "Evolution of Chiefdoms." *Current Anthropology* 30, no. 1 (1989): 84–88.

Emery, Walter B. *Archaic Egypt.* Harmondsworth: Penguin, 1961.

——. *Great Tombs of the First Dynasty I.* Service des Antiquités de l'Égypte, Excavations at Saqqara. Cairo: Government Press, Bulâq, 1949.

Erlitou taoqi jicui 二里頭陶器集粹. Edited by Zhongguo shehui kexueyuan kaogu yanjiusuo 中國社會科學院考古研究所. Beijing: Zhongguo shehui kexue chubanshe, 1995.

Fairbank, Wilma. "Piece-Mold Craftsmanship and Shang Bronze Design." *Archives of the Chinese Art Society of America* 16 (1962): 8–15. Reprinted in idem., *Adventures in Retrieval: Han Murals and Shang Bronze Molds,* 183–201. Cambridge, MA: Harvard University Press, 1972.

Falkenhausen, Lothar von. "On the Historiographical Orientation of Chinese Archaeology." *Antiquity* 67, no. 257 (1993): 839–49.

Fan Weiyue 樊維岳 and Wu Zhenfeng 吳鎮烽. "Shaanxi Lantian xian chutu Shangdai qingtongqi" 陝西藍田縣出土商代青銅器. *Wenwu ziliao congkan* 文物資料叢刊 3 (1980): 25–26.

Feinman, Gary M., and Joyce Marcus, eds. *Archaic States.* Santa Fe, NM: School of American Research Press, 1998.

Finley, M. I. "The Fifth Century Athenian Empire: A Balance Sheet." In *Imperialism in the Ancient World,* ed. P. D. A. Garnsey and C. R. Whittaker, 103–26. Cambridge: Cambridge University Press, 1978.

Firth, Cecil M. *The Archaeological Survey of Nubia: Report for 1910–1911.* Cairo: Ministry of Finance, Survey Department, 1927.

Flad, Rowan. "Divination and Power: A Multi-regional View of the Development of Oracle Bone Divination in Early China." *Current Anthropology* 49, no. 3 (2008): 403–38.

Flannery, K. V. "The Ground Plans of Archaic States." In *Archaic States,* ed. Gary M. Feinman and Joyce Marcus, 15–57. Santa Fe, NM: School of American Research Press, 1998.

Fong, Wen, ed. *The Great Bronze Age of China: An Exhibition from the People's Republic of China.* New York: The Metropolitan Museum of Art, 1980.

Fried, Morton. "On the Evolution of Social Stratification and the State." In *Culture in History,* ed. Stanley Diamond, 713–31. New York: Columbia University Press, 1960.

Gao Quxun 高去尋. *Houjiazhuang (Henan Anyang Houjiazhuang Yin dai mudi) dierben, 1001 hao da mu* 侯家莊 (河南安陽侯家莊殷代墓地) 第二本 1001 號大墓. 2 vols. Taipei: Academia Sinica, 1962.

——. *Houjiazhuang (Henan Anyang Houjiazhuang Yin dai mudi) diliuben, 1217 hao da mu* 侯家莊 (河南安陽侯家莊殷代墓地) 第六本 1217 號大墓. Taipei: Academia Sinica, 1968.

——. *Houjiazhuang (Henan Anyang Houjiazhuang Yin dai mudi) diwuben, 1004 hao da mu* 侯家莊 (河南安陽侯家莊殷代墓地) 第五本 1004 號大墓. Taipei: Academia Sinica, 1970.

Gao Zhixi 高至喜 and Xiong Chuanxin 熊傳薪, eds. *Zhongguo yinyue wenwu daxi II: Hunan juan* 中國音樂文物大系 II: 湖南卷. Zhengzhou, Henan: Daxiang chubanshe, 2006.

Gaocheng Taixi Shangdai yizhi 藁城台西商代遺址. Edited by Hebei sheng wenwu yanjiusuo 河北省文物研究所. Beijing: Wenwu chubanshe, 1985.

Ge Jieping 葛介屏. "Anhui Funan faxian Yin Shang shidai de qingtongqi" 安徽阜南發現殷商時代的青銅器. *Wenwu* 文物 1959.1: page preceding table of contents.

Ge Zhigong 葛治工. "Anhui Jiashan xian Bogang Yinhe chutu de sijian Shangdai tongqi" 安徽嘉山縣泊崗引河出土的四件商代銅器. *Wenwu* 文物 1965.7: 23–26.

Gettens, Rutherford John. *The Freer Chinese Bronzes.* Vol. 2, *Technical Studies.* Washington, DC: Smithsonian Institution, 1969.

Giddens, Anthony. *A Contemporary Critique of Historical Materialism: Power, Property and the State.* Vol. 1. London: Macmillan Press, 1981.

Glück, Birgit. "Zur Frage der Datierung der frühen C-Gruppe in Unternubien." *Ägypten und Levante* 15 (2005): 131–53.

Golas, Peter J. *Science and Civilisation in China.* Vol. 5, *Chemistry and Chemical Technology,* pt. 13: *Mining.* Cambridge: Cambridge University Press, 1999.

Greenberg, Raphael, David Wengrow, and Sarit Paz. "Cosmetic Connections? An Egyptian Relief Carving from Early Bronze Age Tel Bet Yerah (Israel)." *Antiquity* 84, no. 324 (2010). http://antiquity.ac.uk /projgall/greenberg324/.

Gregor, Neil. *How to Read Hitler.* New York: W. W. Norton, 2005.

Guo Binglian 郭冰廉. "Hubei Huangpi Yangjiawan de gu yizhi diaocha" 湖北黃陂楊家灣的古遺址調查. *Kaogu tongxun* 考古通訊 1958.1: 56–58.

Guo Moruo 郭沫若. "Qingtongqi shidai" 青銅器時代. In *Qingtong shidai* 青銅時代, 297–308. Beijing: Kexue chubanshe, 1957.

Guo Shengbin 郭勝斌. "Tonggushan Shangdai yicun wenhua yinsu fenxi" 銅鼓山商代遺存文化因素分析. *Jiang Han kaogu* 江漢考古 2001.4: 40–48, 22.

——. "Yueyang Shangdai kaogu shulüe" 岳陽商代考古述略. *Jiang Han kaogu* 江漢考古 2005.3: 63–69.

Guo Yong 郭勇. "Shanxi Changzi xian beijiao faxian Shangdai tongqi" 山西長子縣北郊發現商代銅器. *Wenwu ziliao congkan* 文物資料叢刊 3 (1980): 198–201.

Haeger, John W. "Between North and South: The Lake Rebellion in Hunan, 1130–1135." *Journal of Asian Studies* 28, no. 3 (May 1969): 469–88.

Hao Xin 赫欣 and Sun Shuyun 孫叔雲. "Panlongcheng Shangdai qingtongqi de jianyan yu chubu yanjiu" 盤龍城商代青銅器的檢驗與初步研究. In *Panlongcheng: 1963–1994 nian kaogu fajue baogao* 盤龍城: 1963–1994 年考古發掘報告, ed. Hubei sheng wenwu kaogu yanjiusuo 湖北省文物考古研究所. Vol. 1, app. 1. Beijing: Wenwu chubanshe, 2001.

Hartung, Ulrich. *Umm el-Qaab II: Importkeramik aus dem Friedhof U in Abydos (Umm el-Qaab) und die Beziehungen Ägyptens zu Vorderasien im 4. Jahrtausend v. Chr.* Deutsches Archäologisches Institut, Abteilung Kairo, Archäologische Veröffentlichungen 92. Mainz: Philipp von Zabern, 2001.

Hay, John. *Ancient China.* London: Bodley Head, 1973.

Hayden, Brian. "Are Emic Types Relevant to Archaeology?" *Ethnohistory* 31, no. 2 (1984): 79–92.

He Jiejun 何介鈞 and Cao Chuansong 曹傳松. "Hunan Lixian Shang Zhou shiqi gu yizhi diaocha yu tanjue" 湖南澧縣商周時期古遺址調查與探掘. *Hunan kaogu jikan* 湖南考古輯刊 4 (1987): 1–10.

Hebei sheng chutu wenwu xuanji 河北省出土文物選集. Edited by Beijing shi wenwu guanlichu 北京市文物管理處. Beijing: Wenwu chubanshe, 1980.

Helck, Wolfgang. "Die Bedeutung der Inschriften J. Lopez, Inscripciones Rupestres Nr. 27 and 28." *Studien zur Altägyptischen Kultur* 1 (1974): 215–25.

Henan sheng bowuguan 河南省博物館 and Lingbao xian bowuguan 靈寶縣博物館. "Henan Lingbao chutu yipi Shangdai qingtongqi" 河南靈寶出土一批商代青銅器. *Kaogu* 考古 1979.1: 20–22.

Henan sheng wenwu kaogu yanjiusuo 河南省文物考古研究所. "Zhengzhou Shang cheng xin faxian de jizuo Shang mu" 鄭州商城新發現的幾座商墓. *Wenwu* 文物 2003.4: 4–20.

Henan sheng wenwu yanjiusuo 河南省文物研究所. "Zhengzhou Beierqilu xin faxian sanzuo Shang mu" 鄭州北二七路新發現三座商墓. *Wenwu* 文物 1983.3: 60–77.

Henan wenwu gongzuodui diyidui 河南文物工作隊第一隊. "Zhengzhou shi Baijiazhuang Shangdai muzang fajue jianbao" 鄭州市白家莊商代墓葬發掘簡報. *Wenwu cankao ziliao* 文物參考資料 1955.10: 24–42.

Hendrickx, Stan. "La chronologie de la préhistoire tardive et des débuts de l'histoire de l'Égypte." *Archéo-Nil* 9 (1999): 13–107.

Howe, Stephen. *Empire: A Very Short Introduction.* Oxford: Oxford University Press, 2002.

Huang Zhanyue 黃展岳. *Gudai rensheng renxun tonglun* 古代人牲人殉通論. Beijing: Wenwu chubanshe, 2004.

Hubei sheng bowuguan 湖北省博物館. "1963 nian Hubei Huangpi Panlongcheng Shangdai yizhi de fajue" 1963 年湖北黃陂盤龍城商代遺址的發掘. *Wenwu* 文物 1976.1: 55.

Hubei sheng bowuguan 湖北省博物館, Beijing daxue kaogu zhuanye 北京大學考古專業, and Panlongcheng fajuedui 盤龍城發掘隊. "Panlongcheng 1974 niandu tianye kaogu jiyao" 盤龍城1974年度田野考古集要. *Wenwu* 文物 1976.2: 5–16.

Huixian fajue baogao 輝縣發掘報告. Edited by Zhongguo kexueyuan kaogu yanjiusuo 中國科學院考古研究所. Beijing: Kexue chubanshe, 1956.

Huixian Mengzhuang 輝縣孟莊. Edited by Henan sheng wenwu kaogu yanjiusuo 河南省文物考古研究所. Zhengzhou, Henan: Zhongzhou guji chubanshe, 2003.

Hulsewé, A. F. P. *Remnants of Ch'in Law: An Annotated Translation of the Ch'in Legal and Administrative Rules of the 3rd Century B.C. Discovered in Yün-meng Prefecture, Hu-pei Province, in 1975.* Leiden: Brill, 1985.

Hunan chutu Yin Shang Xi Zhou qingtongqi 湖南出土殷商西周青銅器. Edited by Hunan sheng bowuguan 湖南省博物館. Changsha, Hunan: Yuelu shushe, 2007.

Hunan kaogu manbu 湖南考古漫步. Edited by Hunan sheng wenwu kaogu yanjiusuo 湖南省文物考古研究所. Changsha, Hunan: Hunan meishu chubanshe, 1999.

Hunan sheng bowuguan 湖南省博物館. "Hunan sheng bowuguan xin faxian de jijian tongqi" 湖南省博物館新發現的幾件銅器. *Wenwu* 文物 1966.4: 2.

Hunan sheng wenwu kaogu yanjiusuo 湖南省文物考古研究所. "Hunan Shimen Zaoshi Shang dai yicun" 湖南石門皂市商代遺存. *Kaogu xuebao* 考古學報 1992.2: 185–219.

Hunan sheng wenwu kaogu yanjiusuo 湖南省文物考古研究所 and Xiangxi zizhizhou wenwu guanlichu 湘西自治州文物管理處. "Xiangxi Yongshun Buermen fajue baogao" 湘西永順不二門發掘報告. In *Hunan kaogu 2002: Shang* 湖南考古 2002: 上, 72–125. Changsha, Hunan: Yuelu shushe, 2002.

Jiang Gang 蔣剛. "Panlongcheng yizhi qun chutu Shangdai yicun de jige wenti" 盤龍城遺址群出土商代遺存的幾個問題. *Kaogu yu wenwu* 考古與文物 2008.1: 35–46.

Jingzhou diqu bowuguan 荊州地區博物館 and Beijing daxue kaoguxi 北京大學考古系. "Hubei Jiangling Jingnansi yizhi diyi, erci fajue jianbao" 湖北江陵荊南寺遺址第一, 二次發掘簡報. *Kaogu* 考古 1989.8: 679–92, 698.

Jingzhou Jingnansi 荊州荊南寺. Edited by Jingzhou bowuguan 荊州博物館. Beijing: Wenwu chubanshe, 2009.

Kaiser, Werner. "Einige Bemerkungen zur ägyptischen Frühzeit II: Zur Frage einer über Menes hinausreichenden Geschichtsüberlieferung." *Zeitschrift für Ägyptische Sprache und Altertumskunde* 86 (1961): 39–61.

———. "Einige Bemerkungen zur ägyptischen Frühzeit III: Die Reichseinigung." *Zeitschrift für Ägyptische Sprache und Altertumskunde* 91 (1964): 86-125.

———. "Zur Entstehung des gesamtägyptischen Staates." *Mitteilungen des Deutschen Archäologischen Instituts, Abteilung Kairo* 46 (1990): 287-99.

———. "Zur inneren Chronologie der Naqadakultur." *Archaeologia Geographica* 6 (1957): 69-77.

Kaiser, Werner, and Günter Dreyer. "Umm el-Qaab: Nachuntersuchungen im frühzeitlichen Königsfriedhof, 2. Vorbericht." *Mitteilungen des Deutschen Archäologischen Instituts, Abteilung Kairo* 38 (1982): 211-69.

Kanan-shō Hakubutsukan 河南省博物館 (Chūgoku no hakubutsukan 中国の博物館 7). Tokyo: Kōdansha, 1983.

Kaogu zhonghua 考古中華. Edited by Zhongguo shehui kexueyuan kaogu yanjiusuo 中國社會科學院考古研究所. Beijing: Kexue chubanshe, 2010.

Karlbeck, Orvar. "Anyang Moulds." *Bulletin of the Museum of Far Eastern Antiquities* 7 (1935): 39-60.

Karlgren, Bernhard. "New Studies on Chinese Bronzes." *Bulletin of the Museum of Far Eastern Antiquities* 9 (1937): 9-117.

Keightley, David N. *The Ancestral Landscape: Time, Space, and Community in Late Shang China.* China Research Monograph 53. Berkeley: Institute of East Asian Studies, University of California, Berkeley, 2000.

———. "The Late Shang State: When, Where, and What?" In *The Origins of Chinese Civilization*, ed. David N. Keightley, 523-64. Berkeley: University of California Press, 1983.

———. "Shamanism, Death, and the Ancestors: Religious Mediation in Neolithic and Shang China." *Asiatische Studien* 52, no. 3 (1998): 763-832.

———. "The Shang State as Seen in the Oracle-Bone Inscriptions." *Early China* 5 (1979-80): 25-34.

Kemp, Barry J. "Explaining Ancient Crises." *Cambridge Archaeological Journal* 1 (1991): 239-44.

———. "Why Empires Rise." Review of *Askut in Nubia*, by Stuart Tyson Smith. *Cambridge Archaeological Journal* 7, no. 1 (1997): 125-31.

Kenoyer, Jonathan. *Ancient Cities of the Indus Valley Civilization.* Oxford: Oxford University Press, 1998.

Kerr, Rose, and Nigel Wood. *Science and Civilisation in China.* Vol. 5, *Chemistry and Chemical Technology*, pt. 12: *Ceramic Technology.* Cambridge: Cambridge University Press, 2004.

Kitchen, K. A. *Pharaoh Triumphant: The Life and Times of Ramesses II.* Warminster: Aris & Phillips, 1982.

Kōga bunmei tenran 黄河文明展覧. Edited by Tōkyō Kokuritsu Hakubutsukan 東京国立博物館 et al. Tokyo: Chūnichi Shimbunsha, 1986.

Konan-shō Hakubutsukan 湖南省博物館 (Chūgoku no hakubutsukan 中国の博物館 2). Tokyo: Kōdansha, 1981.

Laizi biluo yu huangquan: Zhongyang yanjiuyuan lishi yuyan yanjiusuo lishi wenwu chenlieguan zhanpin tulu 來自碧落與黃泉: 中央研究院歷史語言研究所歷史文物陳列館展品圖錄. Taipei: Academia Sinica, 2002.

Lan Wei 藍蔚. "Hubei Huangpi xian Panlongcheng faxian gu cheng yizhi ji shiqi deng" 湖北黃陂縣盤龍城發現古城遺址及石器等. *Wenwu cankao ziliao* 文物參考資料 1955.4: 118-19.

Latour, Bruno. *We Have Never Been Modern.* Cambridge, MA: Harvard University Press, 1993.

Lattimore, Owen. "The Frontier in History." In *Studies in Frontier History: Collected Papers, 1928-1958*, 469-91. London: Oxford University Press, 1962.

Lee, Gyoung-ah, G. W. Crawford, Li Liu, and Xingcan Chen. "Plants and People from the Early Neolithic to Shang Periods in North China." *Proceedings of the National Academy of Sciences* 104, no. 3 (2007): 1087-92.

Lee, Yun-kuen. "Building the Chronology of Early Chinese History." *Asian Perspectives* 41, no. 1 (2002): 15-42.

Lesure, Richard. "Shared Art Styles and Long-Distance Contact in Early Mesoamerica." In *Mesoamerican Archaeology: Theory and Practice*, ed. Julia Hendon and Rosemary Joyce, 73-96. Oxford: Blackwell, 2004.

Li Chi [Li Ji 李濟]. *Anyang.* Seattle: University of Washington Press, 1977.

———. *The Beginnings of Chinese Civilization: Three Lectures Illustrated with Finds at Anyang.* Seattle: University of Washington Press, 1957.

———. "Diverse Backgrounds of the Decorative Art of the Yin Dynasty." *Annals of Academia Sinica* (*Zhongyang Yanjiuyuan yuankan* 中央研究院院刊) (Taipei), no. 2, pt. 1 (1955): 119-30.

———. "Importance of the Anyang Discoveries in Prefacing Known Chinese History with a New Chapter." *Annals of Academia Sinica* (*Zhongyang Yanjiuyuan yuankan* 中央研究院院刊) (Taipei), no. 2, pt. 1 (1955): 91-102.

Li Ji 李濟 [Li Chi]. "Anyang fajue yu Zhongguo gushi wenti" 安陽發掘與中國古史問題. In *Li Ji kaoguxue lunwen ji (xia)* 李濟考古學論文記 (下), 825-66. Taipei: Lianjing, 1977.

———. "Ji Xiaotun chutu zhi qingtongqi" 記小屯出土之青銅器. *Zhongguo kaogu xuebao* 中國考古學報 3 (1948): 1-99.

Li Ji 李濟 and Wan Jiabao 萬家保 [Li Chi and Wan Chia-pao]. *Yinxu chutu wushisanjian qingtong rongqi zhi yanjiu* 殷墟出土伍拾叁件青銅容器之研究 (*Studies of Fifty-three Ritual Bronzes*). Taipei: Institute of History and Philology, Academia Sinica, 1972.

Li Ling 李零. *Rushan yu chusai* 入山與出塞. Beijing: Wenwu chubanshe, 2004.

Li Taoyuan 李桃元, He Changyi 何昌義, and Zhang Hanjun 張漢軍, eds. *Panlongcheng qingtong wenhua* 盤龍城青銅文化. Wuhan, Hubei: Hubei meishu chubanshe, 2002.

Li Wenjie 李文傑. "Yuanqu Shang cheng taoqi de zhizuo gongyi" 垣曲商城陶器的制作工藝. In *Yuanqu Shang cheng I: 1985–1986 niandu kancha baogao* 垣曲商城 (一) 1985–1986 年度勘查報告, ed. Zhongguo lishi bowuguan kaogubu 中國歷史博物館考古部 et al., 309–15. Beijing: Kexue chubanshe, 1996.

Li Xueqin 李學勤, ed. *Zhongguo gudai wenming yu guojia xingcheng yanjiu* 中國古代文明與國家形成研究. Kunming: Yunnan renmin chubanshe, 1997.

Li Xueshan 李雪山. *Shangdai fenfeng zhidu yanjiu* 商代分封制度研究. Beijing: Zhongguo shehuikexue chubanshe, 2004.

Li Zegao 黎澤高 and Zhao Ping 趙平. "Zhicheng shi bowuguan cang qingtongqi" 枝城市博物館藏青銅器. *Kaogu* 考古 1989.9: 775–76.

Lin Yun 林澐. "Guanyu Zhongguo zaoqi guojia xingshi de jige wenti" 關於中國早期國家形式的幾個問題. In *Lin Yun xueshu wenji* 林澐學術文集, 85–99. Beijing: Zhongguo dabaike quanshu chubanshe, 1998.

———. "Jiaguwen zhong de Shangdai fangguo lianmeng" 甲骨文中的商代方國聯盟. In *Lin Yun xueshu wenji* 林澐學術文集, 69–84. Beijing: Zhongguo dabaike quanshu chubanshe, 1998. Originally published in *Guwenzi yanjiu* 古文字研究 6 (1982): 69–74.

———. "Shuo wang" 說王. In *Lin Yun xueshu wenji* 林澐學術文集, 1–3. Beijing: Zhongguo dabaike quanshu chubanshe, 1998. Originally published in *Kaogu* 考古 1965.6: 311–12.

Liu, Li, and Xingcan Chen. *The Archaeology of China: From the Late Paleolithic to the Early Bronze Age.* Cambridge: Cambridge University Press, 2012.

Liu, Li, and Xingcan Chen. *State Formation in Early China.* London: Duckworth, 2003.

Liu, Li, and Hong Xu. "Rethinking Erlitou: Legend, History and Chinese Archaeology." *Antiquity* 81, no. 314 (2007): 886–901.

Liu Shi'e 劉士莪, ed. *Xi'an Laoniupo* 西安老牛坡. Xi'an, Shaanxi: Shaanxi renmin chubanshe, 2001.

Liu Shizhong 劉詩中 and Lu Benshan 盧本冊. "Jiangxi Tongling tongkuang yizhi de fajue yu yanjiu" 江西銅嶺銅礦遺址的發掘與研究. *Kaogu xuebao* 考古學報 1998.4: 465–96.

Liu Zhongfu 劉忠伏. "Yanshi xian Shang cheng yizhi" 偃師縣商城遺址. In *Yanshi Shang cheng yizhi yanjiu* 偃師商城遺址研究, ed. Du Jinpeng 杜金鵬 and Wang Xuerong 王學榮, 592. Beijing: Kexue chubanshe, 2004. Originally published in *Zhongguo kaoguxue nianjian 1990* 中國考古學年鑒 1990. Beijing: Wenwu chubanshe, 1991.

Loehr, Max. "The Bronze Styles of the Anyang Period." *Archives of the Chinese Art Society of America* 7 (1953): 42–53.

———. "The Fate of the Ornament in Chinese Art." *Archives of Asian Art* 21 (1967–68): 8–18.

———. *The Great Painters of China.* London: Phaidon; New York: Harper & Row, 1980.

Luo Renlin 羅仁林. "Yueyang diqu Shang shiqi de wenhua xulie ji qi wenhua yinsu de fenxi" 岳陽地區商時期的文化序列及其文化因素的分析. *Hunan kaogu jikan* 湖南考古輯刊 (1999): 223–51.

Malek, Jaromir. *Egypt: 4000 Years of Art.* London: Phaidon, 2003.

Marcus, Joyce, and Gary M. Feinman. Introduction to *Archaic States*, ed. Gary M. Feinman and Joyce Marcus, 1–13. Santa Fe, NM: School of American Research Press, 1998.

Marfoe, Leon. "Cedar Forest to Silver Mountain: Social Change and the Development of Long-Distance Trade in Early Near Eastern Societies." In *Centre and Periphery in the Ancient World*, ed. Michael Rowlands, Mogens Trolle Larsen, and Kristian Kristiansen, 25–35. New Directions in Archaeology. Cambridge: Cambridge University Press, 1987.

McNamara, Liam. "The Revetted Mound at Hierakonpolis and Early Kingship: A Reinterpretation." In *Egypt at Its Origins II: Proceedings of the International Conference "Origin of the State: Predynastic and Early Dynastic Egypt," Toulouse, 5th–8th September 2005*, ed. Béatrix Midant-Reynes and Yann Tristant, 899–934. Leuven: Peeters, 2008.

Mei Jianjun. "Cultural Interaction between China and Central Asia during the Bronze Age." *Proceedings of the British Academy* 121 (2003): 1–39.

Meng Xin'an 孟新安. "Yancheng xian chutu yipi Shangdai qingtongqi" 鄢城縣出土一批商代青銅器. *Kaogu* 考古 1987.8: 765–66.

Monmonier, Mark. *How to Lie with Maps.* Chicago: University of Chicago Press, 1996.

———. *Mapping It Out: Expository Cartography for the Humanities and Social Sciences.* Chicago: University of Chicago Press, 1993.

———. *No Dig, No Fly, No Go: How Maps Restrict and Control.* Chicago: University of Chicago Press, 2010.

Morenz, Ludwig D. *Bild-Buchstaben und symbolische Zeichen: Die Herausbildung der Schrift in der hohen Kultur Altägyptens.* Orbis Biblicus et Orientalis 205. Fribourg: Academic Press; Göttingen: Vandenhoeck & Ruprecht, 2004.

Morris, Ian. *Death-Ritual and Social Structure in Classical Antiquity.* Cambridge: Cambridge University Press, 1992.

Moseley, Michael E. *The Incas and Their Ancestors: The Archaeology of Peru.* New York: Thames & Hudson, 2001.

Nan Bo 南波. "Jieshao yijian tong nao" 介紹一件銅鐃. *Wenwu* 文物 1975.8: 87–88.

Nan Puheng 南普恒, Qin Ying 秦穎, Li Taoyuan 李桃元, and Dong Yawei 董亞巍. "Hubei Panlongcheng chutu bufen Shangdai qingtongqi zhuzaodi de fenxi" 湖北盤龍城出土部份商代青銅器鑄造地的分析. *Wenwu* 文物 2008.8: 77–82.

Ning Jingtong 寧景通. "Henan Yichuan faxian Shangmu" 河南伊川發現商墓. *Wenwu* 文物 1993.6: 61-64.

Nissen, Hans. "Uruk: Key Site of the Period and Key Site of the Problem." In *Artefacts of Complexity: Tracking the Uruk in the Near East*, ed. J. N. Postgate, 1-16. London: British School of Archaeology in Iraq, 2002.

Nissen, Hans, Peter Damerow, and Robert Englund. *Archaic Bookkeeping*. Translated by Paul Larsen. Chicago: University of Chicago Press, 1993.

O'Connor, David. *Ancient Nubia: Egypt's Rival in Africa*. Philadelphia: University Museum, University of Pennsylvania, 1993.

O'Shea, John M. *Mortuary Variability: An Archaeological Investigation*. Orlando, FL: Academic Press, 1984.

———. "Social Configurations and the Archaeological Study of Mortuary Practices: A Case Study." In *The Archaeology of Death*, ed. Robert Chapman, Ian Kinnes, and Klavs Randsborg, 39-52. Cambridge: Cambridge University Press, 1981.

Palmgren, Nils. *Selected Chinese Antiquities from the Collection of Gustave Adolf, Crown Prince of Sweden*. Stockholm: Generalstabens Litografiska Anstalts Förlag, 1948.

Panlongcheng: 1963-1994 nian kaogu fajue baogao 盤龍城: 1963-1994 年考古發掘報告. Edited by Hubei sheng wenwu kaogu yanjiusuo 湖北省文物考古研究所. 2 vols. Beijing: Wenwu chubanshe, 2001.

Parker Pearson, Michael. *The Archaeology of Death and Burial*. College Station: Texas A&M University Press, 1999.

Patterson, Thomas Carl. "The Huaca La Florida, Rimac Valley, Perú." In *Early Ceremonial Architecture in the Andes*, ed. Christopher B. Donnan, 59-69. Washington, DC: Dumbarton Oaks, 1985.

———. *Inventing Western Civilization*. New York: Monthly Review Press, 1997.

Pirazzoli-t'Serstevens, Michèle, ed. *La Cina*. 2 vols. Turin: UTET, 1996.

Pollock, Susan. "Bureaucrats and Managers, Peasants and Pastoralists, Imperialists and Traders: Research on the Uruk and Jemdet Nasr Periods in Mesopotamia." *Journal of World Prehistory* 6 (1992): 297-336.

Pool, Christopher. *Olmec Archaeology and Early Mesoamerica*. Cambridge: Cambridge University Press, 2007.

Porter, Anne. "Beyond Dimorphism: Ideologies and Materialities of Kinship as Time-Space Distanciation." In *Nomads, Tribes and the State in the Ancient Near East: Cross Disciplinary Perspectives*, ed. Jeffery Szuchman, 201-26. Oriental Institute Seminars 5. Chicago: University of Chicago Press, 2009.

Possehl, Gregory L., ed. *Harappan Civilization: A Recent Perspective*. 2nd rev. ed. New Delhi: American Institute of Indian Studies and Oxford and IBH Publishing, 1993.

Postgate, J. N. "The Debris of Government: Reconstructing the Middle Assyrian State Apparatus from Tablets and Potsherds." *Iraq* 72 (2010): 19-37.

———. "In Search of the First Empires." *Bulletin of the American Schools of Oriental Research* 293 (1994): 1-13.

Puett, Michael. *To Become a God: Cosmology, Sacrifice and Self-Divinization in Early China*. Cambridge, MA: Harvard University Asia Center, 2002.

Qi Wentao 齊文濤. "Gaishu jinnian lai Shandong chutu de Shangzhou qingtongqi" 概述近年來山東出土的商周青銅器. *Wenwu* 文物 1972.5: 3-18.

Qian Pingxi 千平喜. "Wuzhi xian zao Shang muzang qingli jianbao" 武陟縣早商墓葬清理簡報. *Henan wenbo tongxun* 河南文博通訊 1980.3: 38-39.

Qin Xiaoli 秦小麗. "Jin xinan diqu Erlitou wenhua dao Erligang wenhua de taoqi yanbian yanjiu" 晉西南地區二里頭文化到二里岡文化的陶器演變研究. *Kaogu* 考古 2006.2: 56-65.

Qiu Xigui 裘錫圭. "Shuo Yinxu buci de 'dian'—shilun Shangren chuzhi fushuzhe de yizhong fangfa" 說殷墟卜辭的 "奠"—試論商人處置服屬者的一種方法. *Bulletin of the Institute of History and Philology, Academia Sinica* [Zhongyang yanjiuyuan lishi yuyan yanjiusuo jikan 中央研究院歷史語言研究所集刊] 64, no. 3 (1993): 659-86.

Ratnagar, Shereen. *Trading Encounters: From the Euphrates to the Indus in the Bronze Age*. Oxford: Oxford University Press, 2004.

Rawson, Jessica. "The Ancestry of Chinese Bronze Vessels." In *History from Things: Essays on Material Culture*, ed. Steven Lubar and W. David Kingery, 51-73. Washington, DC: Smithsonian Institution Press, 1993.

———. Review of *The Great Bronze Age of China: An Exhibition from the People's Republic of China*, ed. Wen Fong. *Ars Orientalis* 13 (1982): 193-95.

———. "Western Zhou Archaeology." In *The Cambridge History of Ancient China: From the Origins of Civilization to 221 B.C.*, ed. Michael Loewe and Edward L. Shaughnessy, 352-449. Cambridge: Cambridge University Press, 1999.

———, ed. *Mysteries of Ancient China: New Discoveries from the Early Dynasties*. London: British Museum Press, 1996.

Reisner, George Andrew. *A Provincial Cemetery of the Pyramid Age, Naga-Ed-Dêr*. University of California Publications in Egyptian Archaeology 6. Oxford: University Press, John Johnson, 1932.

Renfrew, Colin. *British Prehistory: A New Outline*. London: Duckworth, 1974.

———. "Space, Time and Polity." In *The Evolution of Social Systems*, ed. J. Friedman and M. J. Rowlands, 89-112. Pittsburgh, PA: University of Pittsburgh Press, 1978.

Renfrew, Colin, and Paul Bahn. *Archaeology: Theories, Methods and Practice*. 5th ed. London: Thames & Hudson, 2008.

Rice, Prudence M. "Contexts of Contact and Change: Peripheries, Frontiers, and Boundaries." In *Studies in Culture Contact: Interaction, Culture Change, and Archaeology*, ed. James G. Cusick, 44–66. Occasional Paper No. 25. Carbondale: Center for Archaeological Investigations, Southern Illinois University, 1998.

Roaf, Michael. *Cultural Atlas of Mesopotamia and the Ancient Near East*. New York: Facts on File, 1990.

Romano, James F. *The Luxor Museum of Ancient Egyptian Art: Catalogue*. Cairo: American Research Center in Egypt, 1979.

Rothe, Russell D., William K. Miller, and George Rapp Jr. *Pharaonic Inscriptions from the Southeastern Desert of Egypt*. Winona Lake, IN: Eisenbrauns, 2008.

Rothman, Mitchell. "The Local and the Regional: An Introduction." In *Uruk Mesopotamia & Its Neighbors: Cross-Cultural Interactions in the Era of State Formation*, ed. Mitchell Rothman, 3–26. Santa Fe, NM: School of American Research Press, 2001.

———, ed. *Uruk Mesopotamia & Its Neighbors: Cross-Cultural Interactions in the Era of State Formation*. Santa Fe, NM: School of American Research Press, 2001.

Roy, Jane. *The Politics of Trade: Egypt and Lower Nubia in the 4th Millennium BC*. Culture and History of the Ancient Near East 47. Leiden: Brill, 2011.

Sanxingdui jisi keng 三星堆祭祀坑. Edited by Sichuan sheng wenwu kaogu yanjiusuo 四川省文物考古研究所. Beijing: Wenwu chubanshe, 1999.

Saxe, Arthur A. *Social Dimensions of Mortuary Practices*. PhD diss., University of Michigan, 1970.

Schwartz, Glenn. "Syria and the Uruk Expansion." In *Uruk Mesopotamia & Its Neighbors: Cross-Cultural Interactions in the Era of State Formation*, ed. Mitchell Rothman, 233–64. Santa Fe, NM: School of American Research Press, 2001.

Scott, James C. *Domination and the Arts of Resistance: Hidden Transcripts*. New Haven, CT: Yale University Press, 1990.

Service, Elman. *The Origin of the State and Civilization: The Process of Cultural Evolution*. New York: Norton, 1975.

Shaanxi chutu Shang Zhou qingtongqi 陝西出土商周青銅器. Edited by Shaanxi kaogu yanjiusuo 陝西考古研究所, Shaanxi sheng wenwu guanli weiyuanhui 陝西省文物管理委員會, and Shaanxi sheng bowuguan 陝西省博物館. Vol. 1. Beijing: Wenwu chubanshe, 1979.

Shaanxi sheng kaogu yanjiusuo 陝西省考古研究所, Weinan shi wenwu baohu kaogu yanjiusuo 渭南市文物保護考古研究所, and Hancheng shi wenwu lüyouju 韓城市文物旅遊局. "Shaanxi Hancheng Liangdaicun yizhi M26 fajue jianbao" 陝西韓城梁帶村遺址 M26 發掘簡報. *Wenwu* 文物 2008.1: 4–21.

Shandong daxue dongfang kaogu yanjiu zhongxin 山東大學東方考古研究中心. "Daxinzhuang yizhi 1984 nian qiu shijue baogao" 大辛莊遺址 1984 年秋試掘報告. *Dongfang kaogu* 東方考古, no. 4 (2008): 288–521.

Shandong daxue lishi wenhua xueyuan kaoguxi 山東大學歷史文化學院考古系 and Shandong sheng wenwu kaogu yanjiusuo 山東省文物考古研究所. "Jinan Daxinzhuang yizhi 139 hao Shangdai muzang" 濟南大辛莊遺址139号商代墓葬. *Kaogu* 考古 2010.10: 3–6.

Shang Zhou qingtongqi wenshi 商周青銅器紋飾. Edited by Shanghai bowuguan qingtongqi yanjiuzu 上海博物館青銅器研究組. Beijing: Wenwu chubanshe, 1984.

Shangdai Jiangnan: Jiangxi Xingan Dayangzhou chutu wenwu jicui 商代江南: 江西新干大洋洲出土文物輯粹. Edited by Zhongguo guojia bowuguan 中國國家博物館 and Jiangxi sheng wenhuating 江西省文化廳. Beijing: Zhongguo shehui kexue chubanshe, 2006.

Shen Zhenzhong 沈振中. "Xinxian Liansigou chutu de qingtongqi" 忻縣連寺溝出土的青銅器. *Wenwu* 文物 1972.4: 67–69.

Shi Zhangru 石璋如. *Xiaotun diyiben: Yizhi de faxian yu fajue: Yibian: Jianzhu yicun* 小屯第一本: 遺址的發現與發掘: 乙編: 建築遺存. Taipei: Academia Sinica, 1959.

Shima Kunio 島邦男. *Inkyo bokuji kenkyū* 殷虛卜辭研究. Hirosaki, Japan: Chūgokugaku kenkyūkai, 1958.

Shodō zenshū 書道全集. 28 vols. Tokyo: Heibonsha, 1954–68.

Sinopoli, Carla. *Approaches to Archaeological Ceramics*. New York: Plenum Press, 1991.

Sirén, Osvald. *A History of Early Chinese Art*. Vol. 1, *The Prehistoric and Pre-Han Periods*. London: Ernest Benn, 1929.

Smith, Harry S. "The Princes of Seyala in Lower Nubia in the Predynastic and Protodynastic Periods." In *Nubie, Soudan, Éthiopie*, vol. 2 of *Hommages à Jean Leclant*, ed. Catherine Berger, Gisèle Clerc, and Nicolas Grimal, 361–76. Bibliothèque d'Étude 106/2. Cairo: Institut Français d'Archéologie Orientale, 1994.

So, Jenny F. "Antiques in Antiquity: Early Chinese Looks at the Past." *Journal of Chinese Studies* 48 (2008): 373–406.

Song Guoding 宋國定. "Zhengzhou Xiaoshuangqiao yizhi chutu taoqi shang de zhushu" 鄭州小雙橋遺址出土陶器上的朱書. *Wenwu* 文物 2003.5: 35–44.

Song Xinchao 宋新潮. *Yin Shang wenhua quyu yanjiu* 殷商文化區域研究. Xi'an, Shaanxi: Shaanxi renmin chubanshe, 1991.

Soper, Alexander. "Early, Middle, and Late Shang: A Note." *Artibus Asiae* 28 (1966): 5–38.

Sowada, Karin N. *Egypt in the Eastern Mediterranean during the Old Kingdom: An Archaeological Perspective*. Orbis Biblicus et Orientalis 237. Fribourg: Academic Press; Göttingen: Vandenhoeck & Ruprecht, 2009.

Spence, Kate. "Royal Walling Projects in the Second Millennium BC: Beyond an Interpretation of Defence." *Cambridge Archaeological Journal* 14, no. 2 (2004): 265–71.

Stein, Gil J. "Colonies without Colonialism: A Trade Diaspora Model of Fourth Millennium B.C. Mesopotamian Enclaves in Anatolia." In *The Archaeology of Colonialism*, ed. Claire Lyons and John Papadopoulos, 26–64. Los Angeles: Getty Research Institute, 2002.

———. "From Passive Periphery to Active Agents: Emerging Perspectives in the Archaeology of Interregional Interaction." *American Anthropologist* 104, no. 3 (2002): 903–16.

———. "Indigenous Social Complexity at Hacınebi (Turkey) and the Organization of Uruk Colonial Contact." In *Uruk Mesopotamia & Its Neighbors: Cross-Cultural Interactions in the Era of State Formation*, ed. Mitchell Rothman, 265–306. Santa Fe, NM: School of American Research Press, 2001.

Strudwick, Nigel. *Texts from the Pyramid Age*. Writings from the Ancient World 16. Atlanta, GA: Society of Biblical Literature, 2005.

Suizhou shi bowuguan 隨州市博物館. "Hubei Suixian faxian Shangdai qingtongqi" 湖北隨縣發現商代青銅器. *Wenwu* 文物 1981.8: 46–48.

Sun Hua 孫華. "Guanyu Xingan da mu de jige wenti" 關於新干大墓的幾個問題. In *Shangdai Jiangnan: Jiangxi Xingan Dayangzhou chutu wenwu jicui* 商代江南: 江西新干大洋洲出土文物輯粹, ed. Zhongguo guojia bowuguan 中國國家博物館 and Jiangxi sheng wenhuating 江西省文化廳, 337–52. Beijing: Zhongguo shehui kexue chubanshe, 2006.

Sutton, Donald S. "Violence and Ethnicity on a Qing Colonial Frontier: Customary and Statutory Law in the Eighteenth-Century Miao Pale." *Modern Asian Studies* 37, no. 1 (February 2003): 41–80.

Tainter, Joseph. "Woodland Social Change in West-Central Illinois." *Mid-Continental Journal of Archaeology* 2, no. 1 (1977): 67–98.

Tan Yuanhui 譚遠輝. "Hunan Cendan nongchang faxian Shangdai tongqi mu" 湖南涔澹農場發現商代銅器墓. *Huaxia kaogu* 華夏考古 1993.2: 54–56.

Tang Aihua 唐愛華. "Xinxiang shi bowuguan shoucang de wuyan shoumianwen gu" 新鄉市博物館收藏的無眼獸面紋觚. *Wenwu* 文物 1983.7: 72.

Tang Jigen 唐際根. "Kaoguxue, zhengshi qingxiang, minzu zhuyi" 考古學・證史傾向・民族主義. *Dushu* 讀書 2002.1: 42–51.

———. *The Social Organization of Late Shang China: A Mortuary Perspective*. PhD diss., University of London, 2004.

———. "The True Face of Antiquity: Anyang Yinxu Sacrificial Pits and the Dark Side of 'Three Dynasties Civilization'." Unpublished manuscript, 2005.

Tang, Jigen, Zhichun Jing, and George (Rip) Rapp. "The Largest Walled Shang City Located in Anyang, China." *Antiquity* 74, no. 285 (2007): 479–80.

Tang Jigen, Zhichun Jing, James B. Stoltman, and George Rapp. "Ceramic Production in Shang Societies of Anyang." *Asian Perspectives* 48, no. 1 (2009): 182–203.

Tch'ou Tö-I. *Bronzes antiques de la Chine appartenant à C.T. Loo et Cie*. Paris and Brussels: Librairie National d'Art et d'Histoire, 1924.

Tengzhou shi bowuguan 滕州市博物館. "Shangdong Tengzhou shi faxian Shangdai qingtongqi" 山東滕州市發現商代青銅器. *Wenwu* 文物 1993.6: 95–96.

———. "Shandong Tengzhou shi Xuehe xiayou chutu de Shangdai qingtongqi" 山東滕州市薛河下游出土的商代青銅器. *Kaogu* 考古 1996.5: 29–31.

Thorp, Robert L. *China in the Early Bronze Age: Shang Civilization*. Encounters with Asia. Philadelphia: University of Pennsylvania Press, 2006.

———. "Erlitou and the Search for the Xia." *Early China* 16 (1991): 1–38.

Tian Kai 田凱, ed. *Zhongguo chutu yuqi quanji: 5 Henan* 中國出土玉器全集: 5 河南. Beijing: Kexue chubanshe, 2005.

Tongchuan shi wenhuaguan 銅川市文化館. "Shaanxi Tongchuan faxian Shang Zhou qingtongqi" 陝西銅川發現商周青銅器. *Kaogu* 考古 1982.1: 107, 102.

Tonglüshan gu kuangye yizhi 銅綠山古礦冶遺址. Edited by Huangshi shi bowuguan 黃石市博物館. Beijing: Wenwu chubanshe, 1999.

Trigger, Bruce G. "The Archaeology of Government." *World Archaeology* 6, no. 1 (1974): 95–106.

———. "Going Still Further?" *Cambridge Archaeological Journal* 15 (2005): 256–58.

———. *A History of Archaeological Thought*. Cambridge: Cambridge University Press, 1989.

———. *A History of Archaeological Thought*. 2nd ed. Cambridge: Cambridge University Press, 2006.

———. *Understanding Early Civilizations: A Comparative Study*. Cambridge: Cambridge University Press, 2003.

Ucko, Peter J. "Ethnography and Archaeological Interpretation of Funerary Remains." *World Archaeology* 1, no. 2 (1969): 262–90.

Underhill, Anne. *Craft Production and Social Change in Northern China*. New York: Kluwer Academic Publishers, 2002.

———. "Warfare and the Development of States in China." In *The Archaeology of Warfare: Prehistories of Raiding and Conquest*, ed. Elizabeth Arkush and Mark Allen, 253–85. Malden, MA: Blackwell, 2006.

Van De Mieroop, Marc. *The Ancient Mesopotamian City*. Oxford: Oxford University Press, 1997.

———. *The Eastern Mediterranean in the Age of Ramesses II*. Oxford and Malden, MA: Blackwell, 2007.

———. *A History of Ancient Egypt*. Blackwell History of the Ancient World. Chichester: Wiley-Blackwell, 2011.

van den Brink, Edwin C. M., and Eliot Braun. "Appraising South Levantine–Egyptian Interaction: Recent Discoveries from Israel and Egypt." In *Egypt at Its Origins II: Proceedings of the International Conference "Origin of the State: Predynastic and Early Dynastic Egypt," Toulouse, 5th–8th September 2005*, ed. Béatrix Midant-Reynes and Yann Tristant, 643–88. Orientalia Lovaniensia Analecta 172. Leuven: Peeters, 2008.

van den Brink, Edwin C. M., and Thomas E. Levy, eds. *Egypt and the Levant: Interrelations from the 4th through the Early 3rd Millennium BCE*. New Approaches to Anthropological Archaeology. London: Leicester University Press, 2002.

———. "Interaction Models, Egypt and the Levantine Periphery." In *Egypt and the Levant: Interrelations from the 4th through the Early 3rd Millennium BCE*, ed. Edwin C. M. van den Brink and Thomas E. Levy, 3–38. London: Leicester University Press, 2002.

Voretzsch, Ernst Arthur. *Altchinesische Bronzen*. Berlin: J. Springer, 1924.

Wang Guangyong 王光永. "Shaanxi Qishan xian faxian Shangdai tongqi" 陕西岐山縣發現商代銅器. *Wenwu* 文物 1977.12: 86–87.

Wang Guowei 王國維. *Guantang jilin* 觀堂集林. 2nd rev. ed. Beijing: Zhonghua shuju, 1959.

Wang Haicheng 王海城. *Writing and the State in Early China in Comparative Perspective*. PhD diss., Princeton University, 2007.

Wang Jinxian 王進先. "Shanxi Changzhi shi jianxuan, zhengji de Shangdai qingtongqi" 山西長治市揀選, 徵集的商代青銅器. *Wenwu* 文物 1982.9: 49–52.

Wang Jun 王俊. "Shi lun Maanshan qingtong da nao de niandai ji qi xingzhi" 試論馬鞍山青銅大鐃的年代及其性質. *Dongnan wenhua* 東南文化 2006.3: 23–27.

Wang Lixin 王立新. *Zao Shang wenhua yanjiu* 早商文化研究. Beijing: Gaodeng jiaoyu chubanshe, 1998.

Wang Xuerong 王學榮 and He Yuling 何毓靈. "Anyang Yinxu Xiaomintun yizhi de kaogu xin faxian ji xiangguan renshi" 安陽殷墟孝民屯遺址的考古新發現及相關認識. *Kaogu* 考古 2007.1: 54–63.

Wannan Shang Zhou qingtongqi 皖南商周青銅器. Edited by Anhui daxue 安徽大學 and Anhui sheng wenwu kaogu yanjiusuo 安徽省文物考古研究所. Beijing: Wenwu chubanshe, 2006.

Wei Si 衛斯. "Pinglu xian Qianzhuang Shangdai yizhi chutu wenwu" 平陸縣前莊商代遺址出土文物. *Wenwu jikan* 文物季刊 1992.1: 18–19.

Wengrow, David. *The Archaeology of Early Egypt: Social Transformations in North-East Africa, 10,000 to 2650 BC*. Cambridge World Archaeology. Cambridge: Cambridge University Press, 2006.

———. "The Evolution of Simplicity: Aesthetic Labour and Social Change in the Neolithic Near East." *World Archaeology* 33, no. 2 (2001): 168–88.

Wengrow, David, and John Baines. "Images, Human Bodies, and the Ritual Construction of Memory in Late Predynastic Egypt." In *Egypt at Its Origins: Studies in Memory of Barbara Adams*, ed. S. Hendrickx et al., 1081–1114. Leuven: Peeters, 2004.

Whitehouse, Helen. "King Den in Oxford." *Oxford Journal of Archaeology* 6 (1987): 257–67.

Williams, Bruce Beyer. *Excavations between Abu Simbel and the Sudan Frontier I, the A-Group Royal Cemetery at Qustul: Cemetery L*. Oriental Institute Nubian Expedition 3. Chicago: Oriental Institute, University of Chicago, 1986.

Williams, Bruce Beyer, and Thomas J. Logan. "The Metropolitan Museum Knife Handle and Aspects of Pharaonic Imagery before Narmer." *Journal of Near Eastern Studies* 46 (1987): 245–85.

Winkler, Hans A. *Rock-Drawings of Southern Upper Egypt: Sir Robert Mond Desert Expedition, Preliminary Report*. Vol. 1, *Season 1936–1937*. London: Egypt Exploration Society; Humphrey Milford, Oxford University Press, 1938.

Wodzińska, Anna. "Main Street Ceramics." In *Giza Reports: The Giza Plateau Mapping Project*. Vol. 1, *Project History, Survey, Ceramics, and Main Street and Gallery III.4 Operations*, ed. Mark E. Lehner and Wilma Wetterstrom, 143–52. Boston: Ancient Egypt Research Associates, 2007.

Wright, Henry T. "Cultural Action in the Uruk World." In *Uruk Mesopotamia & Its Neighbors: Cross-Cultural Interactions in the Era of State Formation*, ed. Mitchell Rothman, 123–48. Santa Fe, NM: School of American Research Press, 2001.

———. "Toward an Explanation of the Origin of the State." In *Origins of the State: The Anthropology of Political Evolution*, ed. Ronald Cohen and Elman R. Service, 49–68. Philadelphia: Institute for the Study of Human Issues, 1978.

Wu Tung. *Tales from the Land of Dragons: 1,000 Years of Chinese Painting*. Boston: Museum of Fine Arts, Boston, 1997.

Wucheng: 1973–2002 nian kaogu fajue baogao 吳城: 1973–2002 年考古發掘報告. Edited by Jiangxi sheng wenwu kaogu yanjiusuo 江西省文物考古研究所 and Zhangshu shi bowuguan 樟樹市博物館. Beijing: Kexue chubanshe, 2005.

Xi'an Banpo bowuguan 西安半坡博物館. "Shaanxi Lantian Huaizhenfang Shang dai yizhi shijue jianbao" 陝西藍田懷真坊商代遺址試掘簡報. *Kaogu yu wenwu* 考古與文物 1981.3: 48.

Xiang Taochu 向桃初. "Hunan Ningxiang Tanheli Xi Zhou chengzhi yu muzang fajue jianbao" 湖南寧鄉炭河里西周城址與墓葬發掘簡報. *Wenwu* 文物 2006.6: 4–35.

———. "Nanfang Shang Zhou tong nao de fenlei xulie he niandai wenti" 南方商周銅鐃的分類序列和年代問題. In *Hunan chutu Yin Shang Xi Zhou qingtongti* 湖南出土殷商西周青銅器, ed. Hunan sheng bowuguan 湖南省博物館, 718–43. Changsha, Hunan: Yuelu shushe, 2007.

———. *Xiangjiang liuyu Shang Zhou qingtong wenhua yanjiu* 湘江流域商周青銅文化研究. Beijing: Xianzhuang shuju, 2008.

Xiaxian Dongxiafeng 夏縣東下馮. Edited by Zhongguo shehui kexueyuan kaogu yanjiusuo 中國社會科學院考古研究所, Zhongguo lishi bowuguan 中國歷史博物館, and Shanxi sheng kaogu yanjiusuo 山西省考古研究所. Beijing: Wenwu chubanshe, 1988.

Xin Zhongguo de kaogu faxian he yanjiu 新中國的考古發現和研究. Edited by Zhongguo shehui kexueyuan kaogu yanjiusuo 中國社會科學院考古研究所. Beijing: Wenwu chubanshe, 1984.

Xin Zhongguo de kaogu shouhuo 新中國的考古收穫. Edited by Zhongguo shehui kexueyuan kaogu yanjiusuo 中國社會科學院考古研究所. Beijing: Wenwu chubanshe, 1961.

Xingan Shangdai da mu 新干商代大墓. Edited by Jiangxi sheng wenwu kaogu yanjiusuo 江西省文物考古研究所, Jiangxi sheng bowuguan 江西省博物館, and Xingan xian bowuguan 新干縣博物館. Beijing: Wenwu chubanshe, 1997.

Xu Hong 許宏 and Liu Li 劉莉. "Guanyu Erlitou yizhi de xingsi" 關於二里頭遺址的省思. *Wenwu* 文物 2008.1: 43–52.

Xu, Jay, ed. "Special Section: Art and Archaeology of the Sichuan Basin." *Journal of East Asian Archaeology* 5 (2003 [2006]): 101–469.

Xu Jinsong 徐勁松 and Dong Yawei 董亞巍. "Panlongcheng chutu da kou taogang de xingzhi ji yongtu" 盤龍城出土大口陶缸的性質及用途. In *Panlongcheng: 1963–1994 nian kaogu fajue baogao* 盤龍城: 1963–1994 年考古發掘報告, ed. Hubei sheng wenwu kaogu yanjiusuo 湖北省文物考古研究所. Vol. 1, app. 8. Beijing: Wenwu chubanshe, 2001.

Xu Lianggao 徐良高. "Wenhua yinsu dingxing fenxi yu Shangdai qingtong liqi wenhua quan yanjiu" 文化因素定性分析與商代青銅禮器文化圈研究. In *Zhongguo Shang wenhua guoji xueshu taolunhui lunwenji* 中國商文化國際學術討論會論文集, ed. Zhongguo shehui kexueyuan kaogu yanjiusuo 中國社會科學院考古研究所, 227–36. Beijing: Zhongguo dabaike quanshu chubanshe, 1998.

Xu Weihua 胥衛華. "Hunan Yueyang shi Tonggushan yizhi chutu Shangdai qingtongqi" 湖南岳陽市銅鼓山遺址出土商代青銅器. *Kaogu* 考古 2006.7: 90–91.

Xue Wencan 薛文燦. "Henan Xinzheng xian Wangjinglou chutu de tongqi he yuqi" 河南新鄭縣望京樓出土的銅器和玉器. *Kaogu* 考古 1981.6: 556.

Yang Debiao 楊德標. "Anhui sheng Hanshan xian chutu de Shang Zhou qingtongqi" 安徽省含山縣出土的商周青銅器. *Wenwu* 文物 1992.5: 92–93.

Yang Xizhang 楊錫璋. "Yinren zun dongbei fangwei" 殷人尊東北方位. In *Qingzhu Su Bingqi kaogu 55 nian lunwen ji* 慶祝蘇秉琦考古五十五年論文集, ed. Qingzhu Su Bingqi kaogu 55 nian lunwenji bianjizu 慶祝蘇秉琦考古五十五年論文集編輯組, 305–14. Beijing: Wenwu chubanshe, 1989.

Yang Xizhang 楊錫璋 and Tang Jigen 唐際根. "Yubei Jinan diqu de zhong Shang yicun yu Pangeng yi xian de Shang du qianxi" 豫北冀南地區的中商遺存與盤庚以先的商都遷徙. In *Sandai wenming yanjiu 1* 三代文明研究 (一), 248–56. Beijing: Kexue chubanshe, 1999.

Yanshi Erlitou: 1959 nian–1978 nian kaogu fajue baogao 偃師二里頭: 1959 年–1978 年考古發掘報告. Edited by Zhongguo shehui kexueyuan kaogu yanjiusuo 中國社會科學院考古研究所. Beijing: Zhongguo dabaike quanshu chubanshe, 1999.

Yekutieli, Yuval. "Symbols in Action—the Megiddo Graffiti Reassessed." In *Egypt at Its Origins II: Proceedings of the International Conference "Origin of the State: Predynastic and Early Dynastic Egypt," Toulouse, 5th–8th September 2005*, ed. Béatrix Midant-Reynes and Yann Tristant, 807–37. Leuven: Peeters, 2008.

Yinxu 殷墟. Edited by Yinxu weiyuanhui 殷墟委員會. Beijing: Wenwu chubanshe, 2001.

Yinxu de faxian yu yanjiu 殷墟的發現與研究. Edited by Zhongguo shehui kexueyuan kaogu yanjiusuo 中國社會科學院考古研究所. Beijing: Kexue chubanshe, 2001.

Yinxu Fu Hao mu 殷墟婦好墓. Edited by Zhongguo shehui kexueyuan kaogu yanjiusuo 中國社會科學院考古研究所. Rev. ed. Beijing: Wenwu chubanshe, 1984.

Yoffee, Norman. "The Evolution of Simplicity: Review of James C. Scott, *Seeing Like a State*." *Current Anthropology* 42 (2001): 767–69.

———. *Myths of the Archaic State: Evolution of the Earliest Cities, States, and Civilizations*. Cambridge: Cambridge University Press, 2005.

Yuan Guangkuo 袁廣闊 and Zeng Xiaomin 曾曉敏. "Lun Zhengzhou Shang cheng neicheng he waiguocheng de guanxi" 論鄭州商城內城和外郭城的關係. *Kaogu* 考古 2004.3: 59–67.

Yuan Jing and Rod Campbell. "The Origins of Chinese Civilization: Recent Archaeometric Advances and Remaining Issues." *Antiquity* 83 (2009): 96–109.

Yuan Jing and Rowan Flad. "New Zooarchaeological Evidence for Changes in Shang Dynasty Animal Sacrifice." *Journal of Anthropological Archaeology* 24, no. 3 (2005): 252–70.

Yuanqu pendi juluo kaogu yanjiu 垣曲盆地聚落考古研究. Edited by Zhongguo guojia bowuguan kaogubu 中國國家博物館考古部. Beijing: Kexue chubanshe, 2007.

Yuanqu Shang cheng 1: 1985–1986 niandu kancha baogao 垣曲商城 (一): 1985–1986 年度勘查報告. Edited by Zhongguo lishi bowuguan kaogubu 中國歷史博物館考古部, Shanxi sheng kaogu yanjiusuo 山西省考古研究所, and Yuanqu xian bowuguan 垣曲縣博物館. Beijing: Kexue chubanshe, 1996.

Yueyang shi wenwu guanlisuo 岳陽市文物管理所. "Yueyang shi xin chutu de Shang Zhou qingtongqi" 岳陽市新出土的商周青銅器. *Hunan kaogu jikan* 湖南考古輯刊 2 (1984): 26–28.

Yueyang shi Yunxi qu wenwu guanlisuo 岳陽市雲溪區文物管理所. "Yueyangshi shijiao Tonggushan yizhi xin chutu de qingtongqi" 岳陽市市郊銅鼓山遺址新出土的青銅器. *Hunan kaogu* 湖南考古 (2002): 455–59.

Zhang Changping 張昌平 and Guo Weimin 郭偉民, eds. *Zhongguo chutu yuqi quanji: 10 Hubei, Hunan* 中國出土玉器全集: 10 湖北, 湖南. Beijing: Kexue chubanshe, 2005.

Zhang Heshan 張河山. "Henan Zhecheng Xinmensi yizhi faxian Shangdai tongqi" 河南柘城心悶寺遺址發現商代銅器. *Kaogu* 考古 1983.6: 560-61.

Zhang Jiuyi 張久益. "Henan Linru xian Lilou chutu Shangdai qingtongqi" 河南林汝縣李樓出土商代青銅器. *Kaogu* 考古 1983.9: 839-40.

Zhang Weilian 張渭蓮. "Erlitou wenhua dui Shang wenming xingcheng de yingxiang" 二里頭文化對商文明形成的影響. In *Erlitou yizhi yu Erlitou wenhua yanjiu* 二里頭遺址與二里頭文化研究, ed. Du Jinpeng 杜金鵬 and Xu Hong 許宏, 387-94. Beijing: Kexue chubanshe, 2006.

Zhang Zengwu 張增午. "Henan Linxian jianxuan dao sanjian Shangdai qingtongqi" 河南林縣揀選到三件商代青銅器. *Wenwu* 文物 1986.3: 92-93.

Zhao Xinlai 趙新來. "Zhongmu xian Huangdian, Dazhuang faxian Shangdai tongqi" 中牟縣黃店, 大莊發現商代銅器. *Wenwu* 文物 1980.12: 89-90.

Zhejiang sheng wenwu guanli weiyuanhui 浙江省文物管理委員會. "Zhejiang Changxing xian chutu liang jian tongqi" 浙江長興縣出土兩件銅器. *Wenwu* 文物 1960.7: 48-49.

Zhejiang sheng wenwu kaogu yanjiusuo 浙江省文物考古研究所. "Hangzhou shi Yuhang qu Liangzhu gu cheng yizhi 2006-2007 nian de fajue" 杭州市余杭區良渚古城遺址 2006-2007 年的發掘. *Kaogu* 考古 2008.7: 3-10.

Zhejiang sheng wenwu kaogu yanjiusuo 浙江省文物考古研究所, Wenzhou shi wenwu baohu kaogusuo 溫州市文物保護考古所, and Ouhai qu wenboguan 甌海區文博館, eds. "Zhejiang Ouhai Yangfushan Xi Zhou tudunmu fajue jianbao" 浙江甌海楊府山西周土墩墓發掘簡報. *Wenwu* 文物 2007.11: 25-35.

Zhengzhou Shang cheng: 1953-1985 nian kaogu fajue baogao 鄭州商城: 1953-1985 年考古發掘報告. Edited by Henan sheng wenwu kaogu yanjiusuo 河南省文物考古研究所. 3 vols. Beijing: Wenwu chubanshe, 2001.

Zhengzhou Shangdai tongqi jiaocang 鄭州商代銅器窖藏. Edited by Henan sheng wenwu kaogu yanjiusuo 河南省文物考古研究所 and Zhengzhou shi wenwu kaogu yanjiusuo 鄭州市文物考古研究所. Beijing: Kexue chubanshe, 1999.

Zhengzhou shi bowuguan 鄭州市博物館. "Zhengzhou shi Minggonglu xice de liangzuo Shangdai mu" 鄭州市銘功路西側的兩座商代墓. *Kaogu* 考古 1965.10: 500-506.

Zhengzhou Xiaoshuangqiao: 1990-2000 nian kaogu fajue baogao 鄭州小雙橋 1990-2000 年考古發掘報告. Edited by Henan sheng wenwu kaogu yanjiusuo 河南省文物考古研究所. 2 vols. Beijing: Kexue chubanshe, 2012.

Zhongguo gu qingtongqi xuan 中國古青銅器選. Beijing: Wenwu chubanshe, 1976.

Zhongguo gudai keji wenwu zhan 中國古代科技文物展. Beijing: Zhaohua chubanshe, 1997.

Zhongguo kaoguxue: Xia Shang juan 中國考古學: 夏商卷. Edited by Zhongguo shehui kexueyuan kaogu yanjiusuo 中國社會科學院考古研究所. Beijing: Zhongguo shehui kexue chubanshe, 2003.

Zhongguo lishi ditu ji 中國歷史地圖集. 8 vols. Shanghai: Zhonghua ditu xueshe, 1975.

Zhongguo qingtongqi quanji 中國青銅器全集. 16 vols. Beijing: Wenwu chubanshe, 1993-98.

Zhongguo shehui kexueyuan kaogu yanjiusuo 中國社會科學院考古研究所. "Henan Yanshi Shang cheng Shangdai zaoqi wangshi jisi yizhi" 河南偃師商城商代早期王室祭祀遺址. *Kaogu* 考古 2002.7: 6-8.

Zhongguo shehui kexueyuan kaogu yanjiusuo and Anyang gongzuodui. "Survey and Test Excavation of the Huanbei Shang City in Anyang." Translated by Jing Zhichun. *Chinese Archaeology* 4 (2004): 1-20.

Zhongguo shehui kexueyuan kaogu yanjiusuo 中國社會科學院考古研究所 and Henan dier gongzuodui 河南第二工作隊. "1983 nian qiuji Henan Yanshi Shang cheng fajue jianbao" 1983 年秋季河南偃師商城發掘簡報. *Kaogu* 考古 1984.10: 870-79.

Zhongguo shehui kexueyuan kaogu yanjiusuo Anyang gongzuodui 中國社會科學院考古研究所安陽工作隊. "Anyang Guojiazhuang xinan de Yindai chemakeng" 安陽郭家莊西南的殷代車馬坑. *Kaogu* 考古 1988.10: 882-93.

———. "1986-1987 nian Anyang Huayuanzhuang Nandi fajue baogao" 1986-1987 年安陽花園莊南地發掘報告. *Kaogu xuebao* 考古學報 1992.1: 97-128.

Zhongguo taoci quanji: 2 Xia, Shang, Zhou, Chunqiu, Zhanguo 中國陶瓷全集: 2 夏, 商, 周, 春秋, 戰國. Shanghai: Shanghai renmin meishu chubanshe, 2000.

Zhongguo wenwu ditu ji: Hunan fence 中國文物地圖集: 湖南分冊. Edited by Guojia wenwuju 國家文物局. Changsha, Hunan: Hunan ditu chubanshe, 1997.

Zhu Fenghang 朱鳳瀚. *Shang Zhou jiazu xingtai yanjiu* 商周家族形態研究. Tianjin: Tianjin guji chubanshe, 1991.

Zhu Fusheng 朱福生. "Jiangxi Xingan Niutoucheng yizhi diaocha" 江西新干牛頭城遺址調查. *Nanfang wenwu* 南方文物 2005.4: 4-7.

Zhu Zhi 朱幟. "Beiwudu Shangdai tongli" 北舞渡商代銅鬲. *Kaogu* 考古 1983.9: 841.

———. "Henan Wuyang xian luxu faxian Shangdai wenwu" 河南舞陽縣陸續發現商代文物. *Kaogu* 考古 1987.3: 275.

Zou Heng 鄒衡. *Xia Shang Zhou kaoguxue lunwenji* 夏商周考古學論文集. 2nd ed. Beijing: Kexue chubanshe, 2001.

Index

Italic/bold page numbers indicate illustrations.

Abydos, 102, *102*, *103*, 106, *106*, 108

adzes, *109*

Agrawal, D. P., 71–72

agriculture: in Egypt, 108; in the Erligang period, 86–87, 87n66, 91, 127, 182

Algaze, Guillermo, 71

An Jinhuai 安金槐, 76n28

An Zhimin 安志敏, 82n55

ancestor ritual, 116, 130, 132, 133. *See also* ritual

animal motifs: sources of, 27, 28, 40–42, 46; on southern vessels, 152, 159, 197. *See also* birds; deer; dragons; *taotie*; tigers

animals. *See* animal motifs; cattle; sacrificial animals

Anthony, David W., 173n2

Anyang 安陽: in art history instruction, 205, 210; attention devoted to, compared to Erligang, 11, 46, 210; bronzes, 20, 22, *22*, 23, 24, *24*, *25*, 27, 60, 102, 129, 129n39, *161*, *193*; center of metropolitan-type material culture, 129, 129n38, 146; centralization of power at, 135; compared with Erlitou and Erligang, 129–33, 143; as a consumer of resources, 145–46; culture of, in Hunan, 177, 178–79, 183; and the dynastic model, 138, 141–42; excavations at, 20–24, *23*; fall of, 127; foundry remains from Miaopu Beidi site 28, *28*; Guojiazhuang chariot burial, *24*; inscriptions from, *26*, 43, *45*; interregional interactions of, 143, 145–46; looting at, 22–24; mortuary ritual, 130; origins of, 26–27, 28–29, 122; sacrifices at, 43, 82, 132; size and scale of, 122; and the territorial state, 100. *See also* Fu Hao, tomb of; Huanbei; Huayuanzhuang; Tiesanlu; Wuguan Beidi; Xiaotun; Xibeigang

architecture, 82n57

arrowheads: from Tonggushan, Hunan, 177; from Xingan, Jiangxi, 156–58, *158*

art history instruction, 199–207, 205, 209–11; revised course handout, *211*

Aurelian wall (Rome), *122*

axes: from Erligang tombs, 86, *86*; from Xingan Dayangzhou, Jiangxi, 154, *155*, 156, *158*

Ba 巴 culture. *See* Ba-Shu culture

Ba-Shu 巴蜀 culture (Sichuan), 184, 184n34

Bagley, Robert: on the Erligang expansion, 77–78n33; on Erligang influence, 101n8, 130; on Keightley's model of the late Shang state, 144n28; *Max Loehr and the Study of Chinese Bronzes*, 197n5, 206; "Shang Ritual Bronzes: Casting Technique and Vessel Design," 206; use of term "empire," 77n33, 79; on use of traditional historiography in archaeology, 137–38

Baijiazhuang 白家莊 (Zhengzhou): *ding* from, **55**; jade *ge* from, **56**; *jia* from, **55**; *pan* from, **30**, **31**; *zun* from, **30**

Baines, John, 75n21, 77n29, 86n65, 121

Baota 寶塔 (Hunan), 180–82, *181*

Barnhart, Richard M. (Dick), 193–94

basketry, 40, 117

Beierqilu 北二七路 (Zhengzhou), plan and tomb inventory, **54**, **85**

bells: from Anhui, 163–64; Erligang ancestors of, 160–61; from Hunan, 164–66, 179, 184, 184n33; lower Yangzi, 160–61, 164–66; from Xingan, Jiangxi, 151, 156, 163, 164n25; from Zhejiang, *164*. *See also* nao (bells)

bianzhong 編鐘 (bells), from Yueyang, Hunan, 184n33

birds, 41, 206–7

Birds in a Thicket of Bamboo and Plum (early 12th century), **200**, 201

bo 鎛 (bell), from Xingan, Jiangxi, 164n25

Boas, Franz (1858–1942), 27

bookkeeping systems, Mesopotamia, 43–44

bovine scapula **45**. *See also* oracle bones

Bronze Age: archaeological sites of, **20**, 121n1, *152*; in art history instruction, 205; Central Plain, 126, 127–29, 142–43; and the Erligang expansion, 68, 168–69; in Hunan, 173–75, *175*, 178–80, 182n21, 185; late Shang and Eastern Zhou, 79; official chronology of, 137; sources of, 28–29; in the south, 166; Western Zhou, 79, 101n8. *See also* Anyang; bronze casting; bronze industry; Erligang bronzes; metallurgy

bronze casting: and the invention of rectangular shapes, 38; latitude for invention in, 78, 78n36; movement of craftsmen, 87n65, 169; piece-mold process, 28, 40, 54, *204*, 206, 207; and repairs, 61–63; sequential casting, 40, 153, 153n6, 163. *See also* bronze industry

bronze decoration: design principles from Erligang, 45–46, 113; Eastern Zhou transfer processes, 46, 207; Erligang and Xingan compared, 153–54; Ge *you* from Ningxiang, Hunan, 206–7, *207*; handles and, 32, 152, 159; imitated in wood and pottery, 78, **80, 81,** 117; and Loehr's vessel typology, 38; and piece-mold casting, 28, 206; similarity at Zhengzhou and Panlongcheng, 54; sources of, 27, 40–42; thread-relief, 37–38, 41–42; and wood carving, 27–28. *See also* animal motifs; birds; deer; dragons; *taotie*; tigers

bronze industry: Anyang, 129; designers and craftsmen, 78, 87n65, 124; dissemination of, 81n48, 166–70; of Erligang compared with Indus civilization, 80n44; foundries, 61–63, 78, 79, 86–87n65; organization of, 124; origins of, 27–28, 38, 40, 170; and political power, 74; and social organization, 40, 46, 80, 121; southern, 151–52, 154, 166, 169, 183–84. *See also* bronze casting

bronze studies, 32, 191–92, 196–97, *196*, 198–99, 205–7, *211*

bronzes. *See* Anyang, bronzes; bronze casting; bronze decoration; bronze industry; bronze studies; Erligang bronzes; metallurgy, vessel shapes; weapons

brush writing: from Anyang 24, *26*; from Xiaoshuangqiao near Zhengzhou, 43, *44*

burial customs: Central Plain Bronze Age elaboration of, 132–33, *134*; Erligang, 53–54, 82, 130; Neolithic, 43; tomb offerings, 57, 59

Cahill, James, *Chinese Painting*, 201

calligraphy, 153, 194–96. *See also* brush writing

cast iron, 46

cattle, 127, 146. *See also* bovine scapula

Central Plain, civilization of, 127–29, 142–43

ceramics. *See* pottery

Chang, Kwang-chih (Zhang Guangzhi; 1931–2001), *Archaeology of Ancient China* by, 138

Changjiang 長江 (Yangzi River), 19. *See also* Yangzi region

Changxing 長興 (Zhejiang), bronzes from, *164*

chariots, Anyang period, 22, *24*, 26, 42–43, 127, 146

Chase-Dunn, Christopher, 145

Chen, Xingcan, 86n65

Chen Mengjia 陳夢家 (1911–1966), 141–42, 144

Chenggu 城固 (Shaanxi), 166

Chengtoushan 城頭山 (Hunan), 180, 180n15, 182

chevron motif, 153, 153n5, 159, 160. *See also* Xingan

Childe, V. Gordon (1892–1957), 73n11

Chinese Calligraphy (Metropolitan Museum of Art exhibition), 193

Chinese writing: from Anyang, 24, *26*, *45*; Erligang, 112; origins of, 28–29, 43–45, 46; pictographic characters in, 44, *44*, 45, *45*; and the Wucheng culture, 169, *169*; from Xiaoshuangqiao near Zhengzhou, 43, *44*. *See also* brush writing; inscriptions; writing systems

chisel, from Xingan, Jiangxi, *158*

Chu, Charles, 192

cinnabar, 82, 85

city walls: Panlongcheng, 52, 53. rammed-earth, 29, *29*, 53, 67, 123, 123n11; Zhengzhou, 29, *29*, 51, *53*, 67, 123, *123*, 123n11. *See also* walled cities

city-states, 99–100

civilization: birthplace of, 26; Central Plain, 127–29, 142–43; use of the term, 121, 126

clay disks, from Zhengzhou: nonfunerary context, *85*; found in tombs, 82, 82n55, *85*, 86, *86*

clay piece molds, from Anyang, 28, *28*. *See also* bronze casting

coffins, Erligang culture, 78; wood, from Lijiazui, Panlongcheng, *59*, *81*

colony formation, 83–84, 91, 127

cong 琮, jade, from Xingan, Jiangxi, *157*

cooking vessels, 54, 76–77, *77*, 77n29, 159. *See also* *ding*; food vessels; *li*; *yan*

copper: Egyptian vessels, 117; implements from North Saqqara, *109*, 110; mines, 163, 166–68, 177, 177n10; ore, 166–68, 186; tools from Sayala, Lower Nubia, *109*, 110. *See also* metallurgy

craftsmen, 86, 87n65, 124. *See also* bronze casting

cultural contact, 12, 26–27, 28–29, 146, 168–70. *See also* interregional networks

culture: definition of, 73, 73n11; dissemination of, 69–73, 77n29, 90, 118, 125; elite and nonelite, 116; ideology and, 92. *See also* cultural contact

cuneiform, 45, *45*

Da yi Shang (Great Settlement Shang), 122. *See also* Anyang; Shang state

Da yitong 大一統 (Grand Unity), 145

Davidson, J. Leroy (1908–1980), 41–42, 206

Dawu 大悟 (Hubei), 56

Daxi 大溪 culture, 180n15, 182n21

Daxinzhuang 大辛莊 (Shandong), 74n17, 81, 82, 86n65

Dayangzhou 大洋洲. *See* Xingan

decoration: Egyptian, compared with Erligang, 113–14; integrated with writing, 114; of painted pottery, 40, 202–4; running spiral, 27, 40, 41, *42*, 48, 202, 203, 204. *See also* bronze decoration

deer, 159

descent groups, 130, 135

diguo 帝國 (empire), 77n33. *See also* empire

Di Xin 帝辛 (last Shang king; 11th century BCE), 135

ding 鼎: as ancient name, 32; from Anyang, *22*; from Baijiazhuang, Zhengzhou, *55*; from Erlitou, 39, *41*; from Huarong, Hunan, 184n30; with jade legs, 156; from Lijiazui, Panlongcheng, *33*, 40, 41, 42, *43*, *55*, *62*; from Panlongcheng, 32, *32*, 54, 60, *84*; piece-mold casting of, *204*; pottery, from the Yueyang region, Hunan, 183; as pottery shape, 38; *pou-ding* from Xingan, Jiangxi, 159, *161*; repairs to, 61–63; with running spiral decoration, 40, *43*; from Tonggushan, Hunan, 179, *179*; used in Erligang ritual, 60; from Xingan, Jiangxi, 156, *157*, 159; from Yangjiawan, Panlongcheng, *62*; from the Zhengzhou deposits, 35, *37*. *See also* *fangding*

disk-axes, jade, *131*

disks. *See* clay disks

divination, 24

dogs, sacrifice of, 82, *85*, 123

Dong Zuobin 董作賓 (Tung Tso-pin; 1895–1963), 141

Dongting Lake 洞庭湖 region (Hunan), 173n2, *177*

Dongxiafeng 東下馮 (Shanxi), 56, 124; pottery types from, *76*, 77

dragons, 40, 153, 163

drinking vessels, 77, 129. *See also* wine vessels

Duimenshan 對門山 (Hunan), 183

dynastic model, 138–39, 142–43, 144–45, 197

dynastic seals, Egyptian, 103, *103*

Ecke, Tseng Yu-ho, 193

"eggshell ware" vessels, from Qustul, Lower Nubia, *107*, 108

Egypt: archaeological periods of, 100n4, 101–2; compared with Erligang culture, 99, 100–101, 112–17, 118; elite culture of, 101, 116–17; expansion of, 103–6, 108–10, 110–11; kinglists, 103, *103*; lack of elite settlements abroad, 105; mentioned, 86n65; in Naqada III, *104*; as a territorial state, 99; writing of, *106*, 112, 114. *See also* Abydos; Naqada II culture; Naqada III culture; Saqqara

Emperor Wu of Han 漢武帝, 92n85

empire, 77n33, 79, 99, 103, 118

Erligang 二里崗 (type site), 19, 29, 67, 74n17, 75, 82, 211. *See also* Erligang bronzes; Erligang culture; Erligang expansion; Erligang pottery; Zhengzhou

Erligang bronzes: connections with southern bronzes, 152, 154; and contact between Zhengzhou and Panlongcheng, 56; discovery of, 29–31; distribution of, *68*, 81, *83*, 125–26; foundry sites, 60–61, 79, 86–87n65; functions of, 57, 126; imitated in pottery vessels and wooden coffins, 78, *80*, *81*; interpretation of, 46–47; in Ming dynasty tomb, Beijing, 82; misidentification of, 19–20; Panlongcheng, 57; production of, 60–61; repairs of, 61–63; ritual use of, 32, 57, 59–60, 86n65; and social status, 57, 59–60; in southern Anhui, 163; use of, for defining elite culture, 74; vessel types, 32, 54, 59–60, 82; weaponry, 87; from Zhengzhou, *30*, 67. *See also* bronze industry; cooking vessels; *ding*; *fangding*; foundries; *gu*; *gui*; *he*; *jia*; *jue*; *lei*; *li*; *pan*; *yan*; Panlongcheng; wine vessels; *you*; Zhengzhou; *zun*

Erligang culture: burial features of, 82, 130; center of, 82; as a civilization, 121–22, 135; compared with Anyang, 130–32, 135, 143; compared with Egypt, 100–101, 112–17, 118; compared with Uruk, Indus Valley, and the Olmec, 79–80; defined by pottery assemblage, 67; definition of, 73–74, 82; discovery of, 19; divided into Lower Erligang and Upper Erligang, 82; duration of, 74–75, 74n17, 80, 100–101; and the dynastic model, 143; elite and nonelite, 116; as an empire, 99, 118; geographic distribution of, 67–68; influence in the south, 152, 154, 175–76; interregional interactions of, 143, 178–79, 178n11; major achievements of, 45–46; political and social organization, 124–25, 135; precedents and descendants of, 100–101, 122, 126, 129–30, 135; regional perspective of, *128*; and a revised history of Chinese art, 209–10; and the Shang dynasty, 138; sites of, 51, *58*, 124; social stratification, 58–59, 124; stoneware, 158n10; trade with the south, 169; type site of, 19, 29, 67, 74n17, 75, 82, 211; and writing, 43, 45, 169. *See also* Erligang bronzes; Erligang expansion; Erligang pottery; Erligang sites

Erligang expansion: and access to natural resources, 168–69, 186; aftermath of, 151; agriculture and, 86–87; building program, 124, 133; as a colonizing empire, 83–84, 111; compared to expansion in Egypt, 103–6, 105n20, 110–11; as continuation of Erlitou expansion, 126; deposition of bronzes, 117–18; European analogies for, 87, 127; evidence from pottery and bronzes, 69, 75–80, 77–78n33; into Hunan, 182–83, 185, 186; impact in the south, 152–58, 161, 163–64, 170; interpretation of, 83–90, 104–5, 124–25; and interregional interaction, 184, 186; landscape of, 81–82; and local cultures, 83; military nature of, 69, 69n3, 91, 105, 126; objectives of, 91–92, 168–69, 186; parallels to Harrapa and Olmec cultures, 71; parallels to Uruk expansion, 69–71, 75; and the rise of the state, 185–86; route of, 182, 182n21; study of, 68–69; transfer of the bronze industry, 46, 81n48; in the Yuanqu basin, 91

Erligang pottery: decoration of, 78, *79*, *80*; discovery of, 29; distribution of, 68, *71*, 75–78, 77n29, 81, *83*, 124; Dongxiafeng type, *76*; and Erligang colonies, 86; and Hunan pottery, 176–77, 176n7; at Jingnansi, Hubei, 182n21; lack of information on production and consumption, 125; Panlongcheng type, *76*; and political structure, 77, 78n33; regional variation in, 75, 77–78n33, 82, 116; types of vessels, 55, 77; Upper and Lower Erligang assemblages, *76*; utilitarian nature of, 77, 116; at the West Minggonglu workshop site, Zhengzhou, *79*; Zhengzhou and Panlongcheng compared, 51, 56, 85; workshops, 76–77, 76n28

Erligang sites, 94–97, 124–25, *125*; in Hubei, *58*; walled, *52*. *See also* Fucheng; Gucheng Nanguan; Panlongcheng; Xiaxian Dongxiafeng; Yanshi; Yunmeng; Zhengzhou

Erligang tombs, 58–59, *59*, 60, 124; plans of *54, 59, 85, 86, 134*. *See also* Panlongcheng; Zhengzhou

Erlitou 二里頭 culture: bronze vessels of, 39, *41*, 45, 57, 129; compared with Anyang, 143; cooking vessels of, 75–76; and the dynastic model, 143; labeled as Xia, 138; and hammered metal production, 39; interregional interactions of, 143; jade weaponry of, *131*; *jue* from Tomb II, Zone VI, *129*; as precedent for Erligang culture, 122; and the Shang dynasty, 67n1; size of, 122; spread of, 56, 83n59, 126, 182n20, 182n21; as a state, 100; tomb features of, 82

"evolution of simplicity" (Yoffee and Wengrow), 116

facture, 197, 198, 206

Fairbank, Wilma (1910–2002), 197, 206

Falkenhausen, Lothar von, 137

fangding 方鼎: from bronze hoards at Zhengzhou, 32–35, *36*, 37; with human faces, from Ningxiang Huangcai, Hunan, 174, *174*, 174n4; from Pinglu, Shanxi, 35, *37*, 92, *92*, 117–18; from Xibeigang, Anyang, *24*; from Xingan, Jiangxi, 152, *153*, 159, *162*; from Zhangzhai Nanjie bronze hoard, Zhengzhou, 67, 152, *153*

fangyi 方彝, from Anyang: clay piece molds for, 28, *28*; in the Winthrop Collection, *22*, 42, *193*

fangyou 方卣, Anyang-period, from Xingan, Jiangxi, 159, *161*. See also *you*

fangzun 方尊, four-ram, from Ningxiang county, Hunan, 174, *174*, 174n4

farmers. *See* agriculture

feasting, 129–30

Feijiahe 費家河 culture, 183, 183n24, 184

Feixi 肥西 (Anhui), 163, *165*

figurines, jade, from Xingan, Jiangxi, *157*

Finley, M. I. (1912–1986), 84n61

Flad, Rowan, 132

Fong, Wen, 198, 199

food vessels: bronze, 60, 129–30; untempered pottery, 77. *See also* cooking vessels; *ding*; *gui*; *li*; *yan*

foundries. *See* bronze casting; bronze industry

Freer Gallery of Art, 196

Fu Hao 婦好 (consort of Wu Ding, ca. 12th century BCE), tomb of (Xiaotun): discovery of, 197–98, 210; *jue* from, *129*; *ge* with bronze handle with turquoise inlay, *131*; mentioned, 156; plan, *134*; wine vessels of, 159. *See also* Wu Ding

fu pots, 183

Fu Shen, 194n2

Fucheng 府城 (Henan), 56, 81, 124

Funan 阜南 (Anhui): wine vessels from, 163; *zun* from, 163, *165*

Gan River 贛江, 151, 154, 186

gang 缸, 55

Gansu province, 166

Gaocheng Taixicun 藁城台西村 (Hebei), 159n14

Gaozong 高宗 (Song dynasty emperor; 1107–1187, r. 1127–62), 208

ge 戈, *131*; jade, 55, *56*, *131*

Ge *you* 戈卣, 206–7, *207*

Gebel Sheikh Suleiman rock relief, 110, *110*, 118

Gettens, John (1900–1974), 197, 206

Giddens, Anthony, 130

goats, 127

grindstones, from Qustul, Lower Nubia, *107*, 108

gu 觚: Anyang-period, from Hunan, 184; in the collection of the Qianlong emperor, 20, *21*, 31; from Funan, Anhui, 163; from Minggonglu, Zhengzhou, *30*, 31; with openwork decoration from Lijiazui, Panlongcheng, 40, *43*; from Panlongcheng, *32*, 54, *61, 84, 159*; in the tomb of Fu Hao, 159; from Tonggushan, Hunan, 179, *179*; use of, in wine vessel ritual sets, 59–60; from Yangjiawan, Panlongcheng, *35*

Gu Kaizhi 顧愷之 (ca. 344–ca. 406), 208n20

guan 罐: Erlitou period, 75–76, *77*; glazed stoneware, from Xingan, Jiangxi, *169*

Guangxi province, 185

Gucheng Nanguan 古城南關 (Shanxi): 76n28, 79n39, 91, 143; plans of, *91*; represented on topographic map, *89*

gui 簋: from Changxing, Zhejiang, *164, 167*; from Lijiazui, Panlongcheng, 31, 32, *33, 34*; pottery, from Zhengzhou, *80*

Guo Shengbin 郭勝斌, 176–77, 180n17, 183, 183n24, 184

Guo Xi 郭熙 (ca. 1000–ca. 1090), *Early Spring*, 191, *194*

Guojiazhuang 郭家莊 (Anyang), chariot burial from, *24*

Habuba Kabira, 90; topographic map of main excavation areas, *88*

Hacınebi (Turkey), 88–90; topographic map of main excavation areas, *88*

Hall, Thomas, 145

hammered metal vessels, 39–40. *See also* metallurgy

Han dynasty, 47, 78n33, 92n85

Han River 漢江, 166

Hancheng Liangdaicun 韓城梁帶村 (Shaanxi), 159n11

Harappa culture, 71, 72. *See also* Indus Valley culture

Hayden, Brian, 140

he 盉: from Avery Brundage Collection, *38*, 41, 42; compared by Loehr, 37, 38; from Erlitou, 39, *41*; formerly in Berlin Museum, 19, *21*, 38–39; from Lijiazui, Panlongcheng, 31, *38*, 40; pottery, of Qijia type, *39*; sources of, 38–39; use of, in wine vessel ritual sets, 60; from Xibeigang, Anyang, 24, *25*

Hearn, Maxwell K. (Mike), 193, 193n1

Heavenly Omen Stele (*Tianfa Shenzhen bei* 天發神讖碑), 195n3

Helck, Wolfgang, 110n34

helmet, bronze, from Xingan, Jiangxi, 156, *158*

Hierakonpolis Main Deposit (Egypt), *113*, 114, *114, 115*

historiographic model, 137–38

Hitler, Adolf, 92n85

Hongshan 紅山 culture, 159n11

horses, 127

Houma 侯馬 foundry, 207

Huai River 淮河, 163

Huaizhenfang 懷真坊 (Shaanxi), 79n39

Huanbei 洹北 (Anyang), 130, 153n4

Huangpi 黃陂 (Hubei), 56

Huarong 華容 (Hunan), 179n14, 184, 184n30

Huayuanzhuang 花園莊 (Anyang), 54, 128, 128n34, 146; jade disk-ax from, *131*; turtle shells from, 24, *26*

Hubei Provincial Museum, 52

Huixian Mengzhuang 輝縣孟莊 (Henan), 56, 81

Huizong 徽宗 (Zhao Ji 趙佶, Song-dynasty emperor, 1082–1135, r. 1100–25), 208; *Finches and Bamboo*, *200*, 201; *Silk Beating*, 208, *208–9*, 208n20

human sacrifice, 43, 130, 132; evidence of, from Zhengzhou, 123, *124*; evidence of, from Anyang, 22, *23*

Hunan province: Anyang bronzes in, 185; Anyang-period sites in, 176, 183; Bronze Age in, 173–75, *175*, 179–80, 182n21, 185; bronze workshops in, 180; bronze finds, 179, 179n14; Erligang expansion into, 186; Erligang influence in, 173, 185; interregional interactions of, 180, 182; *nao* bells from, 184, 184n33; Neolithic in, 179–80, 180n15; as a "perpetual frontier," 173, 173n2; pottery of, 176–77, 176n7. *See also* Ningxiang county; Tonggushan; Yueyang region; Zaoshi

Hushu 湖熟 tradition, 127

incense burners, from Qustul, Lower Nubia, *107*, 108, 108n28

Indus Valley culture, 79–80, 80nn43, 44, 45, 90. *See also* Harappa culture

Ink Plum (unidentified artist, Qing dynasty), 192, *192*, 193–94, 194n2, *198*

Inka, 99, 100, 123

inscriptions: from Anyang, 24, *26*, 43, 45, *45*, 141, 198; on bone tags from Egypt, *106*; on bronzes compared with paintings, 199; cuneiform, 45, *45*; on ink paintings, 191–92, 199; from Xiaoshuangqiao, Zhengzhou 43, *44*; from Xingan, Jiangxi, 169, *169*. *See also* brush writing; oracle bones

interregional networks: in Bronze Age China, 143, 145–46, 177–79, 178n11; and the emergence of the state, 185–87; in Hunan, 182, 184–85

Israel. *See* Tel Bet Yerah

ivory artifacts, 113–14; from the Hierakonpolis Main Deposit (Egypt), *114*

jade: *cong* from Xingan, Jiangxi, *157*; figure from Xingan, *157*; *ge* from Panlongcheng, 55, *56*; handle-shaped objects, from Erligang sites, 55, *56*, 82, *86*; Neolithic, 159n11; from Panlongcheng and Zhengzhou, 54–55, *56, 131*; pendants, from Xingan, *157*; of the Shijiahe culture, 156; tripod legs, 156, *157*; weapons, from Erlitou, Erligang, and Anyang, 130, *131*; from Xingan, Jiangxi, 156, *157*, 159n11

jia 斝: ceramic, from Panlongcheng, 55; from Erlitou, 39, *41*; from Feixi, Anhui, *165*; from Funan, Anhui, 163; from Lijiazui, Panlongcheng, 31, *33*, *55*; from Panlongcheng, 31, *32*, *33*, 52, 54, *55*, *61*, *84*, *159*; repairs to, 63; from the Shanghai Museum collection, 153, *155*; in a Swedish collection, 19, *21*, 38; from the tomb of Fu Hao, 159; from Tongling, Anhui, *165*; use of, in wine vessel ritual sets, 59–60; from Wangjiazui, Panlongcheng, 32, *35*, *65*, *159*

Jianghan 江漢 valley, cultures of, 56

Jiangning Hengxi 江寧橫溪 (Jiangsu), *nao* from, *162*

Jiangxi Provincial Museum, *140*

Jiaozuo Fucheng 焦作府城. See Fucheng

Jin Nong 金農 (1687–1764+), 194–96

Jing Zhichun, 146n37

Jingdezhen 景德鎮 porcelain kilns, 46

Jingnansi 荊南寺 (Hubei), 87n71, 178n11, 182, 182nn19, 21, 184n34

Jinzhong 晉中 tradition, 127

jue 爵: Anyang-period, from Hunan, 184; from Central Plain elite tombs, *129*; ceramic, from Panlongcheng, 55; from Erlitou, 39, *41*, *129*, *205*, 206; from Feixi, Anhui, 163, *165*; from Funan, Anhui, 163; from Lijiazui, Panlongcheng, 40; modern steel sculpture of, 46, *47*; from Panlongcheng, *32*, 52, 54, *61*, 84, *129*, *159*; sources of, 39; from the tomb of Fu Hao, *129*, 159; use of, in wine vessel ritual sets, 59–60

jugs, 38–39. See also *he*; *jue*

Kaiser, Werner, 100n4, 102, 102n12

Kanesh Kültepe (Anatolia), 87n71

Karlbeck, Orvar (1879–1967), 197, 206

Karlgren, Bernhard (1889–1978), A, B, and C elements, *196*, 197

Keightley, David, 143–44; map of the late Shang state, *144*

Kemp, Barry J., 110n34

Kenoyer, Jonathan, 80n42

Kerr, Rose, 158–59n10

kilns: dragon, at Wucheng site, Jiangxi, 169n41; at Erligang sites in southwest Shanxi, 77n29; at Feijiahe, Hunan, 183; types of, 74n13; at West Minggonglu pottery workshop site, Zhengzhou, 76, 76n28, *78*

knives: from North Saqqara, *109*; from Panlongcheng, 54

La Florida (Peru), 123

Lantian Huaizhenfang 藍田懷真坊 (Shaanxi), 79n39

Laoniupo 老牛坡 (Shaanxi), 81, 82

Laoyazhou 老鴉洲 (Hunan), 183

lapis lazuli, 105

Lattimore, Owen (1900–1989), 145

Lebanon, 105, 106

lei 罍: bronze, from Zhengzhou, *81*; from Lijiazui, Panlongcheng, *33*; from Panlongcheng, *32*, *84*; pottery, from West Minggonglu workshop, Zhengzhou, *81*; from Sanxingdui, Sichuan, 126; use of in wine vessel ritual sets, 60; from Xiangyang Huizu Shipinchang bronze hoard, Zhengzhou, 74n15; from Xingan, Jiangxi, 159, *161*; from the Yueyang region, Hunan, 179n14

Lesure, Richard, 72

Levant, 111

li 鬲: ceramic, from Panlongcheng, 55; as an Erligang pottery type, 76, 76n27, *77*; from Panlongcheng, 54; pottery, from Wucheng, Jiangxi, 160, *160*; from Xingan, Jiangxi, 153, *155*, 159

Li Ji 李濟 (Li Chi; 1896–1979): analysis of Anyang bronzes, 27–28, 40, 42; and Anyang archaeology, 20, 24, 141, 146; dust jacket of *Anyang* by, *210*; on origins of the Anyang bronze industry, 27–28, 38; on origins of Anyang civilization, 26–27, 28–29, 42–43; on origins of Chinese writing, 28–29, 43; Western education of, 20, 26

Li River 澧水, 180, 182

Li Wenjie 李文傑, 76n28

Liangdaicun 梁帶村 (Shaanxi), 159n11

Liangzhu 良渚 culture, 127, 156, 159n11, 169–70

Libya, 104

Lijiazui 李家嘴 (Panlongcheng): bronze assemblage of (Tomb 2), 60; *ding* from, *55*, *62*, 63; jade *ge* from, *56*, *131*; jade handles from, *56*; *jia* from, *55*; *jue* from, *129*; orientation of, 85; plan and inventory of (Tomb 2), *86*, *134*; richest Erligang tomb (Tomb 2), 58–59, *59*, *134*; sacrificial victims, *86*; stoneware *zun* from, *57*; vessel count, 57; wood coffin from, *81*; *yue* from, *132*. See also Panlongcheng

Lin Yun 林澐, 144

ling 鈴 (bells), 164n25

Liu E 劉鶚 (1857–1909), 210

Liu, Li, 86n65, 138

Loehr, Max (1903–1988): on the demise of painted pottery, 75n23; on painting, 208; sequence of bronze styles, 79, 80, 197, 198, 205–6; study of bronzes, 35–38, 40; on thread relief bronze decoration, 41

Longshan 龍山 culture, 182n21

looting, 22–24

Louziwan 樓子灣 (Panlongcheng), 52, 61

Lower Nubia; abandonment of, 110, 110n34; Egypt's expansion to, 104, 108–10, 111; A-Group, 101, 108; material culture of, 112; in Naqada III, *104*. See also Gebel Sheikh Suleiman rock relief; Qustul; Sayala

Lujiang Nihequ 廬江泥河區 (Anhui), *nao* from, *167*

Luo Zhenyu 羅振玉 (1866–1940), 24

Maanshan 馬鞍山 (Anhui), bells from, *166*

mace, from Sayala, Lower Nubia, *108*, 110

Majiayao 馬家窯 culture: narrow-necked jar of, *202*; painted pottery of, compared with Qing dynasty porcelain vase, 203–4

Manetho, *Aegyptiaca*, 103

maps: archaeological sites of early Bronze Age China, *20*, *152*; based on pottery morphology, 139–41, 143; David Keightley's map of the late Shang state, 144, *144*; distribution of Erligang bronzes, 68; distribution of Erligang bronzes and pottery, 83; distribution of Erligang pottery assemblages, *71*; distribution of Shang culture as conceived by Song Xinchao, 142, *142*; and the dynastic model, 139; early Bronze Age archaeological sites in the lower Yangzi River region, *163*; early Bronze Age sites in northern Hunan province, *175*; Egypt, Lower Nubia,

and Palestine in Naqada III, *104*; Erligang-period sites
in Hubei, *58*; Erligang tradition in regional perspective,
128; Erligang walled centers, *125*; Erligang walled sites,
52; major Near Eastern sites during the Uruk period,
72; politics of, 139, 139n12; topographic maps of the
distribution of settlements in the Yuanqu basin, *89*;
Yueyang area and Dongting Lake (Hunan), *177*; Zaoshi
and Baota sites (Hunan), *181*

Maqiao 馬橋 tradition, 127

material culture. *See* culture

McArthur's Universal Corrective Map of the World, 139n13

Meketre, 86n65

Mengzhuang. See Huixian Mengzhuang

Mesoamerica. *See* Olmec culture

Mesopotamia, 22, 75, 80n42; writing in, 43–45. *See also* Uruk
culture; Uruk expansion

metallurgy: hammered metal vessels, 39–40; mining, 81n48,
90, 166–69; origins of, 27–28, 38, 40, 170; sources of, 163.
See also Bronze Age; bronze casting; bronze industry;
copper

Metropolitan Museum of Art, 193, 193n1, 196

Miaopu Beidi 苗圃北地. *See* Anyang

millet, 86

Ming dynasty, 82, 101n8, 139

mining, 81n48, 90, 166–69. *See also* copper; metallurgy

Mi-Luo River 汨羅江, 176, 183

Minggonglu 銘功路 (Zhengzhou): bronzes from, *30*, *31*;
glazed *zun* from, *57*; kiln at, *78*; pottery workshop site,
76n28, *78*, *79*, *81*

Mohenjo-daro. *See* Indus Valley culture

Mongolia, 139n12

Morris, Ian, 124

mortuary ritual, 124, 129, 130

Museum of Fine Arts, Boston, 196, 208

Nanshunchengjie 南順城街 bronze hoard (Zhengzhou), 32,
36, 67, *70*. *See also* Zhengzhou

nao 鐃 (bells), 160; from Changxing, Zhejiang, 164, 166n26;
from Hunan, 166n28, *168*, 174, *174*, 179n14, 184, 184n33;
from Jiangning Hengxi, Jiangsu, *162*; from Lujiang
Nihequ, Anhui, *167*; from Maanshan, Anhui, *166*; from
Ningxiang Shiguzhai, Hunan *168*; from Xingan, Jiangxi,
162, 164n25

Naqada II culture, 75, 101, 105n20, 108

Naqada III culture, 100n4, 101, 102, 111, 116, 118; compared
with Erligang culture, 100–101, 112–15; in Egypt, Lower
Nubia, and Palestine *104*; silt storage jars, *102*

Narmer, 104

Narmer Palette, 113–14, *113*

Near East: ancient sites of, *72*; as birthplace of civilization,
26; and cultural contact with China, 26–27, 166; and
the origins of bronze metallurgy, 170; and the origins
of writing, 170; pottery of, 77n30; as source of high
technology, 28, 166, 170; as source of human sacrifice,
22, 43; as source of painted pottery, 27. *See also* Abydos;
Egypt; Hacınebi; Mesopotamia; Palestine; Uruk culture;
Uruk expansion

Neolithic: burial forms, 43; in Hunan, 179–80, 180n15; jades,
159n11; levels at the Anyang site, 26; painted pottery of,
75, 77, 202–4, *202*; pottery shapes, 27; and rammed-earth
construction, 43. *See also* Daxi culture; Hongshan culture;
Liangzhu culture; Longshan culture; Majiayao culture;
Qujialing culture; Shijiahe culture;

Ningxiang 寧鄉 county (Hunan): bells from, 164–66, 166n28,
168; Bronze Age sites in, 151, 174, 185. *See also* Shiguzhai;
Tanheli (Hunan)

Niutoucheng 牛頭城 (Jiangxi), 151n1

Nubia, 91, 111. *See also* Lower Nubia

Ogata Kōrin 尾形光琳 (1658–1716), *Iris* screens, 193

Olmec culture, 71, 72, 79–80, 80n47, 90

oracle bones: and ancestor ritual, 132; and Anyang, 24–26,
143; inscribed bovine scapula from reign of Wu Ding,
43, *45*; pit deposit at Huayuanzhuang Dongdi, Anyang,
26; study of, 141, 210; Turtle plastron with brush-written
inscription, 24, *26*

painted pottery: compared with Qing porcelain vase, 203–4;
narrow-necked jar with vertical handles from Majiayao,
202; Neolithic, 202–4; sources of, 27; as source of bronze
decoration, 40; standardization of, 75, 77

paintings: and art historical practice, 191–92, 208; *Birds
in a Thicket of Bamboo and Plum* (unidentified artist,
ca. early 12th century), 200, *201*; *Finches and Bamboo*
(Emperor Huizong), 200, *201*; *Ink Plum* (unidentified
artist, Qing dynasty), 192, *192*, *198*; *Ink Plum* (Wang
Mian), *195*; inscriptions on, 191–92, 199; *Silk Beating*
(attributed to Emperor Huizong), 208, *208–9*, 208n20;
Song retrospective, 208–9; *Sparrows, Plum Blossoms, and
Bamboo* (unidentified artist, late 12th century), 200, *201*

palaces, 20, 53, 123, 132, 174; Panlongcheng and Zhengzhou
palace foundations, *54*

Palermo Stone, 103

Palestine, 104, 105–6, 110, 112; in Naqada III, *104*

palettes, Egyptian: relief, Naqada III, from Tel Bet Yerah,
Israel, *105*, 106; Narmer, 113, *113*, 114; Two Dog, 114, *116*

pan 盤, from Baijiazhuang, Zhengzhou, *30*, 31, *31*

Panlongcheng 盤龍城: abandonment of, 74–75, 74n17, 161;
acquisition of food at, 87; bronze vessel types, 52, 54, *84*;
bronzes from, 31–32, *32*, *33*, *34*, *35*, *37*, *38*, *40*, *42*, *43*, 51, *55*,
57, *61*, *62*, 63, *84*, *129*, *132*, 151, *159*; building foundations,
52–53; burials customs, 53–54; city walls, 51, 52, 53, *70*, *84*;
connections with southern bronze industries, 163, 173, 175,
177, 182, 185; discovery and identification of, 31, 51–55; east
wall, *53*; as an Erligang colony, 84–87, 105, 127–28; and the
Erligang culture, 19, 152; and the Erligang expansion, 82,
111; as an Erligang outpost, 55–56, 67, 167, 178; evidence
of repairs to bronzes from, 61–63; excavation report,
57–58, 61; foundries of, 60–61, 79n39; and interregional
networks, 177–78, 182; military class at, 87; palaces, 53,
70, 85; plans of, *53*, *70*; pottery assemblages of, *76*, 77, 177;
pottery types from, 55, 87, *87*; relations with Zhengzhou,
55–57, 87; and social status, 58–59; as source of raw
materials, 90; strategic location of, 90; tombs of, 51, *54*,
58–59, 60; Upper Erligang phase at, 84–85; view from
north of city walls, *53*; wine vessels, 159. *See also* Lijiazui,
Louziwan, Wangjiazui, Yangjiawan, Yangjiazui

Peking University, 52

pendants, jade, from Xingan, Jiangxi, *157*

Pengtoushan 彭頭山 (Hunan), 180, 180n15

People's Republic of China: archaeology in, 29, 84n63, 137–38, 139–40; overseas exhibits in 1970s, 31

"perpetual frontiers," 173, 173n2

pestles, egg-shaped, from Qustul, Lower Nubia, *107*

pigs, 127

Pinggu 平谷 district (Beijing), 166

Pinglu 平陸 (Shanxi), *fangding* from, 35, *37*, 92, *92*

Pool, Christopher, 80n47

porcelain, Qing dynasty vase with *famille rose* enamel decoration, 203–4, *203*

Postgate, J. N., 73, 77n30, 79n41

pottery: centralized production of, 75–77; decoration of, 202–4; distribution of, 139–41; early Bronze Age glazed stonewares, 158–59n10; Egyptian, 105, 116; as evidence for the Erligang expansion, 75–78; of Hunan, 180–84; inscribed, from Xingan, Jiangxi, *169*; interpretation of, 69, 73, 74n13, 75–78, 139–41; Near Eastern, 77n30; as source of bronze vessel shapes, 27, 38; standardized production of, 75; storage area for, at Jiangxi Provincial Museum, *140*; typology of, 139–41; use of, in shipping, 77n29. *See also* Erligang pottery; painted pottery; pottery workshops

pottery workshops, 76–77, 76n28, 183. *See also* kilns

pou 瓿: from Gaocheng Taixicun, Hebei, 159n14; from Wuguan Beidi, Anyang, *161*

pou-ding, from Xingan, Jiangxi, 159, *161*

pouring vessel, siltstone, from Sayala, Lower Nubia, *108*, 110

primacy of the object, 192, 198, 201

Princeton University, 196, 198, 199

printing, invention of, 46

Qianlong 乾隆 (Qing-dynasty emperor; 1711–1799, r. 1736–95), 20

Qijia 齊家, pottery *he*, *39*

Qin dynasty, statutes on artisans, 77

Qing dynasty, 139, 203–204

Qujialing 屈家嶺 culture, 178, 180, 180n15

Qustul (Lower Nubia), 118; cemetery contents, *107*, 108

rammed-earth construction: of foundations from Anyang, 20, *23*; labor force required for, 123, 123n11; Neolithic history of, 43; of walls at Gucheng Nanguan, Shanxi, *91*; of walls at Panlongcheng, 53, 67; of Zhengzhou city wall, 29, *29*, 53, 67, 123, 123n11. *See also* city walls

Rameses II, 92n85

Rawson, Jessica, 167, 177n10

Renfrew, Colin, 73n11

rice cultivation, 86, 182

ring-footed vessels, 32. See also *gu*; *gui*; *lei*; *you*, *yu*

ritual: ancestral, 116, 130, 132, 133; bronzes and, 12, 32, 60, 74, 78; centers of, 57, 177, 182; sacrifices and, 123. *See also* bronzes; Erligang bronzes

Rome, 122; plan of, *122*; sculptures of emperors, 79n40

Rothman, Mitchell, *Uruk Mesopotamia & Its Neighbors*, 71

Ruichang Tongling 瑞昌銅嶺 (Jiangxi), 167. *See also* copper, mining

running spiral, 27, 40, 41, *42*, 48, 202, 203, 204

sacrificial animals, 82, *85*, 123, 127, 132, 147. *See also* sacrificial remains

sacrificial remains: at Sanxingdui, Sichuan, 151; from Xibeigang, Anyang, *133*; from Yanshi, 123, 132; from Zhengzhou, 123, *124*

sacrificial pits. *See* sacrificial remains; waist pits

Sanxingdui 三星堆 (Sichuan), 111, 126, 127, 142, 151, 164n22

Saqqara: stone vessels from, *112*; tomb containing copper vessels and tools, *109*, 110

Sayala, cemetery contents, 108–10, *108*

Scott, James C., 87n69

shaft tombs, 22–24

Shang state: Chen Mengjia's five-tier political geography of, 141–42; Erligang and, 67, 67n1, 102; king of, 24, 141, 144; mapping of, 139, 141–42, *142*; material cultures of, 129n38; political strength of, 143–45; regional variation in, 77n33; and the use of the term "Shang dynasty" in archaeology, 138. *See also* Anyang; "transition period"

sheep, 127

shells, 146. *See also* oracle bones; turtles

Shiguzhai 石鼓寨 (Ningxiang, Hunan), bell of type *nao*, *168*

Shijiahe 石家河 culture, 56, 127, 178, 180, 180n15, 182nn20, 21; jades, 156, 159n11

Shima Kunio 島邦男 (1908–1977), 141

Shimen 石門, 179, 180, 180nn15, 17, 182, 184n34, 185. *See also* Zaoshi

Shimen Zaoshi 石門皂市. *See* Zaoshi

sickles, stone, 86, *86*, 87n66

Siwa 寺洼 tradition, 127

social stratification, 12, 51, 58–60, 73–74, 75

Song dynasty, 208, 209

Song Xinchao, map of the distribution of Shang culture, 139, 142, *142*

Soper, Alexander (1904–1993), 197

Sparrows, Plum Blossoms, and Bamboo (unidentified artist, late 12th century), *200*, 201

Stein, Gil, 83–84, 87–90, 92

stone: decoration of, in Egypt, 113; handle-shaped objects, from Erligang sites, 55, *56*, 82, *85*; sculpture of the Olmec culture, 80; seals of the Indus Valley, 80, 80n45. *See also* stone vessels; stoneware

stone vessels: Egyptian, in the shape of a basket, 116–17, *117*; as prestige goods in Egypt, 113; from Saqqara, *112*.

stoneware: and the ancestry of Chinese porcelain, 169; Erligang, 158n10; glazed, from Xingan, Jiangxi, 156, *157*, 169, *169*; *guan* from Xingan, *157*, *169*; northern, 156, 156–58n9; origins of, 127; southern, 156, 156n9, 169; vase from Xingan, *157*; of Zhengzhou and Panlongcheng, 56; *zun* from Panlongcheng, 55; *zun* from Xingan, *169*.

storage jars, of the Naqada III culture, *102*

stylistic analysis: 68, 194–6, 199. *See also* Loehr

Suizhou 隨州 (Hubei), 182n21

Syria, 90, 106. *See also* Mesopotamia; Uruk culture; Uruk expansion

Taiwan, 139n12, 139n13

Taixicun (Hebei). See Gaocheng Taixicun

Tan Qixiang 譚其驤 (1911–1992), 139

Tang dynasty, 139, 208

Tang Jigen 唐際根, 77–78n33, 138, 146n37

Tanheli 炭河里 (Ningxiang, Hunan), 151, 174, 185n35. *See also* Ningxiang county

taotie 饕餮, 32, 40, 153, 161, 166n26

Tel Bet Yerah (Israel), relief palette from, **105**, 106

tetrapods, 159. See also *fangding*; *he*; *yan*

textiles, 40, 46

thread relief. *See* bronze decoration

Tianfa Shenzhen bei 天發神讖碑. See Heavenly Omen Stele

Tiesanlu 鐵三路 (Anyang), 146

tigers, 152, 153, **154**, 160, 163

timber, 91, 105, 167. *See also* metallurgy; mining

tin, 166

tombs, *See* burial customs

tomb robbers, 22–24

Tonggushan 銅鼓山 (Hunan), 176–79, 176n5, 182, 183, 185; bronze vessels from, 178–79, 184; Erligang occupation of, 178, 184; pottery of, 176n7; satellite image of the site, **176**; strategic location of, 176

Tongling 銅陵 (Anhui): copper deposits, 168; Erligang bronzes from, 163, **165**, 167. *See also* copper; mining

Tongling 銅嶺 (Ruichang, Jiangxi). *See* Ruichang Tongling

Tonglüshan 銅綠山 (Hubei), 166–67, 168. *See also* copper, mining

tools: adzes, **109**; axes, 86, **86**, 154, **155**, 156, **158**; copper, **109**, 110; chisels, **158**; knives, 54, **109**; used to make pottery, 77; from Xingan, Jiangxi, 156–58

trade networks, 87–90, 92, 143, 146

"transition period," 126, 153n4, 159, 166, 180n17.

Trigger, Bruce G. (1937–2006), 74n14, 99

tripods, 32, 38. See also *ding*; *he*; *jia*; *jue*; *li*; *pou-ding*; *yan*

Tung Tso-pin. *See* Dong Zuobin

turtles: plastron with brush-written inscription from Huayuanzhuang Dongdi, Anyang, 24, **26**; as trade goods, 146

Tutankhamun, tomb of, 26

Two Dog Palette, 114, **115**

Underhill, Anne, 129

unicorn motif on Indus valley seals, 80n45

Ur (royal tombs), 22, 43

Uruk culture, 75n18; pottery of, 75n24, 77

Uruk expansion (Mesopotamia), 69–71, 75, 79, 87–90; two types of Uruk colony, **88**

vessel shapes: origins of, 38–40, 45; at Zhengzhou and Panlongcheng, 54, 55; and vessel typology, 37. *See also* bronze casting

visual thinking, 191, 198, 202n9, 205–6, 207

waist pits (*yaokeng*), 82; at Beierqilu, Zhengzhou, **85**; at Zhengzhou and Panlongcheng, 53–54, 85

walled cities; 56, 124, 151; Erligang walled sites, **52**; **125**. *See also* city walls; Dongxiafeng; Fucheng; Gucheng Nanguan; Huixian Mengzhuang; Panlongcheng; Yanshi; Zhengzhou

Wang Guowei 王國維 (1877–1927), 141

Wang Haicheng 王海城, 99, 104–5, 116. *See also* Erligang expansion

Wang Mian 王冕 (d. 1359), *Ink Plum*, **195**

Wang Yirong 王翼容 (1845–1900), 210

Wangjiazui 王家嘴 (Panlongcheng), *jia* from, 32, **35**

weapons, 54, 55, **108**, **109**, 130, 156–58; bronze, 130, **132**, 154, **155**, 156, 158, **158**; jade, **56**, **131**. *See also* arrowheads; axes; *ge*; helmet; knives; mace; *yue*

Wei River 溈河 valley (Hunan), 174–75, 174n4, 179n14, 185, 185n35

Wei River 渭河 valley (Shaanxi), 166

Wengrow, David, 105n20, 116

Wenjiashan 溫家山 (Hunan), 183

Western Zhou bronzes, 79, 101n8

wheat, 127

whiteware, Anyang, 157n9

wine vessels, 54, 59–60, 159, 163; Palestinian, 106. See also *gu*; *he*; *jia*; *jue*; *lei*; *you*; *zun*

Wood, Nigel, 158–59n10

wood carving, 27–28

Woolley, Leonard (1880–1960), 22, 43

world-systems theory, 145, **145**

Wright, Henry, 75n24

writing systems: Near Eastern, 73, 101, 102, 108, 112, 114; origins of, 26, 43–44, 170. *See also* Chinese writing; inscriptions

Wu Ding 武丁 (first king attested at Anyang, ca. 1200 BCE), 135, 198. See also Fu Hao

Wucheng 吳城 culture (Jiangxi): bronze casting, 86n65, 156; connection of pottery with Xingan, 156; dragon kilns, 169n41; glazed stoneware, 158–59n10, 169; inscribed pottery from 169; pottery *li*, 159, **160**; relations with Central Plain, 143; walled city at, 151. *See also* Xingan

Wuguan Beidi 武官北地 (Anyang), *pou* from, **161**. See also Anyang

Xia dynasty, 138

Xia-Shang-Zhou chronology project, 137, 138

Xi'an Laoniupo 西安老牛坡 (Shaanxi), 81, 82

Xiang River 湘江, 151, 173, 174, 175, 176, 178, 185

Xiang Taochu 向桃初, 174, 183n24, 184, 185n35

Xiangfan 襄樊 (Hubei), 182n21

Xiangxi 湘西 region (Hunan), 173n2, 174n3

Xiangyang Huizu Shipinchang 襄陽回族食品廠 bronze hoard (Zhengzhou), 32, **36**, **37**, 67, 74

Xiaogan 孝感 (Hubei), 56

Xiaoshuangqiao 小雙橋 (Zhengzhou), 43, **44**

Xiaotun 小屯 (Anyang), *ge* from, **131**; rammed-earth foundation at, 20, **23**. See also Fu Hao, tomb of;

Xiaxian Dongxiafeng 夏縣東下馮. *See* Dongxiafeng

Xibeigang 西北崗 (Anyang): during excavation, *23*; *fangding* from, *24*; *he* from, 24, *25*; human sacrifice, 132, *133*; sacrificial pits, *133*

Xin xian 忻縣 (Shanxi), 179n13

Xin Zhongguo de kaogu faxian he yanjiu 新中國的考古發現和研究 (Archaeological Excavation and Researches in New China), 138

Xin Zhongguo de kaogu shouhuo 新中國的考古收穫 (Archaeology in New China), 138

Xindian 辛店 tradition, 127

Xingan Dayangzhou 新幹大洋洲. *See* Xingan

Xingan 新幹 (Jiangxi): bells, 160, *166*, 166n28; bronzes, 86–87n65, 126, 142, 151, 152, 156, 158, 159, 161; connections with Erligang, 86–87n65, 152, 158, 161; discovery of tomb, 154; *fangding* from, 152–53, *154*; imports to, 159–60; inventory of, 156, 158, 159; inscribed ceramics, 169, *169*; jades, 156, 159n11; metallurgy of, 163; question of whether it was a tomb, 156n7; stoneware, 156, *157*, 169, *169*; use of local motifs, 153, 164; use of sequential casting, 153; vessel handles with animals from, 152–53, *154*; view of site, *156*; weapons and tools, 156–58. *See also* Wucheng culture

Xinqiang 新墙 River, 176, 183

Xitang zhen 西塘鎮, 184n33

Xu Hong 許宏, 138

Xu Weihua 胥衛華, 179n13

Xuanhe huapu 宣和畫譜, 208n20

yan 甗: four-legged, from Xingan, Jiangxi, 159, *160*; from Lijiazui, Panlongcheng, *37*; as pottery shape, 38

Yang Shoujing 楊守敬 (1839–1915), 139

Yangjiawan 楊家灣 (Panlongcheng): bronze assemblages of, 60; *ding* from, *62*; *gu* from, *35*; plan and tomb inventory, *54*, 86, *86*. *See also* Panlongcheng

Yangjiazui 楊家嘴 (Panlongcheng), 60

Yangzi region: archaeological sites of, *163*; bronze industry of, 152; cultures of, 127

Yanshi Erlitou 偃師二里頭. *See* Erlitou

Yanshi Shang cheng 偃師商城. *See* Yanshi

Yanshi 偃師, 56, 74n17, 79n39, 122, 123, 132

yaokeng 腰坑. *See* waist pits

Yinxu 殷墟, 129n38. *See also* Anyang

Yoffee, Norman, 99, 116, 121

you 卣: Ge, from Ningxiang, Hunan, 206–7, *207*; from Lijiazui, Panlongcheng, 31, 32, *34*, *42*; typology of, 159n15; use of, in wine vessel ritual sets, 60; from Xiangyang Huizu Shipingchang bronze hoard, 74n15. See also *fangyou*

yu 盂, from Lijiazui, Panlongcheng, *33*

Yuan Jing, 132

Yuanqu basin 垣曲盆地 (Shanxi), 90–91, 143; topographic maps of, *89*. *See also* Gucheng Nanguan

Yuanqu Shang cheng 垣曲商城. *See* Gucheng Nanguan

yue 鉞 (weapon type): from Lijiazui, Panlongcheng, *132*; from Panlongcheng, 54

Yue 越 culture, 184

Yueshi 岳石 tradition, 127

Yueyang 岳陽 region (Hunan), 174n3, 179n14, 183, 184; map of, *177*. *See also* Tonggushan

Yun River 溳水, 56

Yunmeng 雲夢 (Hubei), 56

Yusishan 玉笥山 (Hunan), 183

Zaoshi 皂市 (Hunan): as Bronze Age site, 179–80; cultural diversity of, 182; Erligang influence on, 182, 185; and interregional networks, 182, 182n19; looking south from *181*; location of, 180–82, *181*; periods of occupation, 180n17; pottery of, 178n11, 180

Zhang Xuan 張萱 (act. 714–741), 208, 208n20

Zhangshutan 樟樹潭 (Hunan), 183, 183n24, 184

Zhangzhai Nanjie 張寨南街 bronze hoard (Zhengzhou): contents of, 67; *fangding* from, *37*, 152, *153*

Zhangzong 章宗 (Jin-dynasty emperor; 1168–1208, r. 1189–1208), 208

Zhengzhou 鄭州: abandonment of, 74, 74n15; bronze casting technology of, 86–87n65, 124; bronze hoards from, 32–35, *36*, 37, 67, *70*, *74*, *153*; bronze-yielding tombs at, 51; burials at, 53–54, *54*, 59n16, 85, 124; ceramic workshops of, 76–77, 124; city walls of, 29, *29*, 51, *53*, 67, *69*, 123, *123*, 123n11; compared with Anyang, 129, 133; contacts with Panlongcheng, 56–57, 87; as Erligang site, 19, 29, 121; jades from, *56*; and Loehr's bronze sequence, 197; settlers of Panlongcheng from, 85–86; as node in a network, 128; palaces, 53, *56*, *69*, 85, 123; plan of, *69*, *122*; pottery assemblages of, *76*; relationship to other Erligang sites, 125; sacrificial remains from, 59n16, 123, *124*; and Shang dynasty, 67, 74; size and scale of, 122–23, 124; as a source of information, 74–75; southern stoneware found at, 169; southerners at, 128; as superpower, 126–27; vertical cross-section of city wall, *53*. *See also* Baijiazhuang; Beierqilu; Minggonglu; Nanshunchengjie bronze hoard; Xiangyang Huizu Shipinchang bronze hoard; Xiaoshuangqiao; Zhangzhai Nanjie bronze hoard

Zhongguo kaoguxue: Xia Shang juan 中國考古學:夏商卷 (Chinese Archaeology: Xia and Shang), 138

Zhongguo lishi ditu ji 中國歷史地圖集 (Historical Atlas of China), 139

Zhongtiao mountains 中條山, 91

Zhukaigou 朱開溝 tradition, 127

Zou Heng 鄒衡 (1927–2005), 78n33

zun 尊: from Baijiazhuang, Zhengzhou, *30*, 31, *31*; from Feijiahe, Hunan, 179n14; from Funan, Anhui, 163, *165*; glazed stoneware, from Minggonglu, Zhengzhou, *57*; from Huarong, Hunan, 179n14; offered by Paris art dealer in 1924, 19, *21*, 31, 38; pottery and stoneware, from Panlongcheng, 55; from Sanxingdui, Sichuan, 126; stoneware, from Xingan, Jiangxi, *169*; stoneware from Lijiazui, Panlongcheng, *57*

Image Credits

Maps

All maps drawn by International Mapping Associates with the exceptions of map 3 (from Stein, "From Passive Periphery to Active Agents," 910 fig. 1) and map 5 (from *Yuanqu pendi juluo kaogu yanjiu*, plate 78) in chapter 3. Map 2 in chapter 5 was adapted from Campbell, *Blood, Flesh and Bones*, 324. Jeremy Linden of Marquand Books added the inset plans to map 1 in chapter 5 after *Kaogu* 2004.3: 60 fig. 1, *Zhongguo kaoguxue: Xia Shang juan*, 206 fig. 4.5, and *Panlongcheng*, vol. 1, 8 fig. 5.

Cover

Photo: Kyle Steinke, with permission from the Hubei Provincial Museum; from Tch'ou, *Bronzes antiques de la Chine*, plate 16.

Chapter 1

1 From Sirén, *History of Early Chinese Art*, plate 19; **2** From Tch'ou, *Bronzes antiques de la Chine*, plate 16; **3** From Palmgren, *Selected Chinese Antiquities*, plate 2; **4** From Voretzsch, *Altchinesische Bronzen*, plate 19; **5** Royal Ontario Museum © ROM; **6** Imaging Department © President and Fellows of Harvard College; **7, 8** From Shi, *Xiaotun diyiben: Yizhi de faxian yu fajue: Yibian: Jianzhu yicun*, plates 5, 11; **9** From Gao, *Houjiazhuang (Henan Anyang Houjiazhuang Yin dai mudi) diliuben, 1217 hao da mu*, plate 3; **10, 16** From *Yinxu*, plates 11, 24; **11** From *Kaogu* 1988.10: plate 4; **12** From Gao, *Houjiazhuang (Henan Anyang Houjiazhuang Yin dai mudi) diwuben, 1004 hao da mu*, plate 29; **13** From *Laizi biluo yu huangquan*, 19; **14** From Barnard and Satō, *Metallurgical Remains of Ancient China*, frontispiece; **15** Courtesy of the Nezu Museum; **17** Courtesy of Institute of History and Philology, Academia Sinica; **18** From *Zhongguo gudai keji wenwu zhan*, 110; **19, 20, 37** From *Zhengzhou Shang cheng*, vol. 3, b&w plates 38, 39.2, color plate 10.1; **21, 22** From *Wenwu cankao ziliao* 1955.10: 38, 36; **23** From *Kaogu* 1965.10: plate 3; **24** Vessel from *Kanan-shō Hakubutsukan*, plate 54; rubbing from *Shang Zhou qingtongqi wenshi*, no. 707; **25, 28, 40, 43, 46–50** From *Zhongguo qingtongqi quanji*, vol. 1, plates 149, 88, 37, 103, 4, 6, 19, 13, 1; **26, 27, 31–34, 45, 51** (detail only), **52** Photos: Kyle Steinke, with permission from the Hubei Provincial Museum; **29, 39** From *Chūka Jinmin Kyōwakoku kodai seidōki ten*, nos. 4, 1; **30, 41, 51** Courtesy of the Hubei Provincial Museum; **35, 36** From *Zhengzhou Shangdai tongqi jiaocang*, b&w plate 1, color plate 2; **38** From *Kōga bunmei tenran*, plate 32; **42** Photo: Asian Art Museum of San Francisco; **44** From Andersson, *Researches*, plate 38; **53** From *Zhengzhou Xiaoshuangqiao*, vol. 2, color plates 28.1 (right), 28.2 (right), 30.2 (right), 31.3 (right); **54** From Pirazzoli-t'Serstevens, *La Cina*, 1:28; **55** From Roaf, *Cultural Atlas*, 136; **56** Photos: Kyle Steinke.

Chapter 2

1a, 1b, 4, 13, 15a, 15b From *Panlongcheng*, vol. 2, b&w plate 1, color plate 4.1, b&w plates 12, 39.1, color plates 38, 14; **2, 5a, 6** From *Panlongcheng*, vol. 1, 8 fig. 5, fig. 24 (inset between pp. 44 and 45), 236 fig. 171; **3a, 9b, 10b** From *Zhengzhou Shang cheng*, vol. 3, b&w plate 39.2, color plate 19.3, b&w plate 242.3; **3b** After Thorp, *China in the Early Bronze Age*, 69 fig. 2.3; **5b, 7** After *Zhengzhou Shang cheng*, vol. 1, 248 fig. 152, 580 fig. 394; **8a, 8b** From *Zhongguo qingtongqi quanji*, vol. 1, plates 88, 85; **9a, 15c, 16** Courtesy of the Hubei Provincial Museum; **10a, 11b** From Zhang and Guo, *Zhongguo chutu yuqi quanji: 10 Hubei, Hunan*, 48, 44; **11a** From Chen and Fang, *Zhongguo yuqi quanji: 2 Shang, Xi Zhou*, plate 19; **12a** From Li et al., *Panlongcheng qingtong wenhua*, 187; **12b** From *Zhongguo taoci quanji: 2 Xia, Shang, Zhou, Chunqiu, Zhanguo*, plate 28; **14** Photo: Kyle Steinke, with permission from the Hubei Provincial Museum.

Chapter 3

1a After Yuan and Zeng, "Lun Zhengzhou Shang cheng," 60 fig. 1; **1b, 15a** After *Zhengzhou Shang cheng*, vol. 1, 275 fig. 169, 576 fig. 389; **2** From *Zhengzhou Shangdai tongqi jiaocang*, b&w plate 1; **3a, 3b, 16–18** After *Panlongcheng*, vol. 1, 8 fig. 5, 43 fig. 23, 225 fig. 161, 154 fig. 100, 496 fig. 348b (left column); **4, 19a** From Stein, "Colonies without Colonialism," 38 fig. 2, 41 fig. 3; **5** After Zou, *Xia Shang Zhou kaoguxue lunwenji*, inset between pp. 8 and 9; **6** After *Zhongguo kaoguxue: Xia Shang juan*, 194 fig. 4-4; **7a** From *Erlitou taoqi jicui*, no. 184; **7b, 8, 9a–f, 11, 12, 15c–e** From *Zhengzhou Shang cheng*, vol. 3, b&w plates 32.3, 66.2, 79.1, 79.2, 69.4, 76.5, 77.4, 195,

227.2, 144.1, 144.3, 242.3; **9e** Courtesy of the National Museum of China; **10** Photo: Cao Dazhi; **13** From *Panlongcheng*, vol. 2, b&w plate 40.2; **14** Photo: Kyle Steinke, with permission from the Hubei Provincial Museum; **15b** After *Wenwu* 1983.3: 69 fig.16, right; **19b** From Algaze, *Uruk World System*, 26 fig. 5B; **20a, 20b** After *Yuanqu pendi juluo kaogu yanjiu*, 360 fig. 193, 373 fig. 197; **21** From *Zhongguo qingtongqi quanji*, vol. 1, plate 37.

Chapter 4

1 From Dreyer, Hartung, and Pumpenmeier, *Umm el-Qaab I*, plate 24. Courtesy of the German Archaeological Institute; **2a** From Dreyer, "Ein Siegel der frühzeitlichen Königsnekropole von Abydos," 36 fig. 3; **2b** From Dreyer et al., "Umm el-Qaab: Nachuntersuchungen im frühzeitlichen Königsfriedhof, 7./8. Vorbericht," 72 fig. 26. Courtesy of the German Archaeological Institute; **3** Courtesy of Raphael Greenberg; **4** Courtesy of the German Archaeological Institute; **5, 6** From Williams, *Excavations*, plates 34, 105b, 39. Courtesy of the Oriental Institute, University of Chicago; **7a, 7b** Courtesy of the Oriental Institute Museum; **8a, 8b, 9, 10** From Firth, *Archaeological Survey of Nubia*, plate 18b, 205 fig. 8, plates 18f, 22; **11a, 11b** Reproduced from archive prints of the photographs used for the plates in Emery, *Great Tombs of the First Dynasty I*, plates 9, 10. Property of the Egypt Exploration Society; courtesy of the Egypt Exploration Society; **12** From William J. Murnane, "The Gebel Sheikh Suleiman Monument: Epigraphic Remarks," appendix C in Williams and Logan, "Metropolitan Museum Knife Handle," 285 figs. 1A, 1B (merged); **13, 14, 17** Photos: Jürgen Liepe; **15** Courtesy of the Ashmolean Museum. Photos: Liam McNamara; **16** Courtesy of the Ashmolean Museum.

Chapter 5

1a After *Zhongguo kaoguxue: Xia Shang juan*, 220 fig. 4.8; **1b** From Dey, *Aurelian Wall*, 2 fig. 0.1; **2, 3a, 3b** From *Zhengzhou Shang cheng*, vol. 3, b&w plates 4, 87.2, 8.2; **4a** From *Zhongguo qingtongqi quanji*, vol. 1, plate 6; **4b** Photo: Kyle Steinke, with permission from the Hubei Provincial Museum; **4c** From Rawson, *Mysteries of Ancient China*, 95 fig. 41.2; **5a–c** From *Zhongguo kaoguxue: Xia Shang juan*, plates 13.2, 13.1, 12.1; **6a–c** From Zhang and Guo, *Zhongguo chutu yuqi quanji: 10, Hubei, Hunan*, 42, 41, 40; **7a, 7b** From Tian, *Zhongguo chutu yuqi quanji: 5, Henan*, 84, 45; **7c** From Chen and Fang, *Zhongguo yuqi quanji: 2 Shang, Xi Zhou*, plate 34; **8** Courtesy of the Hubei Provincial Museum; **9a–c** From *Yinxu de faxian yu yanjiu*, b&w plates 14.2, 13.1, 15.4; **9d** From Gao, *Houjiazhuang (Henan Anyang Houjiazhuang Yin dai mudi) dierben, 1001 hao da mu*, vol. 2, plate 28.1; **10a** From Thorp, *China in the Early Bronze Age*, 33 fig. 1.3; **10b** After *Panlongcheng*, vol. 1, 154 fig. 100; **10c** From *Yinxu Fu Hao mu*, 14 fig. 7.

Chapter 6

1 Photo: Yung-ti Li; **2** From Song, *Yin Shang wenhua quyu yanjiu*, 201; **3** From Keightley, "Late Shang State," 544; **4** From Chase-Dunn and Hall, "Comparing World-Systems," 15.

Chapter 7

1, 32, 33b From *Zhongguo qingtongqi quanji*, vol. 1, plates 35, 117, 79; **2, 3a, 5–17, 19, 21–23, 25, 26, 28, 29a, 29b, 39a** (vessel), **39b** (vessel) From *Shangdai Jiangnan*, 167, 173, 177, 196, 19, 19, 143, 149, 211, 308, 312, 306–7, 39, 203, 114, 124, 194, 59, 71, 179, 42, 189, 193, 87, 87, 175, 142, 140, with permission from the National Museum of China; **3b, 3c, 30b, 37** Photos: Kyle Steinke; **4** From Chen, *Xia Shang Zhou qingtongqi yanjiu*, vol. 1, no. 39; **18** Photo: Kyle Steinke, with permission from the Hubei Provincial Museum; **20, 35a, 39a** (rubbing), **39b** (rubbing) From *Xingan Shangdai da mu*, b&w plate 67.6, 90 fig. 46B, 165 fig. 83.4, 175 fig. 90.3; **24** From *Zhongguo qingtongqi quanji*, vol. 3, plate 72; **27** Nanjing Museum; **30a** From *Zhongguo qingtongqi quanji*, vol. 11, plate 147; **31a, 31b, 34, 35b** From *Wannan Shang Zhou qingtongqi*, 10, 12, 14, 16; **33a** From *Zhongguo qingtongqi quanji*, vol. 4, plate 55; **36** From *Anhui sheng bowuguan cang qingtongqi*, plate 10; **38** From *Konan-shō Hakubutsukan*, plate 27.

Chapter 8

1 From *Zhongguo gu qingtongqi xuan*, no. 17; **2** From *Konan-shō Hakubutsukan*, plate 11; **3, 5–7** Photos: Robin McNeal; **4** Image © Google, DigitalGlobe.